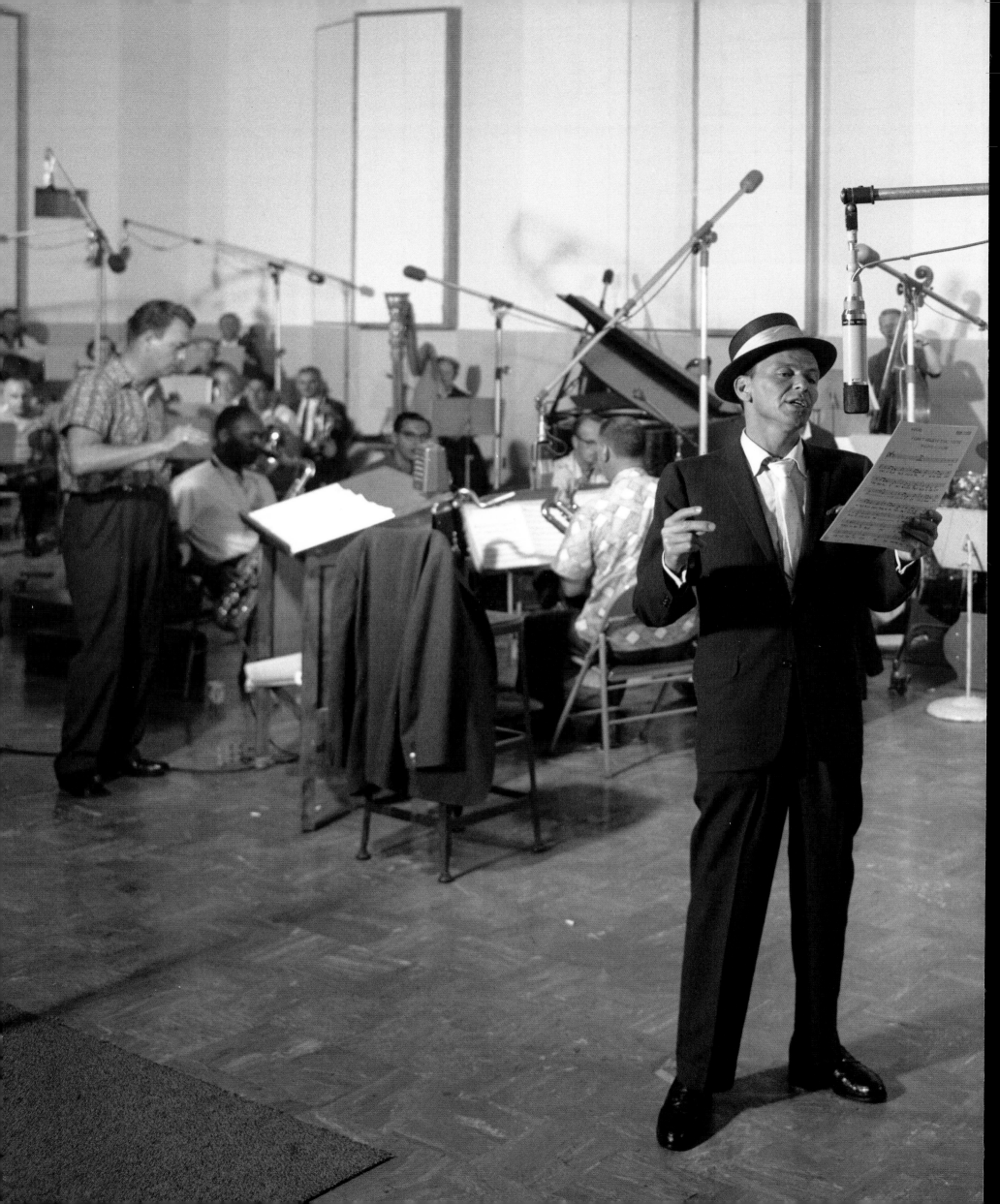

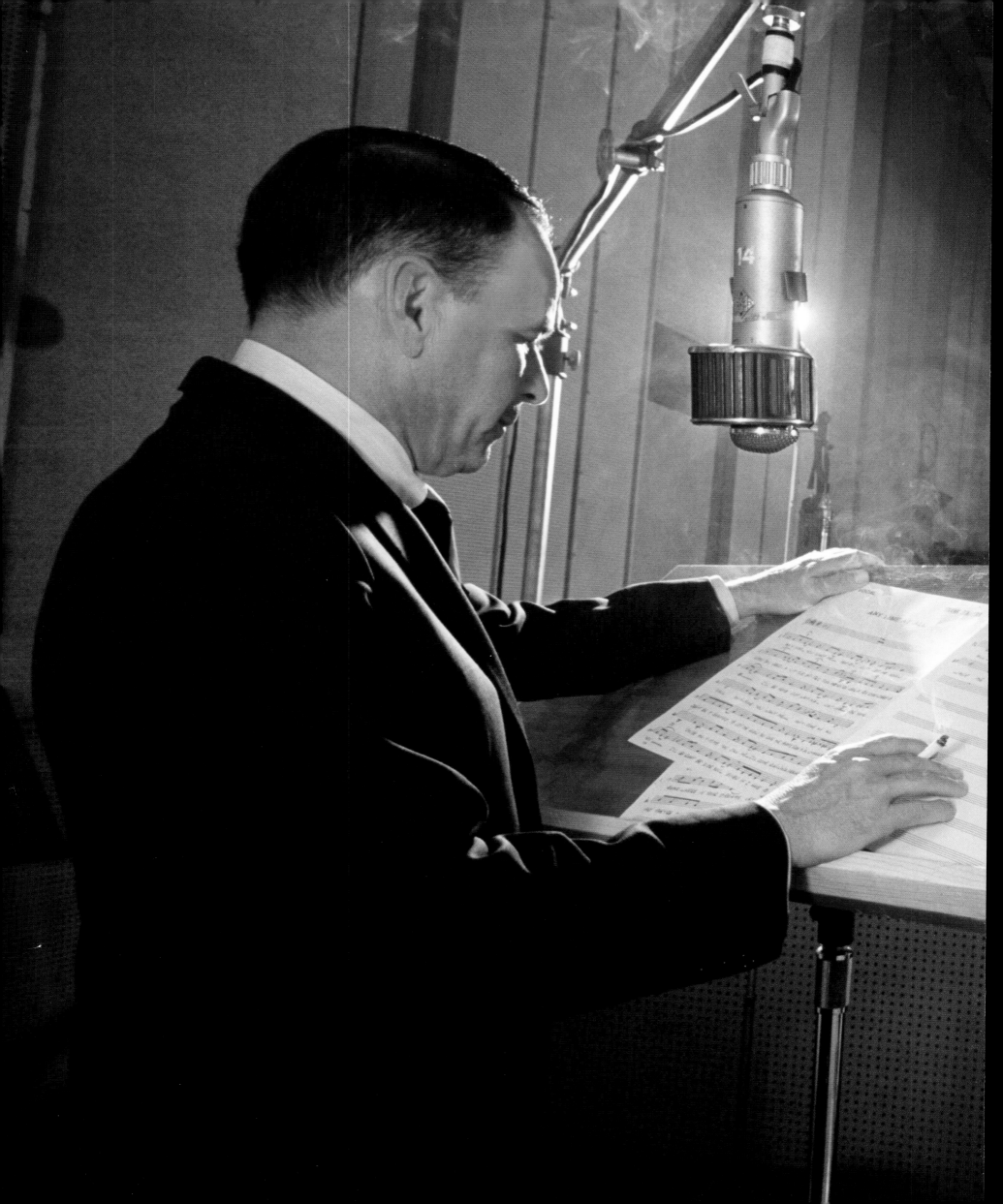

CHARLES PIGNONE

Foreword
TONY BENNETT
STEVE WYNN

Afterwords
NANCY SINATRA
FRANK SINATRA JR.
TINA SINATRA

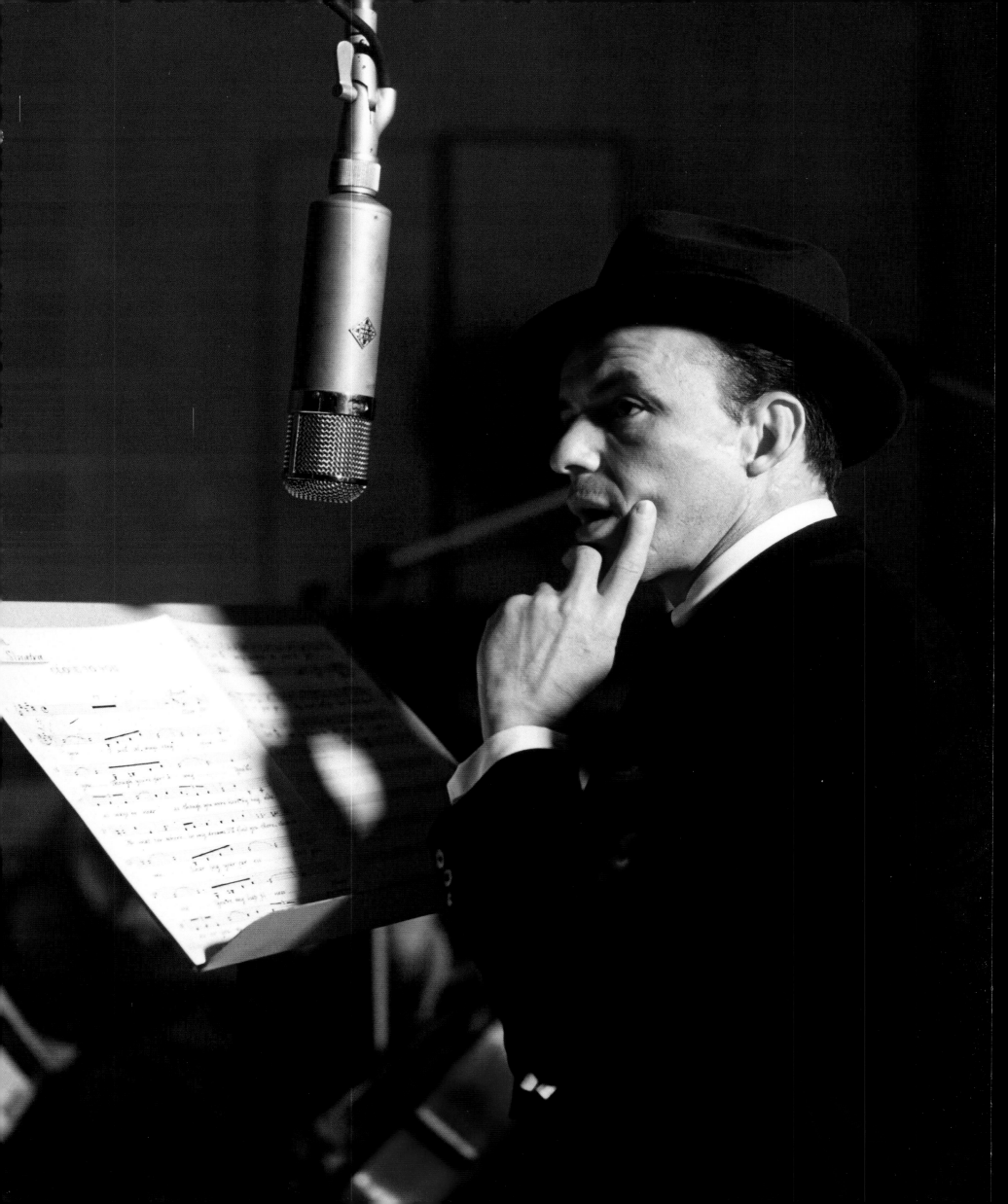

Contents

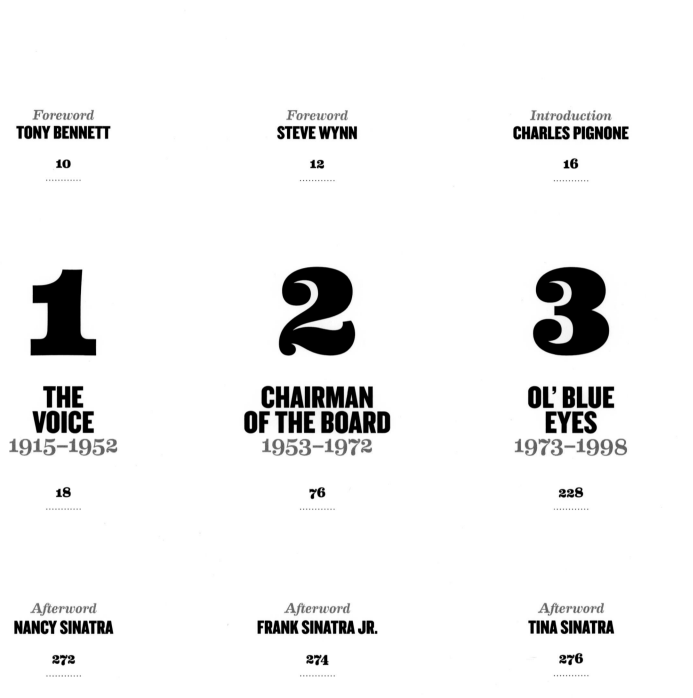

opposite Tony Bennett at his art studio in Manhattan.

n Frank Sinatra I found my greatest mentor. If you ask me, he made the greatest music that ever came out of America.

I'll never forget the first time I met Frank; it was in 1956 at the Paramount Theatre in New York. I was the new kid on the block and Perry Como had given me his summer replacement show. The television network, NBC, cut the budget for my production, affording me very few guests and a smaller band. I was concerned about the impact of these changes and didn't quite know what to do. There was only one person who I believed could help me: Frank Sinatra.

Well, Frank was playing at the Paramount, so I decided to try to meet him. Friends of mine warned me, "you'd better look out, sometimes he can be really tough." Being a huge fan of his since my early teens and loving the way he sang, I thought he'd understand my problem. So I took a shot and went backstage between his performances. I told a guard that I'd like to see Mr. Sinatra. The guard conveyed my request to Frank, who said, "Have him come up."

I entered Frank Sinatra's dressing room and introduced myself: "I'm Tony Bennett." To my delight, he said, "I know, your record is being played all over. What can I do for you, son?" I explained the situation: "I have to perform live on television every week and I'm extremely nervous. I just don't know what to do!" Frank said, "Don't worry about that, kid. If the public sees you're nervous they will support you even more." He taught me the biggest lesson in my professional life. Meeting Frank and receiving his friendly advice helped me overcome my stage fright.

Let me tell you about the "power" of Frank Sinatra. I was in London performing in 1965 and a friend of mine from the States called me and said, "Wait until you read what Sinatra wrote about you in *LIFE* magazine." When I read the article, I was knocked out! Frank told the interviewer, "For my money, Tony Bennett is the best singer in the business. He excites me when I watch him. He moves me. He's the singer who gets across what the composer has in mind, and probably a little more." He was nice enough to give me his whole audience because, after that, every one of his fans started to come and see me. His comments tripled my business. Sinatra's statement changed my life. I've been sold out around the world ever since and I believe it is the single most generous thing any artist has ever done for another.

Another special moment happened in Frank's 1974 live concert TV special *The Main Event*. At that time, my mother was unfortunately very ill. Knowing she was dying, I was with her that evening to watch the show. During the concert, Sinatra mentioned my name and praised my singing. My mom heard his comments and I really believe that made her live another six months. She, along with the rest of my family, was so proud that Frank acknowledged me. I love him for that.

One night, just before he passed away, I had dinner with him at his home. Frank said to me, "I just believe in one thing and nothing else...that's loyalty." I realized then that all of Sinatra's life revolved around that premise. By that I mean that if he liked somebody, he loved them, and if he didn't like them, he wouldn't even let you bring up their name.

Frank Sinatra became my best friend in show business. I had the great pleasure of spending many birthdays with him and was honored to sing at his fiftieth, seventy-fifth, and eightieth birthday celebrations. We did not get to spend much time together, but when we did we always had a great time.

As we celebrate his one-hundredth birthday, Frank Sinatra is still relevant. While I miss him, it is a great comfort that his legacy – the wonderful music he left us – lives on for future generations to enjoy as much as I have.

Tony Bennett

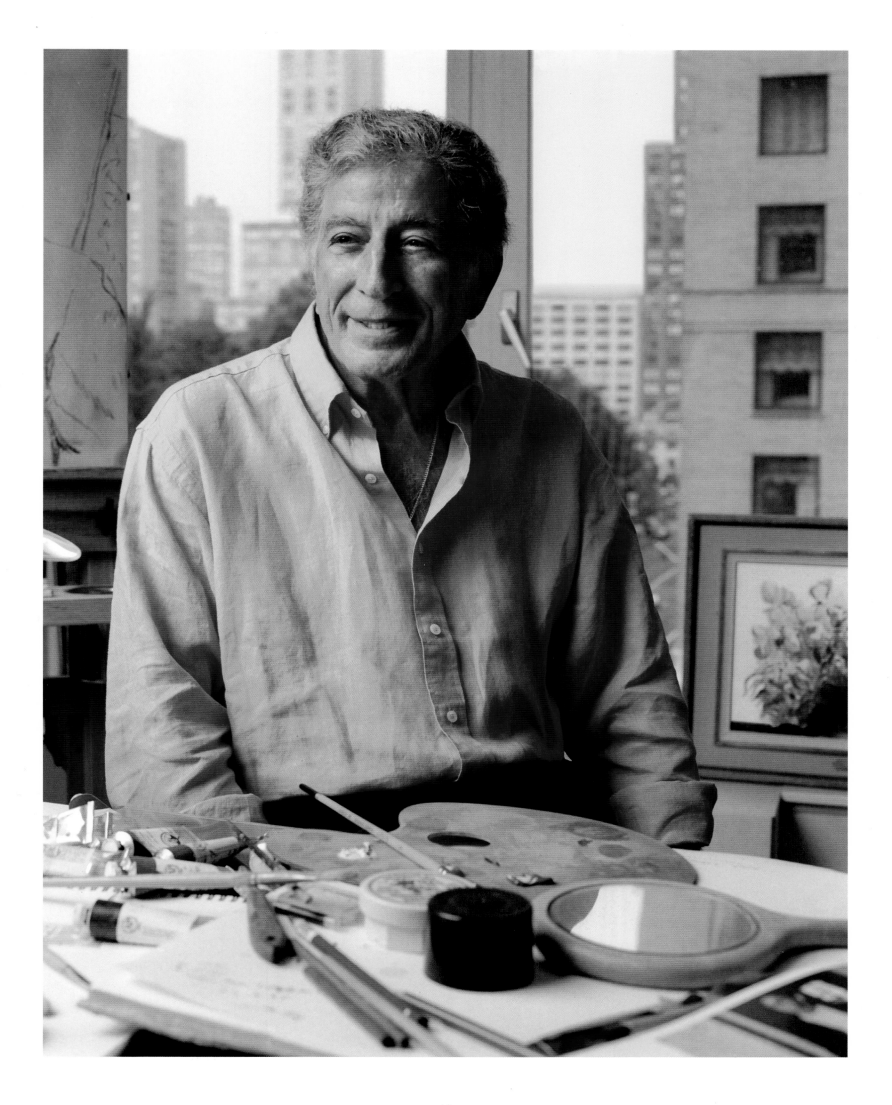

opposite Steve Wynn and Frank Sinatra at the Golden Nugget, Las Vegas.

Frank Sinatra was the greatest vocalist of the twentieth century; that's not debatable. But Frank was more than just an entertainer.

Sinatra was one of us. He grew up in the early part of the century and faced all of the same problems that the majority of Americans faced. That's why people related to him and felt a personal connection with the man and his music. Frank was a very complex man but that was what made him so interesting and his music so honest. Frank tasted all the flavors of life; he knew the good and the bad, the ups and the downs, but he always got back on his feet and moved forward. After his comeback in 1953, no one could touch Sinatra and he never looked back. Women absolutely loved him and men respected him.

So it came to me in the early 1980s that Frank should be the spokesman for my luxury hotel and casino in Las Vegas, the Golden Nugget, and not just a singer we hired for sporadic engagements. What our customers were all dying to get in on was the Sinatra charisma. That's where I came in, with a high-line marketing strategy for Frank. I made commercials with him. I made him available as a host at parties in Hong Kong, Las Vegas, New York, and New Orleans – anyplace. Sinatra flew with me to meet the customers, take a picture with them and say, "Look, the next time you come to Vegas or Atlantic City, let Steve and me take care of you." Frank told me, "Steve, this is what I always wanted to do, but nobody ever asked me. All they wanted me to do was sing at night and then sit in my room all day." He was a powerful magnet and helped introduce people to the Nugget and our brand.

Just answer this one question and you'll understand the power of Sinatra: if you were out on the town and Sinatra was playing and you asked your partner "who should we see tonight, Sinatra, or ?" There is no "OR!" Frank had the type of charisma that only a few people I have met possess. Whenever he entered a room, the atmosphere was charged. Everything would change. His mere presence would make people act differently.

In all my years of working with Sinatra, what I enjoyed most was being in his company. In terms of just hanging out and having a good time, Sinatra was peerless. Frank's favorite thing was to be around a group of friends and tell stories; he'd get a Jack Daniel's in one hand, loosen his tie, and hold court. He was the most attentive host and a marvelous storyteller; I was amazed at his perfect recall of everything from the Harry James and Tommy Dorsey eras up through moments in his movies. He also loved reminiscing about the good friends in his life, such as Joe E. Lewis, Dean Martin, and Sammy Davis Jr.

One of the things that is very rarely explored is just how considerate he was to his friends. Frank could be remarkably caring. The general public never saw the gentle side of him because, apart from his singing, he rarely showed emotion. He loved children and dogs. Years ago, during a world tour, he visited a children's home and a blind girl asked him, "What color is the wind?" With tears in his eyes, he said softly, "Dear, no one knows because the wind moves so fast."

In the realm of tipping, or "duking," as Frank called it, his legend towers. True story: a young parking attendant at a hotel brought Frank's car around. Frank asked him what was his biggest ever tip, and the kid said "a hundred bucks." Sinatra handed the kid two hundred bucks, then asked who gave him the hundred. "You did, Mr. Sinatra, last month." That was Frank!

The untold things Sinatra did for so many during his lifetime are staggering. No one knows the true extent of his generosity because Frank believed that if others knew about it, then it was not done for the proper reason.

Frank Sinatra is timeless. Sinatra stood for intelligent music and arrangements along with the ultimate in integrity, glamor, and class. That is his legacy. Music today is so miserable by comparison and, with few exceptions, disposable. Not a day goes by that I don't listen to his music. It sounds cliché, but his recordings are the soundtrack to our lives. There will never be another Frank Sinatra, nor will there ever be another story like his. It was one of the highlights of my life to have known and worked with that man.

As we celebrate Frank's one-hundredth, my hope is that this book brings back wonderful memories to those who knew the man and his music, and for those who never had the pleasure...enjoy!

Stephen A. Wynn

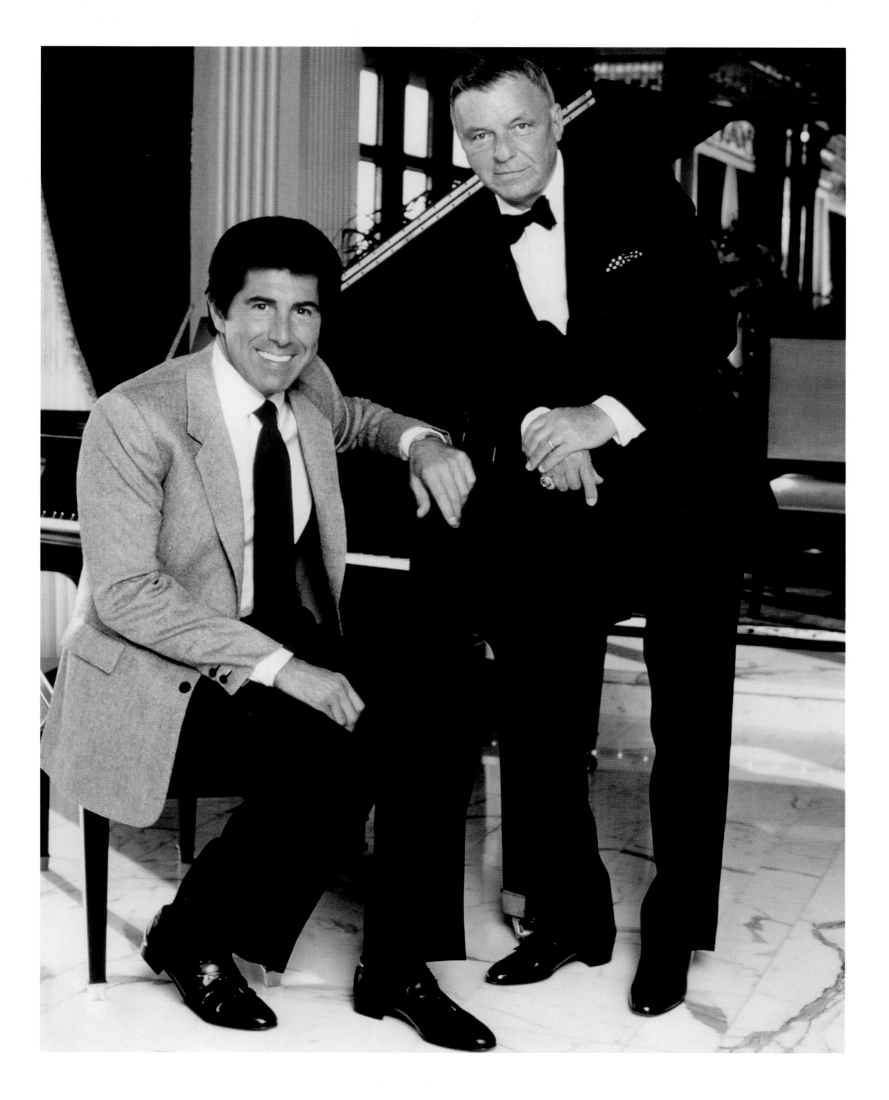

Sinatra never needed an introduction. In nightclubs and on concert stages, in saloons and on screen, Frank was always the center of attention. From New York to London and Las Vegas to Tokyo, he wowed the world over; a genuinely singular sensation, timeless and everlasting. Sinatra was and is an American – and international – treasure.

The story of Frank Sinatra is that of someone born into humble beginnings who became one of the most famous and celebrated entertainers of his time.

Make no mistake, Frank Sinatra was the defining voice of the twentieth century. The man also lived one of the most authentic, exciting, and admired lives in history. His was a life full of courageous decisions: quitting high school to pursue a music career, leaving Tommy Dorsey's band to go solo, starting his own record label, speaking and fighting against racial intolerance and bigotry... it goes on and on.

The astonishing thing is that if you got to know or observe him personally, you realized that Frank was an ordinary guy; similar to the rest of us, but blessed with an extraordinary talent.

In the end, after all is written and said, the music is Sinatra's legacy. Decades after it was first recorded, the body of music that he created remains nonpareil: a monument of artistry in a world of mediocrity.

In the mercurial music business it takes only a millisecond for artists and careers to come and go. Five years is a lifetime; a decade signifies an eternity. How do you classify a musician whose first commercial recording was in 1939 and was still at it in 1993? Frank Sinatra defies classification. He is one of a kind.

Throughout Frank's life, no one even resembled him. There are no artists currently on the scene that are capable of duplicating his extraordinary career. Time only increases his importance and stature.

Frank Sinatra's music is still relevant because in it we discover how our lives evolved, as did his. The songs he sang were always approached on a very strong emotional level; he was more interested in the emotion of the song than its structure.

Frank sang songs written by the greatest writers of his time: Cole Porter, Irving Berlin, Jerome Kern, Harold Arlen, Ted Koehler, Yip Harburg, Johnny Mercer, Sammy Cahn, Jule Styne, Johnny Burke, Jimmy Van Heusen, Oscar Hammerstein, George and Ira Gershwin, Lorenz Hart, Richard Rodgers, Hoagy Carmichael, Vernon Duke, Cy Coleman, Carolyn Leigh, Duke Ellington, and Antonio Carlos Jobim, among others. He is the most celebrated interpreter of the Great American Songbook.

Hundreds of other singers sang the same songs, but they sounded different in Frank's care. The bond he created with the public has never been broken. His music belongs to every generation who live and love.

This book, in words and photos, is a celebration of his life by Sinatra and his family, friends, and co-workers. As you will see in these pages, what he has given us will last well beyond our lifetimes.

But photos and words can never convey the essence or spirit of the man and his music. Nothing I could possibly write would do his legacy justice. That is why included in these pages are reflections by those who knew the man best.

Case in point: in 1992, Tony Bennett reflected, "There is a warm side to Sinatra that has never been played up properly. Being 'on the inside of show business,' I can't begin to tell you how many human stories I've heard about the silent Sinatra. Highly philanthropic, he downplays the thousands of worthwhile benefits he has done over the years. As a private man with a profound sense of loyalty to his friends, he never touts the generosity he has shown to those he loves. That's the man!"

If you want to know what Frank Sinatra was all about, you need only listen to his music; then and only then can you understand the true essence of the man.

Mark Antony's line from William Shakespeare's *Julius Caesar* could have been written for Sinatra:

His life was gentle, and the elements
So mixed in him that Nature might stand up
And say to all the world, "This was a man."

As we celebrate the one-hundredth anniversary of his birth, the world needs the man and his music more than ever.

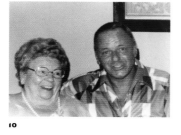

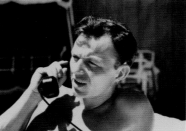

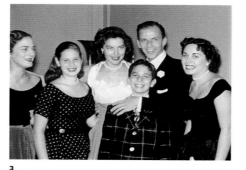

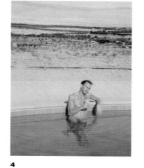

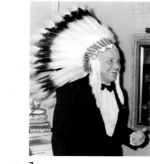

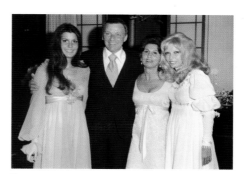

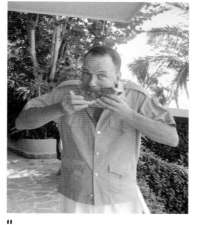

1. Frank Sinatra, 1940s. 2. Sinatra, 1951. 3. Frank on the day of his wedding to Ava Gardner, 1951.
4. Sinatra relaxing in a pool in Palm Springs, 1950s. 5. Christmas with the Martins and the
Sinatras, 1967. 6. Casa Sinatra, 1960s. 7. Sinatra wearing a Native American headdress, 1960s.
8. Sinatra and Bill Miller at a private party – in front of Pablo Picasso's *Le Petit Pierrot aux Fleurs* (1923–24)
– 1965. 9. Frank Sinatra at daughter Nancy Jr.'s marriage to Hugh Lambert, with daughter Tina and wife
Nancy Sr., Rancho Mirage, California, 1970. 10. Frank and his mother Dolly Sinatra, 1970s.
11. Sinatra at home in Palm Springs, 1960s. 12. Sinatra in the studio, 1979.

1915

1952

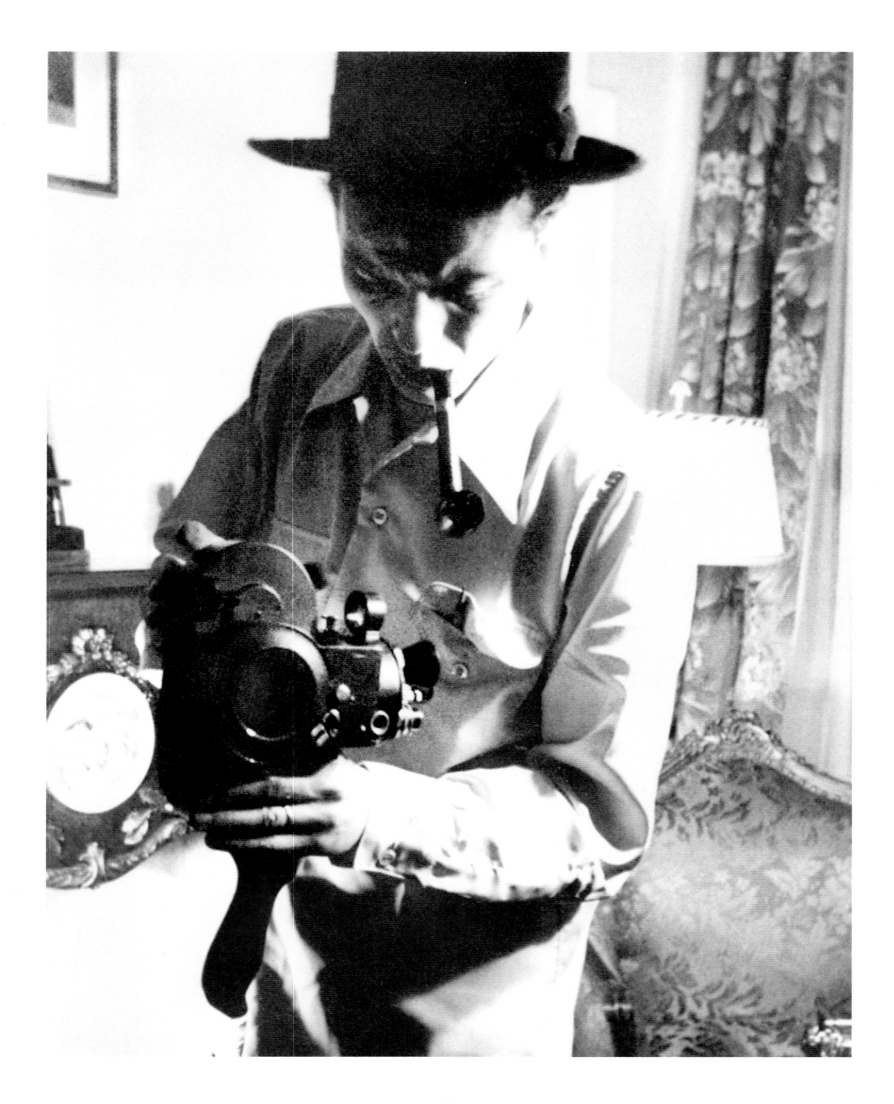

opposite Frank Sinatra *c.* 1940, with his new movie camera.

First impressions, as a rule, tend to be accurate. In the case of Frank Sinatra, this theory holds true. Sinatra was first called "The Voice."

Francis Albert Sinatra was born in Hoboken, New Jersey on December 12, 1915. It was not an easy birth, as Sinatra recalled in 1986:

They told me it was a very wintry and terrible day. My mother weighed approximately ninety-two pounds and I weighed twelve and three-quarter pounds. When I was removed from her womb, by a midwife, there was a problem... I didn't wanna come out. Finally, they sent up a flare for a doctor and, upon removing me, I was pretty well damaged on the left side of my neck, ear, and face. The doctor put me aside in order to save my mother's life. My grandmother knew what to do with me. She stuck me under the ice-cold water and apparently got some blood moving, and whacked me around a little bit. I grew, not large, but I grew and was brought up in a marvelous family. My mother didn't have any more babies after that. I was trouble right from the beginning!

Young Frank discovered singing in his father's bar:

My father was a dear man... a very quiet man, and he had this bar called Marty O'Brien's Bar and Grill. In the bar they had a piano with a roll in it, and you'd put a nickel in and it would play songs. When I was probably about nine, ten or eleven years old occasionally one of the men in the bar would pick me up and put me on the piano and I would sing with the music in the roll. It was a horrendous voice, just

terrible. So one day, I go a nickel or a dime, whatever it was and I said, "this is the racket, this is what you gotta be doing." In a small sense, I thought it's wonderful to sing but the seed was there; it began there. And I never forgot it. Several years later, in junior high school, I sang with the choir, and then in high school I sang with the choir and dance orchestra.

Sinatra left Demarest High School in his senior year.

When I told my father I planned to be a singer he said, "You want to get a decent job or do you want to be a bum?" In those days, if you didn't have a good, decent job, such as working in a factory or shipyard, you were a bum. So, I left home... he was broken-hearted when I said I want to go into music. My father didn't speak to me for one year.

In 1935, Sinatra auditioned for an appearance on *Major Bowes and His Original Amateur Hour*, a popular radio show at the time. He was paired with a local trio and they called themselves "The Hoboken Four." The group toured the country as part of one of the Major Bowes amateur companies, but Sinatra was homesick and returned home early.

Things would soon change for Sinatra and his career. These, as with most, were his formative years. The basis of his being and personality were becoming part of his music.

When I came back, I very quickly got a job in a road house in New Jersey called the Rustic Cabin. From there I went with the Harry James band. Harry had heard me on radio late at night and came over and talked to me, and I joined him.

Frank Sinatra married Nancy Barbato on February 4, 1939 at Our Lady of Sorrows Church in Jersey City, New Jersey.

On July 13, 1939, Frank Sinatra recorded 'From The Bottom Of My Heart' and 'Melancholy Mood' with Harry James in New York. It is unlikely that anyone at the session was aware of the significance of that particular Thursday: it was the beginning of Sinatra's professional career as a recording artist.

My first big break was with the Harry James band because if I hadn't gone with Harry then I don't know whether or not I would have been heard eventually. The fact that I made some records with Harry James that Tommy Dorsey heard on the air (or somebody played them for him), then he eventually made a pitch for me to quit the James band and go with him. Of course, I was delighted because in those days the Dorsey band was considered the showcase for all singers.

Sinatra's star ascended during his tenure with Dorsey and he recalled the "big band years" with fondness.

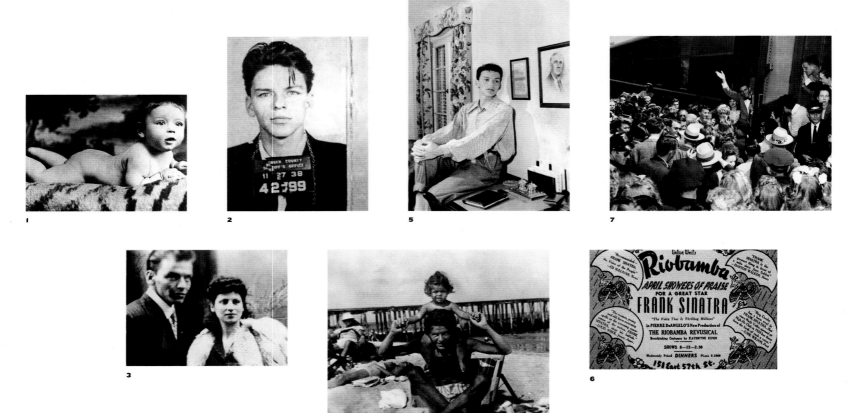

1. Baby blue eyes, 1916; perhaps the first ever publicity still of Francis Albert Sinatra! 2. Seduction arrest, November 27, 1938. 3. Sinatra with wife Nancy Sr., early 1940s. 4. Sinatra on the beach with Nancy Jr., summer 1941. 5. Sinatra at home in New Jersey next to a picture of Franklin D. Roosevelt, early 1940s. 6. Advertisement for Sinatra in the Riobamba Revusical, 1943. 7. Sinatra arrives in Pasadena, California, 1943.

I've experienced some wonderful things in my life. I mean, driving five hundred miles through the night to the next one-night stand, and having forty minutes to get out of the bus, into the hotel, turn on the shower, a lot o' steam, hang the dinner jacket up in so the wrinkles come out of it; grab a sandwich, show up at a bandstand; the greeting from the audience was the greatest reward in the world. It was never a question of money in those days. If you had enough to live on, everything seemed right.

In New Jersey in 1940, Frank's first child, Nancy, was born. Sinatra left the Dorsey band in 1942.

I decided to strike out on my own and from there on with God's will and my stick-to-it-ness, I made some kind of a stance in my business. I believed that everything I was doing was right. That's when the bobbysoxers really began to take the place apart. I listened and watched the reaction of the kids. They got a lot of bum raps because people wrote about the fact that they tore clothes but they really didn't do that. They just wanted to get near you and say hello or shake your hand and look for a handkerchief or bow tie as a souvenir. They had a marvelous affection for me and I, in turn, had a great affection for them. I loved their enthusiasm for me and their sweetness is something I'll never forget as long as I live.

Early on, my phrasing developed from a combination of musicians and singers that I had heard and was influenced by, such as certain nuances that Billie Holiday would use; Louis Armstrong had a great effect on me. Then I began to listen to both jazz and classical musicians. I was fascinated by [Jascha] Heifetz, the way he could make a change of bow in a phrase and continue without missing a beat. I thought that if that can be done with an instrument why not do it with the human voice. It was very tough to do. It took a lot of calisthenics and physical work to get the bellows built up. I worked on that for many years and it came to pass. I didn't study legitimate music and I can't read a single note. I also took some singing lessons; I went and found a vocal coach named John Quinlan. He was a wonderful man and had been an opera singer at the Met. Quinlan was a great teacher of calisthenics in the throat so that you didn't tire when you sang.

To say Frank Sinatra became a national phenomenon would be an understatement. From 1942 to 1946, it seemed he could do no wrong. His popularity in radio, movies, and personal appearances was unprecedented.

In 1943, Sinatra signed with Columbia Records and began his career as a solo recording artist. In 1944, his only son, Frank Jr., was born. A few months after that, the entire Sinatra family relocated to California.

The following year Sinatra starred in *The House I Live In*, a short on racial tolerance that would win him a special Oscar from the Academy of Motion Picture Arts and Sciences. Louis B. Mayer, the head of MGM, signed Sinatra to a contract in 1945, and he would soon be a major movie star. "MGM was really the big time. I used to walk around the lot, wide-eyed, looking at Katherine Hepburn, Spencer Tracy, Lionel Barrymore, and all the people who, a year before, I was paying to see," he recalled.

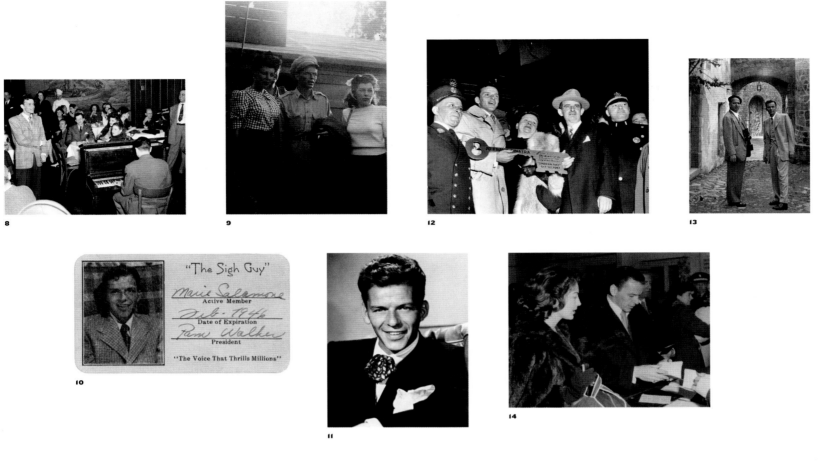

8. Sinatra singing in the 1940s to a small group of fans. 9. Supporting the war effort, 1945. 10. A Sinatra fan club membership card, 1946. 11. 1940s publicity shot. 12. Celebrating "Sinatra Day," October 30, 1947, with his parents in Hoboken, New Jersey. 13. Jimmy Van Heusen and Sinatra sightseeing in Spain, 1950. 14. Ava Gardner, Sinatra, and Jimmy Van Heusen going through British Customs in the early 1950s.

The meteoric rise was followed by a decline in both Sinatra's career and personal life in the late 1940s. One of the only bright spots during this period was the birth of Frank's daughter Tina in 1948.

Sinatra's stardom meant that the press and gossip columnists hounded him. The public's taste in music was also changing; novelty tunes were in fashion. Johnny Ray, Eddie Fisher, and Frankie Lane, among other singers, have now been all but forgotten, but in those days eclipsed Sinatra. It looked as though Frank might be relegated to a footnote in pop music history.

Sinatra blamed only himself for those dark days:

Me. I did it. I'm my own worst enemy. My singing went downhill and I went downhill with it, or vice versa. It happened because I paid no attention to how I was singing. Instead, I wanted to sit back and enjoy my success and sign autographs and bank the heavy cash... I was in trouble, I was busted. I must say that I lost a great deal of faith in human nature because a lot of friends I had in those days disappeared. I don't say it begrudgingly because I found something out about human nature after that.

Not all Frank's friends deserted him. Joe Scognamillo, owner of Patsy's Italian Restaurant in New York, recalled the "lean years:"

We were not open on Thanksgiving Day. This was years back when Frank was having a bad time professionally... everyone said he was finished. We knew he was great, no matter what anyone else said. And whenever Frank came to New York, he would hang out at Patsy's. He was there the day before Thanksgiving for dinner, and you know how terrible people can be? People who knew him just walked right by, didn't talk to him, didn't greet him, nothing. After he finished eating, Frank said to my father, "I think I'll have Thanksgiving dinner here with you guys. What time are you serving?" My dad looked at Frank, and understood how alone he felt. He could have told Frank that the restaurant was closed on Thanksgiving, and invited him home to dinner. But he knew that would hurt Frank's pride, so he just said, "Three o' clock, Frank. We're serving dinner at three." After Frank left, my father called the staff together...there were some groans and moans. But their understanding was helped by my father telling them to bring their families.

Frank noticed that the restaurant was pretty empty, and asked my father about it. "A lot of people stay home on Thanksgiving," my father said. I guess Frank found out later on, but he never said anything about it, and neither did we. Once Frank became your friend, he stayed your friend for life.

The early 1950s did not start well: Frank was separated from Nancy and, in 1951, they divorced. Later that year he would marry actress Ava Gardner.

Frank's career was still floundering in 1952. His CBS television show was canceled, MCA and MGM dropped him, and he did not renew his recording contract with Columbia. "1952 was one of the most frustrating years of my life," said Sinatra, "then one day I woke up and said 'it is time to go back to work.' That's really what happened – it is just as simple as that."

"MY MOTHER WAS VERY MODERN IN A SENSE AND FAIRLY AMBITIOUS. SHE WENT TO NURSING SCHOOL AND BECAME A MIDWIFE. AND SHE WAS A TROUBLESHOOTER; SHE WAS GREAT AT IT. IF THERE WAS A PROBLEM SOMEWHERE, IN ANY ONE OF THE FAMILIES...THE FIRST THING YOU HEARD WAS, 'YOU BETTER CALL DOLLY.'"

– Frank Sinatra

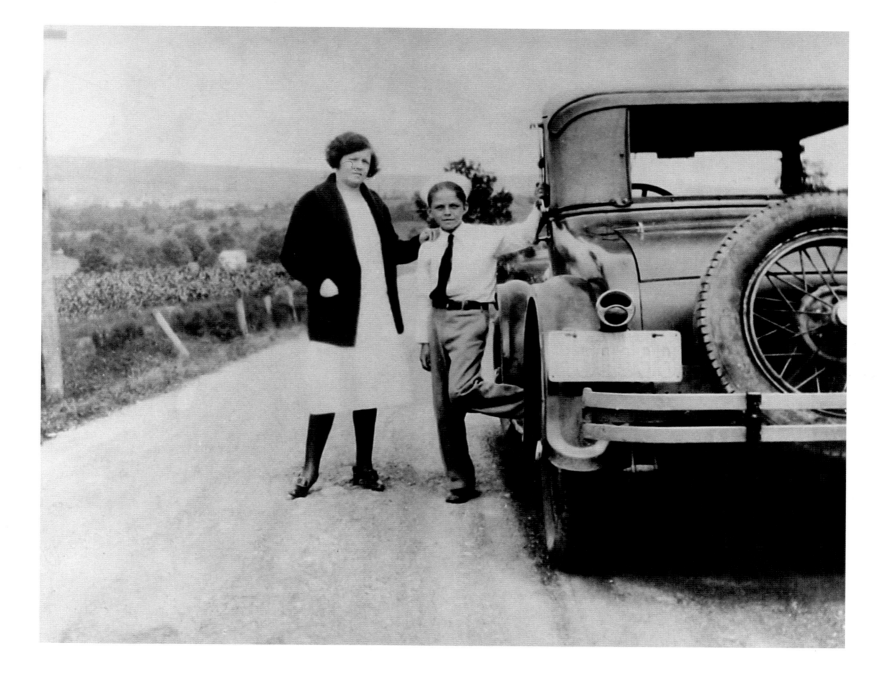

Frank and his mother, Dolly, on a road trip in the mid-1920s.
"My mother wasn't tough; the neighborhood was tough. She was
firm. She wanted me to be safe, to be a gentleman."

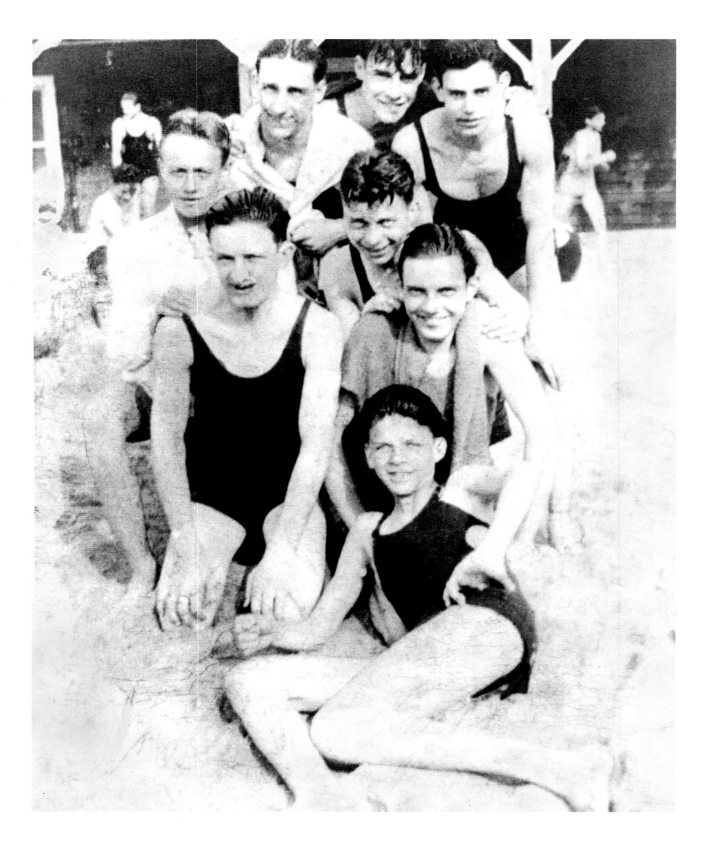

Frank and friends posing for the camera on
the New Jersey Shore in the late 1920s.

"There was a time when I was with a bunch of kids my own age, thirteen or fourteen. In the summer we used to go swimming in a pool at Palisades Park in New Jersey. I was lucky – I had a pass to get in.... I'd get in on my card, go around to the back, and slip another guy the same card through the fence. He'd get in and I'd go back and hand the card to another guy until we were all inside.... One day the attendant caught on...this big guy grabs me by the neck and beats the hell out of me. When he gets through he boots me out the gate. I was hurt all right, but I was hurting from something more. All those times I got those guys into the swimming pool, but when I was getting clobbered not one of them came over to help me. They just...scramsville."

– *Frank Sinatra*

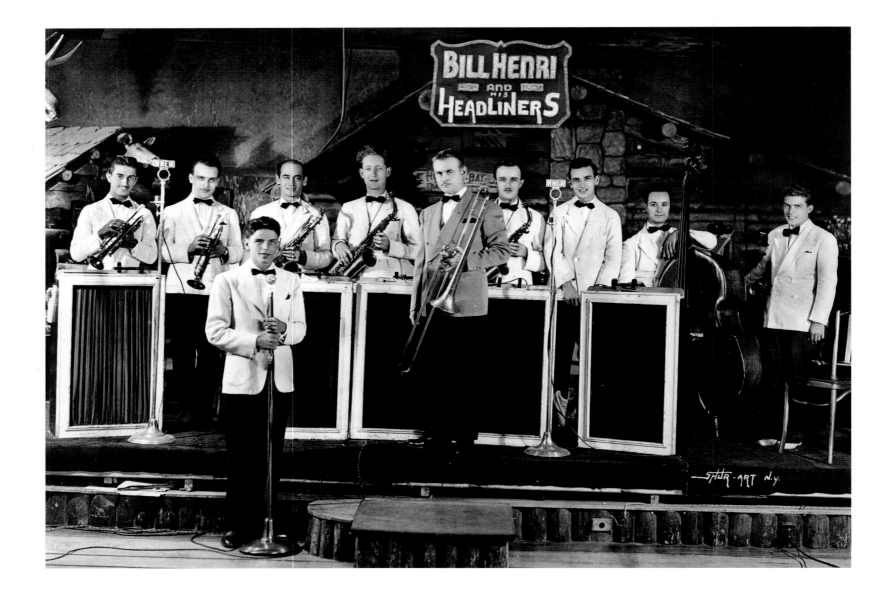

After leaving the Major Bowes unit and the Hoboken Four,
Sinatra sang anywhere he could until, in 1938, he landed a job
at the Rustic Cabin, a roadhouse that broadcast its live shows
on New York radio station WNEW's *Dance Parade*. Sinatra was
hired as a singing waiter and master of ceremonies.

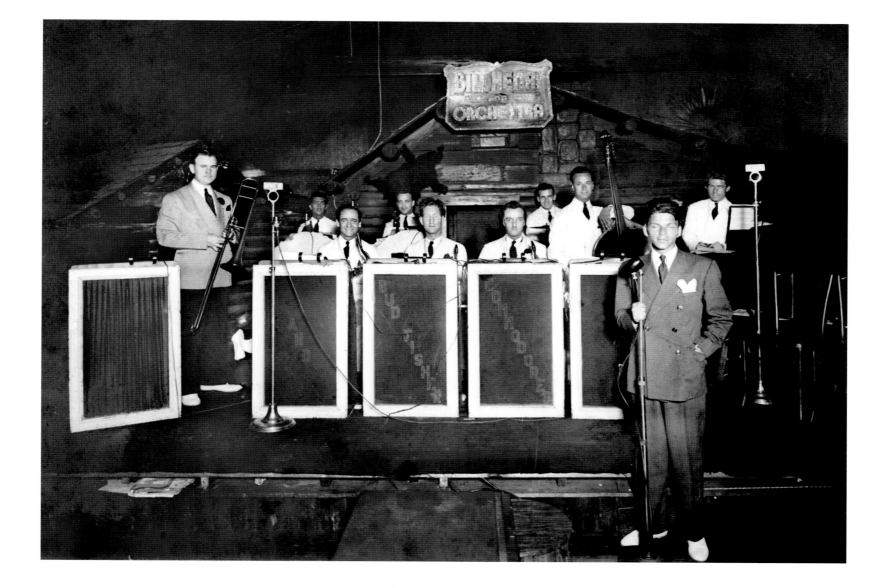

"When I was offered a job at the Rustic Cabin, I snapped it up
even if it was only $15 a week. Radio from there? And how! Four
times a night! Every time you turned around someone handed you
a mike," recalled Sinatra. "It was what we called in those days
a sneak joint. By that I mean all the married guys would be there
with their girlfriends, because there were little cabins inside the
room itself and they were very private."

" I liked Frank's voice and his way of talking a lyric. After the show some of the fellows in the band and I went out to The Rustic Cabin to see him. He asked the boss if he could do a number for me. He sang 'Begin The Beguine.' I signed him for $75 a week for two years. "

— *Harry James*

above Bandleader Harry James and Sinatra reunite at the Hollywood Canteen. **below** Sinatra on the road with the James band. **opposite** Frank and Nancy in 1940. "At the time of this photo, I was pregnant with Nancy, and that's why I put the hat in front of me. This was a good time in our lives. It wasn't about being rich and famous; it was about real feelings." – Nancy Sinatra Sr.

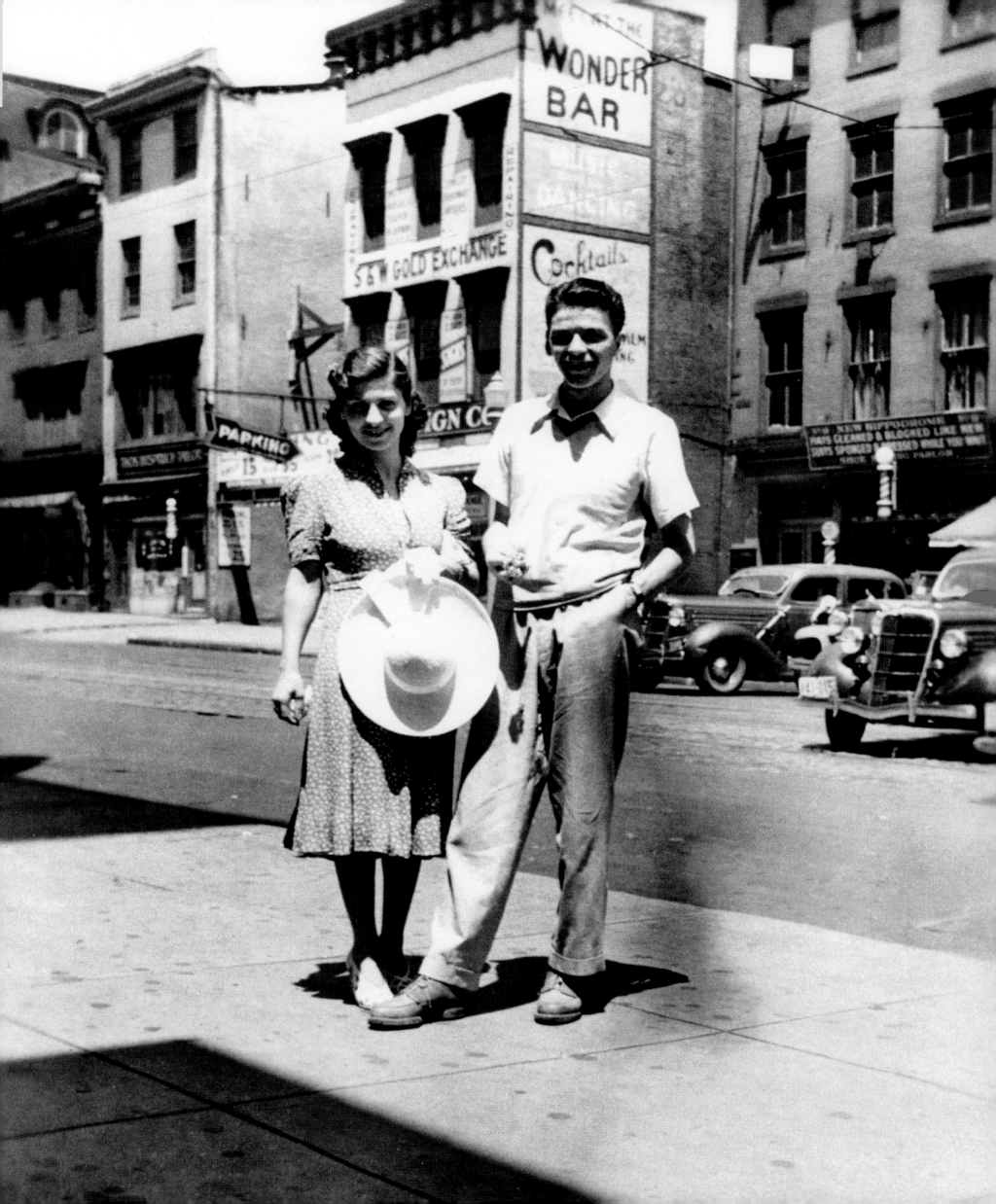

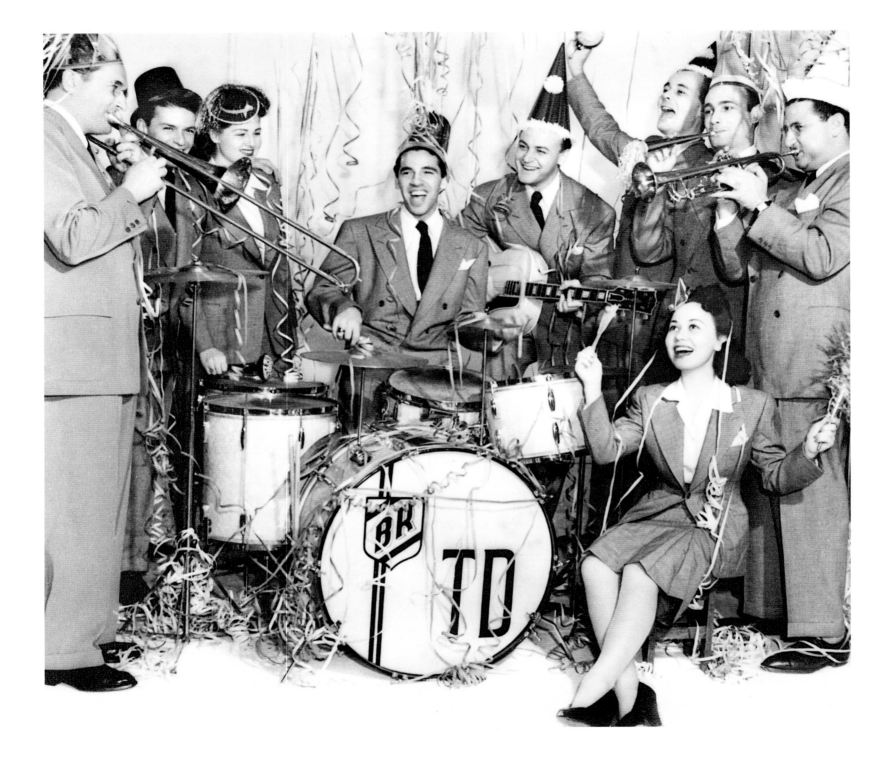

Buddy Rich (on drums) joined Dorsey's band in 1939. "Frank and I were
roommates.... One time at the Astor Hotel we had a little confrontation and
he threw one of those great big heavy glass pitchers of water at me.
I felt this thing just whiz across the room and right where I had been
standing it smashed into a million pieces. If he had hit me, I wouldn't be here
today...perfect aim.... We had a little beef and we settled things later on
and became the greatest of friends." – Buddy Rich.

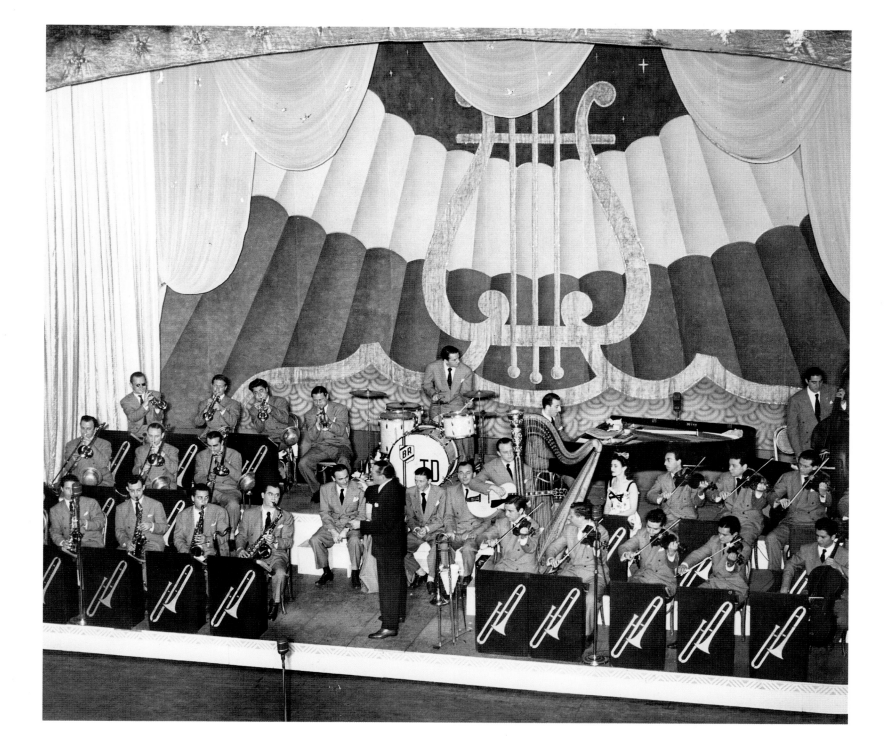

In January 1940, Dorsey officially hired Sinatra for $125 a week, a
substantial raise from his fee with the James band. "I would go and watch
the Dorsey band at Roseland.... I wanted to join his band because of the
way he would feature the vocalists. That was one time in my life that I made
it an objective to do something and tried to plan and make it happen,"
said Sinatra. Touring as the featured vocalist with the Dorsey orchestra,
Sinatra had his first taste of stardom.

"You could almost feel
the excitement coming
up from the crowds
when that kid stood up
to sing. Remember,
he was no matinee idol.
He was just a skinny
kid with big ears.
I used to stand there so
amazed that I'd almost
forget my solos."

— *Tommy Dorsey*

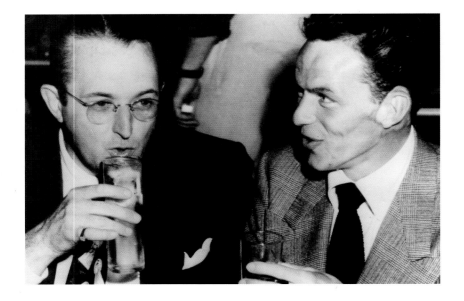

above Sinatra performing with Tommy Dorsey's
band, in the early 1940s. **below** Tommy Dorsey and
Frank Sinatra enjoy a nightcap.

"THROUGH HIS INTERPRETIVE QUALITIES HE HAS NOT ONLY BROUGHT SUCCESS TO HIMSELF, BUT HE HAS MADE MANY HITS FOR THE VARIOUS MUSIC PUBLISHERS AND, OF COURSE, HAS BROUGHT PLEASURE TO THOUSANDS OF LISTENERS."

— Tommy Dorsey

"I knew Frank when he was with the Dorsey band. I was a great friend of Tommy and Jimmy Dorsey and I hung around the band a great deal because it was a swinging band and I loved it, and Frank was the vocalist. Thin, tousle-headed kid with an expansive black bow tie. I was the 'croon' period with Valle and Colombo, he was the 'swoon' period. He was the forerunner of that, he started that hysterical era and every time he uttered a note they'd shriek, fall in the aisles, and carry on. I think it was sort of exhibitionism; each one wanted to show they could swoon deeper and make more noise than the other. He had great talent, a great voice and feel for a song with the wonderful ability to create a mood when he sang which I guess is the hallmark of a good entertainer, particularly a singer."

– *Bing Crosby*

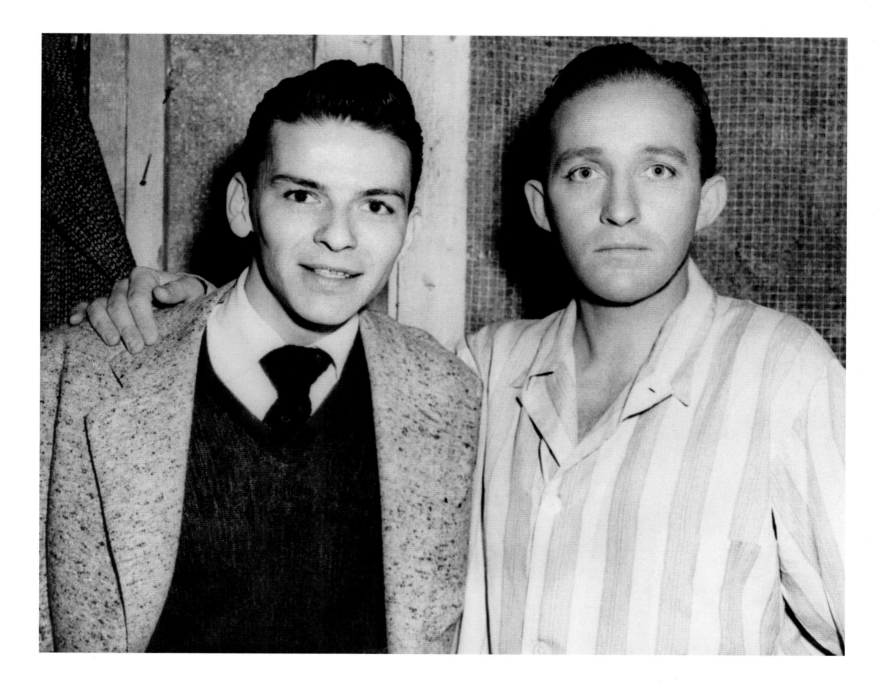

The press may have created a rivalry between the
"crooner" and the "swooner," but Bing Crosby and Frank
Sinatra were friends from the start of Sinatra's career,
as shown in this photo from the early 1940s.

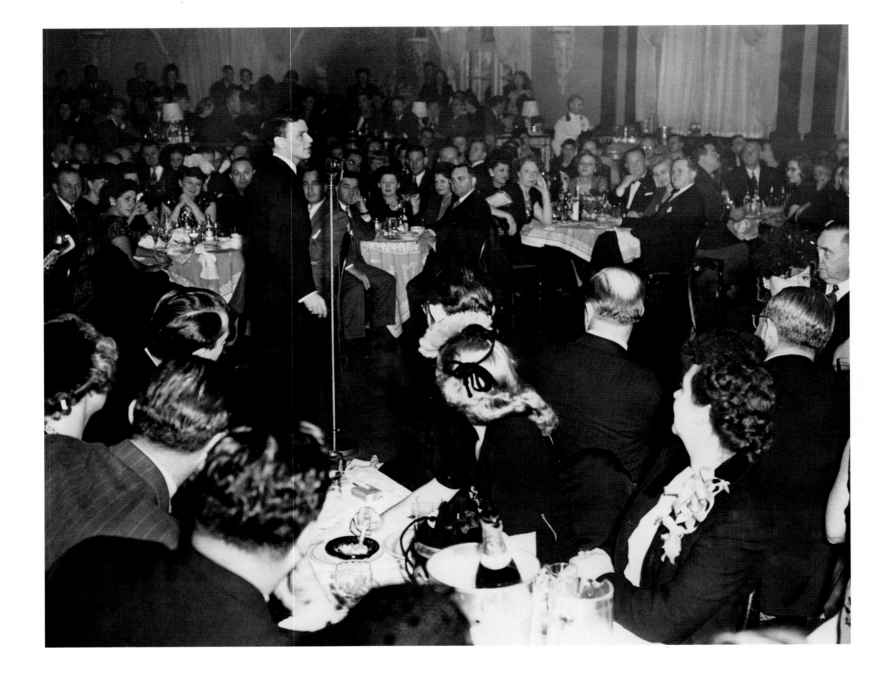

Performing for a nightclub crowd in the mid-1940s. "I think there
was nothing better that happened to me than spending the years on
the bus with the bands because you worked 365 days a year. If you are
going to be good in any job at all, I think if you eat, sleep, walk, talk,
and dream it you're going to be good at it and in the end you'll be
a big man in it." – Frank Sinatra.

" I remember my first club date in New York, 1943, at the Riobamba. I had to open the show walking round the tables and singing. There was no stage or anything and the dance floor was only as big as a postage stamp. I was nervous as hell, but I sang a few songs and went off. Walter O'Keefe was the star of the show and it was his last act. That night he just walked on and said: 'Ladies and gentlemen, I was your star of the evening, but tonight, in this club, we have all just seen a star born.' And he walked out without saying another word. I hadn't really been conscious of a great reception or anything during my act, maybe because I was so nervous, but the next day there was a big explosion in all the papers and all around."

— *Frank Sinatra*

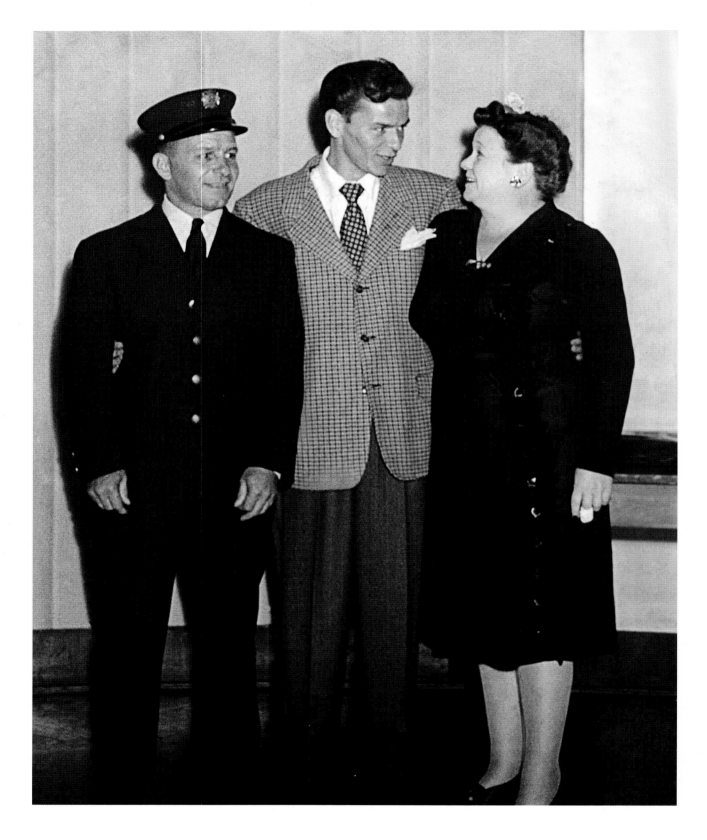

Frank and his parents in the mid-1940s. "I don't think my
father could write more than his name. Nor could he read, not
a hell of a lot, anyhow. If I'd get a letter that was funny,
I wouldn't ask him to read it – we wouldn't do that to him,
not embarrass him – but I'd read it to him, or something
interesting from the newspaper," recalled Sinatra.

Scooperoo! Inside intimate experiences with swoonsational Frank!

SIGHINGLY

YOURS

We Visit Toluca ------

Candid Close-ups.

Exclusive! We interview Eileen Barton

WARNER VALLEY

We took a trip to Frank's home and knowing that so many of you would like to peek inside of it, we concentrated a sharp eye to photograph as much as our mental "plate" would take.

So come with us, if you wish, to the sun-spattered house with the high pink wall around it...press the magic buzzer...and find Nancy's sister, Tina, grinning a welcome at the big, white front door. Close on her heels as we were ushered into the restful green living room was pudgy Nancy Sandra, whose friendliness was quite disarming. Skipping across the room to the record machine, she came back with a nursery disc containing such well-known songs as "Oats, Beans, Peas and Barley Grow," and "Round the Mulberry Bush" and announced that this was all her own record to play on the little white machine which was also her own.

In the flagstone fireplace, soft flame licked at a giant eucalyptus log. "Frank loves a fire," laughed Tina, "and he nurses one-along while there's anything to burn." He happened to be in Palm Springs and talking to his wife on the phone, so while she was tied up, Tina took us on an inspection tour of the house. We noted that the living room was furnished in bright, warm colors, accentuated with deep dubonnet, rich green, and soft yellow and blue. From antique shops, Mrs. Sinatra has collected semi-precious pieces of China, including a number of Dresden objects, a Meisen and several blue and white English china pieces (like the large old-fashioned basin on the piano in which flowers are arranged). On the piano, too, were busts of Chopin and Gershwin; on the coffee table was a Bavarian candy dish; and on the mantel was a set of old apothecary tools in burnished brass.

Next, we inspected Frank's den, very mannishly done in red leather upholstery and redwood panelled walls. In the adjoining dining room, gay with rose-sprinkled wall paper relieved with soft green rug and draperies, there stood a large silver bowl brimming with fruit. The table was set with Rosenthal china and the silver, Tina said, was George and Martha pattern of the House of Westmoreland. (continued p. 15)

FRANK FARE

OFFICIAL CLUB NEWSPAPER OF "SIGHING SOCIETY OF SINATRA SWOONERS"

| Vol. 1 No. 4 | Issued Every Now and Then | July 15th 1943 |

THE DARLING OF A DREAMBOY

The top song on the "Hit Parade" which Frank sings changes almost weekly, but for four years, the top spot on that young man's "Heart Parade" has been held by his charming wife, Nancy. This sweet little Mrs. has charmed the affections of our hero until he "only has eyes for her". For Frank she has been the guiding light which every man needs to lead him to his rightful place in the world. Since this beacon happens to be the love light shining from a pair of snapping brown eyes, how could Frank stray from his path to fame? Nancy's faith, trust, and love have been the inspirations necessary for Frank to climb the ladder of success without wavering.

The story of their life together in a long and a lovely one, and one that will become lovelier as the years grow longer. Nancy and Frank were 15 and 16, respectively, when they first met and liked each other. Friends scoffed at their seriousness, but they both seemed to know deep within their hearts how wrong friends can be. Several years later when their puppy love had become a grown-up and lasting thing, they were married, and Nancy alone helped Frank keep his dream of a singing career polished and bright. It was she who made sure that love did not fly out the window when poverty walked in the door while Frank was a struggling unknown. Yes, Nancy remained steadfastly by Frank's side, and he claims that as the secret of his success. As Frank's star began its ascent, their happiness was made complete with the arrival of an heiress to the gold of Frank's voice. The night Nancy-Sandra made her bow into the world, Nancy Sr., knowing that the news would prevent Frank from singing his best, refused to have him notified until his work for the night was over. With a wife like that, Frank need never fear for his career, and with a love like theirs, we need never be afraid that Nancy and Frank won't live happily ever after! —A.M.I.

CLOSE-UP OF A RING

If you have seen Frankie, you've
 noticed a ring
He dreamingly fondles when songs he
 does sing.
Who gave it to him that he treasures
 it so?
The story is long - it began long ago.

Her name was Nancy; Long Branch, N.J.
 the scene -
The time was mid-summer (you know
 what we mean?)
Their friends said "It's pup love, oh
 you know the kind -
When you're in the 'teens, you don't
 make up your mind!"

But Nancy and Frank had a much differ-
 ent view -
"We're meant for each other", they
 said...and they knew,
So, when his climb to success had not
 yet begun
They met at the altar and there became
 One.

A double-ring ceremony, as they quiet-
 ly said -
(Slipping rings on to fingers): "With
 this I thee wed".
From that very moment his luck made
 some claims
For soon after that Frankie joined
 Harry James.

Frank's singing career from then on
 is well-known
But more important to them, their
 home life has grown:
The two have a home in Hasbrouck
 Heights, N.J.
Only now they're not two - but three,
 four anyway!

So now when he's singing a song to us
And he fondles his ring, we don't make
 a big fuss
For, you see, we don't mind or think
 it too fancy
'Cause Frank's wedding band keeps him
 dreaming of Nancy.
 A.S.

An issue of *Frankfare*, Frank Sinatra's official fanclub newsletter, July 1943. Issued "every now and then," contributed pieces ranged from location visits (in this instance, to the gates of Sinatra's home) to expressive poetry. Note the preoccupation with Frank's married status.

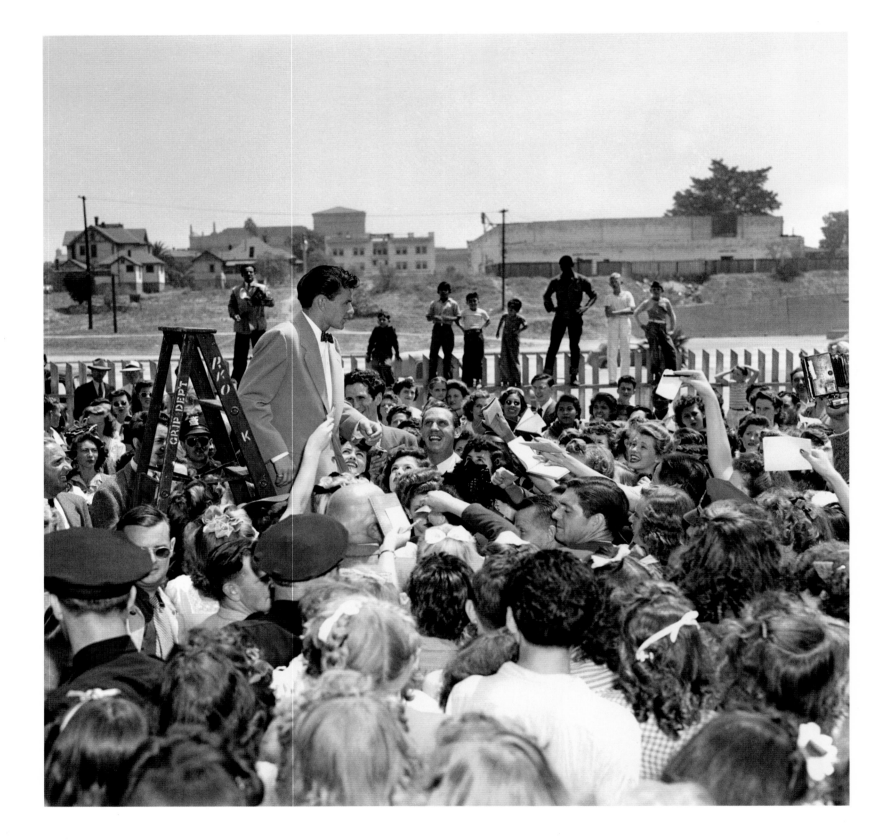

Crowds of fans clamor for Sinatra's autograph in Pasadena, California,
August 1943. On December 11 that year the draft board classified
him as 4-F ("not acceptable for military service") due to a perforated
eardrum. Unable to serve as a soldier, Sinatra entertained the
troops on several USO (United Services Organizations) tours and
became involved with wartime charity drives.

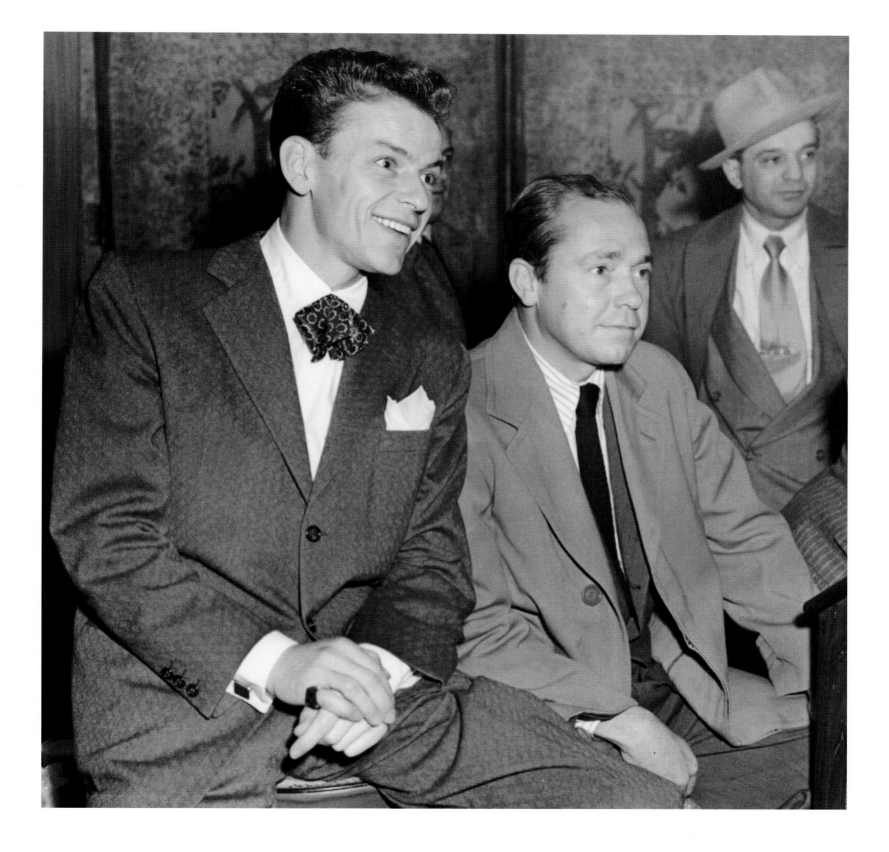

Frank and Johnny Mercer, 1943. Sinatra would record some of his most memorable albums on Capitol Records, the label Mercer founded in 1942. "Frank is very quixotic and tremendously generous. He'd give you the shirt off his back. When he started earning big money, he couldn't give it away fast enough. However, only those in the business are really aware of the extent of his hidden generosity." – Johnny Mercer.

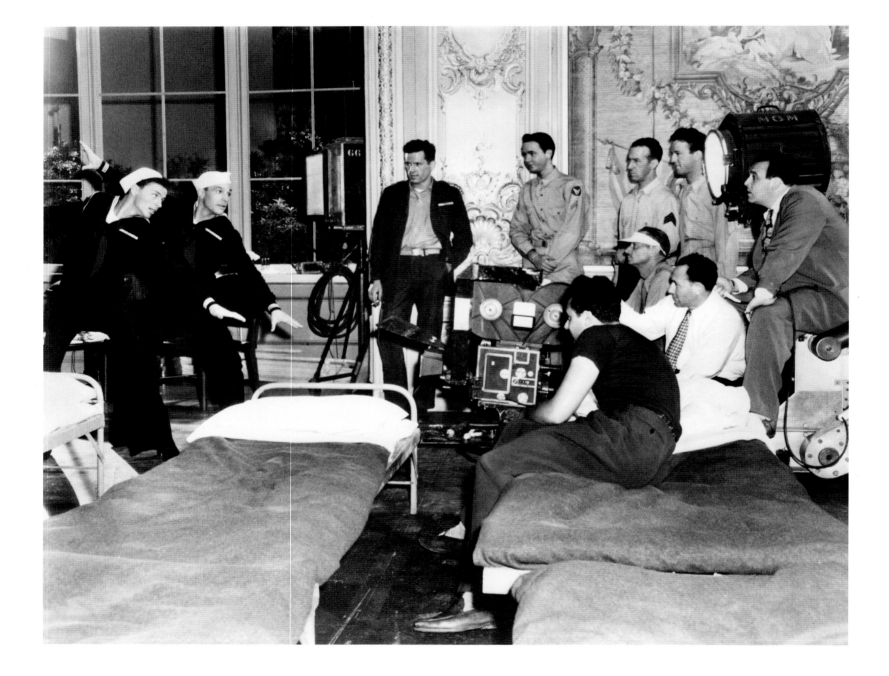

Frank Sinatra began filming *Anchors Aweigh* in June 1944.
"When I arrived at MGM, I was a nobody in movies. What
was I? – just a crooner. It was Gene [Kelly] who saw me
through. I couldn't dance exactly like he danced, so he danced
down to me. He taught me everything I know. He's one of the
reasons I became a star," said Sinatra.

" Back in 1944, MGM signed up some skinny Italian singer to do a picture with me called *Anchors Aweigh*. Of course, this skinny kid at that time was the idol of all the females in America. When he sang, they swooned. And yet, he presented the studio a problem in giving him a characterization in motion pictures. It was simply that he was the complete antithesis of the superstars of that era, like Clark Gable, Gary Cooper, Errol Flynn, etc.... How could you make a leading man out of a fellow you could lift off the floor with one hand? We all, of course, Frank included, found the answer: put him in a sailor suit and make his looks work for him. And we did – and it worked. Francis Albert Sinatra in *Anchors Aweigh* played the shyest and most timid sailor in the United States Fleet."

— *Gene Kelly*

"My eternal loyalties to Frank Sinatra are based on *Anchors Aweigh*. Producer Joe Pasternak asked Frank who he wanted to do the score – Kern, Gershwin, Rodgers and Hart…. Frank casually said, 'Sammy Cahn.' The MGM powers wouldn't hire two unknowns (myself and Jule Styne) to do the first multimillion-dollar musical and it came to such an impasse that Lew Wasserman, Frank's agent, came to me to plead, 'Unless Frank gives in, he'll lose the picture. Won't you talk with him?' I, of course, went to Frank and said, 'Frank, you have already done enough for me. Why don't you pass on this one? There'll be others.' Frank looked at me, and this is where it will always be between us, and said, 'If you are not there on Monday, I'm not there on Monday!' I was there on Monday. So was he."

— *Sammy Cahn*

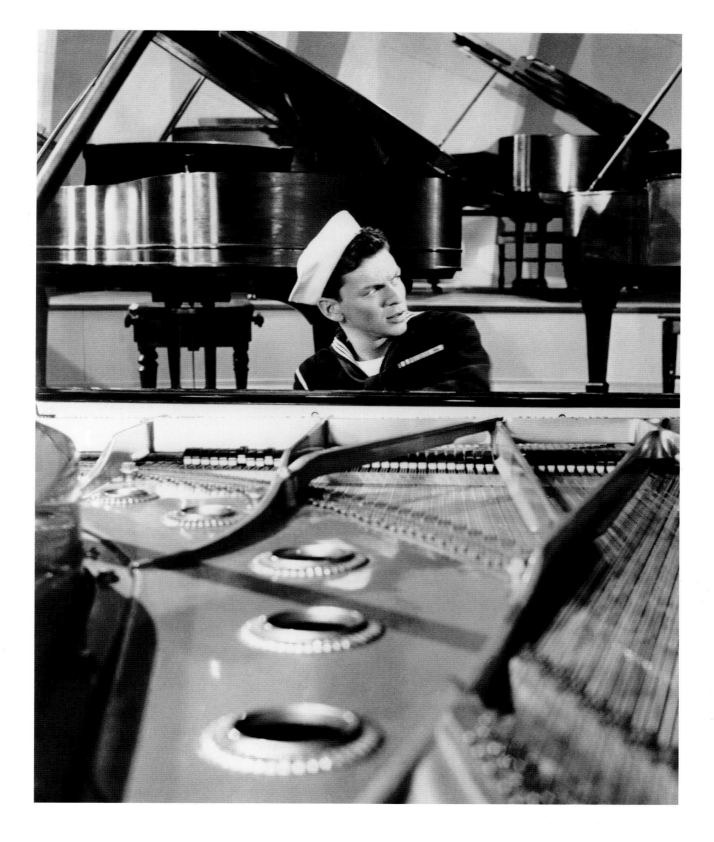

above Sinatra at the piano in a promotional still from *Anchors Aweigh*,
filmed in 1944 and released the following year. overleaf Frank Sinatra
with singer Eileen Barton, pilot Lt. Col. Winn, and actor Walter Huston,
Long Beach, August 30, 1944. The FBI prevented Sinatra from performing
overseas, so he did what he could to support the war effort at home.
The plane was christened "The Voice" in his honor.

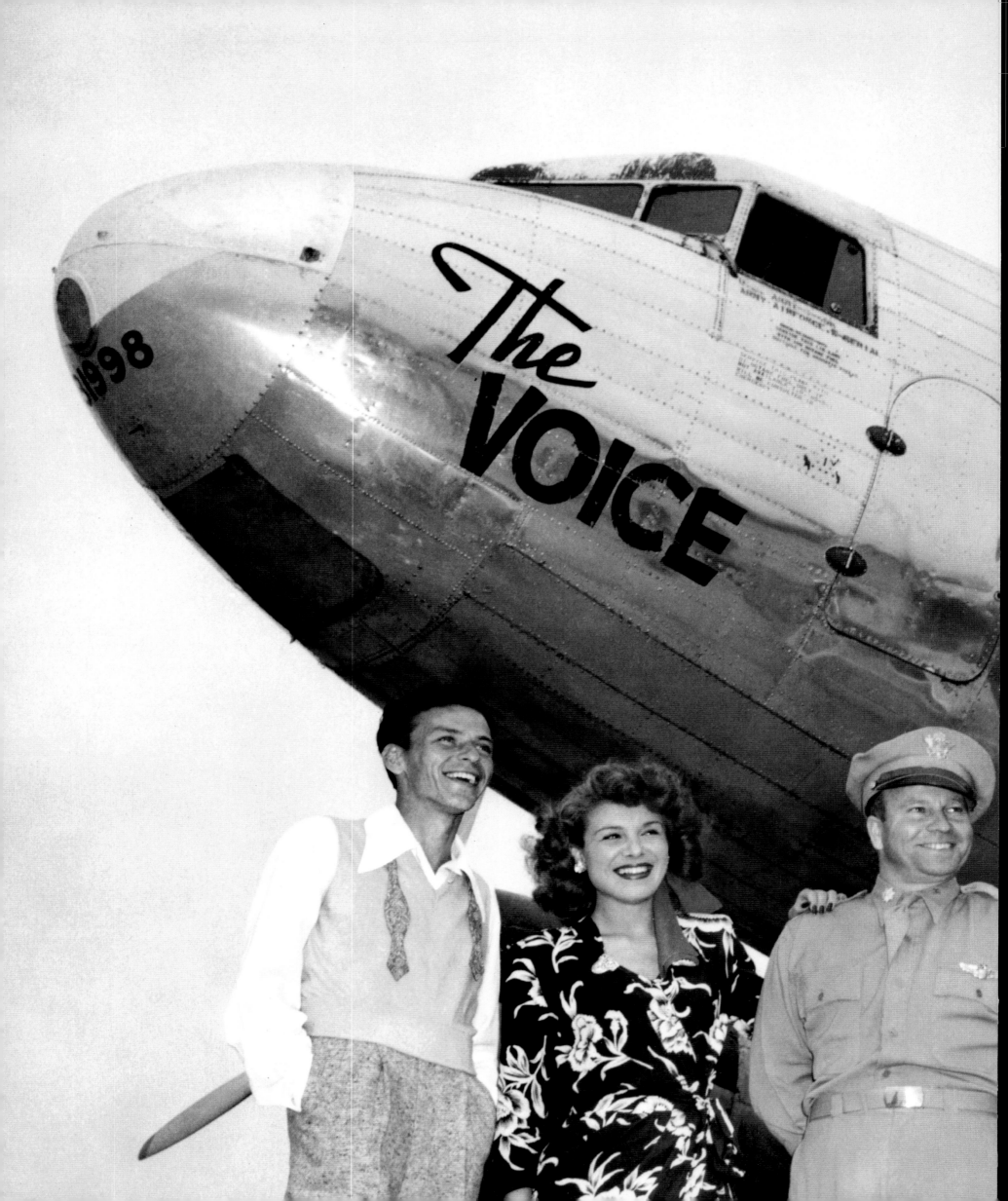

Sinatra's personal copy of the script for *The Frank Sinatra
Show*, October 18, 1944, which on this occasion featured Orson Welles
(opposite) as a guest. In 1944, Sinatra increased his domination of
the airwaves after landing his own half-hour radio show on CBS,
while continuing to co-host *Your Hit Parade*.

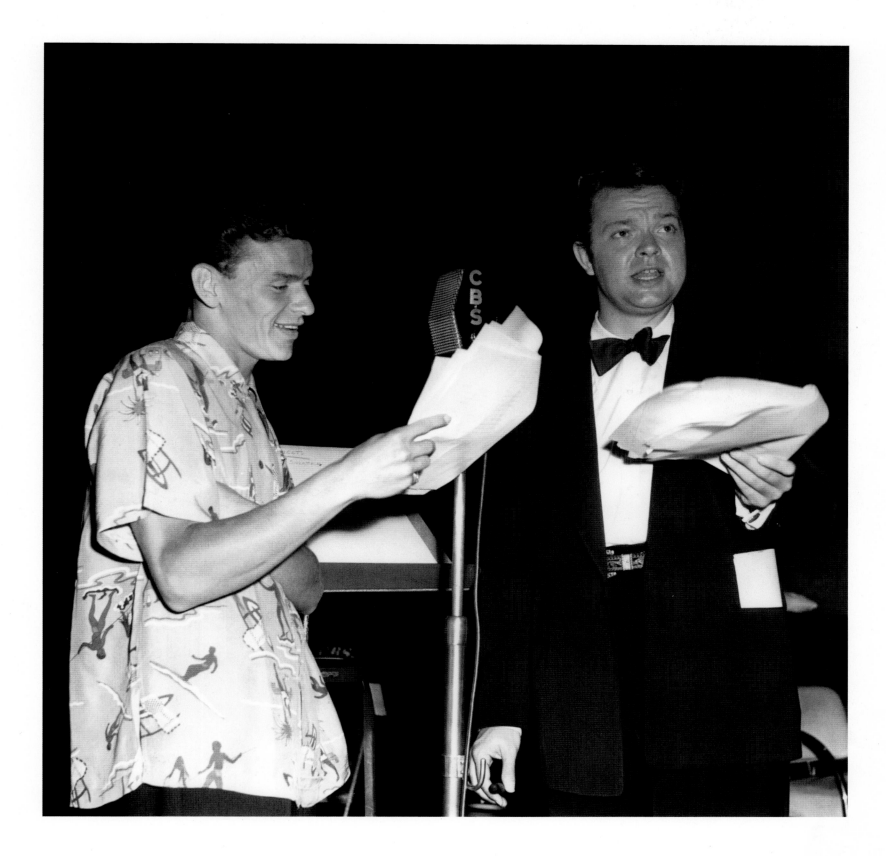

A casually dressed Sinatra with Orson Welles during a
CBS radio show in the 1940s. Sinatra and Welles would
remain close friends for decades.

"I THOUGHT THE GODDAMNED BUILDING WAS GOING TO CAVE IN. I NEVER HEARD SUCH A COMMOTION WITH PEOPLE RUNNING DOWN TO THE STAGE, SCREAMING AND NEARLY KNOCKING ME OFF THE RAMP. ALL THIS FOR A FELLOW I NEVER HEARD OF."

— Jack Benny

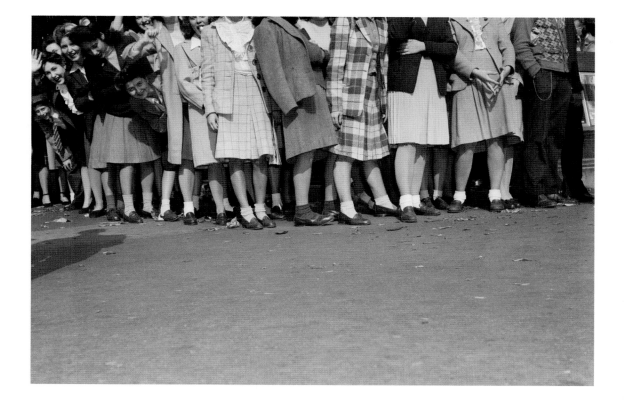

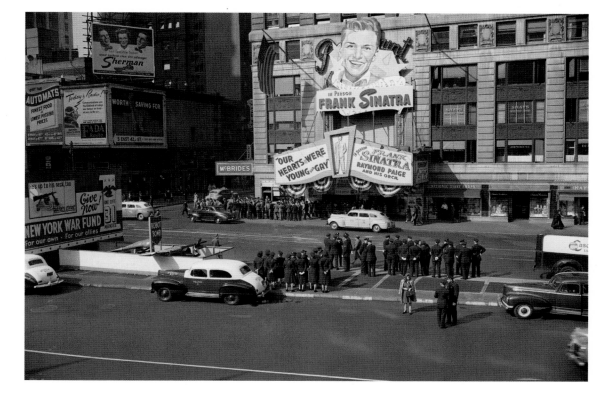

above Sinatra's legendary second appearance at the Paramount
Theatre during the height of "Sinatramania." More than a hundred
policemen were called out to maintain order over several thousand
bobbysoxers in October 1944. It was dubbed the "Columbus Day
Riot" because of the mass hysteria. **overleaf** Bobbysoxers show
their appreciation inside the Paramount while watching
Sinatra sing during his 1944 engagement.

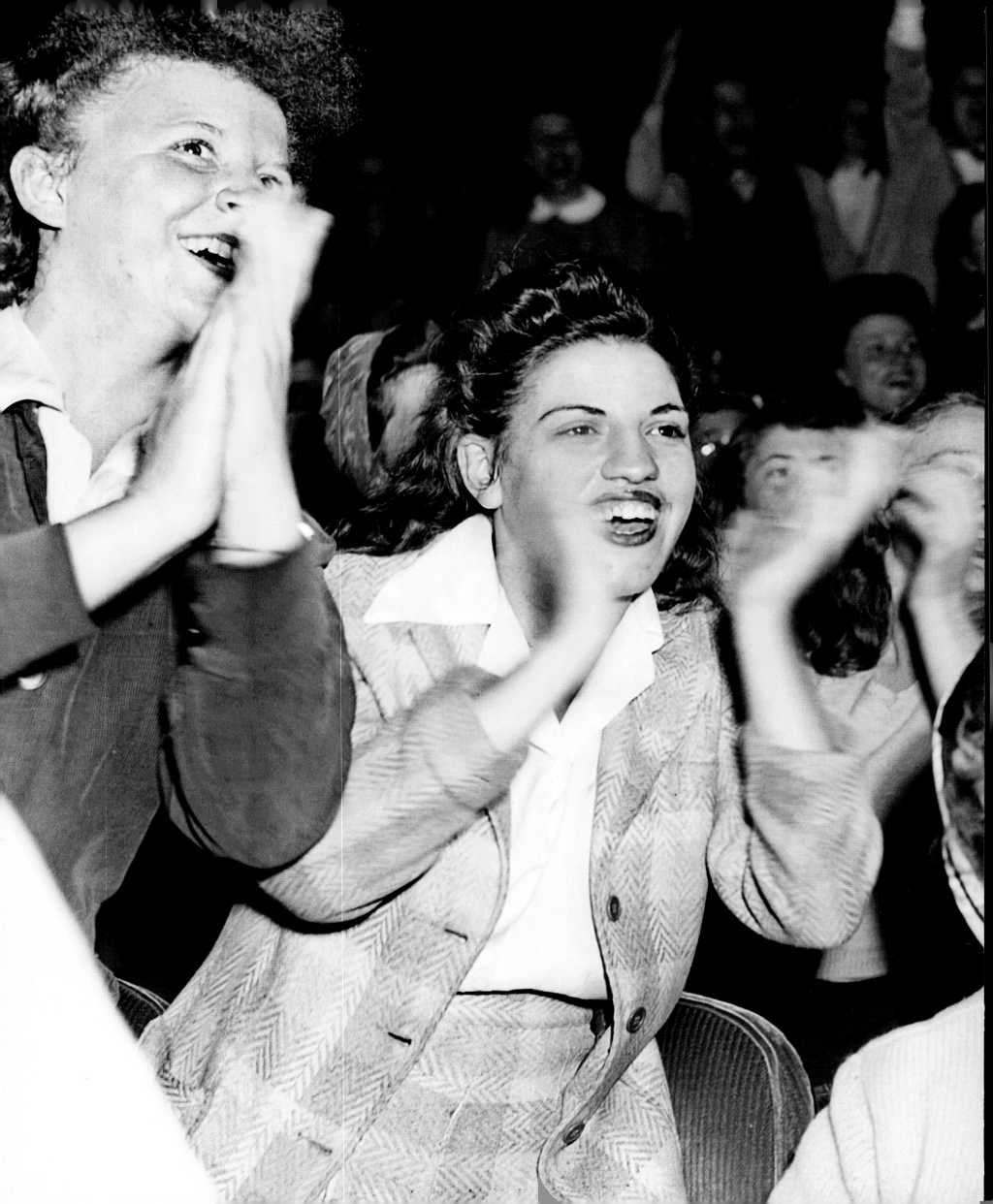

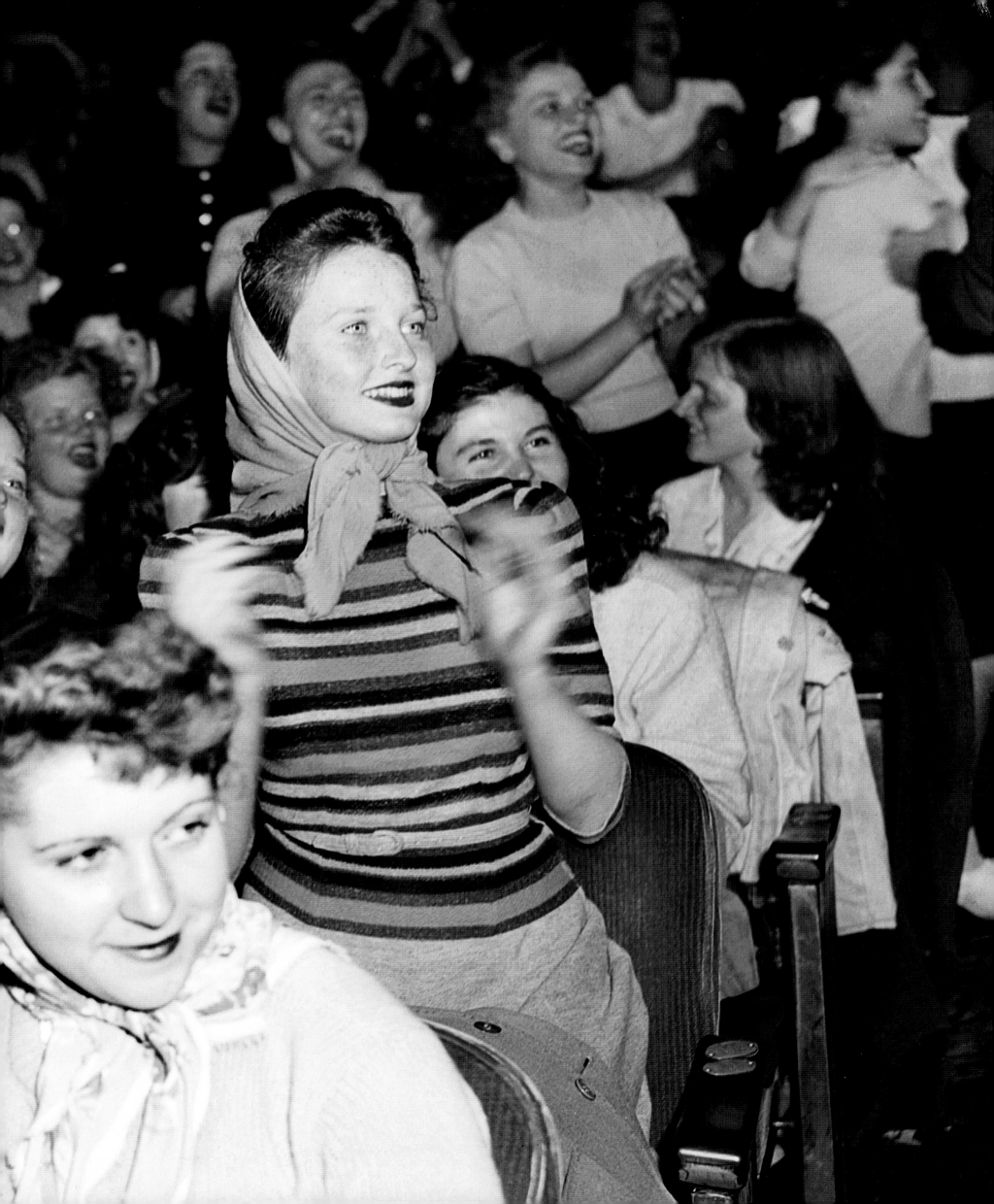

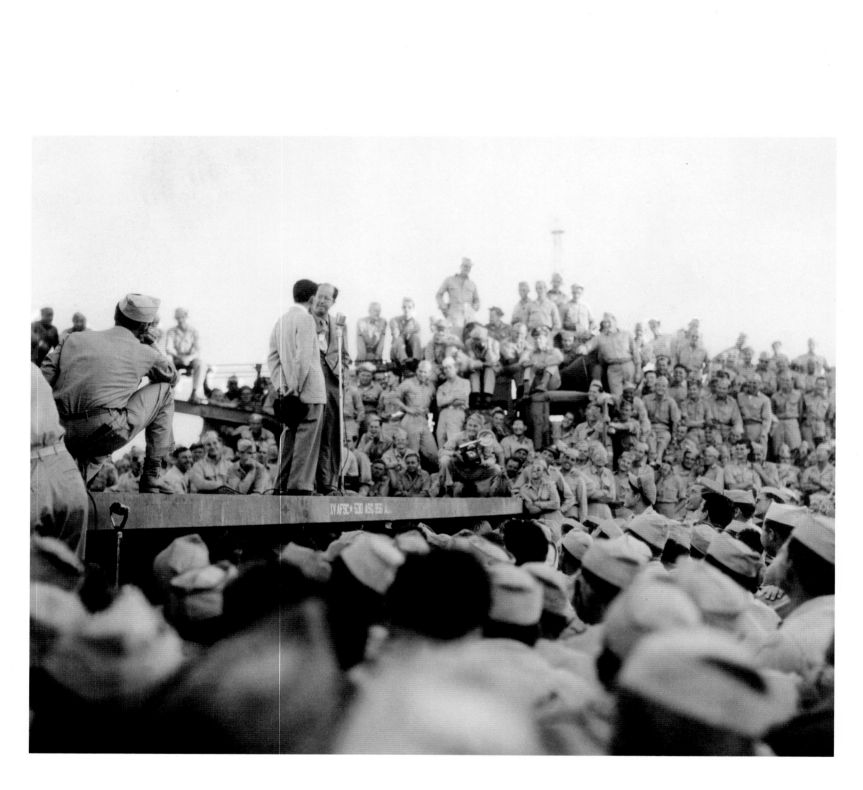

Sinatra performing with Phil Silvers at a post-VE Day
USO event in Italy, 1945. "At the height of his career, Frank
was asked to go overseas to entertain our armed forces. We
were a smash. Talk about women reacting to Frank's singing...
you should have heard the men." – Phil Silvers.

Advertisement for a USO-camp show in Naples, Italy,
June 1945. The group also included Fay McKenzie, actress
and singer, Betty Yeaton, billed as an "acrobatic cutie," and
the pianist and musical arranger, Saul Chaplin.

"HIS FACE HAS A CURIOUS STRUCTURE. THOSE CHEEKBONES! THOSE BULGES AROUND THE CHEEKS! THAT HEAVY LOWER LIP! HE'S LIKE A YOUNG LINCOLN."

— *Jo Davidson*

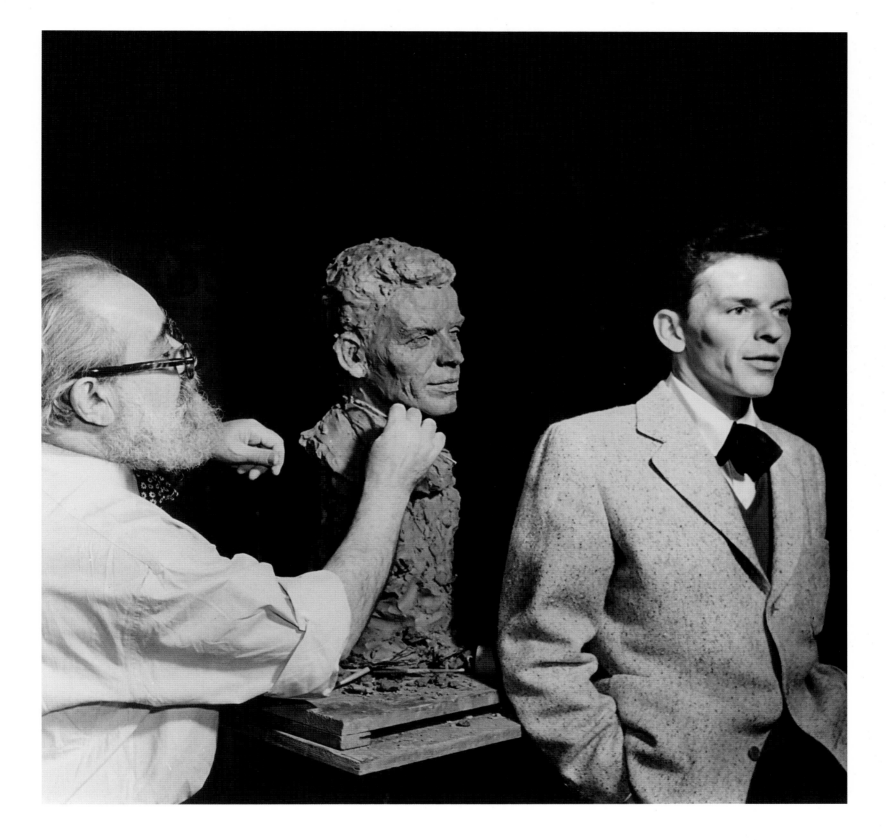

A bust of Frank Sinatra made in clay in 1946 by Jo Davidson
(1883–1952). Once described by actor and humorist Will Rogers
as "last of the savage headhunters," Davidson sculpted an
impressive cast of luminaries including Joseph Conrad, Gertrude
Stein, Sir Arthur Conan Doyle, Theodore Roosevelt, Dwight D.
Eisenhower, Charlie Chaplin, and Albert Einstein.

In 1947, columnist Robert Ruark reported Frank Sinatra was in Cuba
meeting with Lucky Luciano and other organized crime figures at the Hotel
Nacional. Above are some of Sinatra's declassified FBI files referring to the
Cuba incident. The FBI marked him as the target of numerous extortion
attempts, as well as for his contacts with those being investigated for
racketeering and possible involvement with the Communist Party. Files on
Sinatra, spanning five decades from 1943 to 1985, make him one of the FBI's
most scrutinized subjects in the world of popular entertainment.

" The Cuban incident started because I went to
Miami for a couple of days, I did a benefit for the
Damon Runyon Cancer Fund at the Colonial Inn.
After I did the benefit, I decided to go to Cuba
for a few days...I was going to try and sit in the
sun...before I was to meet Nancy in Acapulco for
Valentine's Day. My luggage was of course on
the airplane, but I carried a sketchpad in a thin
attaché case...the bag was little.... If you could
get $2 million dollars in an attaché case,
I'll give you $2 million dollars."

– Frank Sinatra

" Back in 1947, I covered, for kicks, a Frank Sinatra
Columbia record date produced in New York.
Dominating the scene was Sinatra, the one-time
skinny kid, now filled-out, looking handsome and
confident. His voice still had the seamless, carefully
articulated, meaningful quality that could make
everyone, even in a large audience, feel that he
was sending a private message to him or her. At
the recording session in Liederkranz Hall, with a
frequency that puzzled me, Sinatra kept interrupting
'takes' to point out what he felt were mistakes, and to
call for a retake.... Another retake! Lots of overtime!
I couldn't help thinking of the cost, especially with
so large an orchestra and with the instigator as
someone whose career was waning. Did Sinatra
know what he was doing? Were the mistakes he
heard really there, or was this the affectations
of a former star, trying to show himself and others
that he was still the star? I asked the musicians of
the orchestra. Unanimously, they assured me that
when he found fault that day, he was right. "

— William Gottlieb

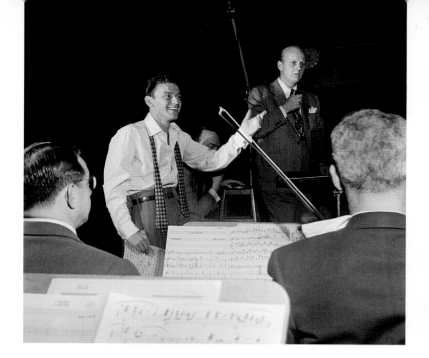
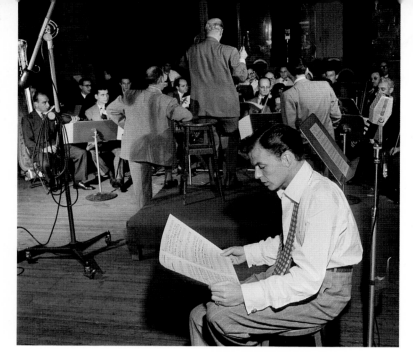
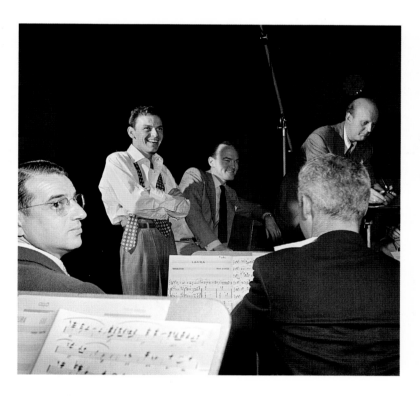
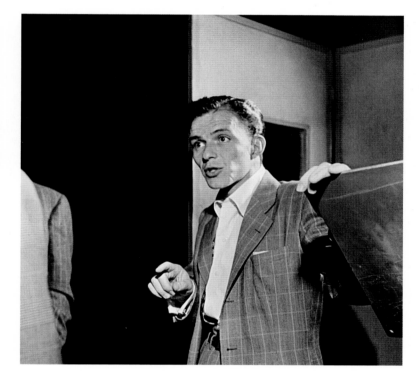
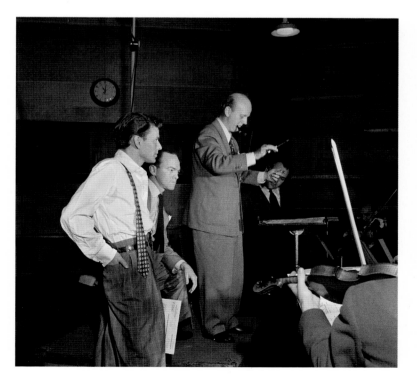
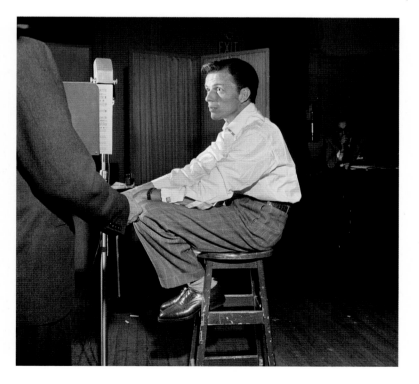

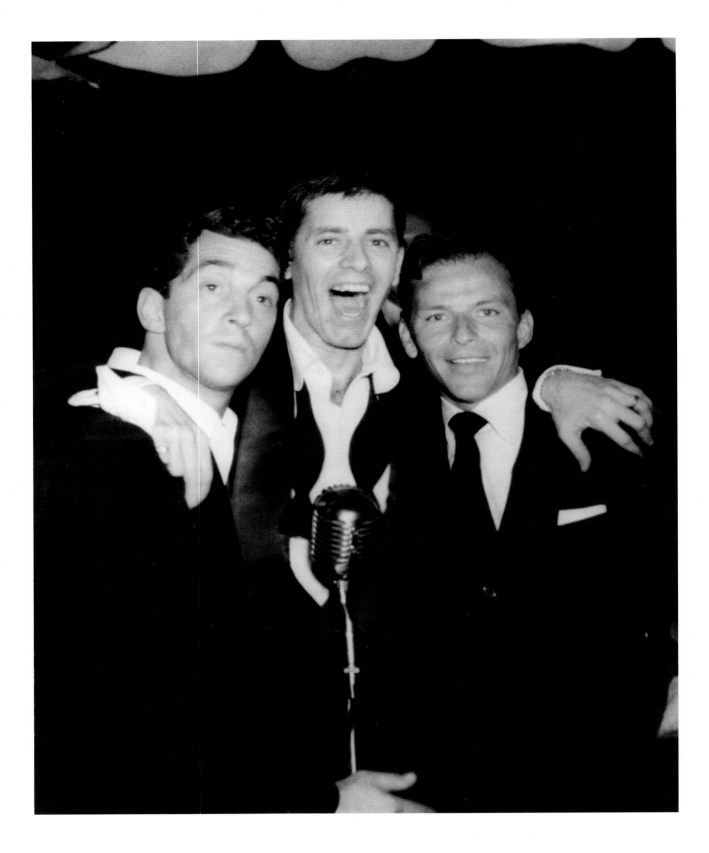

Frank Sinatra with Dean Martin and Jerry Lewis at the
Copacabana nightclub in New York in the late 1940s. At the time,
Martin and Lewis were the top comedy team in show business.
Even after the duo split in 1956, Sinatra remained friends with them
both and they later reunited in 1976 during Lewis' annual telethon
for the Muscular Dystrophy Association (MDA).

"I KNOW A LOT OF
THOSE GUYS. PEOPLE
HAVE SAID TO ME,
'WHY DID YOU HAVE
FRIENDS IN THE
MOB?' I SAY, 'I WAS
NOT FRIENDS WITH
THEM.' WHEN THE
COPACABANA WAS
OPEN, THERE WASN'T
ONE GUY IN SHOW
BUSINESS WHO DIDN'T
MEET THEM THERE.
LET THEM BUY YOU
A DRINK. SO I'VE
STOPPED TRYING
TO EXPLAIN THAT
TO PEOPLE."

– Frank Sinatra

Sinatra sightseeing in Spain after traveling to meet Ava
Gardner on the set of *Pandora And The Flying Dutchman*, May
1950. Sinatra had canceled his engagement that month at the
Chez Paree in Chicago in order to make the trip.

While Ava was filming, Jimmy Van Heusen and
Sinatra enjoyed being tourists in Tossa de Mar, Spain,
on the Mediterranean Sea. These rare photos were
taken by Jimmy Van Heusen.

" I first met Ava in the early 1940s and when
I saw her a few years later I thought this was not
the young little girl from Carolina at the studio,
this was a woman who was glorious. At the start
of the relationship we were really deeply in love;
almost too much in love. She [Ava] was working
at Metro doing a picture here, a picture there,
and then came a job to do a picture in Spain.
Things all of a sudden then didn't fall into place.
This was a turmoil that the whole world knew
about, and I was chasing her around the world and
I was borrowing money to go visit with her. I was
broke...all the guys who made hundreds
of thousands of dollars with me never called and
said what can we do for you, do you need any
money? At that point I had nobody, the only guy
I could talk to was Jimmy Van Heusen and he'd
give me a few dollars for my pocket. "

— *Frank Sinatra*

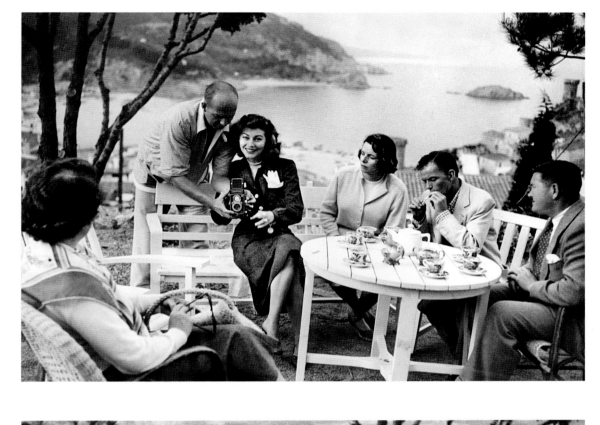

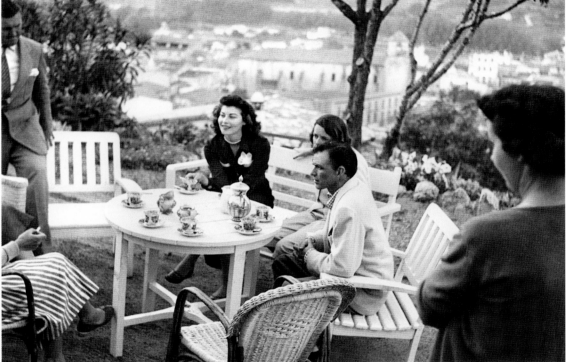

Frank Sinatra, Ava Gardner, and Jimmy Van
Heusen in Spain, 1950. Jimmy Van Heusen (top)
demonstrates his camera to Ava.

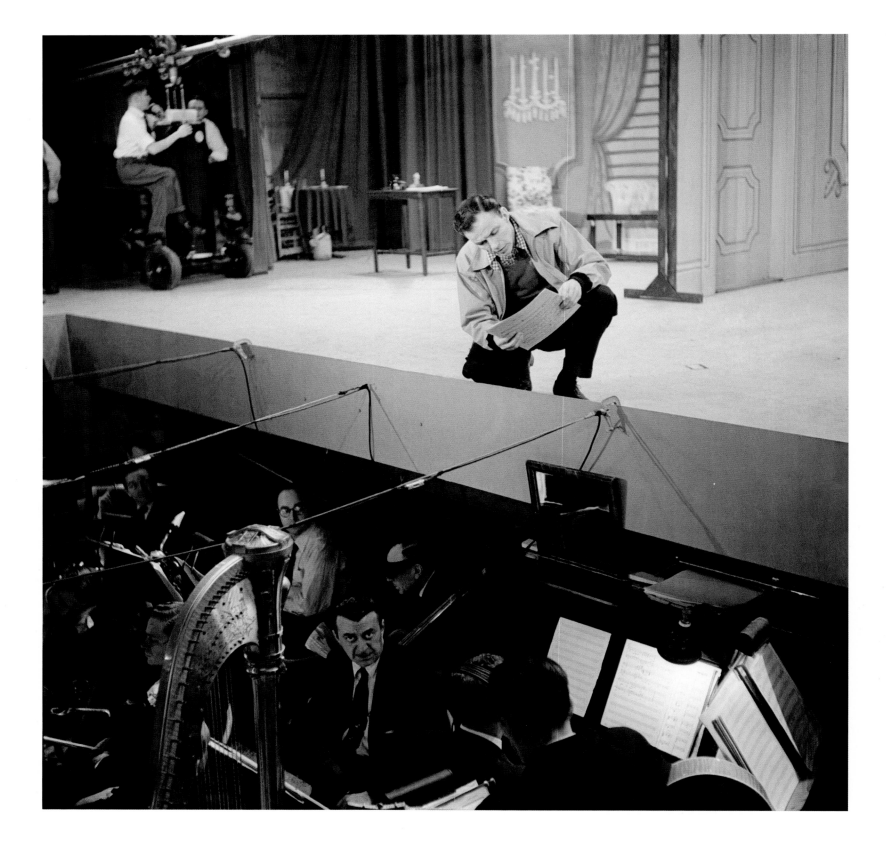

Frank Sinatra reviewing a song with the orchestra
during rehearsal for an episode of *The Frank Sinatra Show*
in 1951. The one-hour variety show premiered on the
CBS television network on October 7, 1950, at what was
already a low point of Sinatra's career, and aired from
9 till 10 p.m. on Saturday nights.

"I WAS HIRED AS THE PIANIST FOR FRANK'S CBS TELEVISION SHOW WHEN IT RETURNED FROM ITS SUMMER HIATUS IN OCTOBER 1951. THE SHOW DIDN'T LAST LONG. FRANK WAS SOMEWHAT UNCOMFORTABLE ON TV. HE HADN'T REACHED THAT TRANSITION POINT IN HIS CAREER."

— *Bill Miller*

"ONE OF THE VITAL FACTORS THAT FRANK APPRECIATES IS THE CAREFUL READING OF A LYRIC. THE LISTENER MUST FEEL THAT YOU MEAN EVERY WORD OF THE LYRIC AND BELIEVE IN IT, THAT IS VERY IMPORTANT. FRANK CONVEYS THIS FEELING...TO HEAR HIM SING A VERY PERSONAL SONG LIKE 'NANCY' CAN BE VERY MOVING."

— Perry Como

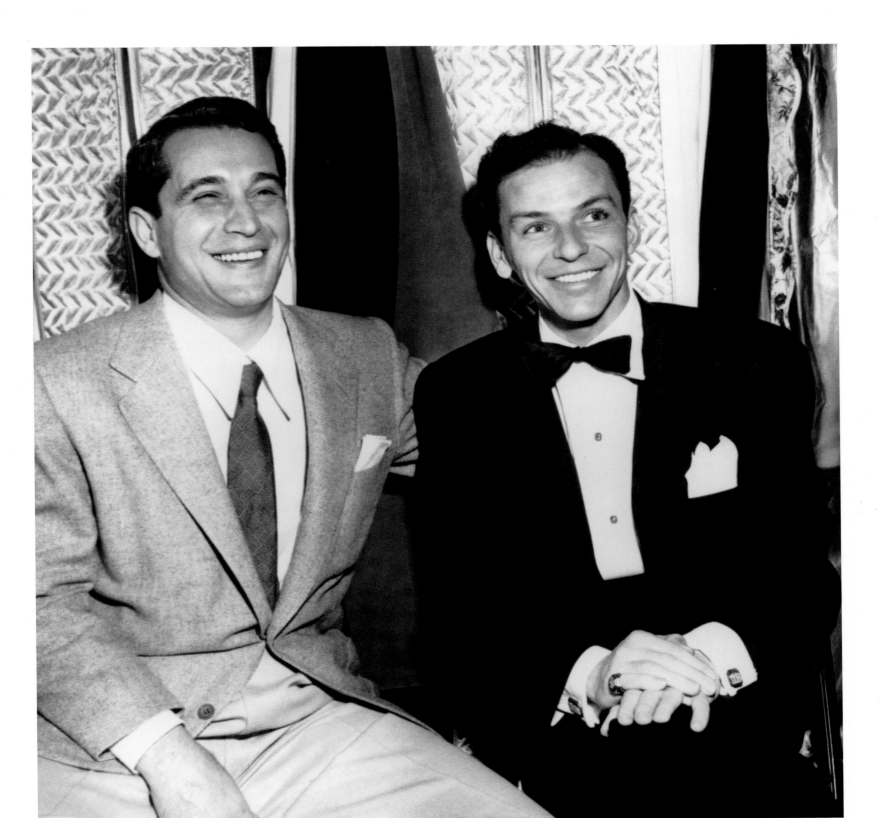

Frank Sinatra with Perry Como. In 1951, Sinatra and Como
appeared with Frankie Laine in a spoof of the Andrews
Sisters on CBS's *The Frank Sinatra Show*.

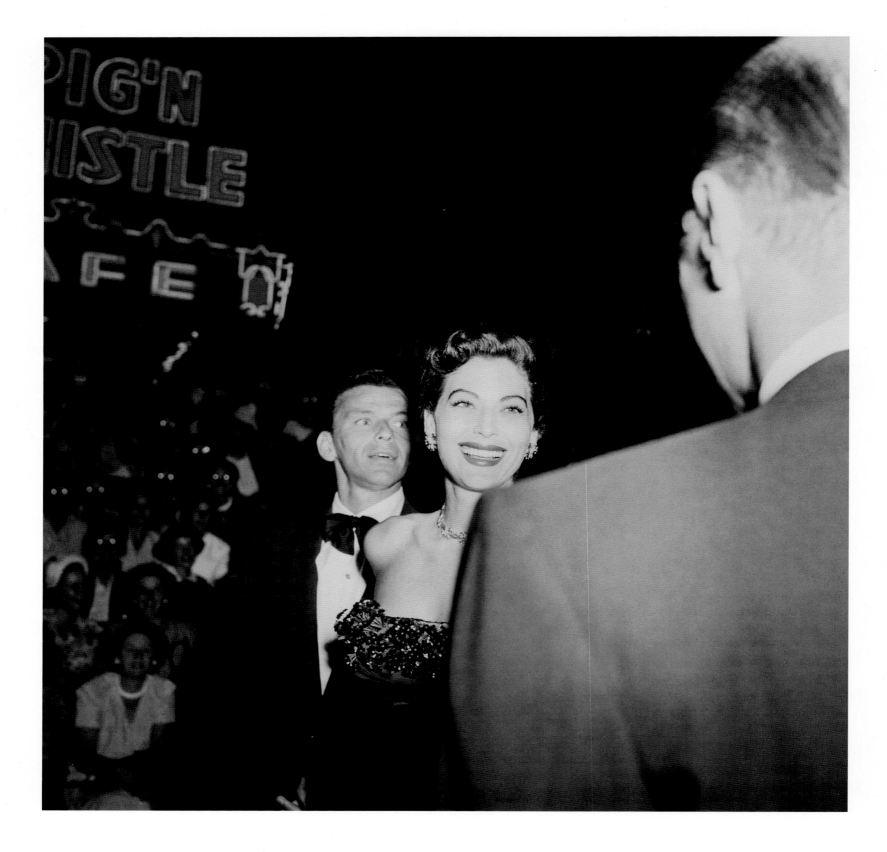

Frank Sinatra and Ava Gardner attend the premiere
of MGM's Technicolor musical *Showboat* at the Egyptian
Theatre in Los Angeles, July 17, 1951. At this point, the couple
had been linked romantically for more than a year.

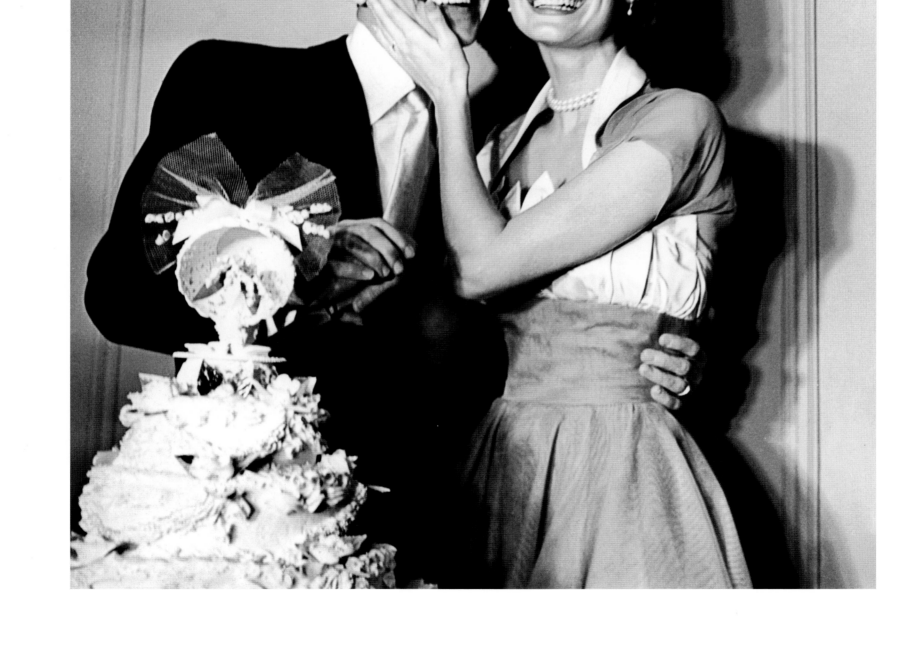

Frank Sinatra and Ava Gardner on their wedding day.
The couple were married on November 7, 1951 in Philadelphia,
at the home of Lester Sacks. Lester was the brother of Sinatra's
good friend and mentor, Manie Sacks.

CHAIR-
MAN
OF THE
BOARD

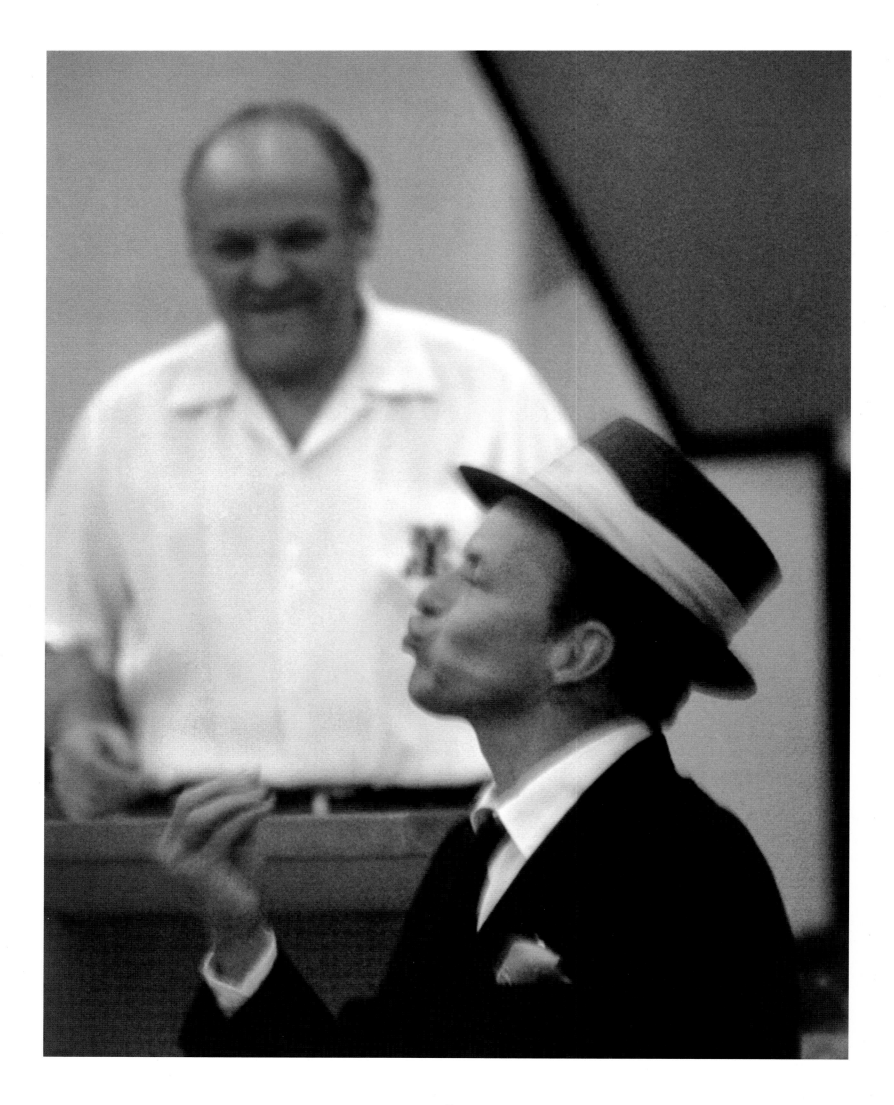

CHAIRMAN OF THE BOARD
1953–1972

1952 had not been a very good year for Frank Sinatra. Personal problems aside, he faced a disintegrating career that was in a spiraling free-fall.

At thirty-eight years old, I was a has-been. My only collateral was a dream. Somewhere along there I discovered that they'll kick you at the top and they'll kick you at the bottom. Well, as long as I was going to get hurt, I might as well get hurt as a success. The sting is not quite so permanent as it is when you're a failure. So I waited.

Never one to give up on himself, Sinatra had his sights set on a new project, a role in a movie that he was born to play.

The day I heard that a movie was to be made from the bestseller From Here To Eternity *I knew, suddenly, that I had something to fight for. I went to [producer] Buddy Adler and I said, "Buddy, I've never asked you for anything before, but I'm ready to beg for that part. Give it to me and you'll never be sorry." I had read the book and I knew one hundred Maggios in my lifetime. I made a test for Harry Cohen; it was of the drunk scene in the bar. After that I went to Africa to see Ava. I heard that Eli Wallach was testing for it [Maggio] and I thought I'd never get the part. I had to come back to make the picture. I would have done it for nothing.*

On March 25, 1954, Sinatra won an Oscar for his portrayal of Private Angelo Maggio. That evening, one of the greatest in Sinatra's professional life, also marked one of the most dramatic and greatest comebacks in the history of show business. Following his success in *From Here To Eternity* (1953), Frank Sinatra was back on top. His film career reached new heights during the fifties and sixties. He won acclaim for diverse roles in dramas such as *The Man With The Golden Arm* (1955), *Some Came Running* (1958), *The Manchurian Candidate* (1962), *Von Ryan's Express* (1965), and *The Detective* (1968), and in comedies and musicals including *Young At Heart* (1954), *The Tender Trap* (1955), *Guys And Dolls* (1955), *High Society* (1956), *Pal Joey* (1957), *A Hole In The Head* (1959), *Ocean's 11* (1960), and *Robin And The 7 Hoods* (1964). For nearly the next two decades Frank Sinatra was a major international box office superstar.

Sinatra had regained his popularity and then some. The Voice was now The Chairman Of The Board.

The other major turning point came when he signed a deal with Capitol Records. He never looked back musically. Between April 1953 and March 1962 Sinatra would record more than three hundred selections on the label. At Capitol, Sinatra conceived and recorded his landmark "concept" albums. Unquestionably, these albums, in which Sinatra collaborated with arrangers Nelson Riddle, Billy May, and Gordon Jenkins, represent the finest body of recorded work in popular music. The concept albums would set Frank Sinatra apart from all other vocalists of the twentieth century and quite possibly all time. *In The Wee Small Hours* (1955), *Songs For Swingin' Lovers!* (1956), *Where Are You?* (1957), *Come Fly With Me* (1958), *Frank Sinatra Sings For Only The Lonely* (1958), *No One Cares* (1959), and *Nice 'n' Easy* (1960), amongst others, are considered masterworks today.

As Sinatra's career was reaching new heights, his personal life was in turmoil.

I had a personal problem then in my life with Ava... and it was beginning to drift away. I think that had a lot to do with my having to be good [career-wise].

In July 1957, Sinatra and Ava Gardner divorced. That same year, he signed with ABC in one of the most lucrative deals in television history – to the tune of three million dollars. The idea was that Sinatra would star in a series of musical and drama shows for the network, broadcasting on Friday nights, with Bulova Watch Company and Chesterfield Cigarettes on board as sponsors. ABC's take on *The Frank Sinatra Show* debuted on October 18, 1957, with guests Bob Hope, Peggy Lee, Kim Novak, and a twenty-seven-piece orchestra under the direction of Nelson Riddle. "What I'm looking for," described Sinatra, "is a family show...casual, almost understated, but always in good taste." However, Sinatra was not made for the grind of weekly television and the show was soon canceled.

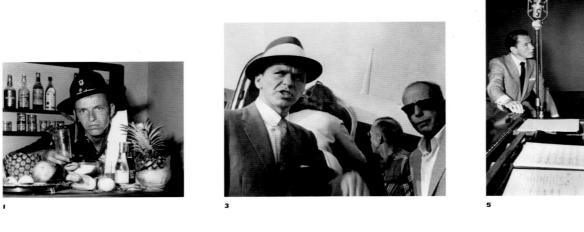

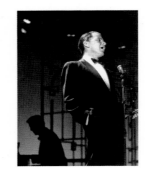

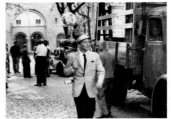

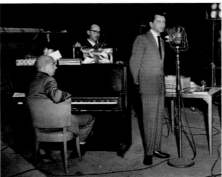

1. Publicity still from the film *From Here To Eternity*, 1953. **2.** Sinatra and Humphrey Bogart at sea. **3.** Frank and Bogart boarding a plane to Las Vegas. **4.** Sinatra with Sammy Cahn and Jimmy Van Heusen. **5.** Sinatra and Peggy Lee rehearsing for his ABC television series in 1957. **6.** Sinatra and Bill Miller on television. **7.** Frank Sinatra sightseeing in Europe, 1961.

Let's face it, I'm just not fond of weekly TV. It takes too much energy...too much tension, havoc, and rehearsal... for the results you get. I've seen TV chew up the talent of a lot of great people. I know what it does to your insides.

In 1960, Sinatra teamed with Dean Martin, Sammy Davis Jr., Joey Bishop and Peter Lawford for the "Summit At The Sands." Dubbed "The Rat Pack" by the press, the show ran for four weeks with two shows every night, at the same time as the "pack" was filming *Ocean's 11*. Joey Bishop would open the show, followed by Martin, then Davis, then Lawford, and finally Sinatra. For the finale, the group returned en masse to joke and sing. More often than not, Davis and Lawford would sing and dance, then Martin and Sinatra would heckle Davis, roll a bar out on stage and sing parodies. In only the first six days of the show, "Summit at the Sands" had to turn down more than eighteen thousand requests for reservations. Frank and friends had conquered the town! No event before it or since has achieved such legendary status in Las Vegas.

After deciding not to re-sign with Capitol, Sinatra realized a long-time dream by forming his own record label, Reprise, in late 1960. At the time Sinatra's business model was highly innovative in the recording industry: he pioneered the concept of having artists own and control their masters.

I wasn't happy during that period with Capitol.... I had said I wanted to quit Capitol and even if it meant not recording at all for two years until the contract ran out. But they let me go on the condition I cut four more albums for them to wind up the deal. I wanted to form my own record company and run it along my own ideas.

"Now a newer, happier, emancipated Sinatra... untrammeled, unfettered, unconfined" is how the early advertisements described Frank on Reprise. On his new label, Sinatra was able to record with musical giants such as Count Basie, Duke Ellington, and Antonio Carlos Jobim.

Between his recording, television, radio, and movie commitments were the legendary live nightclub engagements and concerts at venues such as The Sands in Las Vegas, the Fontainebleau in Miami, and the 500 Club in Atlantic City among others. Sinatra was also one of the first performers to mount a world tour in 1962. The proceeds from that tour would benefit children's charities in the twelve countries in which he performed. "Not only did he have the dream of helping these people, he was also in the position of being able to execute that dream and make it come true," recalled Frank Sinatra Jr.

Aside from being a superstar entertainer, Sinatra was now a fully fledged businessman. One article titled "Sinatra, Inc." detailed his strikingly successful transition into the business world.

"Things are going for me," Sinatra told writer and friend Joe Hyams in 1961. Chairman of the board of a Beverley Hills savings and loan association, four music publishing companies and a movie production company, vice president and stockholder in The Sands Hotel, three radio stations in the Pacific Northwest, and real estate developments in San Rafael and Santa Barbara, California, were just some of Sinatra's investments at the time.

Even the so-called "Rat Pack" films were successful at the box office; it seemed Sinatra could do no wrong.

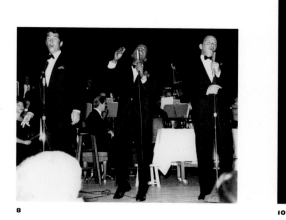

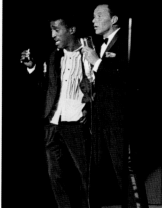

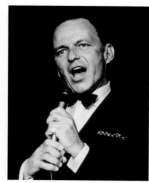

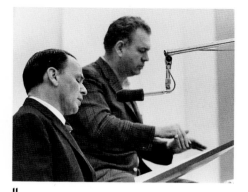

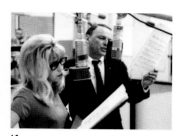

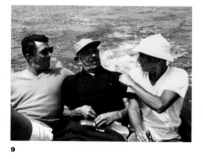

8. Dean Martin, Sammy Davis Jr. and Frank Sinatra at The Sands Hotel, Las Vegas, 1963. 9. Dean Martin, Mike Romanoff, and Sinatra, sailing. 10. Sammy Davis, Jr. and Sinatra clowning around on stage. 11. Frank Sinatra recording with arranger Nelson Riddle, 1960s. 12. Sinatra at The Sands Hotel, Las Vegas, 1964. 13. Sinatra leaving "Sinatra Enterprises" in 1965. 14. Frank and Nancy Jr. recording 'Somethin' Stupid,' 1967.

Of course they're not great movies, no one could claim that…. But every movie I've made through my own company has made money and it's not so easy. Ocean's 11 has grossed millions of dollars and Sergeants 3 is already on the way to doing the same.

In July 1966, after a short courtship, Frank Sinatra married actress Mia Farrow in Las Vegas. During the sixties, there was a seismic culture shift caused by assassinations, racial tensions, the Vietnam War, and other events that defined the decade. Sinatra divorced Farrow in August 1968.

Although the musical landscape was changing, Sinatra enjoyed several hits during the late sixties, including 'Strangers in the Night,' 'Somethin' Stupid' (a duet with daughter Nancy), and 'My Way' during the September of his years.

Then, on March 24, 1971, entertainment columnist Suzy (Aileen Mehle) headlined her column with the following exclusive: "Sinatra Is Going To Do It His Way; Retiring at 55." She wrote, "Frank Sinatra, the star of stars, the voice that thrilled millions and the Academy Award-winning actor, is retiring from show business at the age of fifty-five after an unparalleled thirty-year career."

The full text of Frank Sinatra's official retirement announcement read as follows:

I wish to announce, effective immediately, my retirement from the entertainment world and public life. For over three decades I have had the great and good fortune to enjoy a rich, rewarding, and deeply satisfying career as an entertainer and public figure. Through the years people have been wonderfully warm and generous in their acceptance of my efforts.

My work has taken me to almost every corner of the world and privileged me to learn by direct experience how alike all people really are – the common bonds that tie all men and women of whatever color, creed, religion, age, or social status to one another; the things mankind has in common that the language of music, perhaps more than any other, communicates and evokes.

It has been a fruitful, busy, uptight, loose, sometimes boisterous, occasionally sad, but always exciting three decades.

There has been, at the same time, little room or opportunity for reflection, reading, self-examination, and that need which every thinking man has for a fallow period, a long phase in which to seek a better understanding of the vast transforming changes now taking place everywhere in the world.

This seems a proper time to take that breather, and I am fortunate enough to be able to do so. I look forward to enjoying more time with my family and dear friends, to writing a bit – perhaps even to teaching.

I take this means of expressing my heartfelt thanks and my love and affection to the millions everywhere who have given me so much more than I could possibly hope to give them in return.

– Frank Sinatra, Palm Springs, Calif., March 23, 1971.

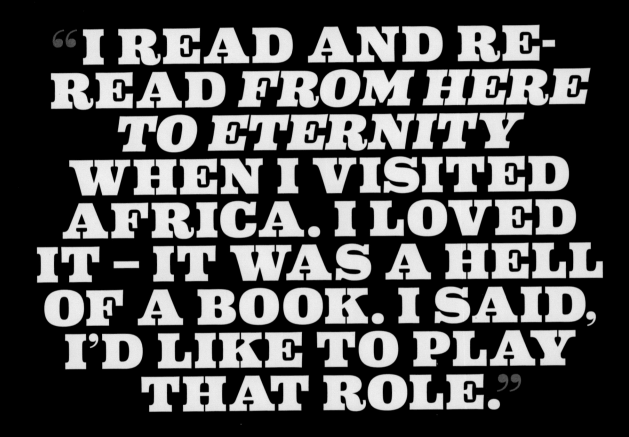

"I READ AND RE-READ *FROM HERE TO ETERNITY* WHEN I VISITED AFRICA. I LOVED IT – IT WAS A HELL OF A BOOK. I SAID, I'D LIKE TO PLAY THAT ROLE."

– *Frank Sinatra*

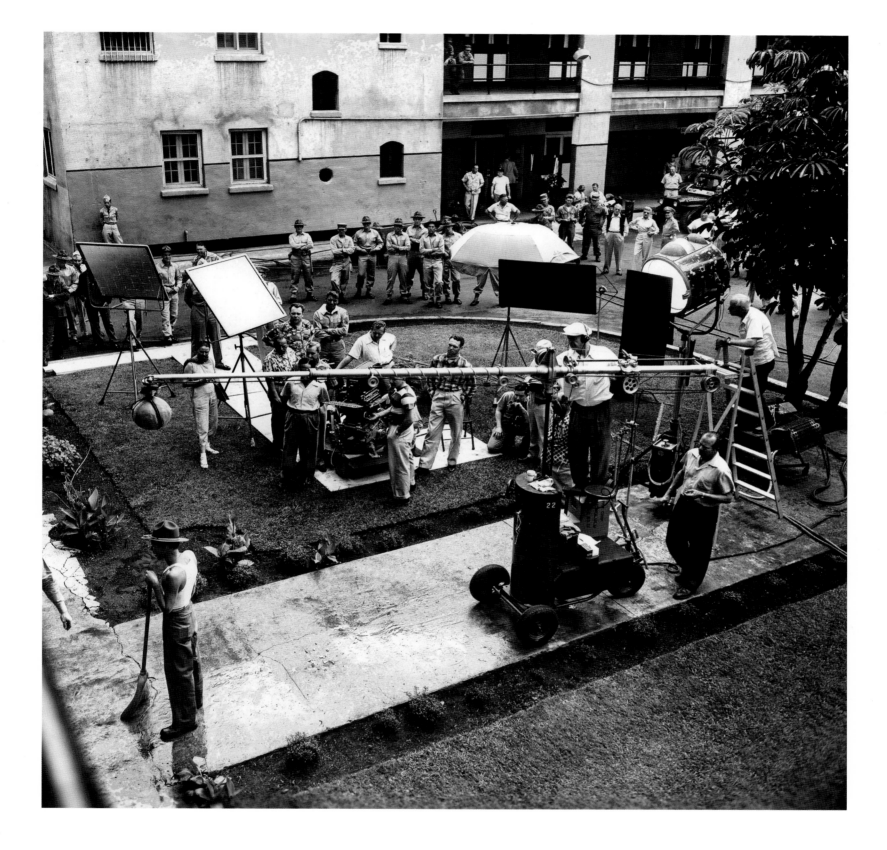

Frank Sinatra on the set of *From Here To Eternity* (1953). Based
on the bestselling book, the film was a critical and commercial
success, and Sinatra was awarded an Academy Award for Best
Supporting Actor. He recalled, "I loved working with all of
those people in the picture. Monty Clift and I became very close
friends; he was so good and helped me tremendously."

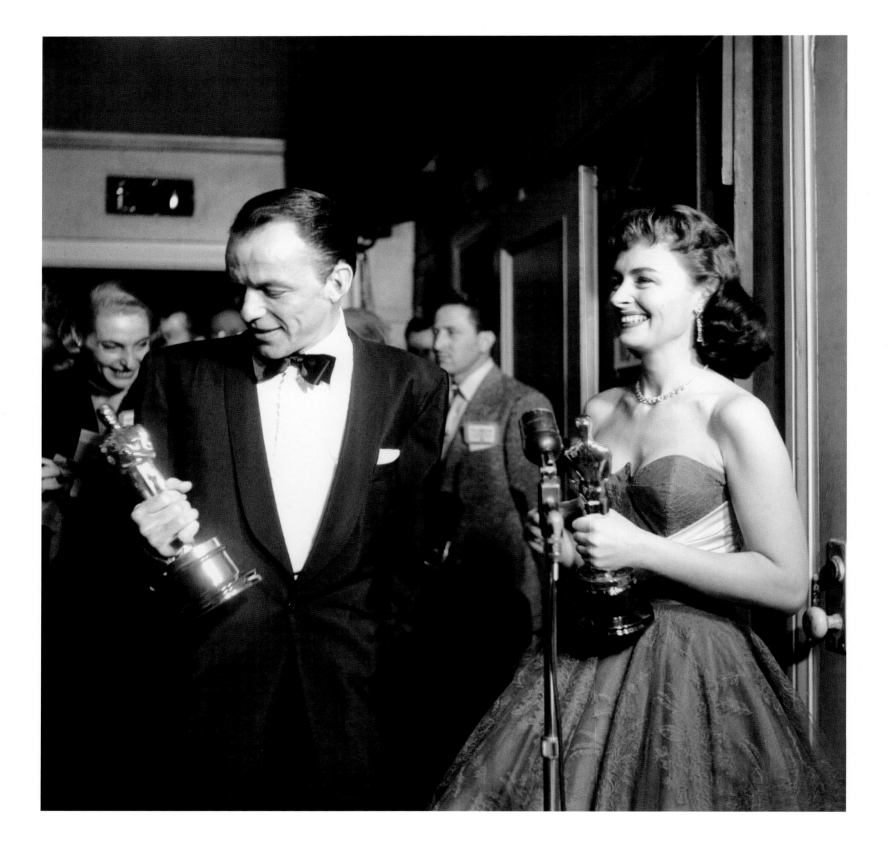

Frank Sinatra and Donna Reed after winning Best Supporting
Actor and Actress Oscars for their roles in *From Here To
Eternity* at the 26th Academy Awards ceremony on March 25,
1954, at the RKO Pantages Theatre in Hollywood.

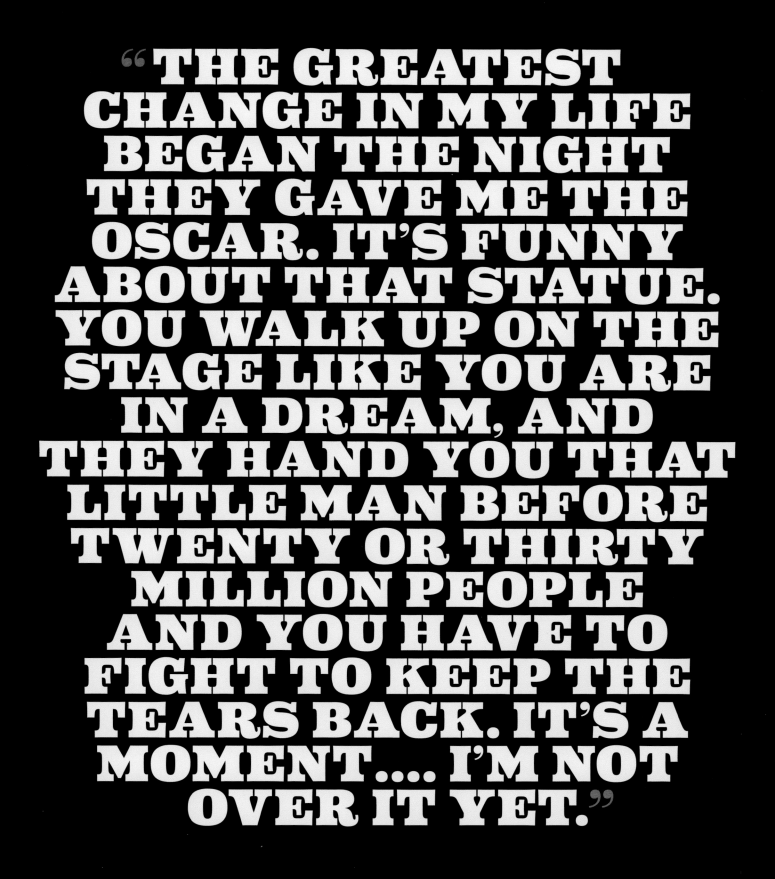

"THE GREATEST CHANGE IN MY LIFE BEGAN THE NIGHT THEY GAVE ME THE OSCAR. IT'S FUNNY ABOUT THAT STATUE. YOU WALK UP ON THE STAGE LIKE YOU ARE IN A DREAM, AND THEY HAND YOU THAT LITTLE MAN BEFORE TWENTY OR THIRTY MILLION PEOPLE AND YOU HAVE TO FIGHT TO KEEP THE TEARS BACK. IT'S A MOMENT.... I'M NOT OVER IT YET."

— *Frank Sinatra*

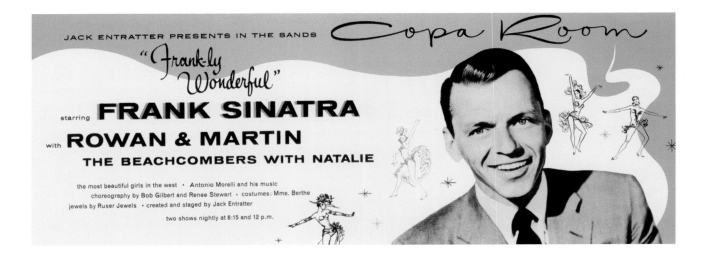

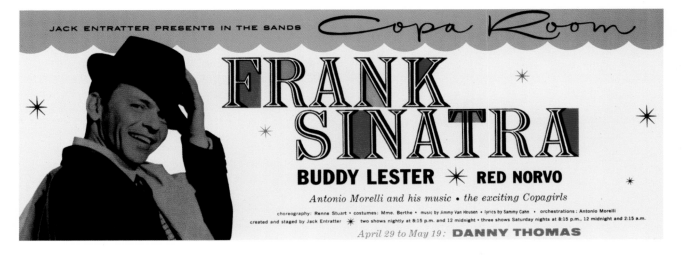

above Placards for Sinatra engagements from the 1950s at The Sands Copa Room in Las Vegas. From December 1956 (top) and from April 1959 (bottom). "Frank Sinatra is to Las Vegas what George Washington is to America; he's the icon of this city." – Steve Wynn.
opposite Sinatra onstage in the Copa Room during his early years as a headliner at The Sands Hotel.

86

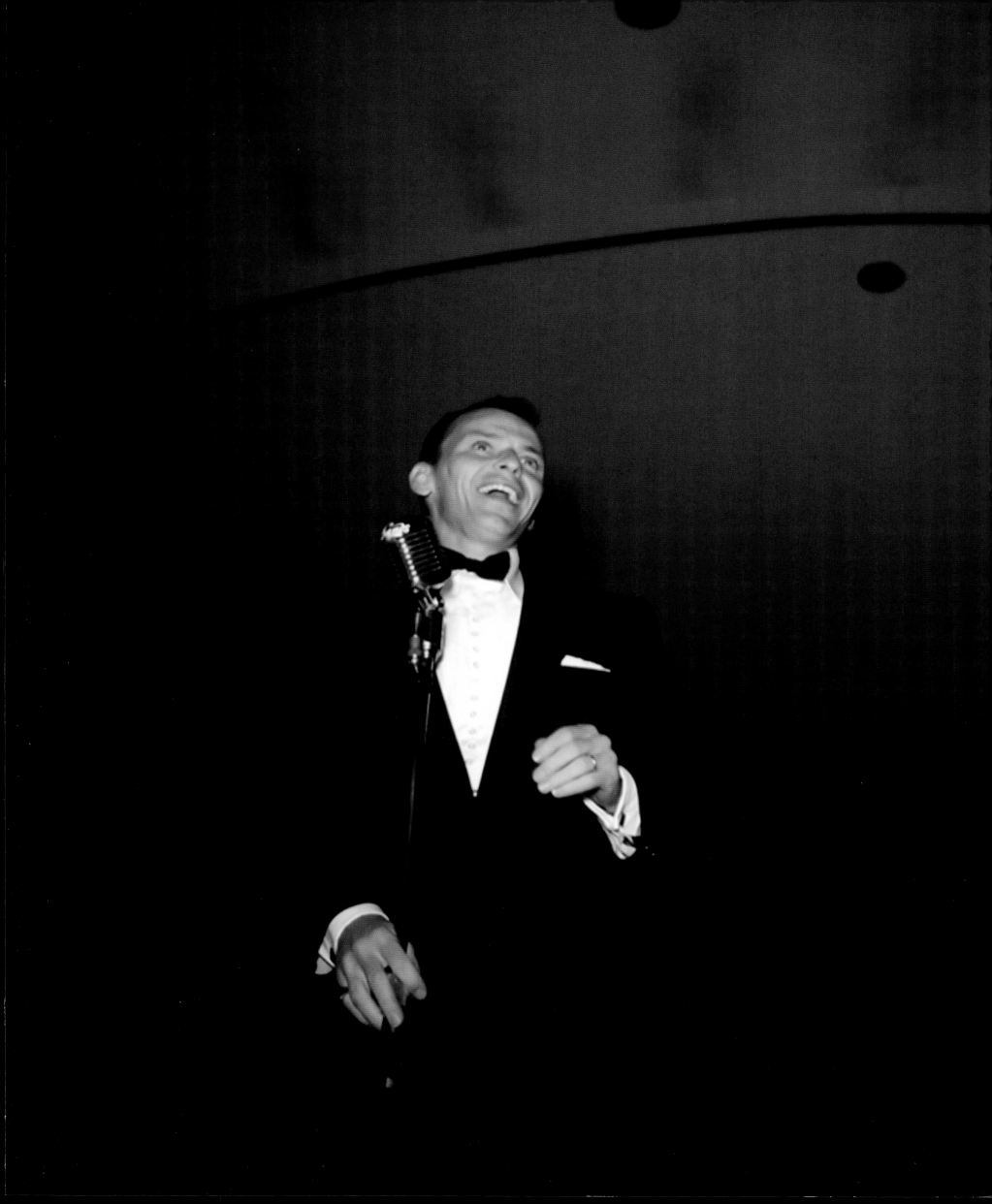

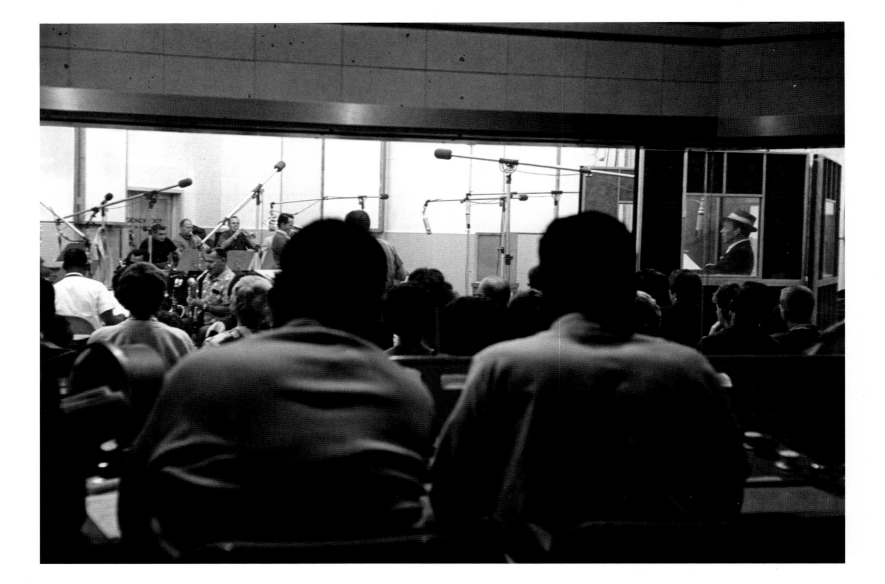

Sinatra at a Capitol Records session. Sinatra started
recording for the label in 1953 and during his years there he
pioneered the "concept album" – songs that were centered
around a particular mood or theme.

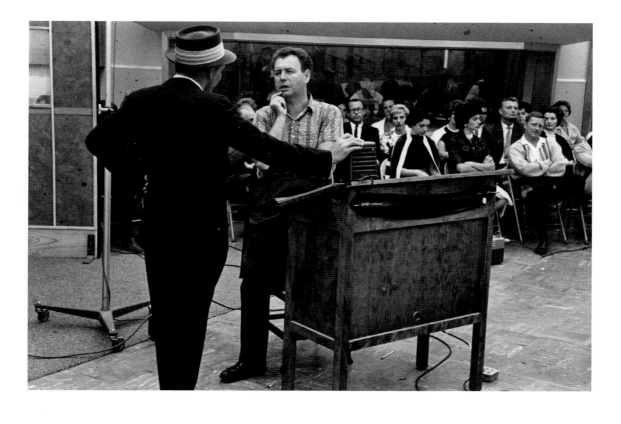

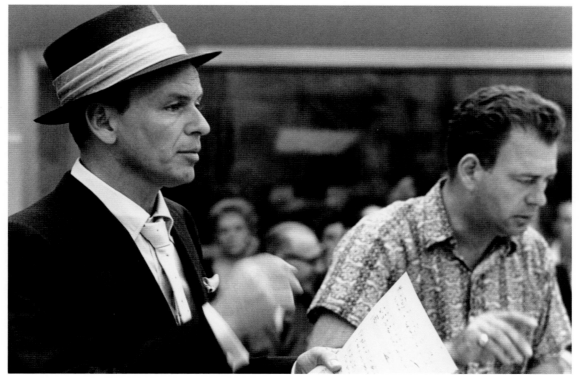

Frank Sinatra and Nelson Riddle at Capitol "Studio A."
"Frank always thought of me as someone who was quite prepared
when he came into the studio. I think my calmness often hid
many last-minute preparations. Very often I had to write three
or four arrangements in one day." – Nelson Riddle.

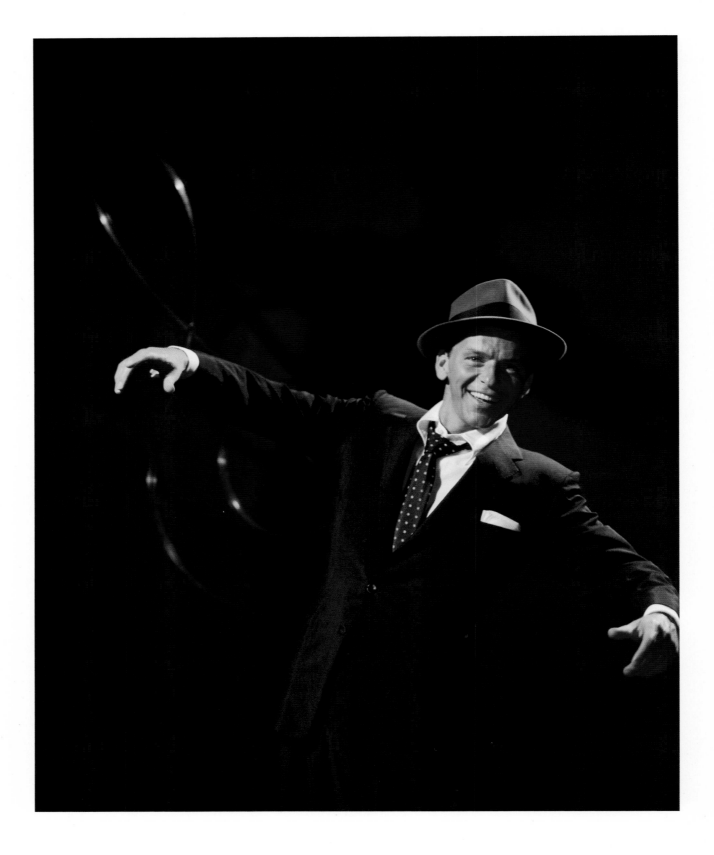

An outtake of Sinatra during a photo shoot for the cover
artwork of his 1954 album *Swing Easy!* It was released as a
10-inch LP and contained eight songs with standards such
as 'All Of Me' and 'Just One Of Those Things.'

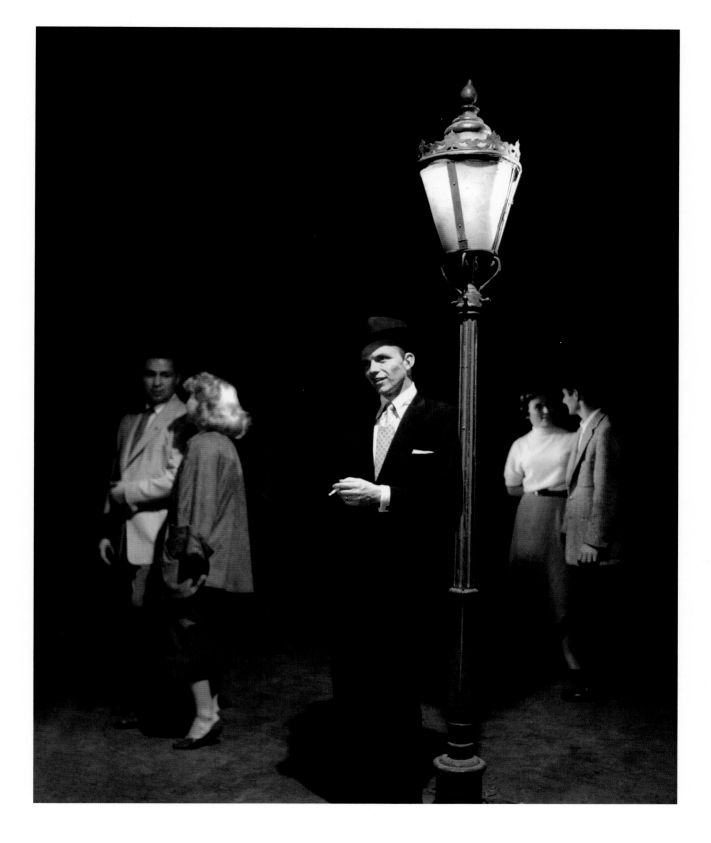

An outtake from the original photo shoot for
Songs For Young Lovers (1954). In 2002, the album
was chosen by the Library of Congress to be added
to the National Recording Registry.

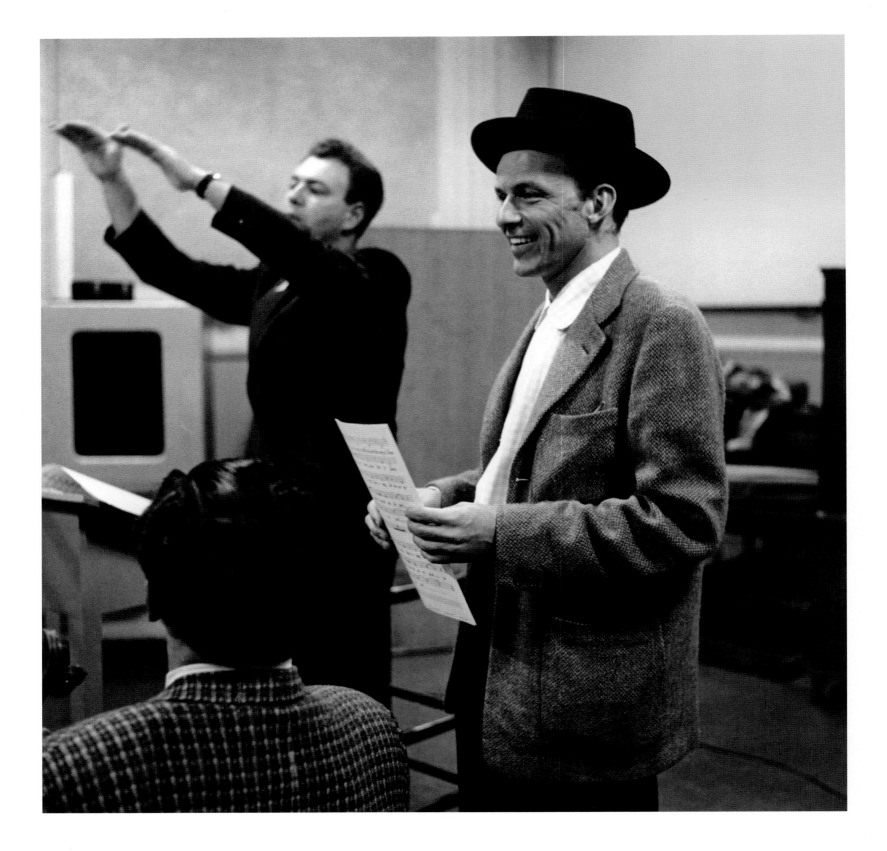

Nelson Riddle runs down an arrangement while Sinatra talks with
members of the orchestra during a session in 1955 for the classic
album *In The Wee Small Hours* at KHJ Studios, Hollywood. "He's
stimulating to work with. You have to be right on mettle all the time.
The man, himself, somehow draws everything out of you, and he
has the same effect on the boys in the band. They know he means
business, so they pull everything out." – Nelson Riddle.

Sinatra at Capitol Records. "There was a tremendous level of excitement – air of expectation – every time he recorded. Everyone knew they were making the best records around. How could they miss? They had the best singer, best arrangers, best musicians, best engineers, and the best studios in town." – Frank Sinatra Jr.

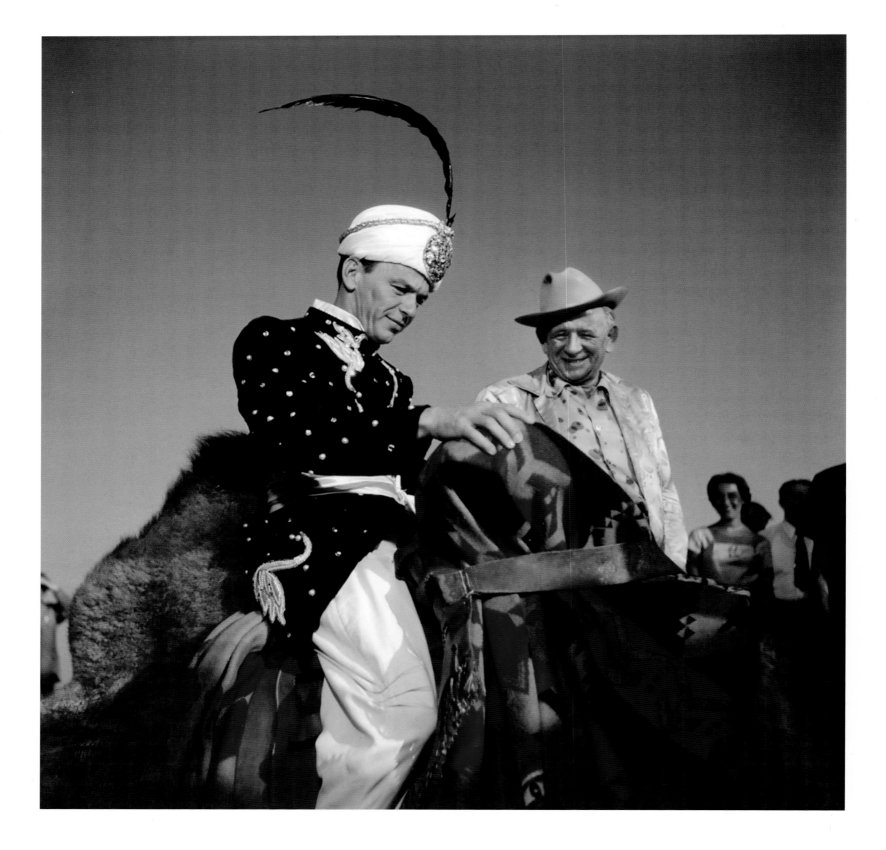

Frank Sinatra, dressed as a sultan and riding a camel, arrives
to help celebrate the opening of the Dunes Hotel in 1955. Sinatra
made his first appearance in Las Vegas in 1951 at the Desert
Inn. In 1953, Sinatra moved to The Sands Hotel, where he would
perform in the Copa Room for the next fourteen years.

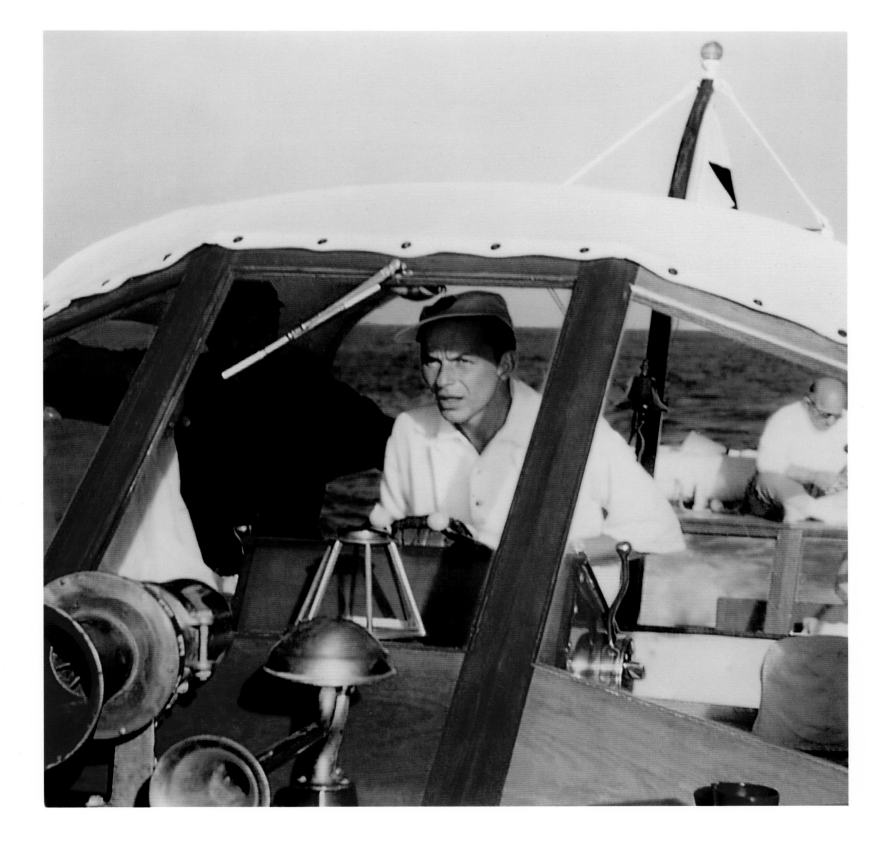

above Frank at the helm enjoying a boating adventure
in 1955. "Frank liked to go out boating with friends, especially
Humphrey Bogart. Frank enjoyed a good time.... I remember many
wonderful trips with Frank and others." – Angie Dickinson.
overleaf Frank Sinatra relaxes backstage with a donut, c.1955.
At this point in his career, he had the world on a string.

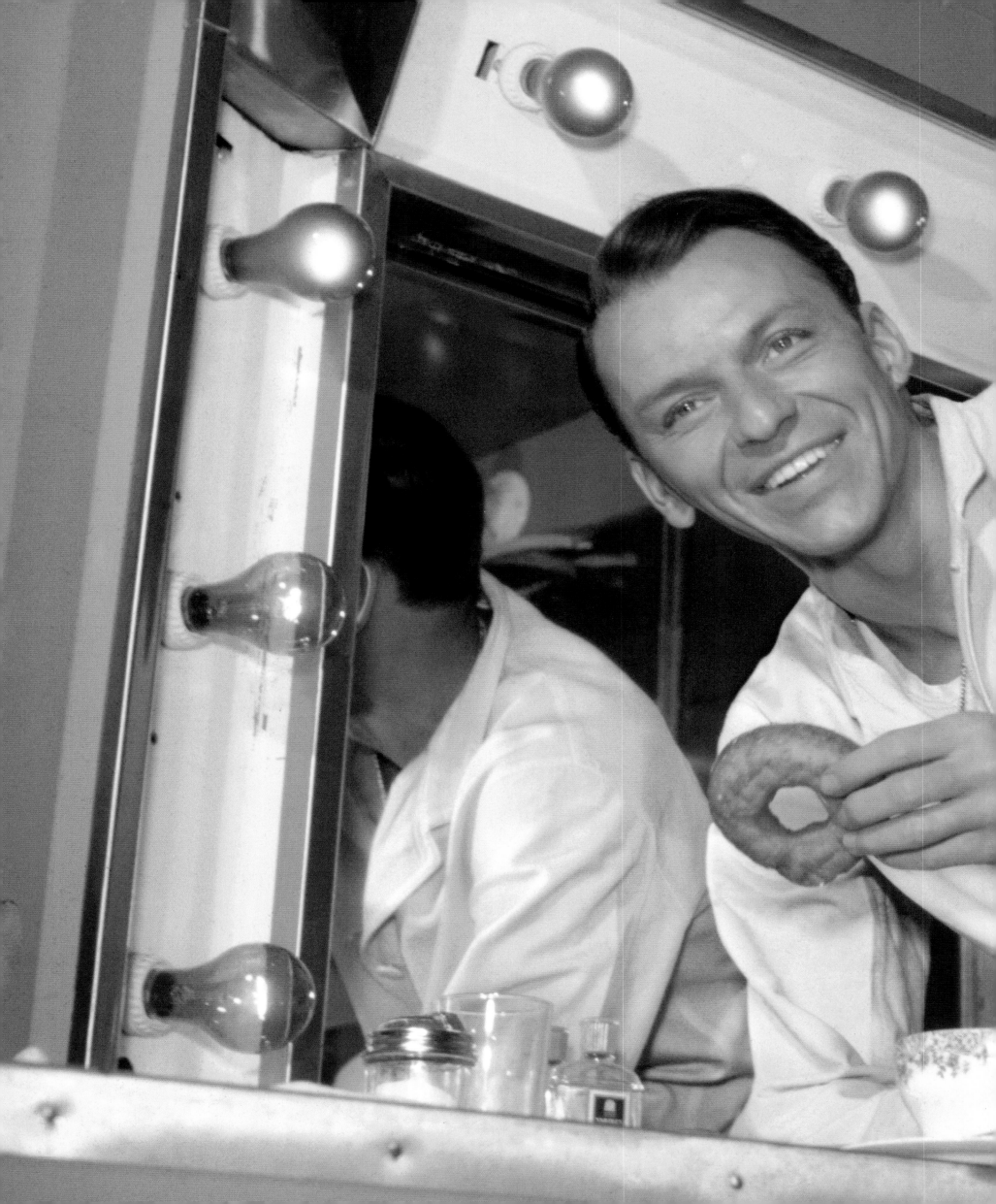

above A rare US lobby card for *Guys And Dolls* (1955).
opposite Marlon Brando and Frank Sinatra on set. "*Guys And Dolls*
was one of the best Broadway plays I had ever seen.... We did *Guys And
Dolls* at the Goldwyn studios and unfortunately it was one of the
worst cast pictures ever made.... However, it couldn't hurt the wonderful
score," recalled Sinatra. He nicknamed Brando "Mumbles," but also
said that he was "one of the greatest actors in the world!"

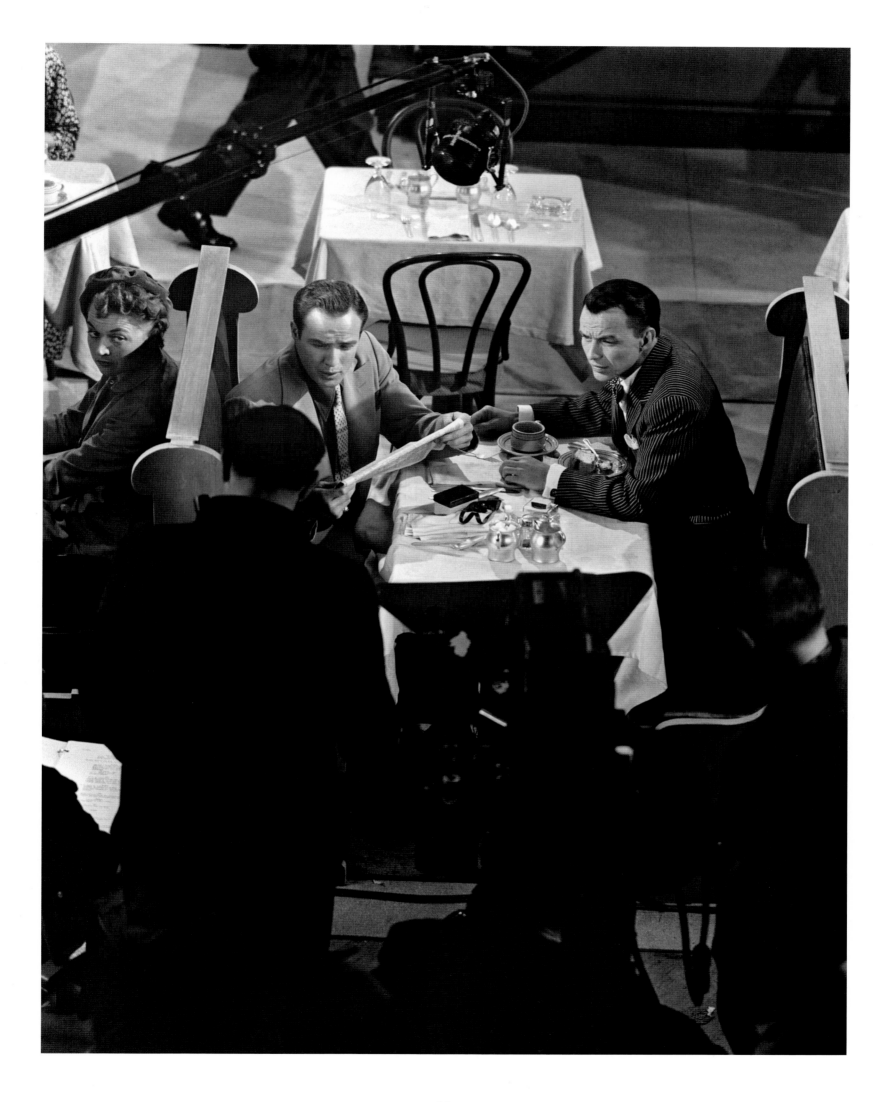

above Otto Preminger directs Sinatra on the set of
The Man With The Golden Arm (1955). **overleaf** Sinatra at
a charity baseball game, with Manhattan restaurant owner
"Toots" Shor and baseball legend Leo Durocher. Frank's
children came along in support.

"I am what I think would be called or categorized as an actor's director. I don't work too much with the technical part of the picture – I do, but not to any great degree. I prefer expending all my energies and concentrations on the performer and the dialogue and the action in the picture. I find you get marvelous performances when you spend some time with the actors. I had rarely worked with a director who talks with the actors...it's a strange thing you know. Otto Preminger was one of the few people when I did *The Man with the Golden Arm*. He was a tremendous help to me...it was a difficult role and he helped considerably. On the other hand, in the beginning, when I started *From Here To Eternity* and a few other pictures, the directors barely spoke to any of us actors."

– *Frank Sinatra*

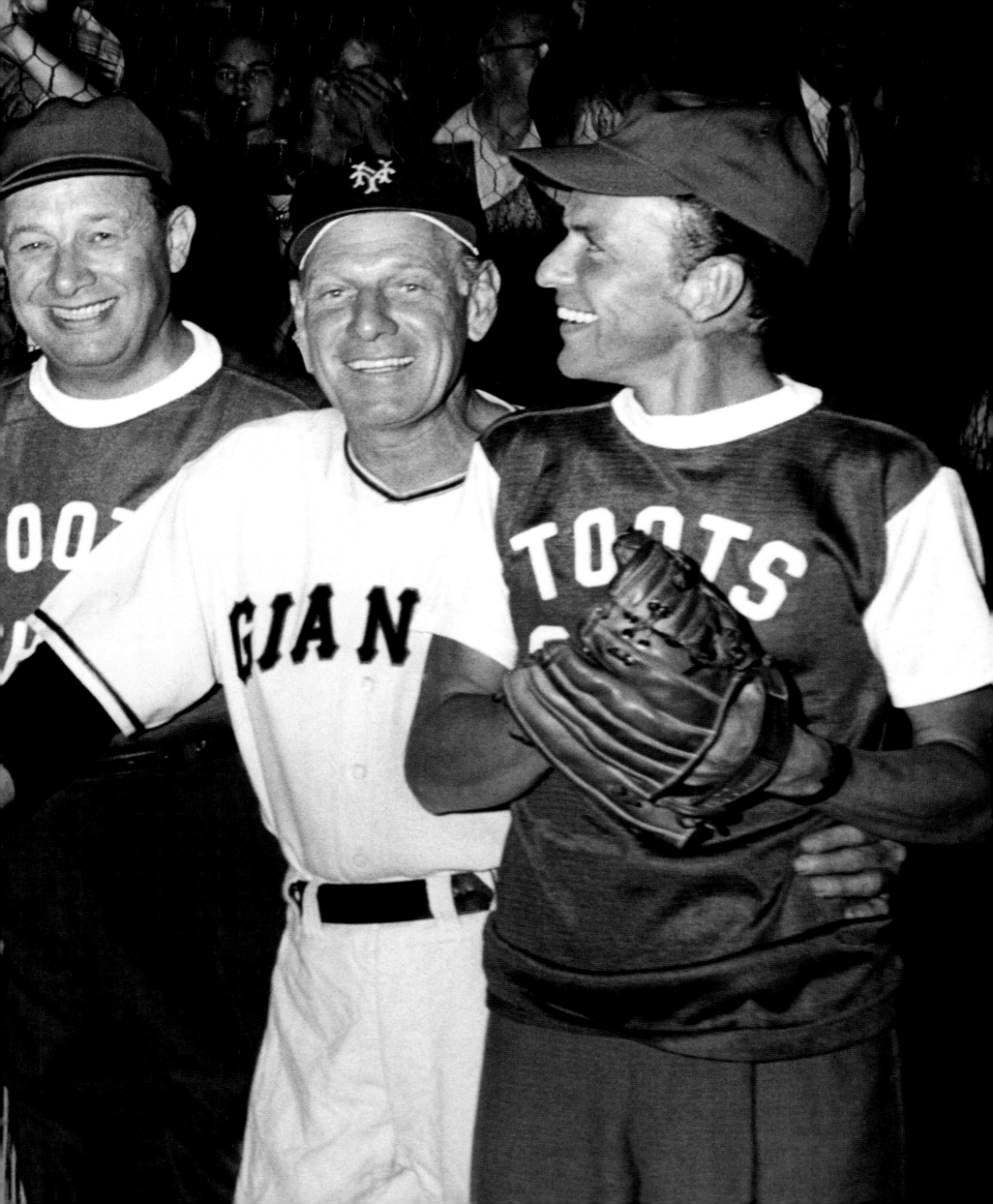

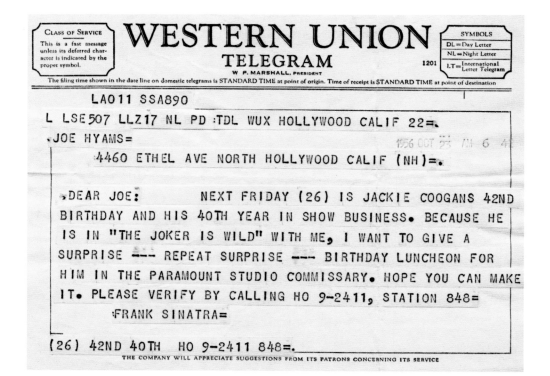

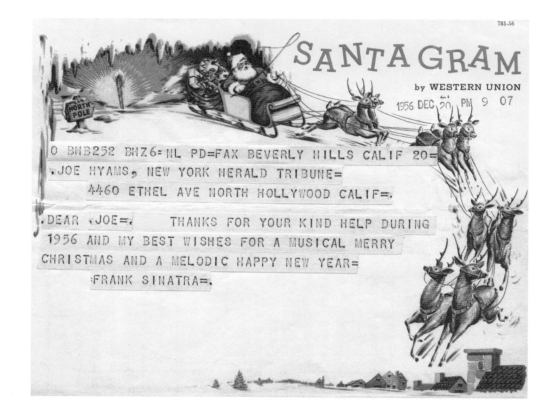

Joe Hyams was a syndicated Hollywood columnist and
biographer who formed strong relationships with many of the
stars he wrote about. Humphrey Bogart introduced Hyams to
Sinatra and, as can be seen in the above telegrams from October
and December 1956, the two became lifelong friends.

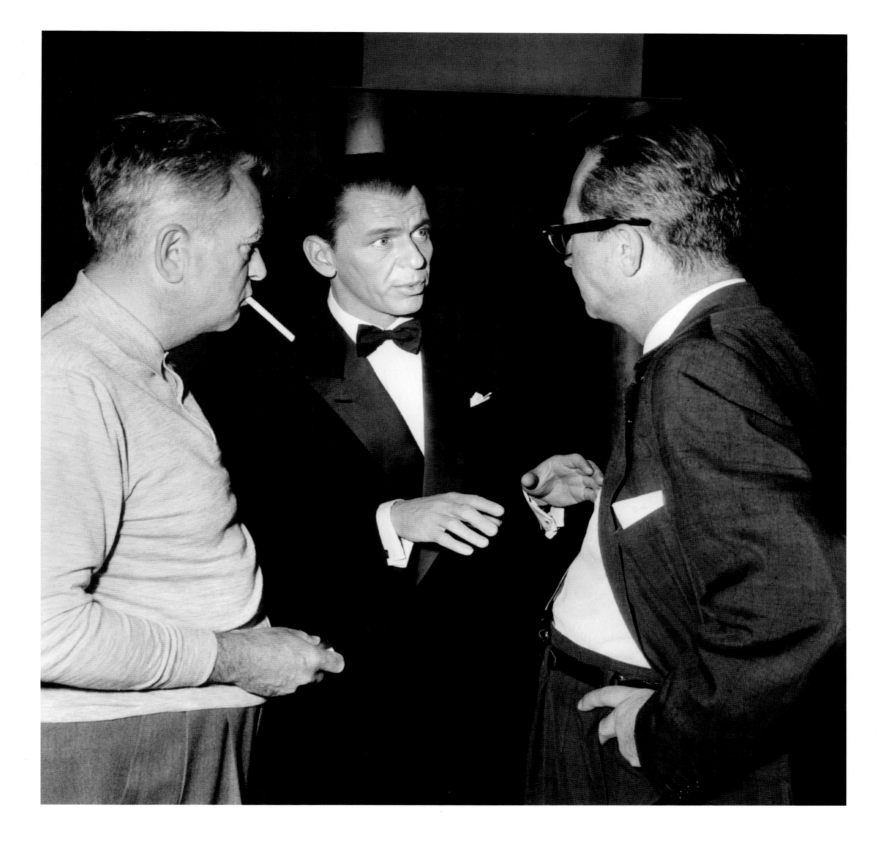

Sinatra with director Charles Vidor and producer Samuel J.
Briskin on the set of *The Joker Is Wild*. The film was based on the
life of nightclub entertainer Joe E. Lewis and released in 1957.
"Joe was humorous, he was sweet, he was gentle, and he was
never blue with his material. I loved that particular film because
I loved him as a human being," said Sinatra.

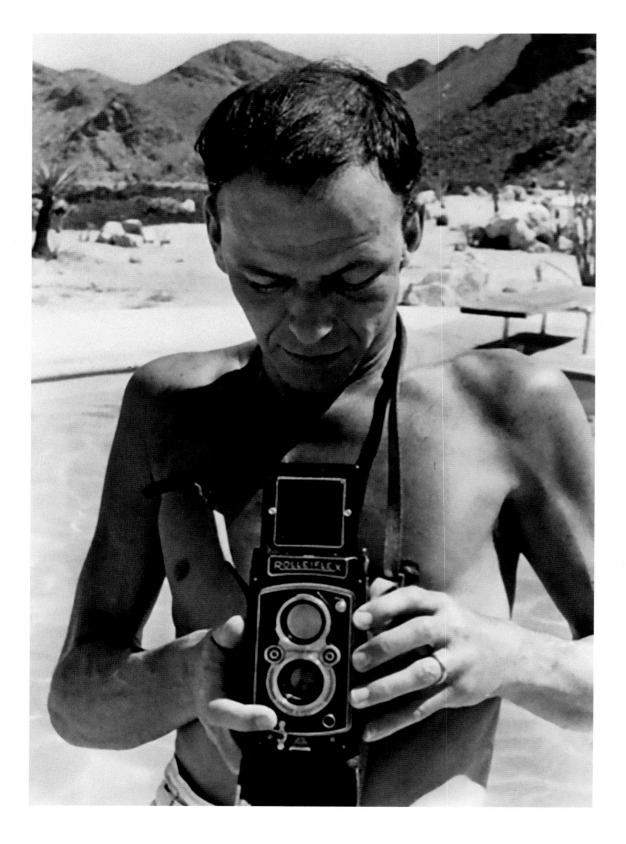

Frank's lifelong interest in photography
can be seen again in this portrait. He is holding
a Rolleiflex medium format camera.

"AFTER A METEORIC BEGINNING HE HAD EVERY CONCEIVABLE REVERSAL AND DISAPPOINTMENT... FEW PEOPLE IN OUR BUSINESS CAN RALLY FROM SOMETHING LIKE THIS. BUT HE DID, AND BIG! AND ALL BY HIMSELF."

– *Bing Crosby*

Television title cards and footage stills from ABC's *The Frank Sinatra Show*, which debuted October 18, 1957. This was Sinatra's second attempt at a weekly television show, but despite a large budget, some impressive guest stars, and his own mammoth popularity, it was not a huge success. Although a title card was made for Rosemary Clooney, she never appeared on the show.

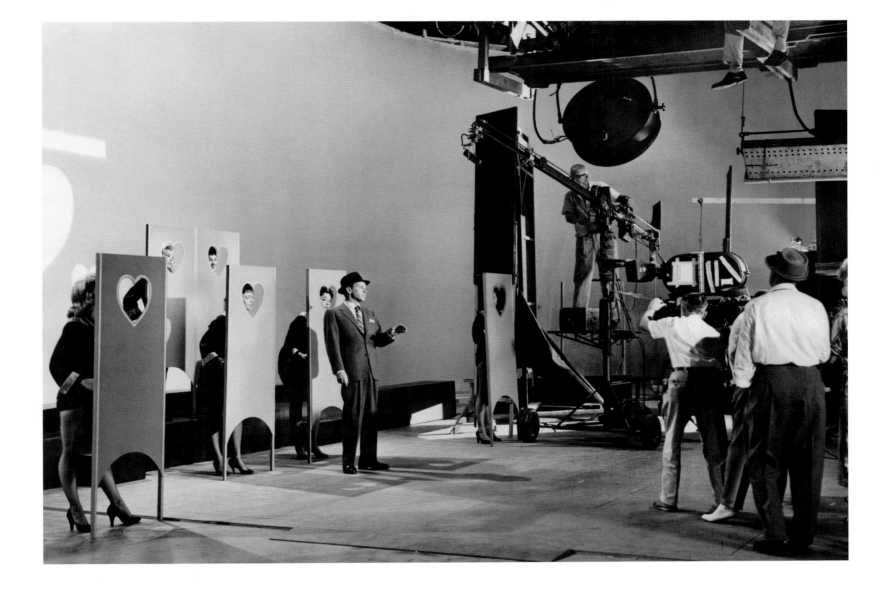

Frank Sinatra sings on a sound stage as women pose behind
heart-shaped windows during the filming of *The Frank Sinatra
Show*, on ABC. "I am not sure how fond he was of doing the
TV show; we usually had only one day of rehearsals. But Frank
took care of business on stage and once the show was over –
look out...we hung out pretty good." – Bill Miller.

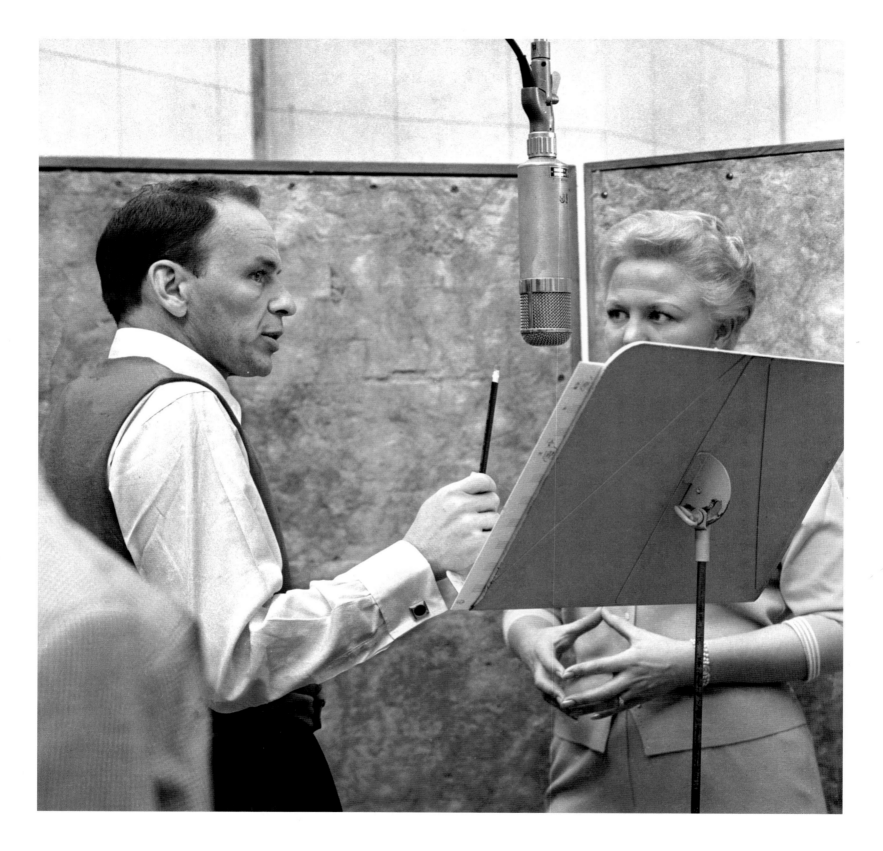

Peggy Lee and Sinatra during an April 1957 recording session for
The Man I Love. "The album was totally his concept. He brought me a long
list of great songs from which to choose...then Frank hired Nelson Riddle to
write those lovely arrangements and Frank conducted them – a marvelously
sensitive conductor, as one would expect. He designed and supervised the
cover. He is a producer who thinks of everything – even putting menthol in my
eyes so I'd have a misty look in the cover photograph." – Peggy Lee.

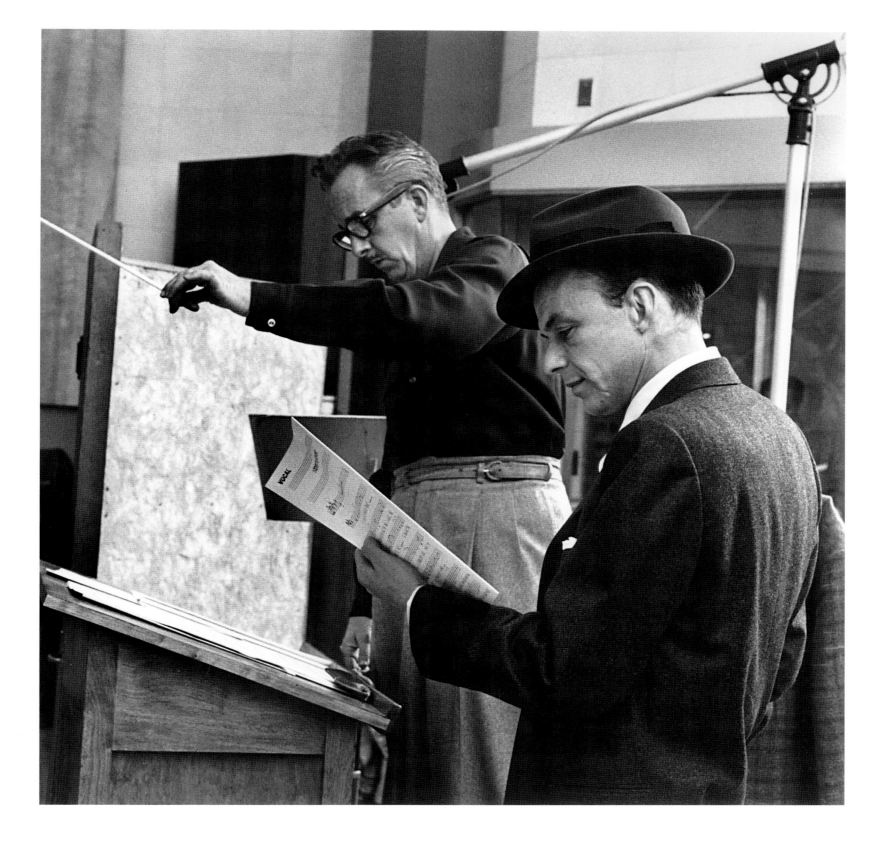

Sinatra with composer and arranger Gordon Jenkins at a Capitol
recording session for the album *Where Are You?* (1957). "Whenever
Frank sings a song, no matter how good or bad the song is, he
believes in it totally. He knows how to sing a song better than
anyone else in the world." – Gordon Jenkins.

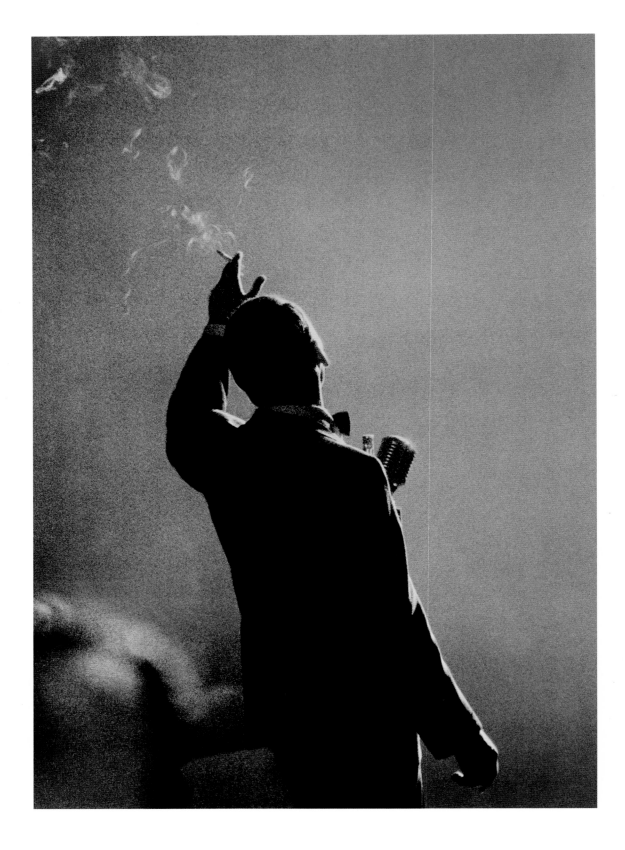

Sinatra performing at a benefit for The United Nations
Refugee Fund in Monte Carlo, June 14, 1958. The photograph
was taken by the great Herman Leonard, who captured
Sinatra with full dramatic effect.

" He was in the back of the room, and then he stops on his way up...he's looking for his cigarette holder, takes one out, lights a cigarette, and I'm like, come on man, hurry up. And as soon as he gets to the stage we go into 'Come Fly With Me.' You know, 'ba-da-da, da-da-da-do-da-di-do-di-do.' And I saw something that night...I thought I was on Mars. Frank is singing and he takes a puff off his cigarette – cut down to pin, spotlight is dark. He sings, 'when I get you up there' – no smoke. Then when he sings 'where the air is rarefied' there was smoke. Herman Leonard, the greatest photographer in the world, takes that picture, a classic picture now, of Frank from behind with the smoke. That's from Sporting Club in '58. Afterwards, Frank said, 'Great job, kid. Cuckoo.' That was it. I didn't know how it registered on the scale. You don't know. But you pray, because that's a dream. Frank Sinatra – are you kidding? That's like going to heaven, man."

— *Quincy Jones*

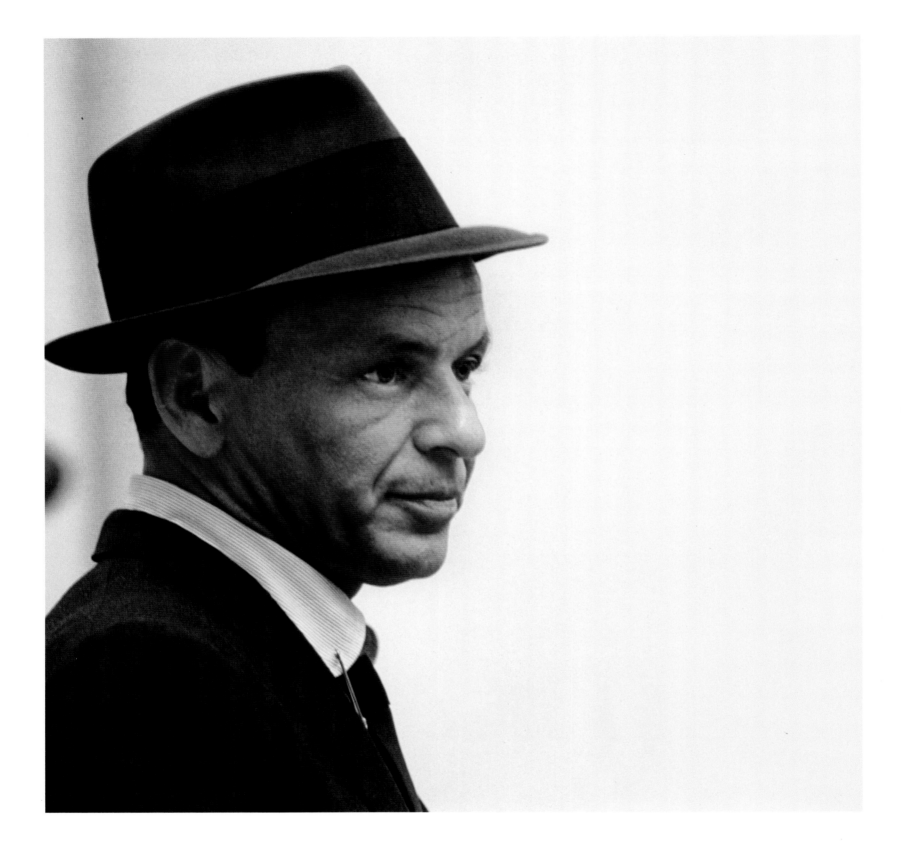

Sinatra listening to a playback during
a Capitol recording session.

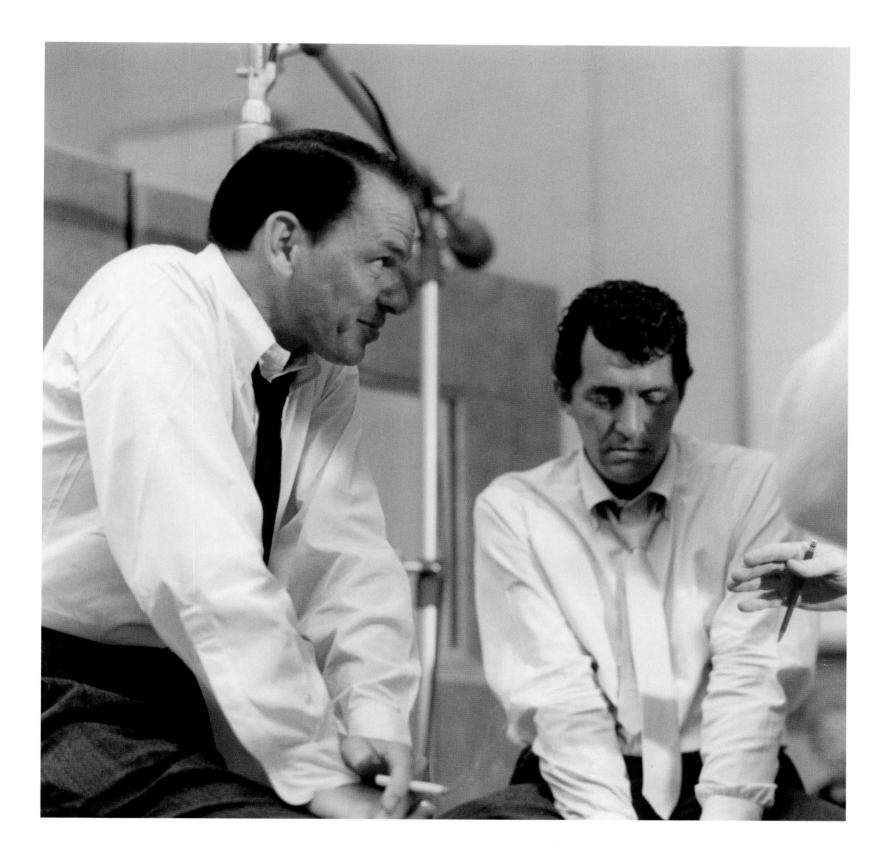

above Sinatra conducted the recording sessions for Dean Martin's
Sleep Warm album in October 1958. "Frank's my dearest and best
friend and he's about the warmest guy I know. That exterior everybody
sees is a lot of bologna; he's very a warm man. He knows what he's
doing all the time; may not be right all the time, but he sure knows
what he's doing all the time." – Dean Martin.

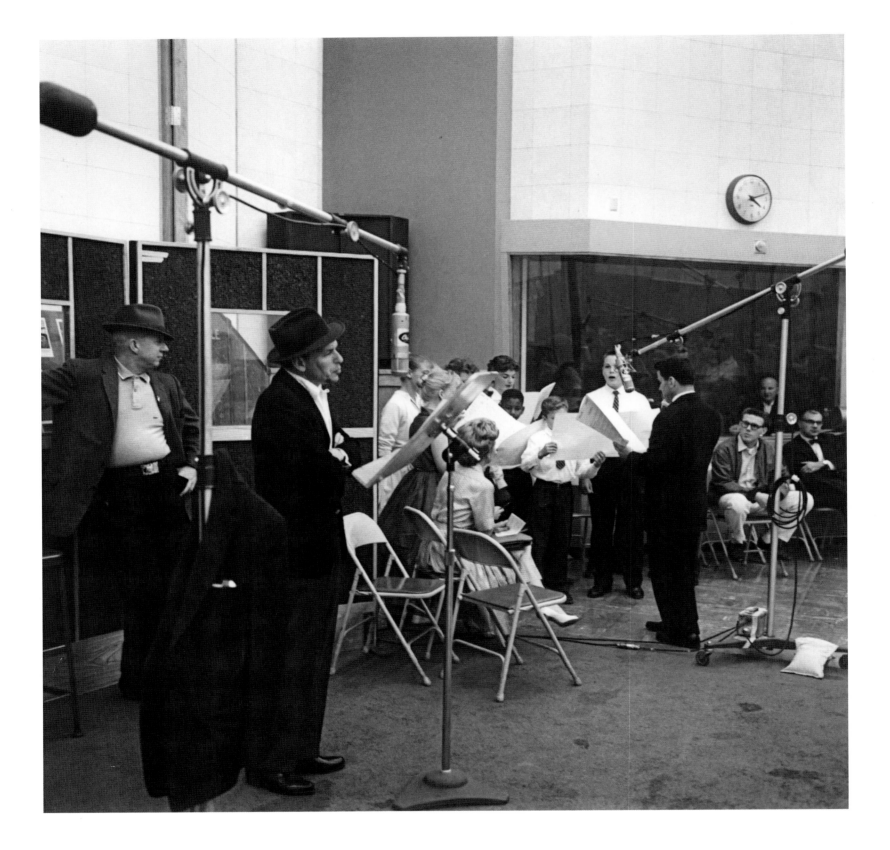

Sinatra recording 'High Hopes' at Capitol Records, with Jimmy
Van Heusen behind him and Jimmy Joyce directing "a bunch of kids,"
May 8, 1959. Notice the clock in the photo: this was a rare afternoon
session (from 4 to 7 p.m.). "I think Frank is the greatest singer of all time.
I feel that I am the most fortunate and honored songwriter to have
been associated with him for so long." – Jimmy Van Heusen.

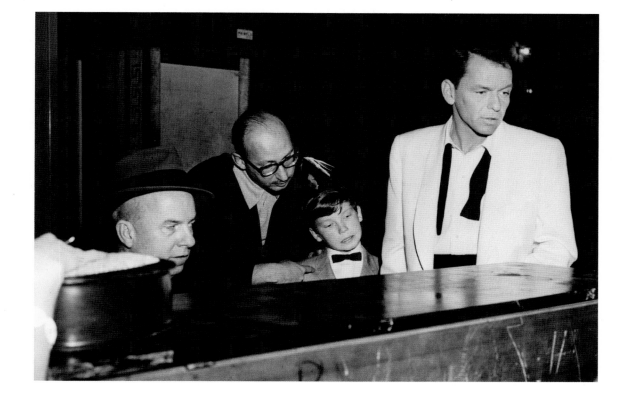

Sinatra with co-star, Eddie Hodges, rehearsing the song 'High Hopes'
on the set of *A Hole In The Head* (1959), with composers Sammy Cahn
and Jimmy Van Heusen. "The idea of 'High Hopes' came from the
picture. Towards the end of production, Sinatra and Capra decided that
they needed a song for Frank to sing to his son. Well, Sam and I wrote
'High Hopes' and it became a big hit, and won the Academy Award,
much to my surprise." – Jimmy Van Heusen.

"PEGGY AND I MET EARLY IN OUR CAREERS WHEN WE BOTH STARTED OUT IN NEW YORK, AND HAVE BEEN GREAT FRIENDS EVER SINCE. HER WONDERFUL TALENT SHOULD BE STUDIED BY ALL VOCALISTS; HER REGAL PRESENCE IS PURE ELEGANCE AND CHARM."

– *Frank Sinatra*

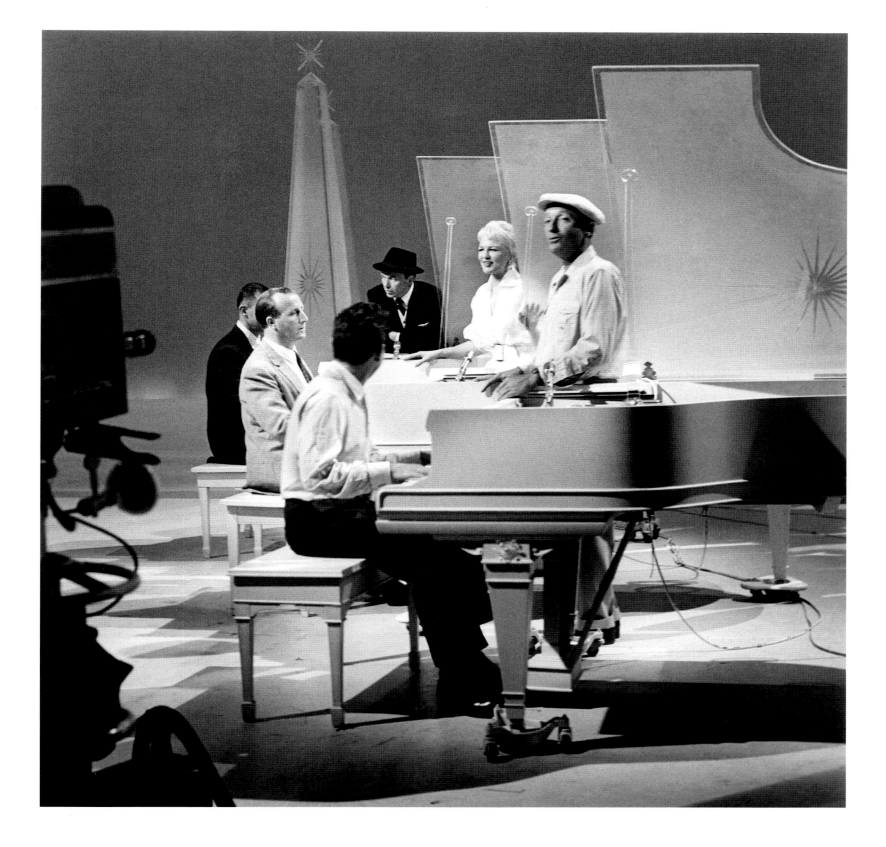

Sinatra, Peggy Lee, and Bing Crosby rehearsing for *The Bing Crosby Show* with pianists Paul Smith, George Shearing, and Joe Bushkin in September 1959. "There are very few men in our business who have affected me so deeply I can't express myself and Frank is one of them, and Bing Crosby another." – Peggy Lee.

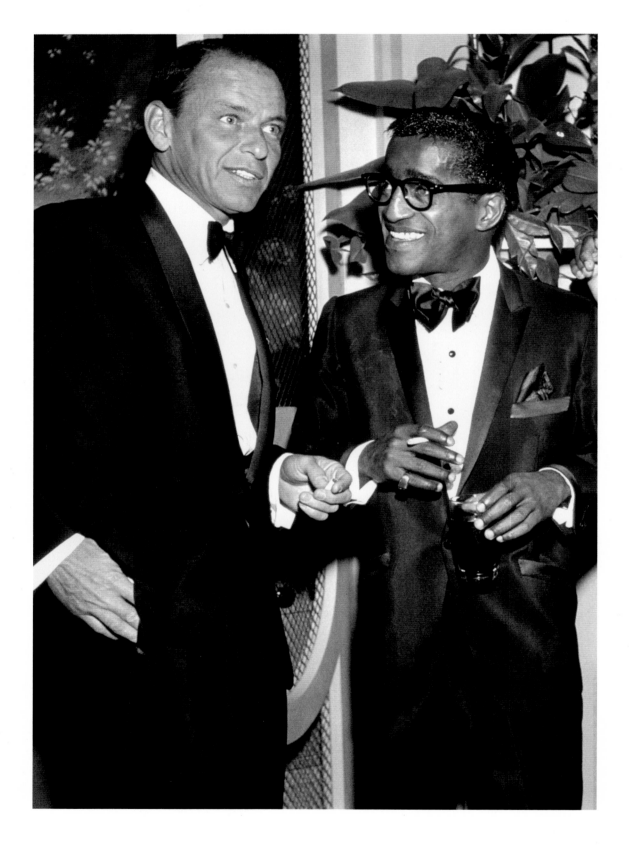

Frank and Sammy enjoying themselves at the Friar's Club
Testimonial Dinner for Dean Martin at the Beverly Hilton in
Los Angeles on November 8, 1959. "It's silly to call us anything like
the Clan or the Rat Pack. If anything, it's more like the P.T.A.
– Perfect Togetherness Association." – Dean Martin.

"**FRANK WAS A FRIEND WHEN IT WASN'T FASHIONABLE TO BE A FRIEND TO A BLACK MAN. WHEN FRANK PUT HIS ARM AROUND MY SHOULDER ONE DAY AND SAID, 'SAM, YOU'VE GOT A FRIEND FOR LIFE,' I KNEW HE MEANT IT.**"

— *Sammy Davis Jr.*

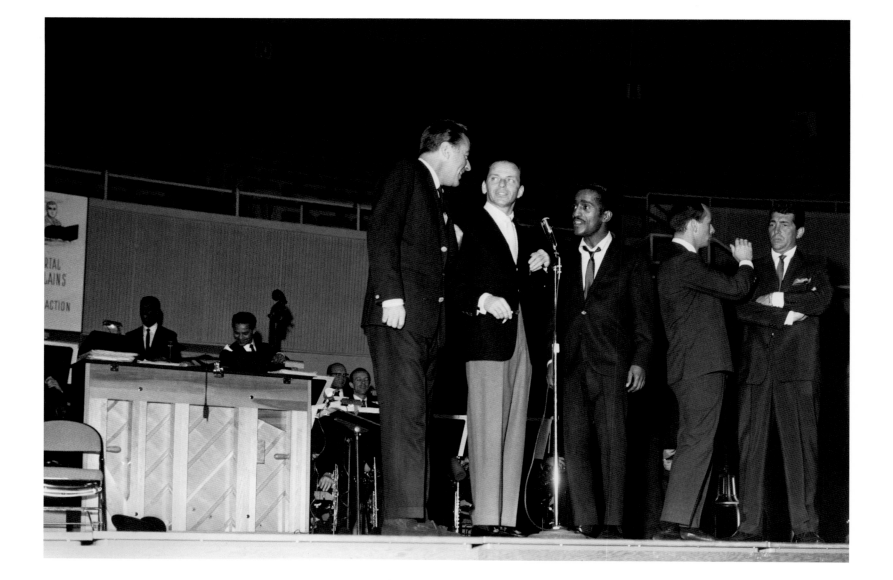

Peter Lawford, Frank Sinatra, Sammy Davis Jr., Joey Bishop,
and Dean Martin performing at the Four Chaplains Day
memorial benefit. Jack Entratter and The Sands Hotel hosted
the event on February 7, 1960 at the Las Vegas Convention
Center. Later that evening, John F. Kennedy would attend
"The Summit" at The Sands Copa Room.

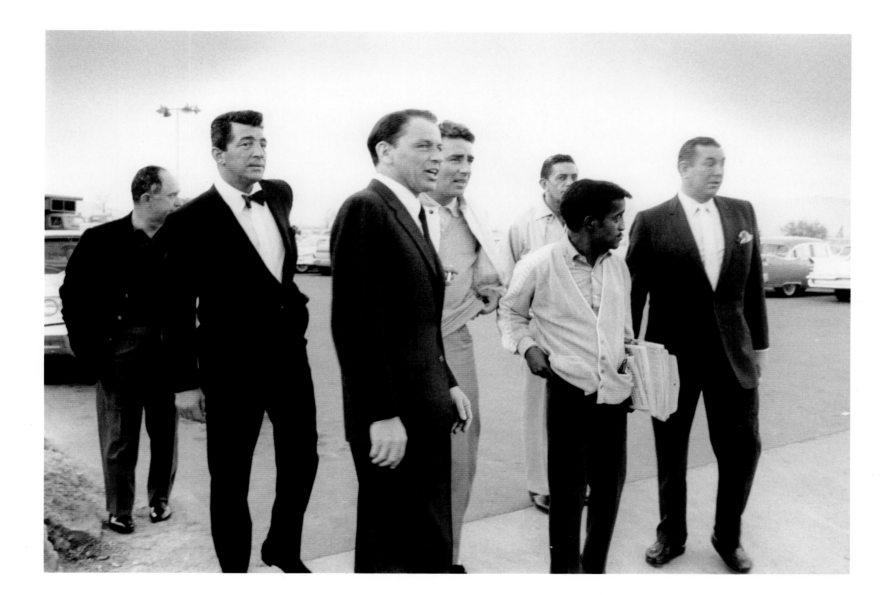

Members of "The Summit" in Las Vegas during the filming
of *Ocean's 11* in 1960. Sinatra, and his friends, helped turn
the desert city into a worldwide tourist destination.

"Elvis and Dad singing 'Witchcraft / Love Me Tender' is a great moment in time. We taped the show in Florida, and I think both guys – I could say this with some authority – were nervous. I mean, here are the two great legends coming together. They were already legends in their own time. It turned out to be a very cute moment in history, the two of them singing. Elvis got a little mixed up on 'Witchcraft' and Dad kind of jazzed up 'Love Me Tender.'"

— *Nancy Sinatra*

above Colonel Tom Parker and Sinatra. Frank welcomed special guest star Elvis Presley home from the army for the Sinatra Timex special *Welcome Home Elvis*, which aired May 12, 1960. Songwriters Jimmy Van Heusen and Sammy Cahn rehearse with Frank and Elvis. **opposite** The Chairman of the Board and The King duet.

above Peter Lawford and Frank Sinatra talking with Edward
M. Kennedy (center right) at the Key Women for Kennedy in
California rally, 1960. opposite Frank Sinatra and Peter Lawford
backstage at the Democratic National Convention, which was
held in Los Angeles, July 1960. overleaf *Ocean's 11* premieres
in downtown Las Vegas, August 3, 1960.

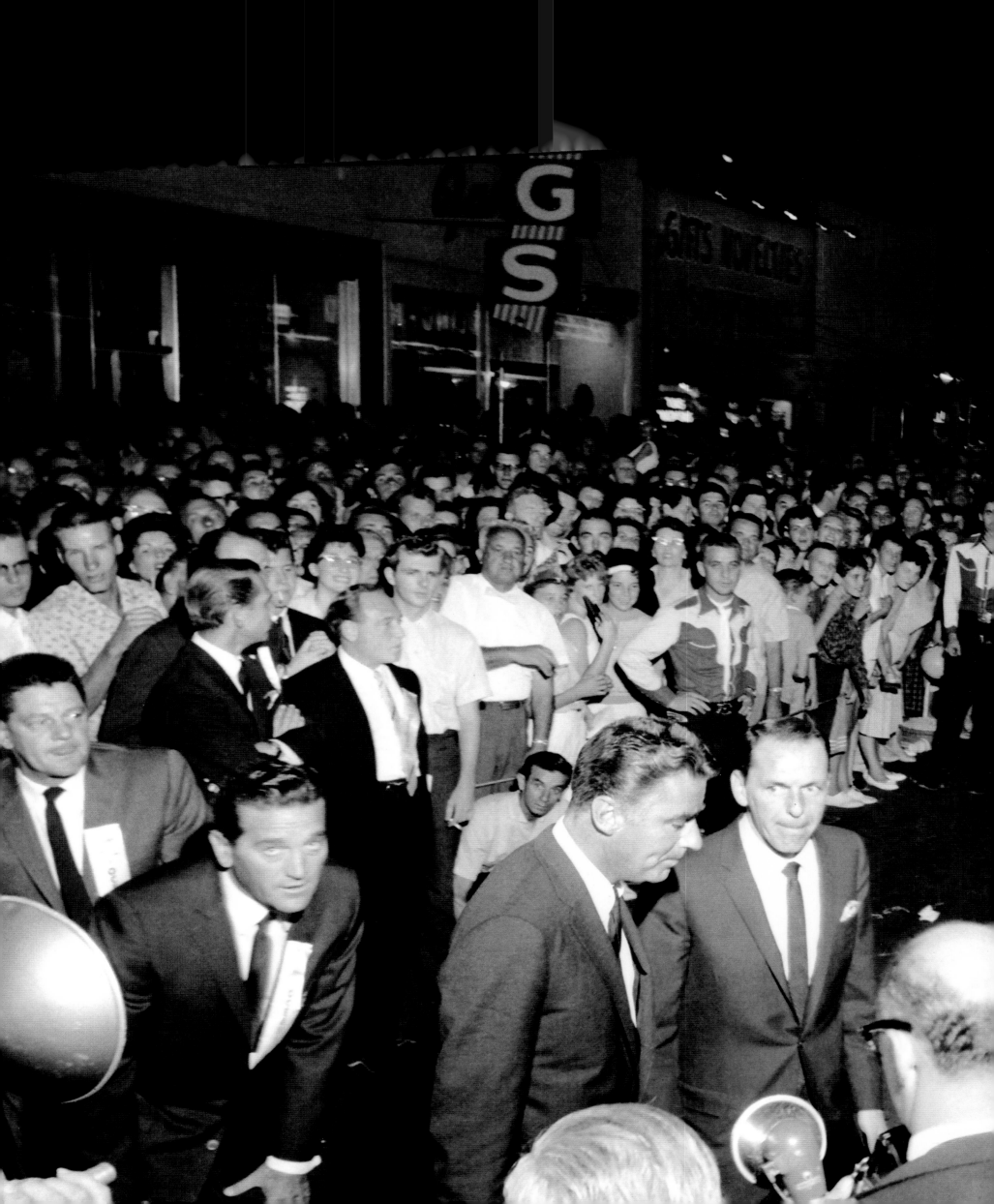

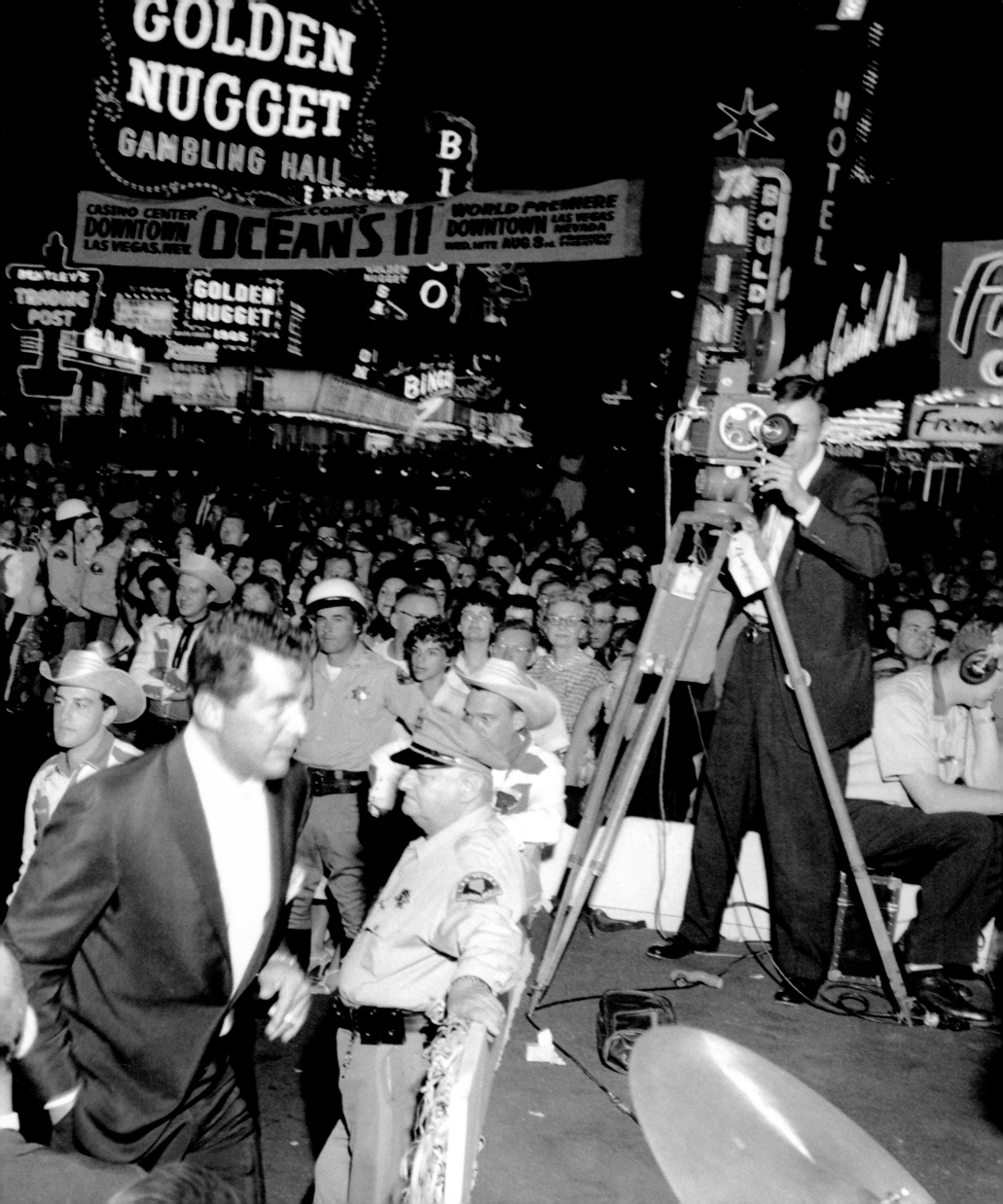

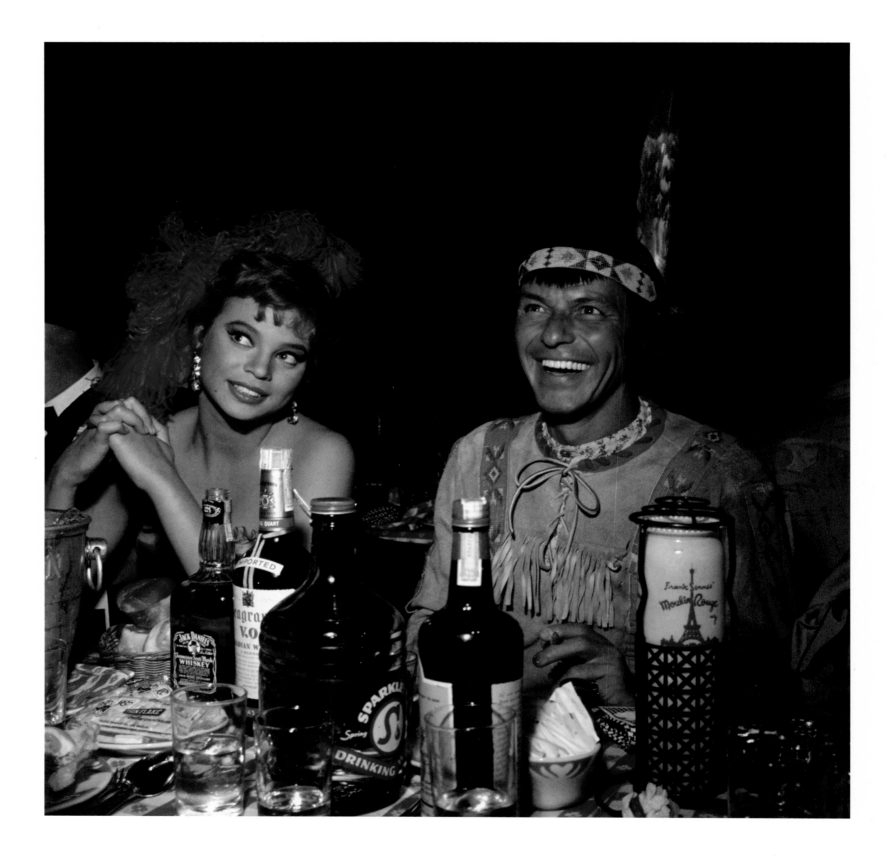

above Frank Sinatra and Juliet Prowse attend the SHARE
Boomtown benefit party at the Moulin Rouge in Los Angeles on
May 13, 1960. The couple was engaged for a short period before
eventually splitting up. **opposite** Photo shoot for the *Sinatra-
Basie: An Historic Musical First* album, 1962.

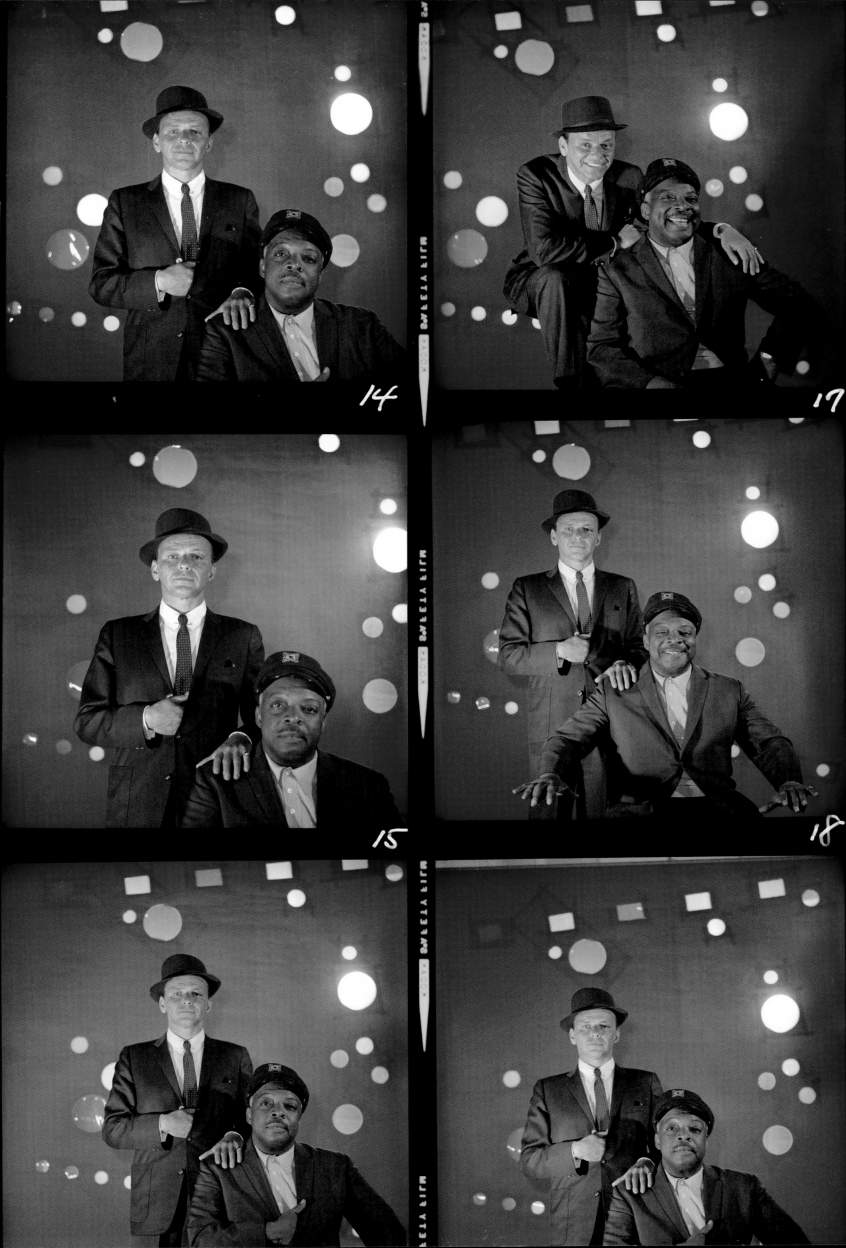

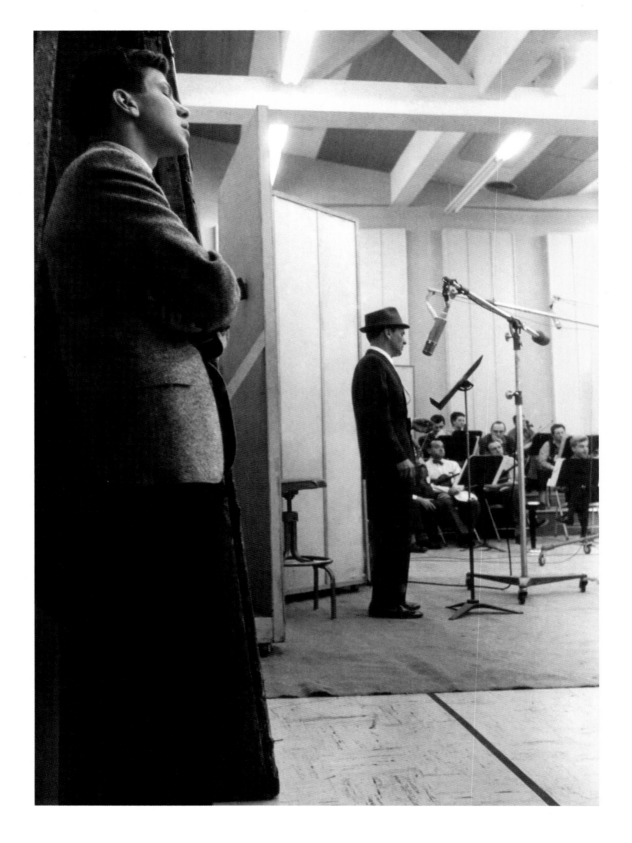

Frank Sinatra Jr. listens to his dad during a December 1960
recording session for the album *Ring-a-ding ding!* (1961). "He was
very definitely a perfectionist. He wanted things to be just so:
I think that's very obvious." – Sinatra Jr.

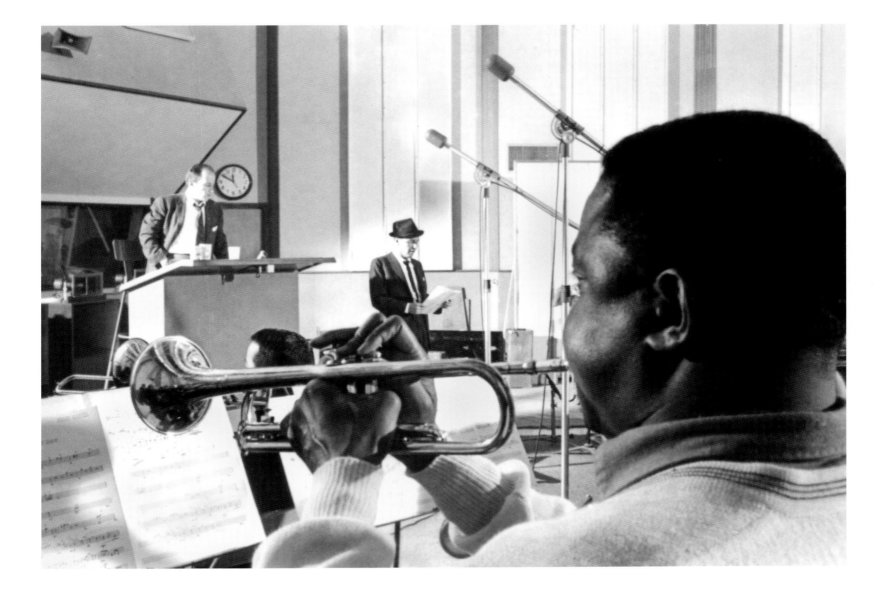

above Johnny Mandel and Sinatra run down 'A Foggy Day' on
December 19, 1960 for *Ring-a-ding ding!* (1961). This would be the first
album for Sinatra's newly formed label, Reprise. **overleaf** Sinatra
performing at The Sands, Las Vegas, with Antonio Morelli conducting
the orchestra in the early 1960s (left). Frank and Dean Martin
in concert during the 1960s (right).

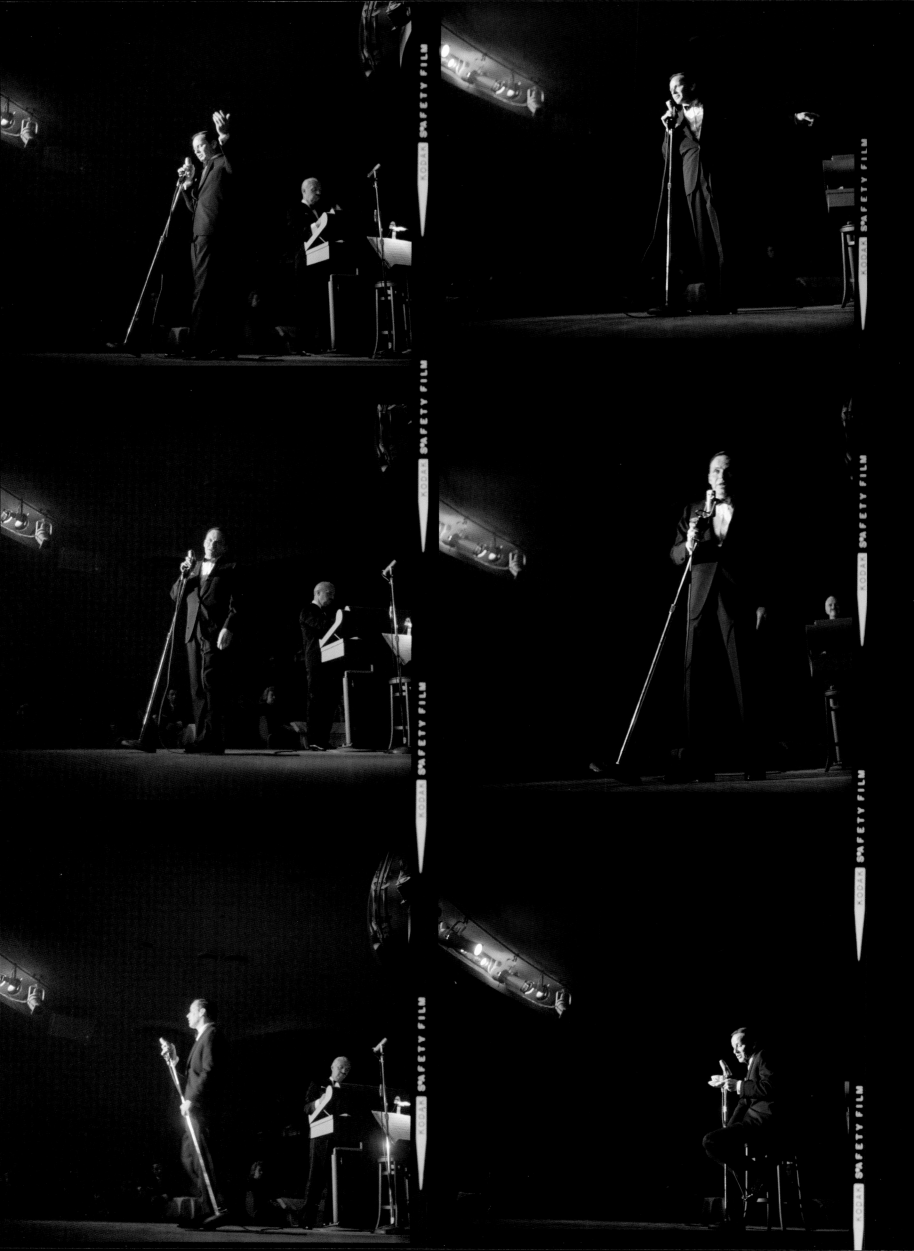

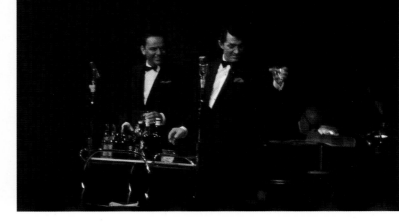

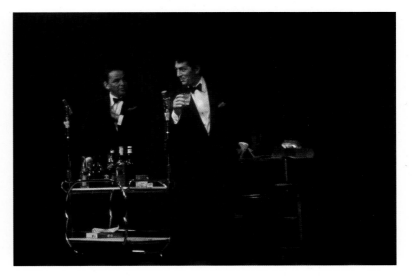

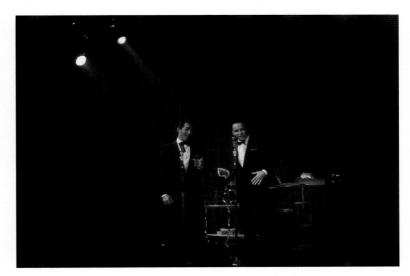

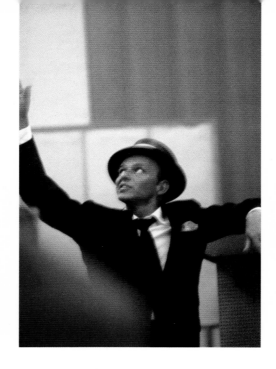

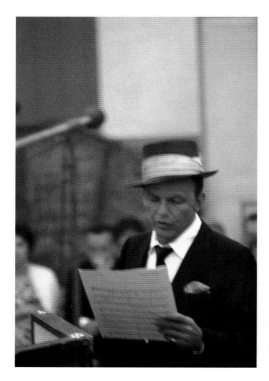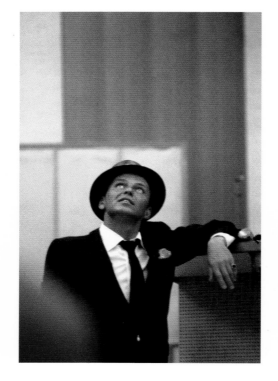

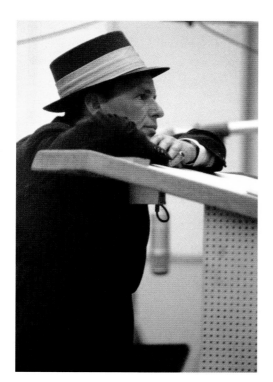

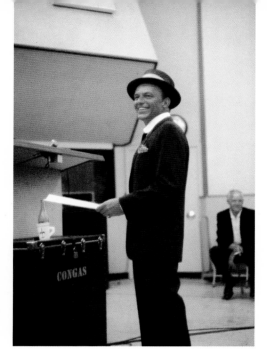
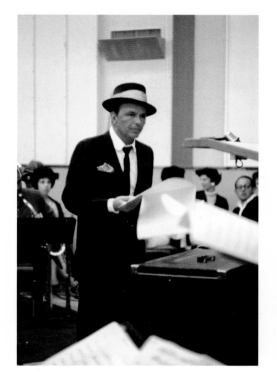
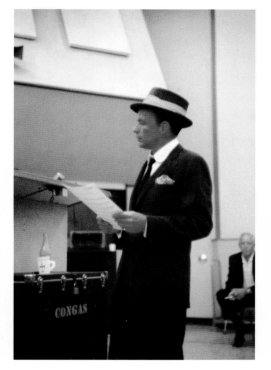
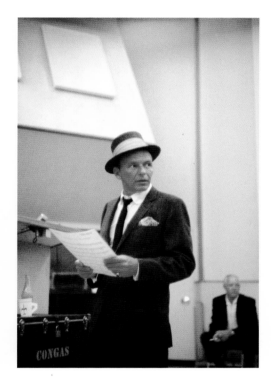

opposite & above Rare photos of Frank Sinatra with Billy
May during the *Swing Along With Me* aka *Sinatra Swings*
sessions, May 1961. The album was billed on the back cover as
"a bold, buoyant Frank Sinatra breaking it up on twelve of the
most uninhibited Sinatra things ever recorded!"

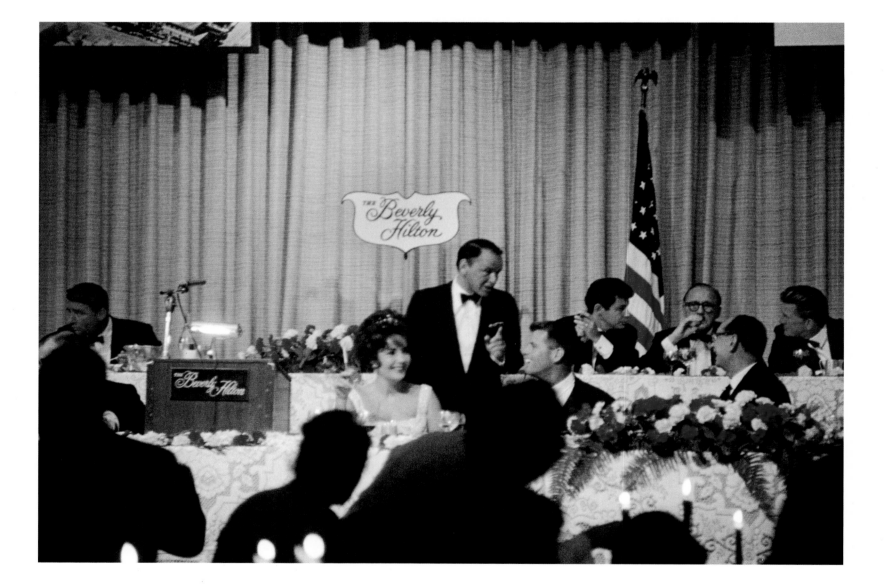

Peter Lawford, Elizabeth Taylor, Frank Sinatra, Robert F.
Kennedy, Eddie Fisher, Jack Benny, and Kirk Douglas attend
a benefit in aid of Los Angeles's Cedars-Sinai Hospital,
at The Beverly Hilton, July 8, 1961.

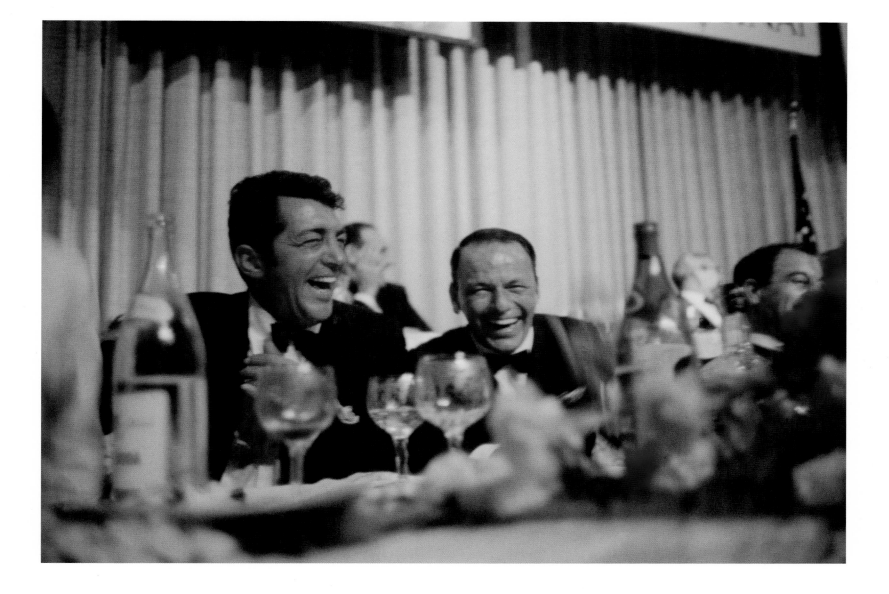

Frank Sinatra and Dean Martin share a laugh
at The Beverly Hilton, July 8, 1961.

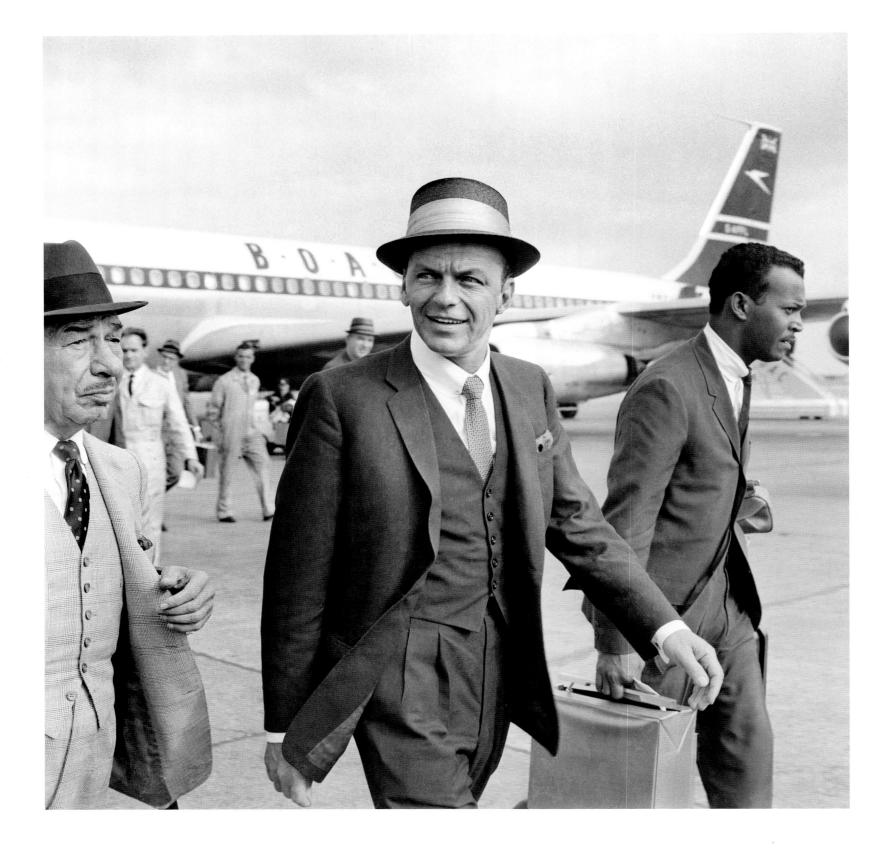

Beverly Hills restaurateur Mike Romanoff, Frank
Sinatra, and valet George Jacobs arriving at
Heathrow Airport, August 4, 1961.

Mike Romanoff, Sinatra, and Dean Martin departing
Heathrow in the back of a limousine, surrounded by
onlookers eager to catch a glimpse of the stars.

"Sammy was always the butt of, obviously, and he loved it.... He took the jokes and was a lot of fun and is a very, very big talent! When we worked at The Sands hotel in Las Vegas, every evening at 5 o'clock, we would go into the steam room...or just lie around and take it easy and order pies.... When everyone got dressed in their tuxedos we'd throw the pies at each other."

— *Frank Sinatra*

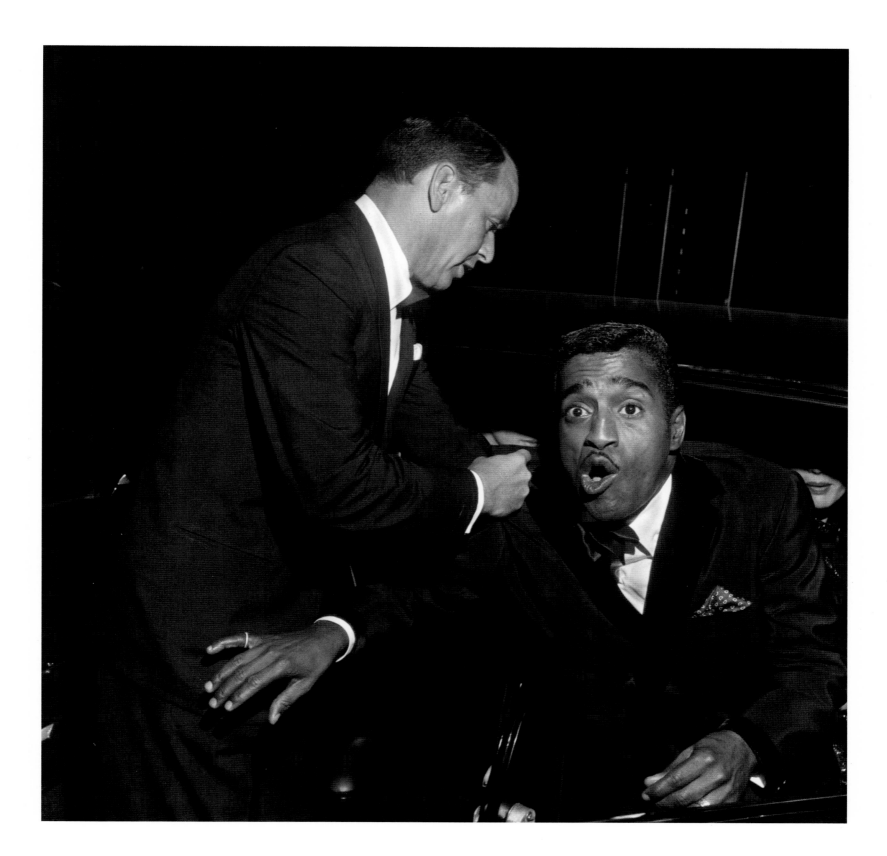

above Frank Sinatra playfully yanks Sammy Davis Jr. from his
car on arrival at an event. "My father had known Sammy since the 1940s.
Sammy was the fall guy for Frank and Dean. They would put him
on so fierce. It was merciless the things they did to poor Sammy, and then
Sammy would turn around and zing them back." – Frank Sinatra Jr.
overleaf Frank Sinatra at CTS Studios, London, recording the
album *Great Songs From Great Britain*, June 1962.

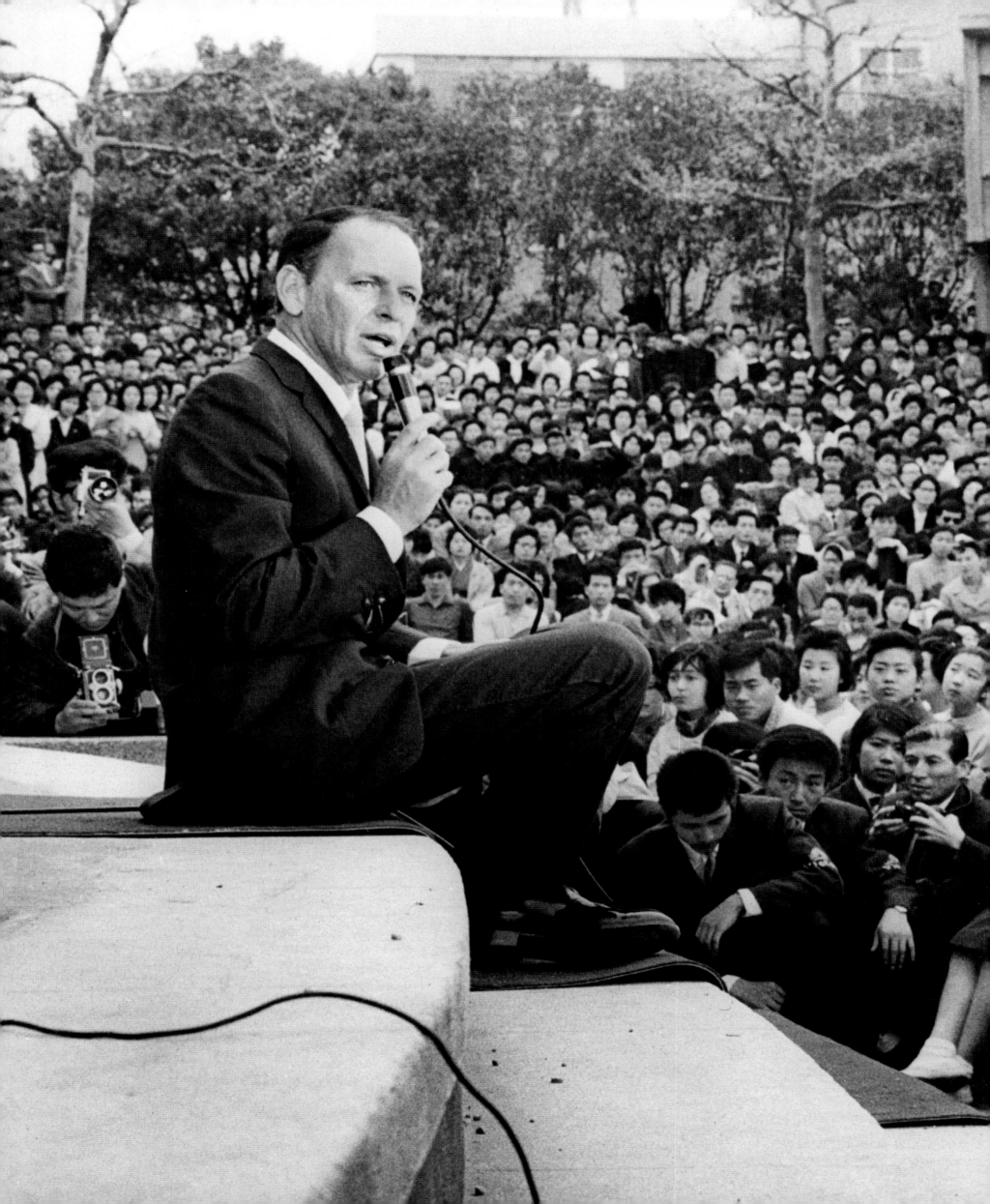

" Frank worked very hard
on that trip because all
proceeds went to children's
charities in each country.
He went to hospitals to
see the children; he was
getting up in the morning
so he could go. Frank
always looked out for the
less fortunate. I can't
begin to tell you how many
benefits Frank did over
the years and paid the
costs of the band out of
his own pocket."

— *Al Viola*

opposite Sinatra at a charity concert in Hibiya Park, Tokyo, Japan,
April 20, 1962. **above** Sinatra relaxing with Mike Romanoff
during his 1962 world tour. **overleaf** Sinatra in Tel Aviv, Israel,
watching the Independence Day parade, May 1962.

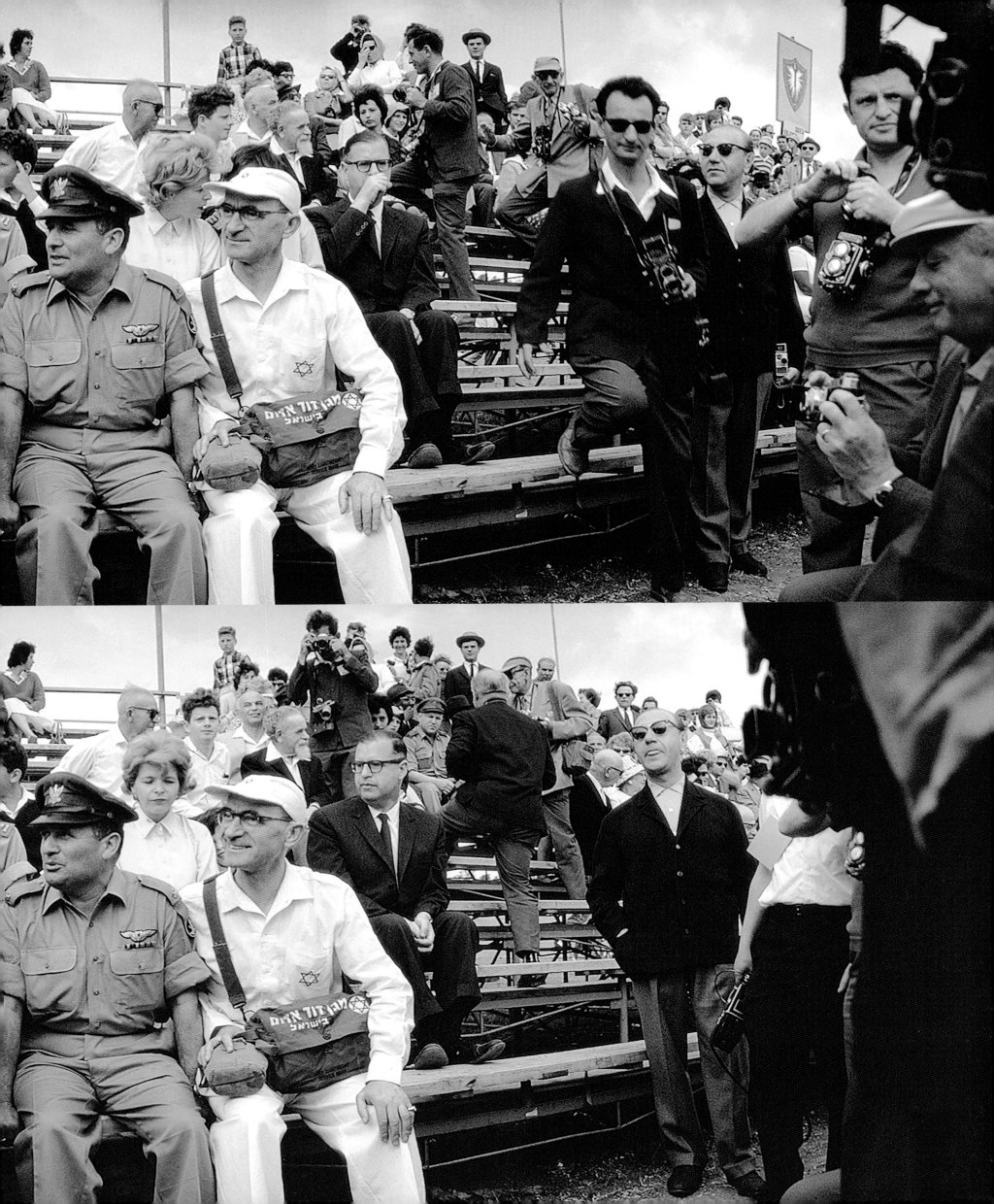

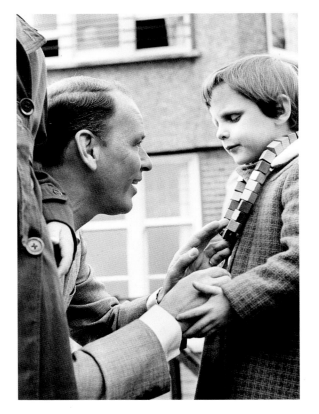

" In 1962, when my father went on a twelve-nation tour around the world to raise money for underprivileged children in twelve different countries, he did this at his own expense and he did it because he wanted to do it. He realized to his great joy that he was in a position that he could do it, and so he did it. And I guarantee you that he got more satisfaction out of that than anything he'd ever done. "

— *Frank Sinatra Jr.*

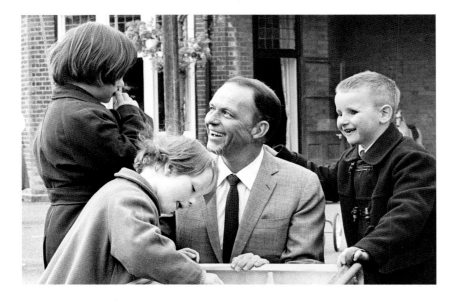

above Frank Sinatra visits the Sunshine Home for
Blind Babies and Children in Middlesex, England, June 1962.
opposite Contact sheet showing a visit to the Broussais
Hospital, Paris, during his charity world tour in 1962.

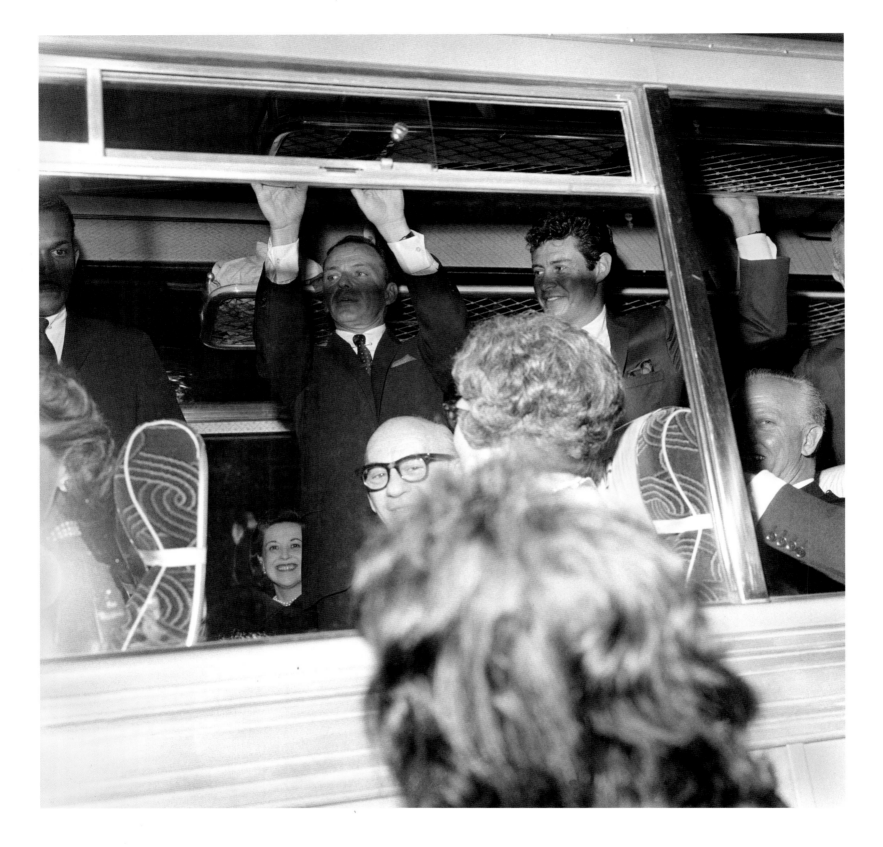

Frank Sinatra, seen here with Eddie Fisher on their way
to the premiere of the Cold War thriller *The Manchurian
Candidate* in London, June 15, 1962.

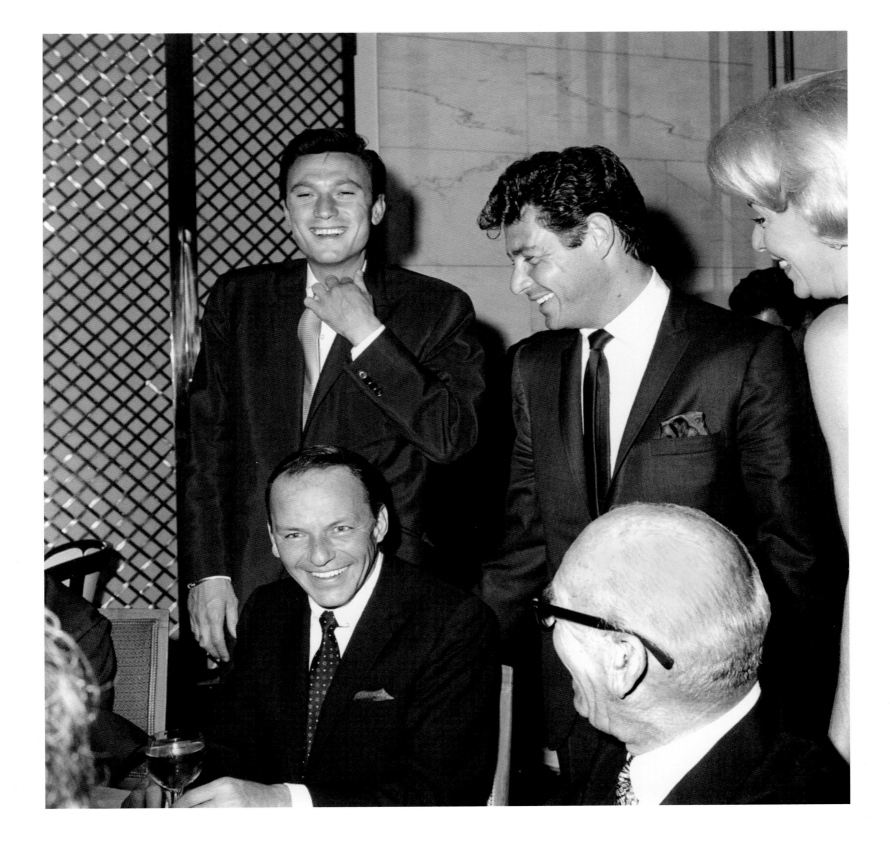

Frank Sinatra with co-star Laurence Harvey and
singer Eddie Fisher at the London premiere of
The Manchurian Candidate, June 15, 1962.

153

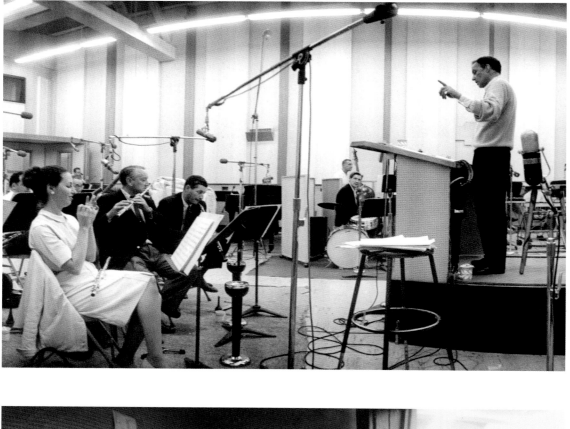

above The sessions for *Frank Sinatra Conducts Music From Pictures And Plays* took place on June 20 and 21, 1962 in Hollywood, California. Sinatra had been back in the US for less than a week after having completed his world tour for children's charities. **opposite** Sinatra with Duke Ellington at a press party in Chicago on November 28, 1962 to announce that Ellington had signed with Reprise Records.

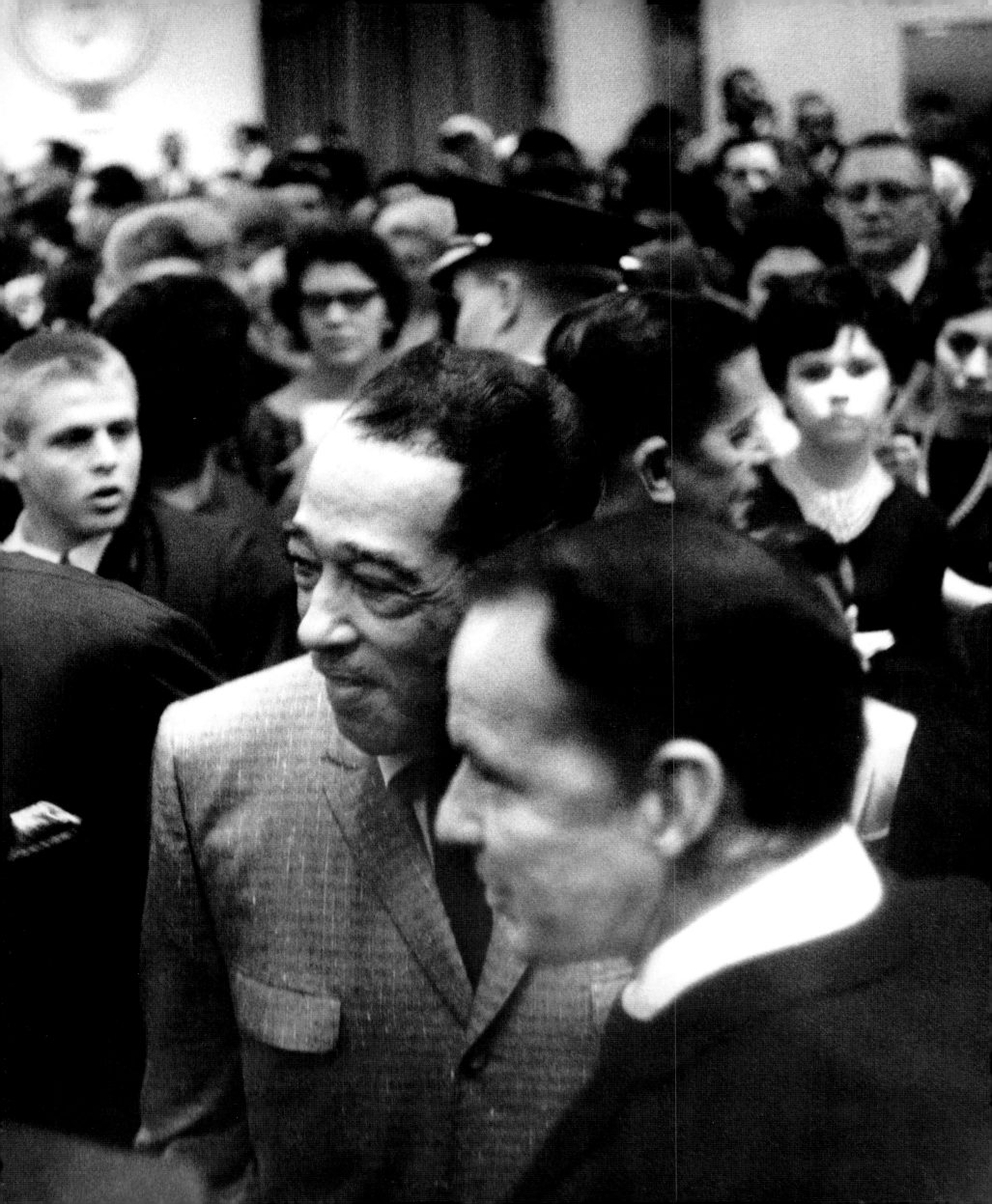

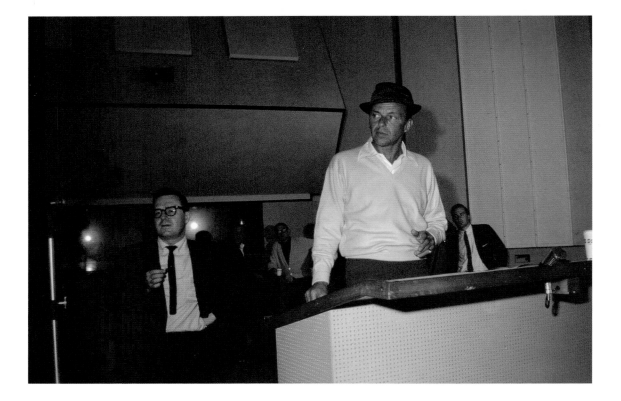

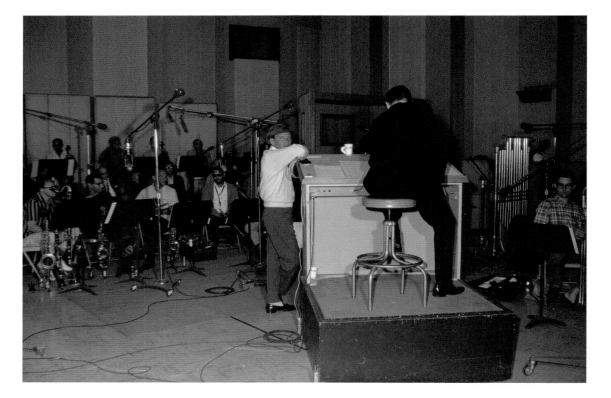

Sinatra in session on August 27, 1962. One of the songs
recorded that day was 'The Look Of Love.'

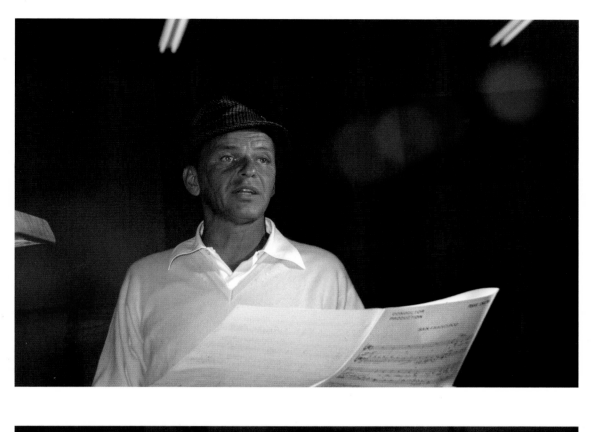

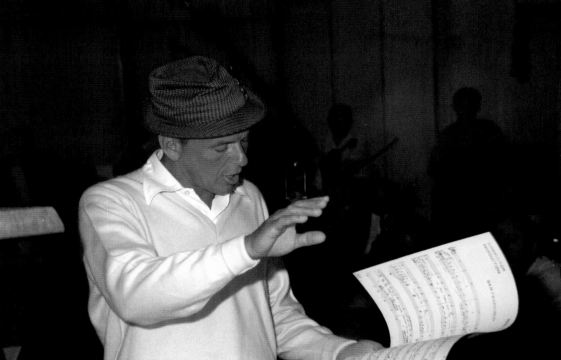

Sinatra recording '(I Left My Heart In) San Francisco,'
which he issued as the B-side of 'The Look Of Love.'
Ever the perfectionist, Sinatra later withdrew the release,
believing it to compare unfavorably with Tony Bennett's
version from earlier that year.

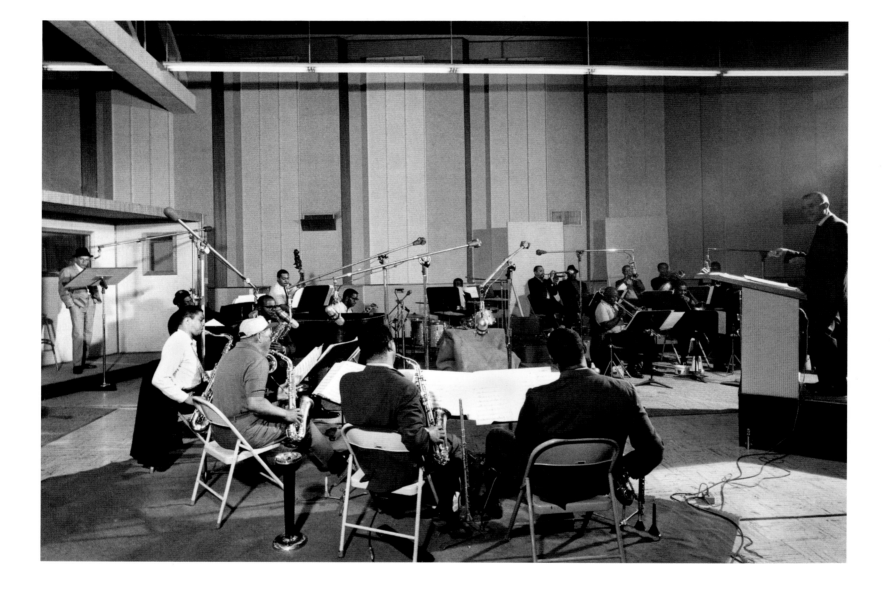

Neal Hefti conducts a session for the *Sinatra–Basie: An Historic Musical First* album in October 1962. "When the album with Count Basie came about, I was excited. I had a relationship with Basie and knew the band, since I had done about fifty sides for Basie. Frank mentioned that he wanted to do tunes that he had already recorded while under contract to Capitol." – Neal Hefti.

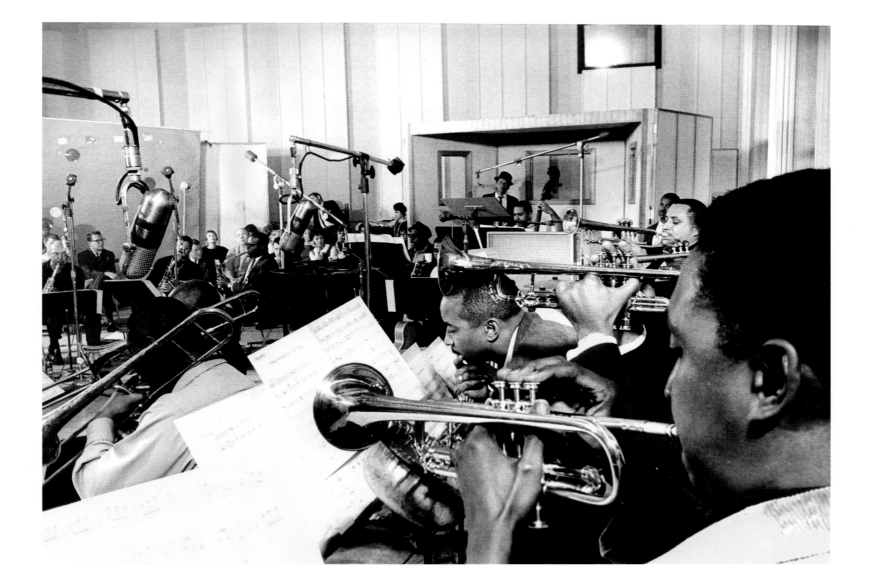

above Count Basie and Frank Sinatra in session, October
1962. The Basie band included legendary musicians such as Sonny
Payne on drums, Freddie Green on guitar, and Thad Jones on trumpet.
overleaf *LIFE* photographer Gjon Mili's contact sheets of Frank
Sinatra with Sammy Davis Jr. recording the duet 'Me And
My Shadow' on October 22, 1962. Sammy and Dean Martin also
recorded 'Sam's Song' at the same session.

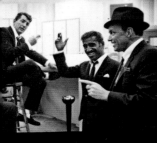
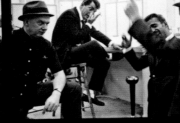
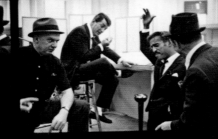

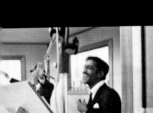
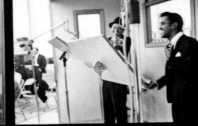
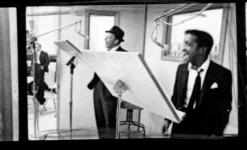
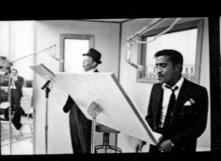
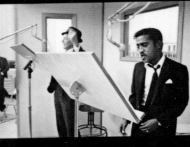

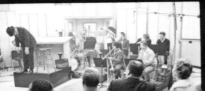
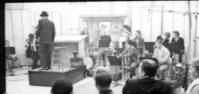
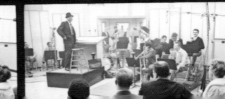
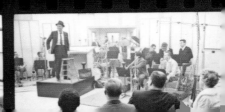

→1 →2 →3 →4 →5

KODAK TRI X PAN FILM KODAK SAFETY FILM

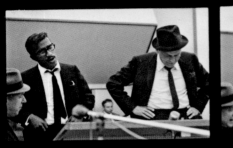
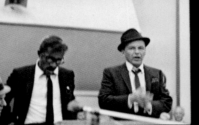
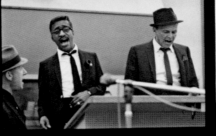
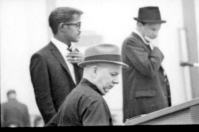
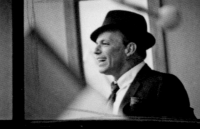

→6 →7 →8 →9 →10

KODAK TRI X PAN FILM KODAK SAFETY FILM

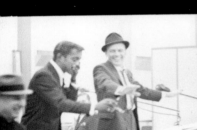
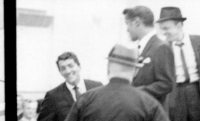
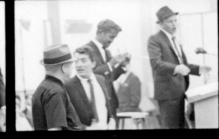

→11 →12 →13 →14 →15

KODAK TRI X PAN FILM KODAK SAFETY FILM

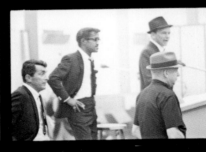

→16 →17 →18 →19 →20

KODAK TRI X P KODAK SAFETY FILM PAN FILM

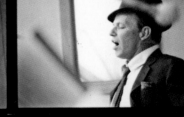

→21 →22 →23 →24 →25

KODAK KODAK SAFETY FILM K TRI X PAN FILM

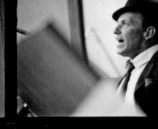

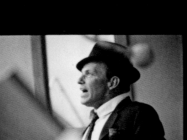
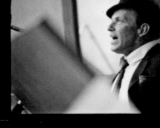
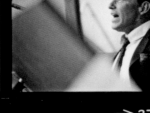
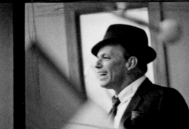
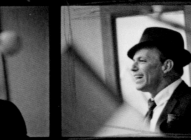
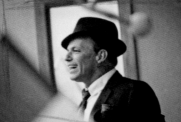
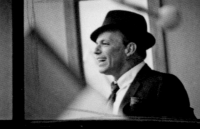
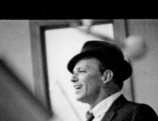

→26 →27 →28 →29 →30

KODAK SAFETY FILM KODAK TRI X PAN FILM

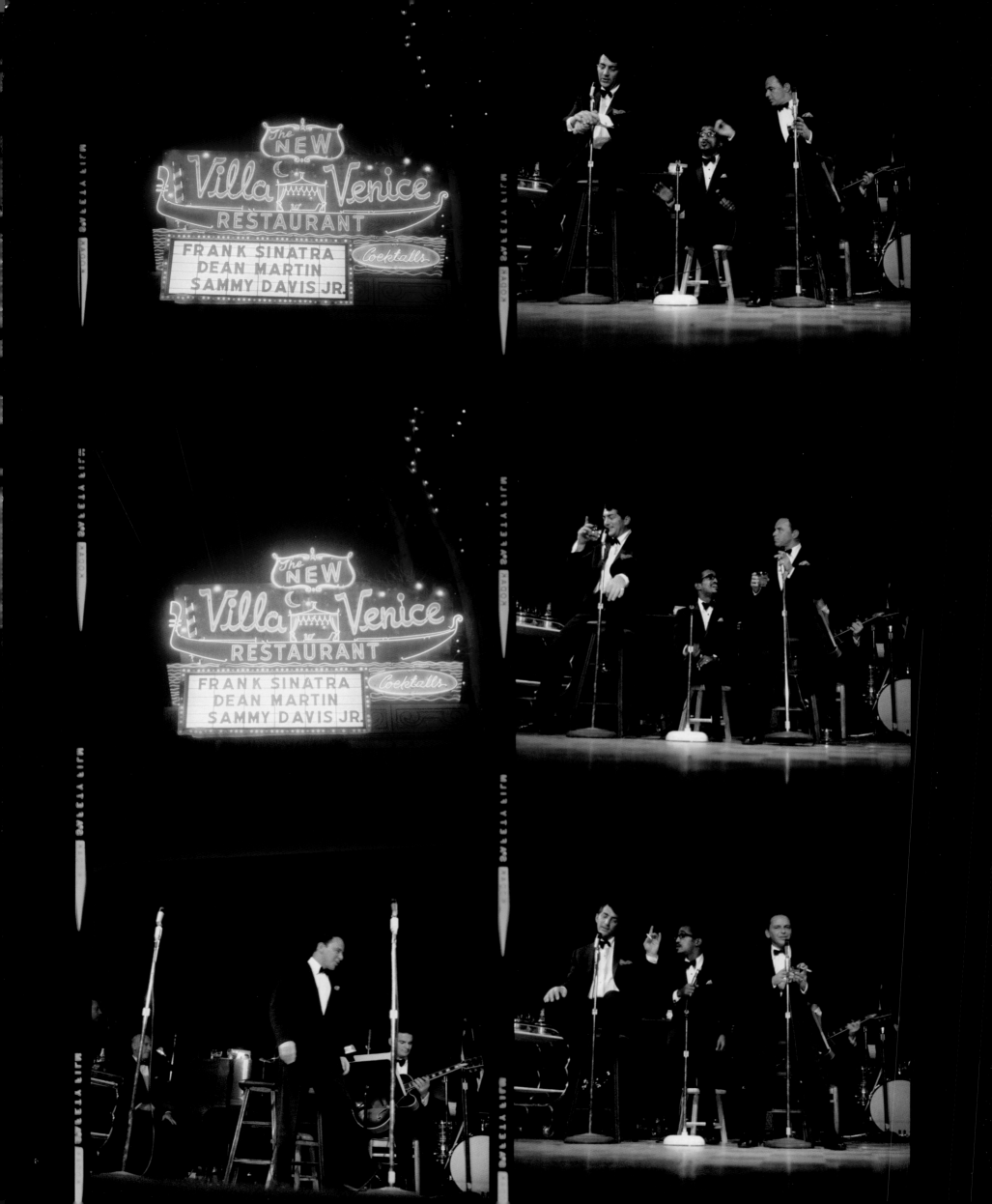

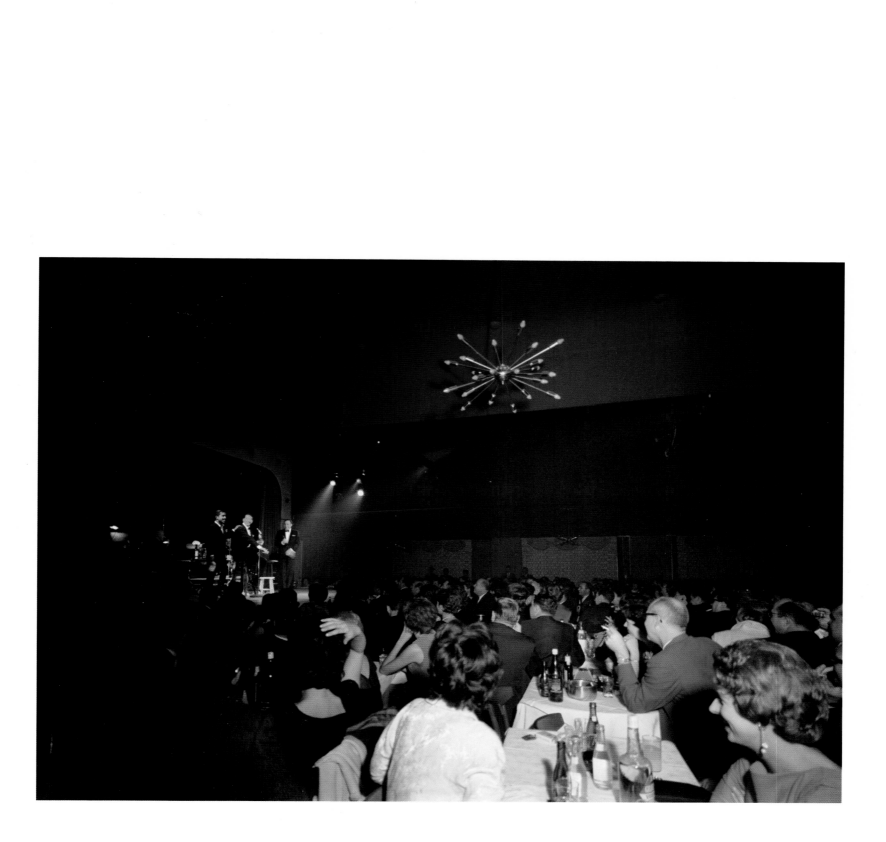

above & opposite Rare film reels and photographs of
Frank Sinatra, Dean Martin, and Sammy Davis Jr. at the
"New" Villa Venice in Northbrook, Illinois, November 1962. Sam
Giancana owned the nightclub and the shows were Sinatra's
way of paying him back for the help provided to Frank's friend
John F. Kennedy's presidential campaign.

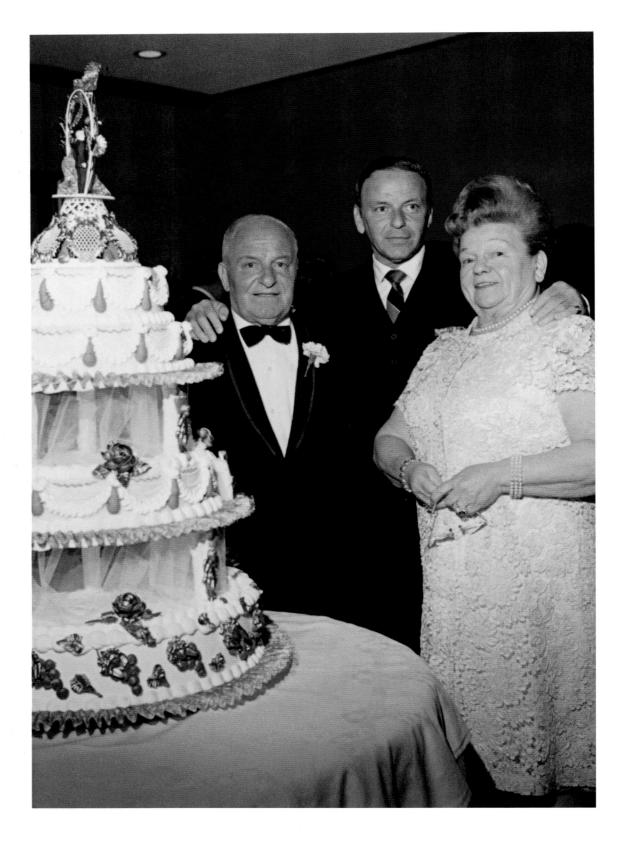

Sinatra with his parents, Marty and Dolly. "My father loved
me, if possible, more than my mother but he never showed it: he was
a terrible introvert. He loved my success but he never mentioned it,
he would never talk about it," recalled Sinatra.

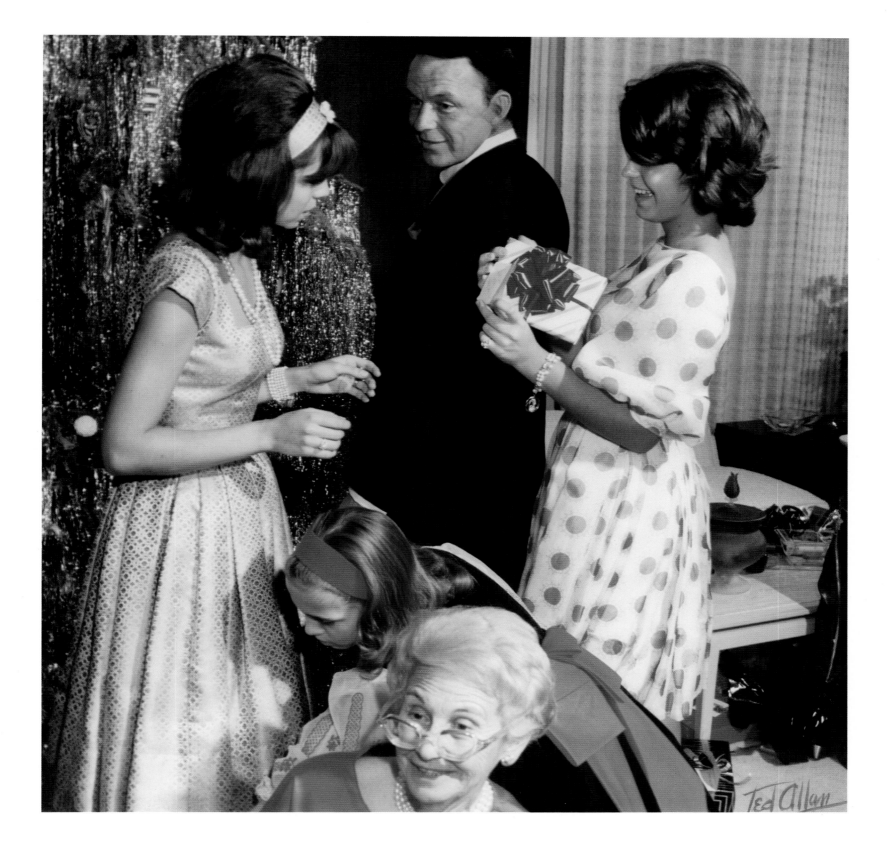

Daughters Nancy and Tina celebrate Christmas with their
dad in the early 1960s. The photograph is signed by Ted Allan,
who Sinatra had under personal contract for many years to
take pictures of his professional and private moments. Sinatra
nicknamed Allan "Farley Focus."

" He trains for a recording session like a fighter would for a championship fight. When he comes into a session he's ready for work; he's cut down on smoking, gotten plenty of sleep. Bill Miller is on salary with him and on call every day… Frank will get with Bill, review the songs. Then we contact the arranger we've picked. Frank will go over the tunes with him, ad-libbing, but quite accurately. For instance, he'll say, 'This one should be a broad, sweeping introduction, then a cut-off immediately into the verse, which should possibly be a piano alone for contrast, and then, at the conclusion of the verse, into a vamp of some kind establishing the time and rhythmic figures that'll be prominent.' He speaks freely, and his ideas are damn good."

— *Sonny Burke*

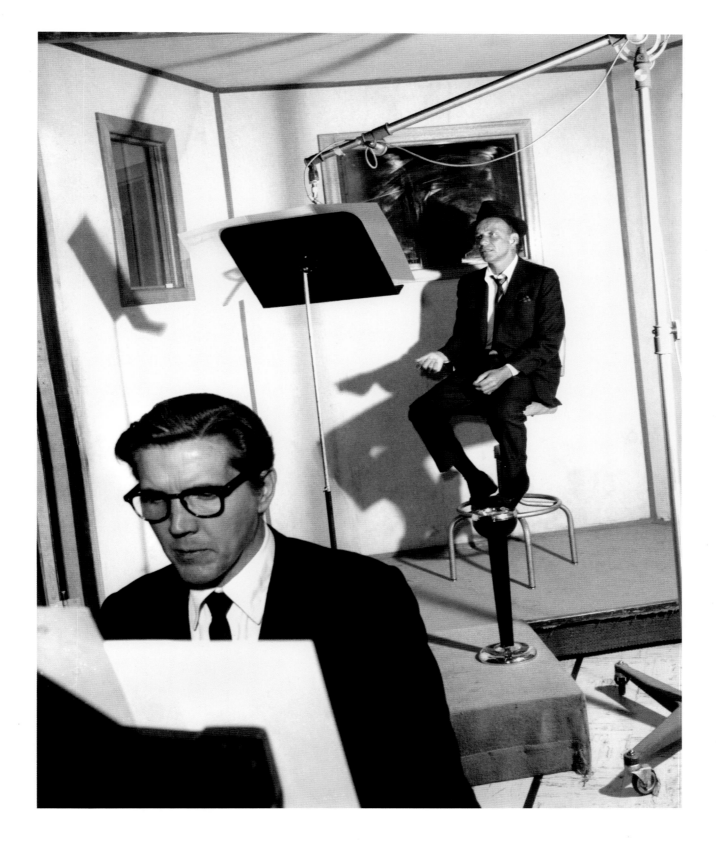

Recording with pianist Bill Miller in the early 1960s. "Somewhere
in my subconscious there's a constant alarm that rings, telling me what
we're putting on tape might be around for a lotta, lotta years. Maybe long
after we're dead and gone somebody will put a record on and say,
'Jeez, he could've done better than that!'" – Frank Sinatra.

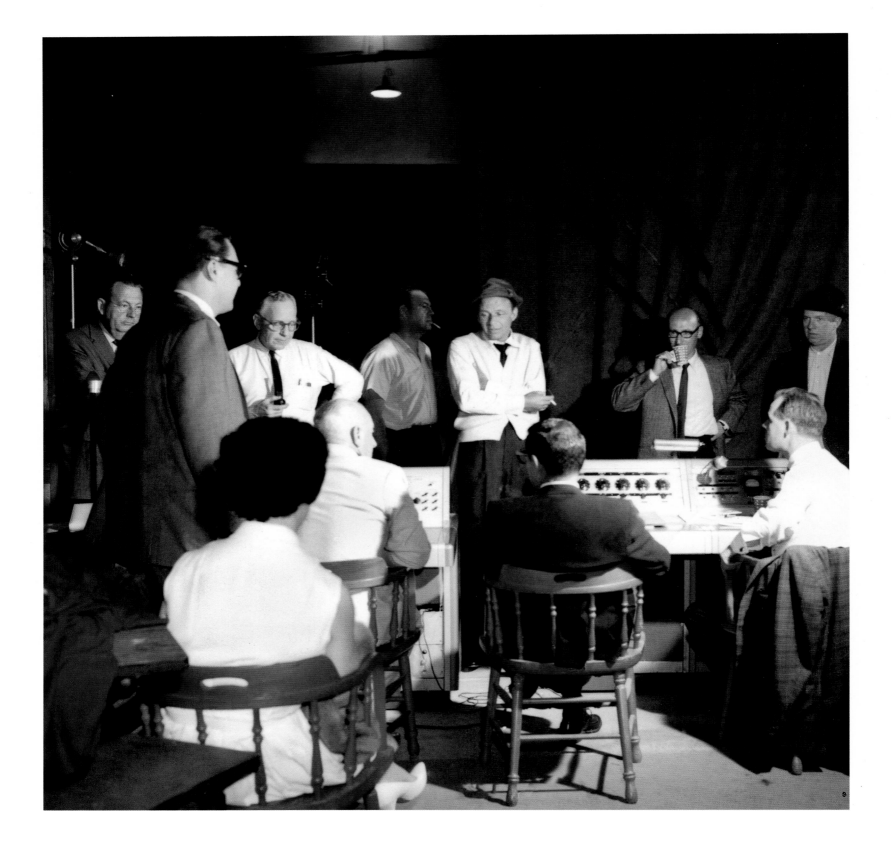

Sinatra with Nelson Riddle, Sammy Cahn, and Jimmy
Van Heusen, among others, at a session in February 1963 for
The Concert Sinatra album. The sessions were held at the
Goldwyn Studios in Hollywood.

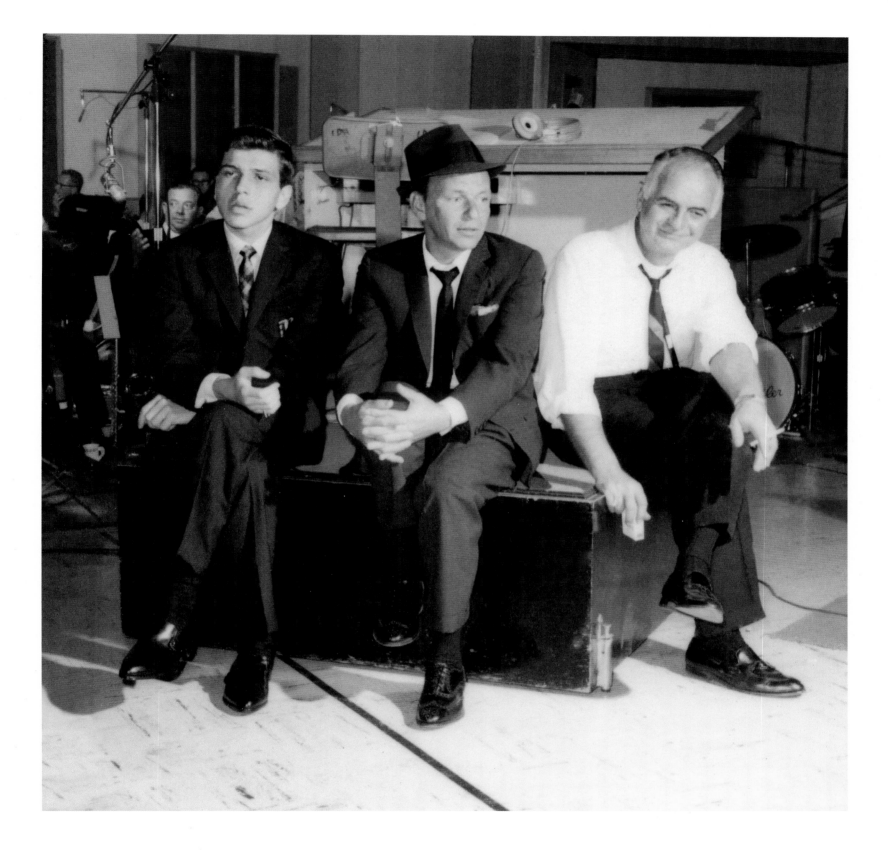

Sinatra Jr. and Sr., along with producer Sonny Burke, listen
to a playback during a session in the mid-1960s.

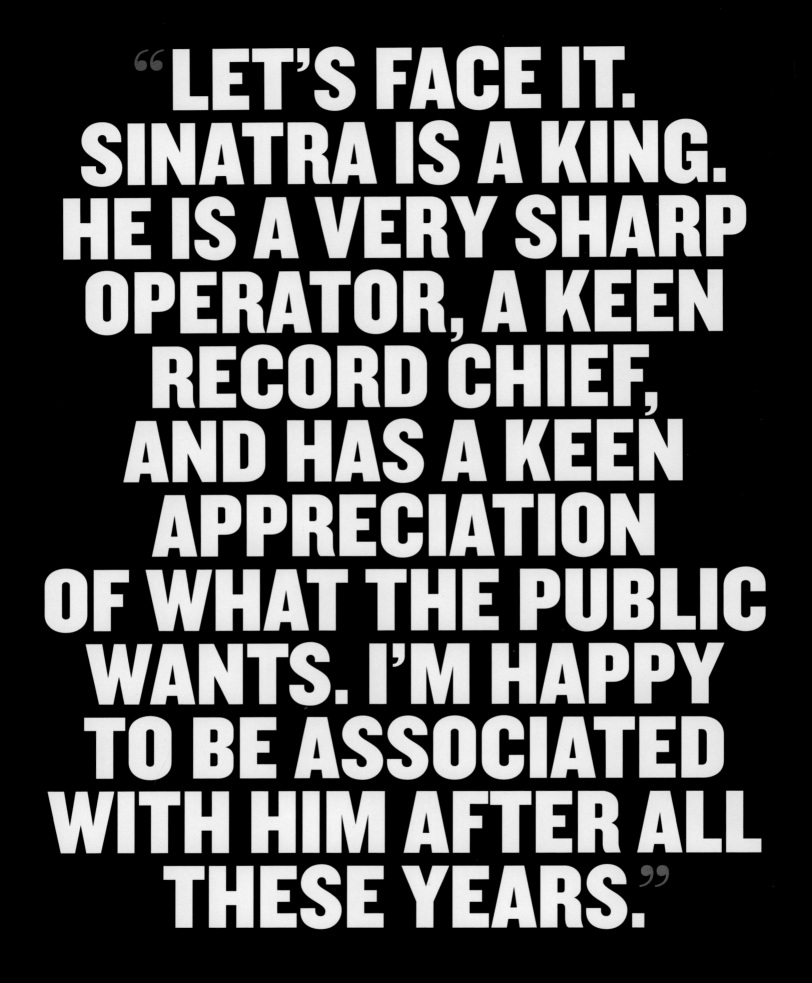

"LET'S FACE IT. SINATRA IS A KING. HE IS A VERY SHARP OPERATOR, A KEEN RECORD CHIEF, AND HAS A KEEN APPRECIATION OF WHAT THE PUBLIC WANTS. I'M HAPPY TO BE ASSOCIATED WITH HIM AFTER ALL THESE YEARS."

— *Bing Crosby*

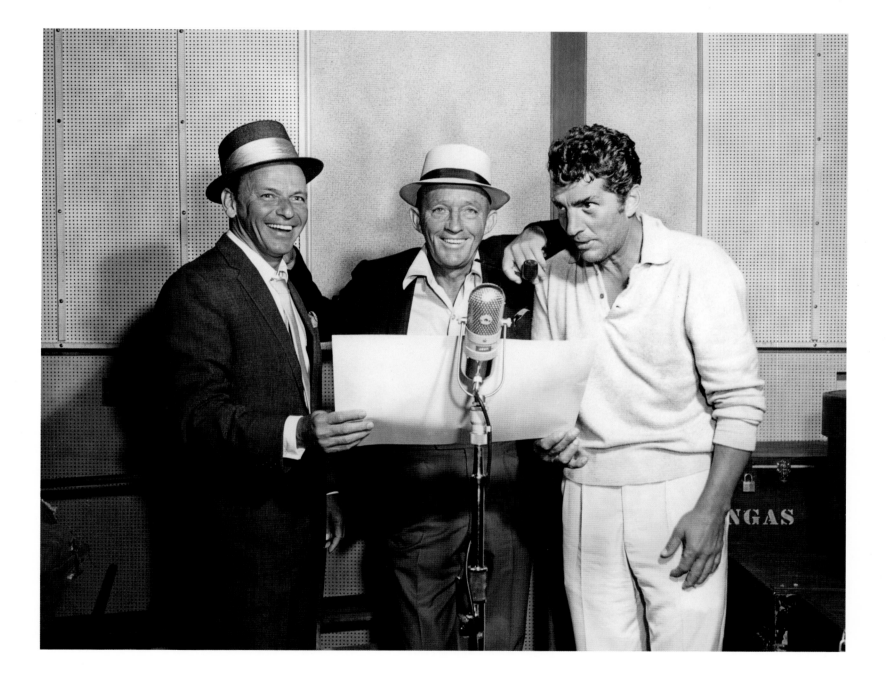

above Sinatra, Bing Crosby and Dean Martin mugging at a July 1963
recording session for 'The Oldest Established (Permanent Floating Crap
Game In New York)' and 'Fugue For Tinhorns' from *Guys And Dolls*.
overleaf Bill Miller, Sinatra, Angie Dickinson, Nancy Wilson, and
friend backstage at the Cow Palace in San Francisco, CA on July 31, 1964.
Sinatra was there to sing at a benefit for the NAACP (National
Association for the Advancement of Colored People).

171

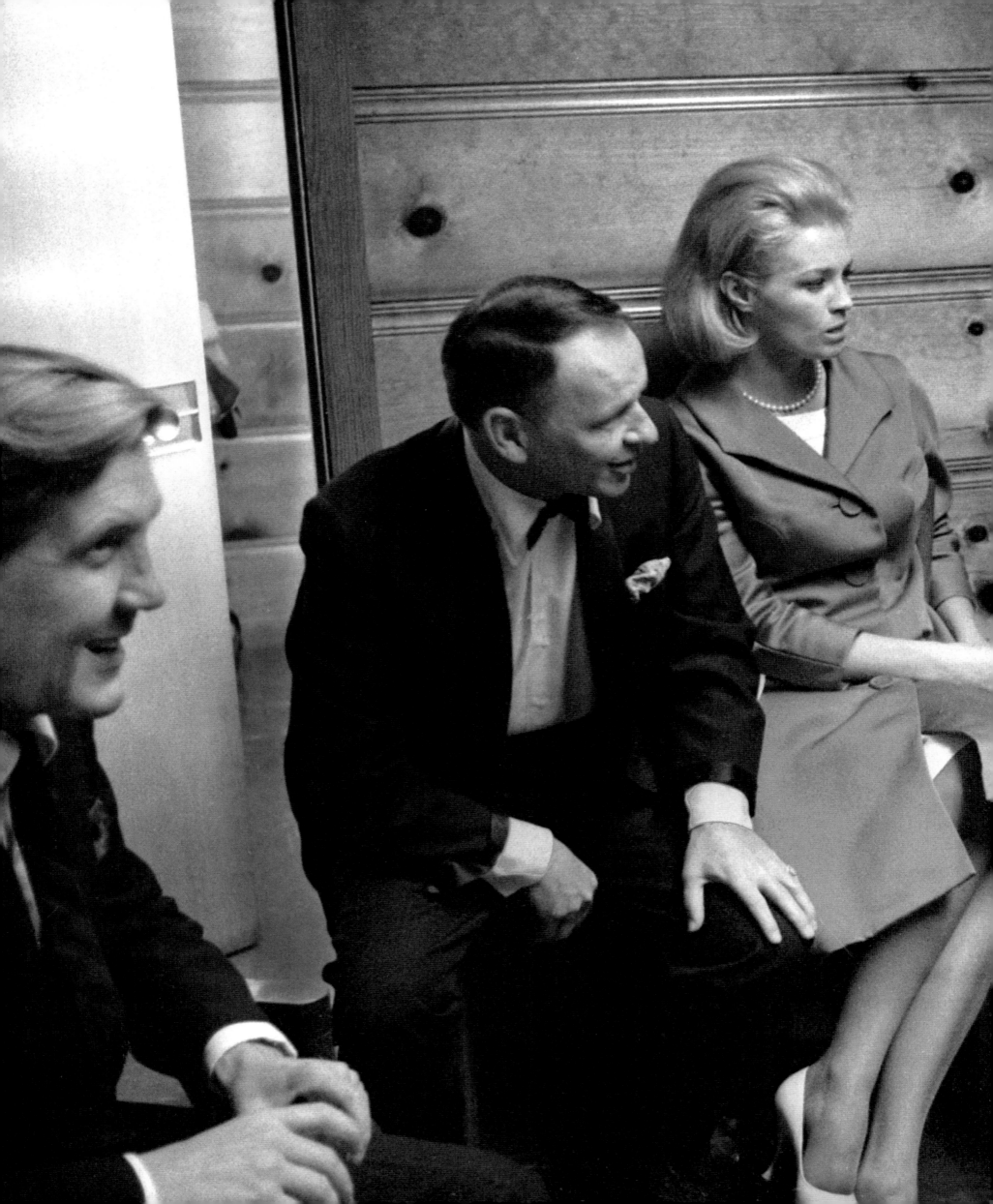

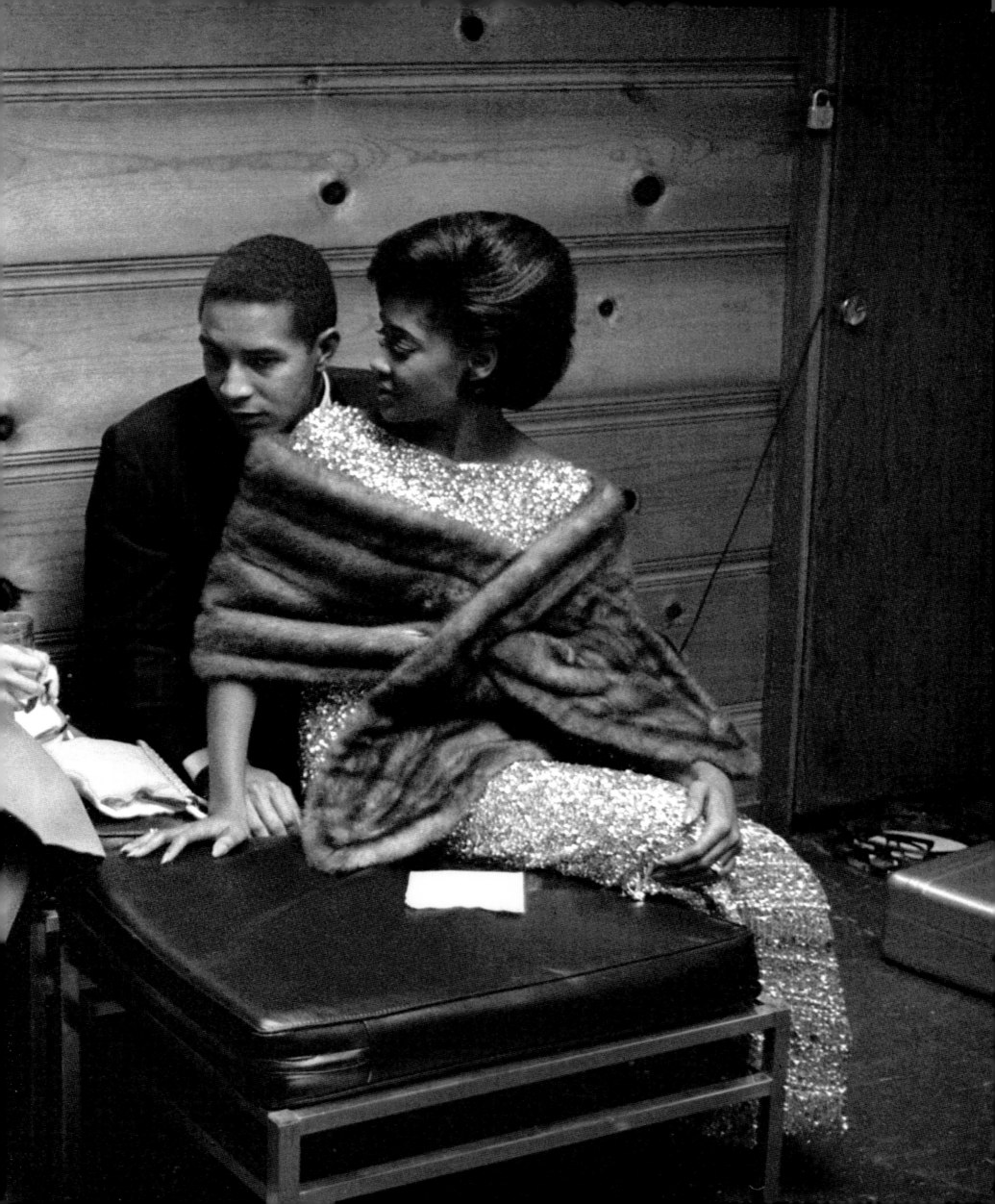

Sinatra in his study, which he called "The Kennedy Room,"
Palm Springs, California. Letters and photographs from
President Kennedy adorn the wall.

" Dad went to Palm Springs after that
[JFK's assassination] and virtually
disappeared. Even I couldn't reach him.
For three days, while the Kennedys and
the nation publicly mourned, my father
grieved alone, locked away in his bedroom.
Afterward, he said of John F. Kennedy,
'For a brief moment, he was the brightest
star in our lives. I loved him.'"

— Nancy Sinatra

" I understand I'm considered to be the songwriter to have put more words into Sinatra's mouth than any other man. Whenever Frank needs a lyric you can bet I'm there. I have been, ever since *Anchors Aweigh...* I do have one great disappointment with Frank Sinatra in my life. I wrote a song for the film *Robin and the 7 Hoods* called 'I Like To Lead When I Dance.' Some songs Sinatra liked better than others and he had never not liked a song of mine.... It was definitely the single best Sinatra song I'd ever written. Frank recorded the song for the soundtrack album but never got around to synching the song for a scene in the film. When I heard he would not be doing it in the film I wrote him a note that said, 'Please don't let this one get away. We're not up at bat that often and don't get that big fat pitch. If you don't do the song in the picture we'll all be punished.' A few days after I sent him the note, his son was kidnapped."

– *Sammy Cahn*

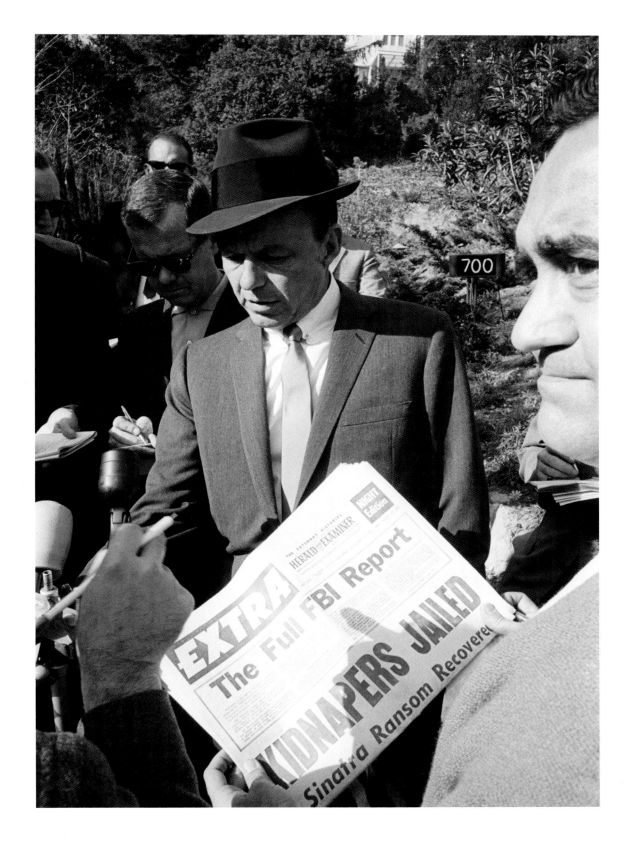

Sinatra spoke at a press conference after the capture of Frank Sinatra
Jr.'s kidnappers, December 1963. "I think fear is part of everybody's
psyche; I don't think we can escape it. I've found fear in my life has
usually been the unknown – something that I couldn't quite understand.
That's why the worst time was in the case of young Frank's kidnapping...
we were all in the dark and had no information."

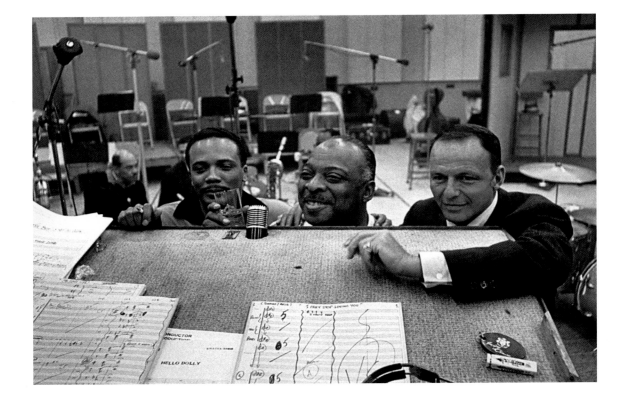

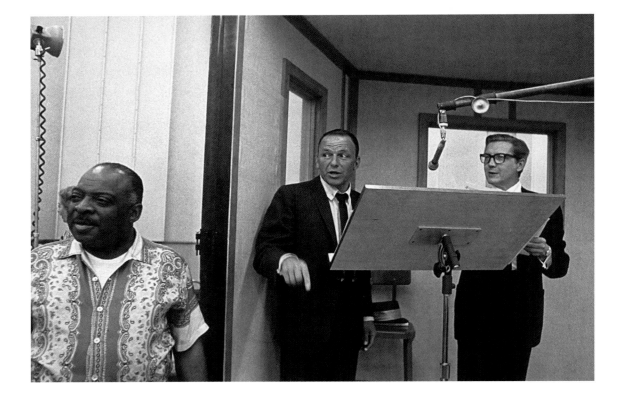

above Frank Sinatra at a recording session with Quincy Jones
and Count Basie, June 1964. The scores on the podium are 'Hello
Dolly' and 'I Can't Stop Loving You.' **below** Basie, Sinatra,
and Bill Miller during the same sessions for the album *It Might
As Well Be Swing* (1964). **overleaf** Sinatra, Quincy Jones,
and producer Sonny Burke review an arrangement.

"SO FAR AS I CAN PUT THE ESSENCE OF FRANK INTO WORDS, I'D SAY THAT HE JUST MAKES EVERYTHING WORK, AND THAT'S EXACTLY WHAT HAPPENED ON THE SESSIONS WITH BASIE. I REMEMBER THOSE RECORD DATES WITH SINATRA AND BASIE LIKE IT WAS YESTERDAY. YOU NEVER FORGET SOME OF THE BEST TIMES OF YOUR LIFE."

— *Quincy Jones*

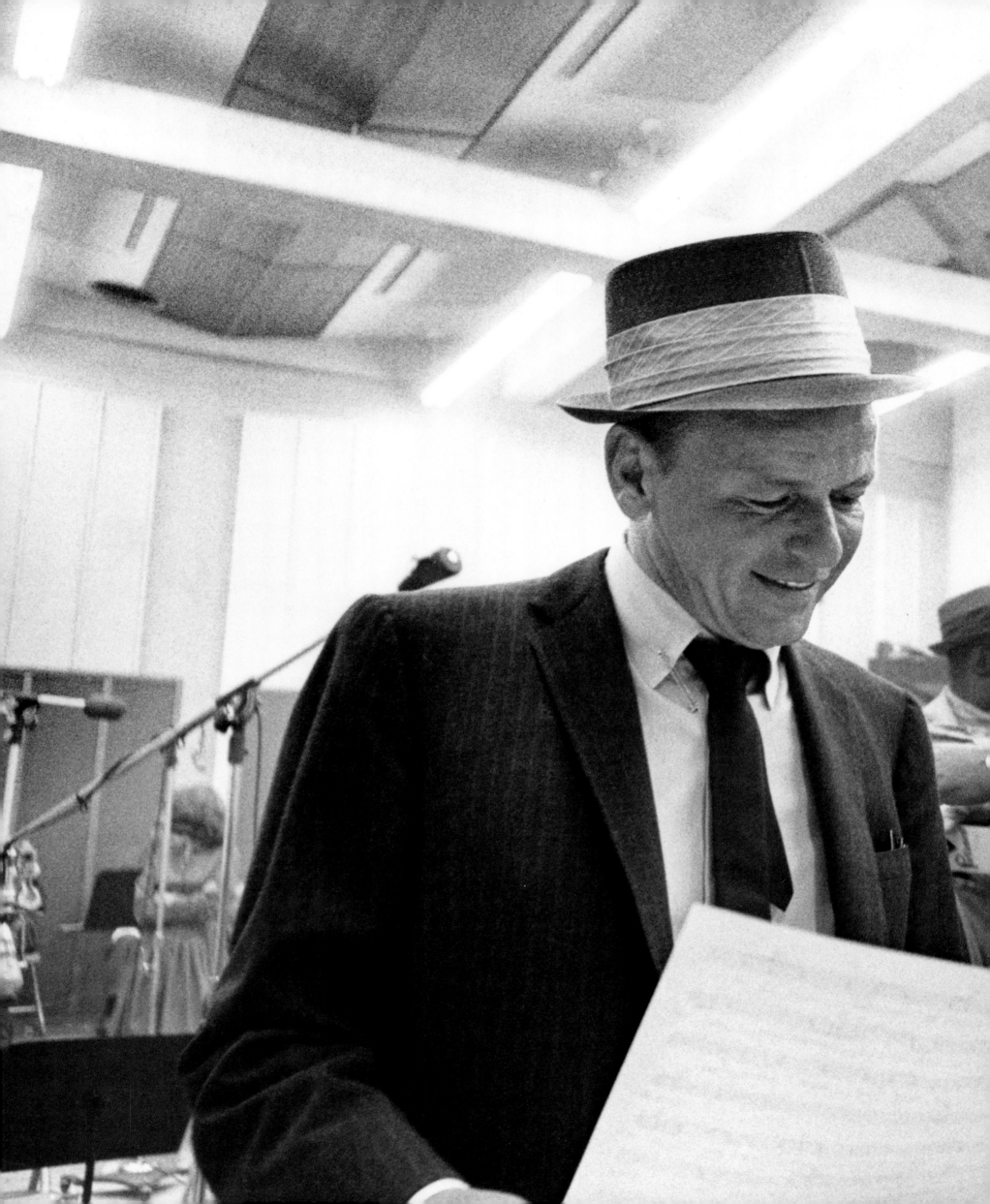

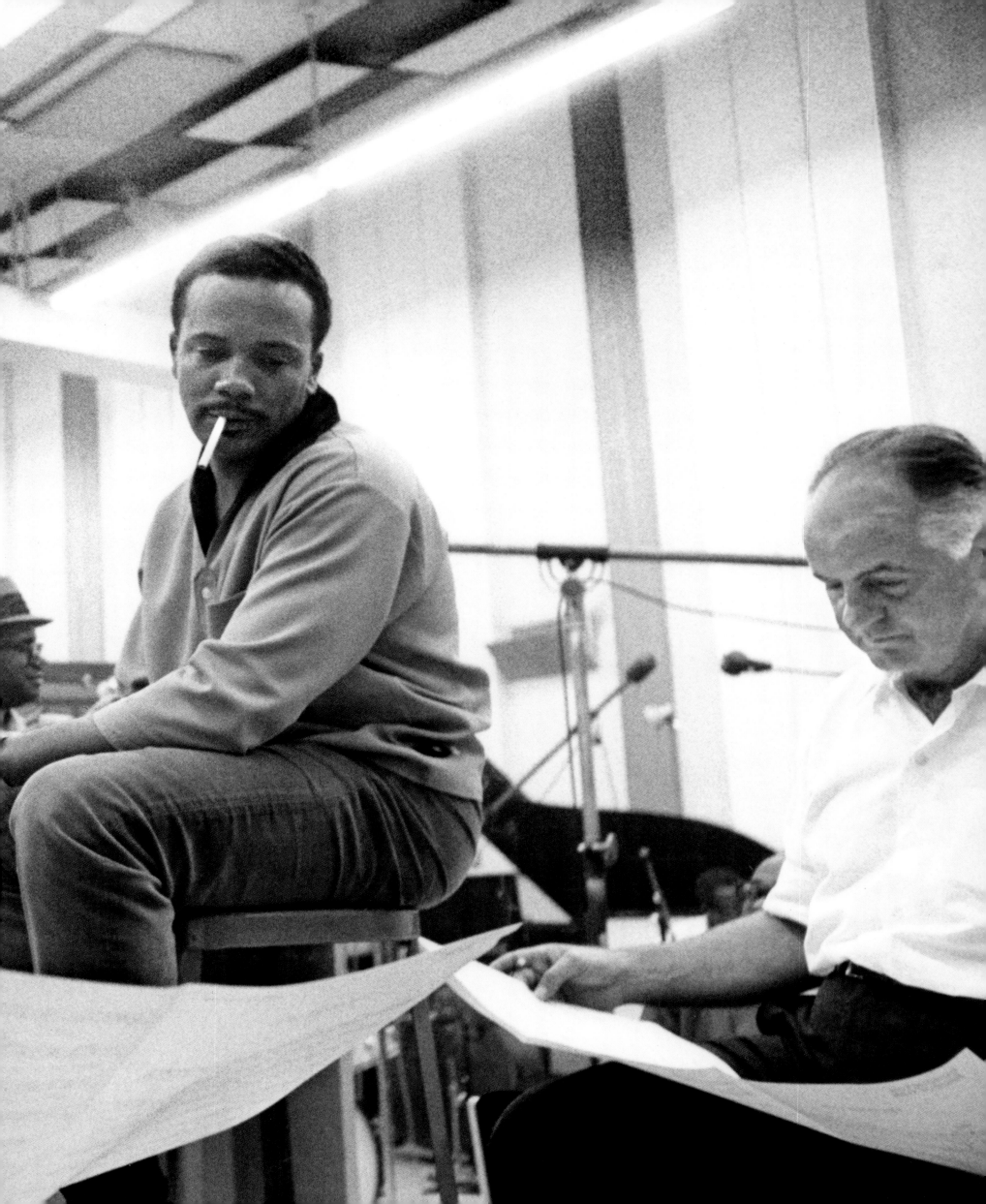

" I have often seen him conduct at a recording session...he would sometimes conduct the orchestra with his hands. He has the most graceful, expressive hands you could imagine and the orchestra would obviously follow him like a hawk. Every little nuance he dictated with his hands, rather than talking about it. I have often said that working with Frank Sinatra is the most memorable experience that a professional recording man could aspire to. He is, in truth, the man of all musical seasons – one of the world's greatest performers, incomparable as a singer of songs, and speaking of songs, if it happens to be one he especially digs, he's capable of turning what might be a mundane lyric into a lovely verse of sheer poetry. He doesn't just read a lyric; he sings it from the heart. Even without any kind of formal training, he's one of today's finest musicians. "

— *Sonny Burke*

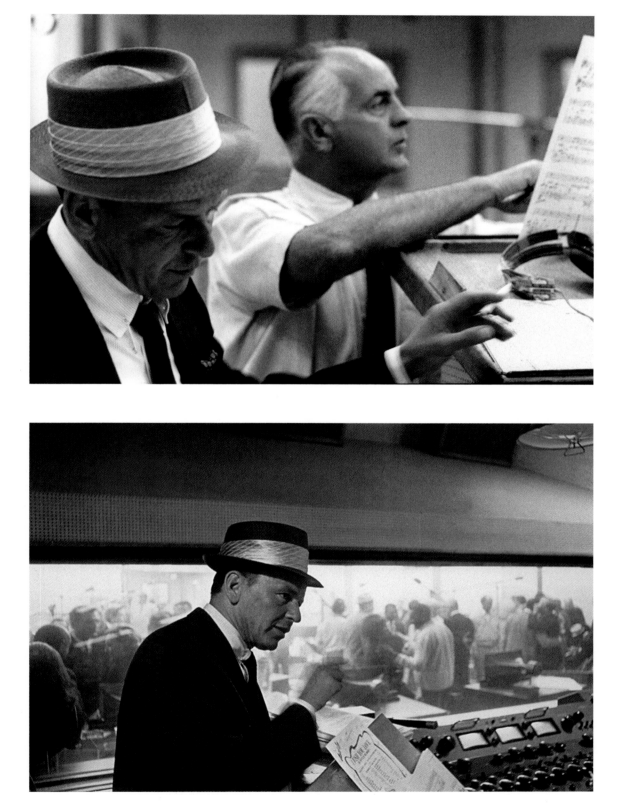

above Sinatra and producer Sonny Burke in a session for the
It Might As Well Be Swing album, June 1964. below Sinatra listens
to a playback during the session. Note the lead sheet on the music
stand for 'I Wish You Love.' overleaf Sinatra and Dean Martin
traveling in style in the 1960s.

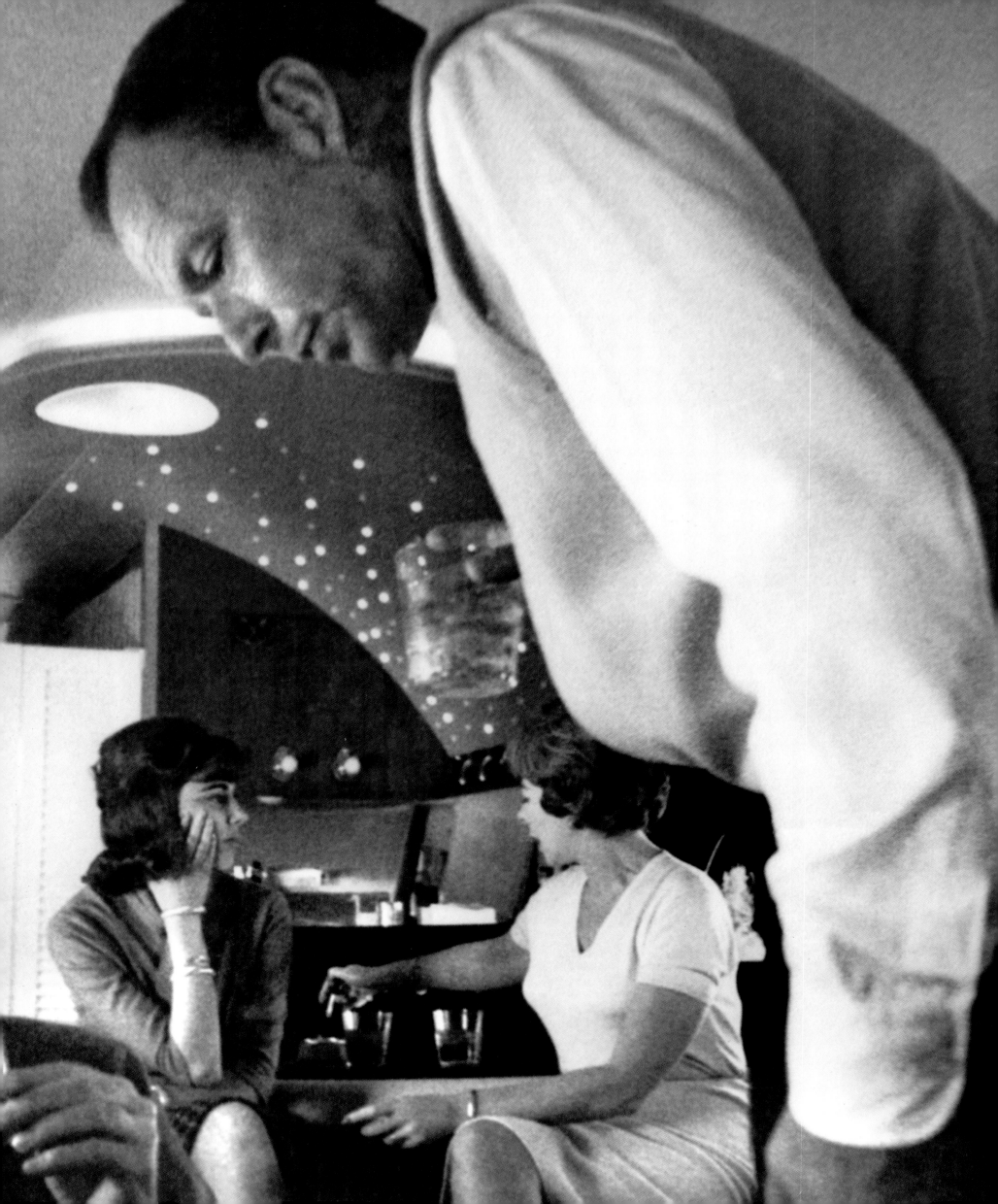

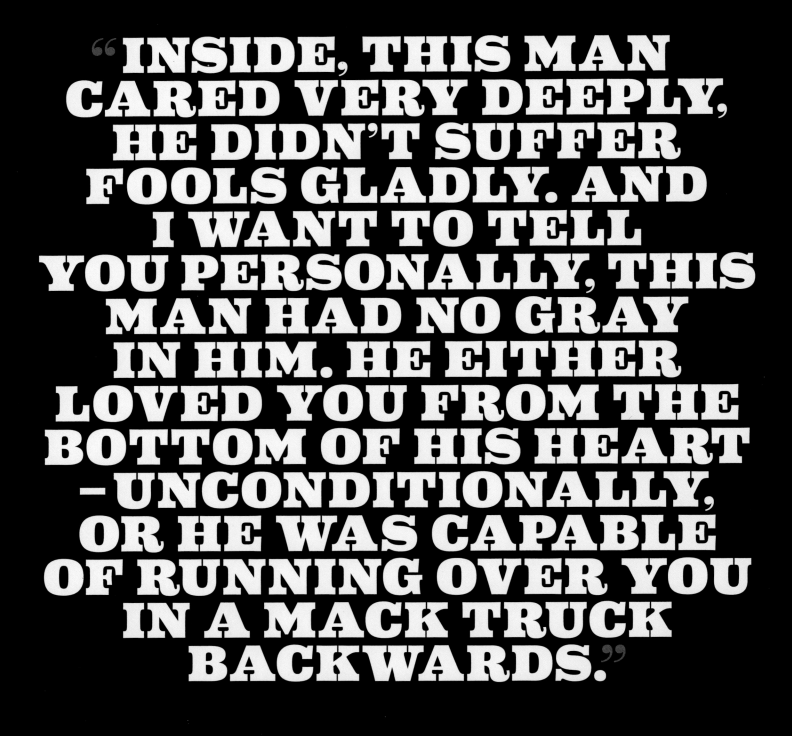

"INSIDE, THIS MAN CARED VERY DEEPLY, HE DIDN'T SUFFER FOOLS GLADLY. AND I WANT TO TELL YOU PERSONALLY, THIS MAN HAD NO GRAY IN HIM. HE EITHER LOVED YOU FROM THE BOTTOM OF HIS HEART – UNCONDITIONALLY, OR HE WAS CAPABLE OF RUNNING OVER YOU IN A MACK TRUCK BACKWARDS."

– Quincy Jones

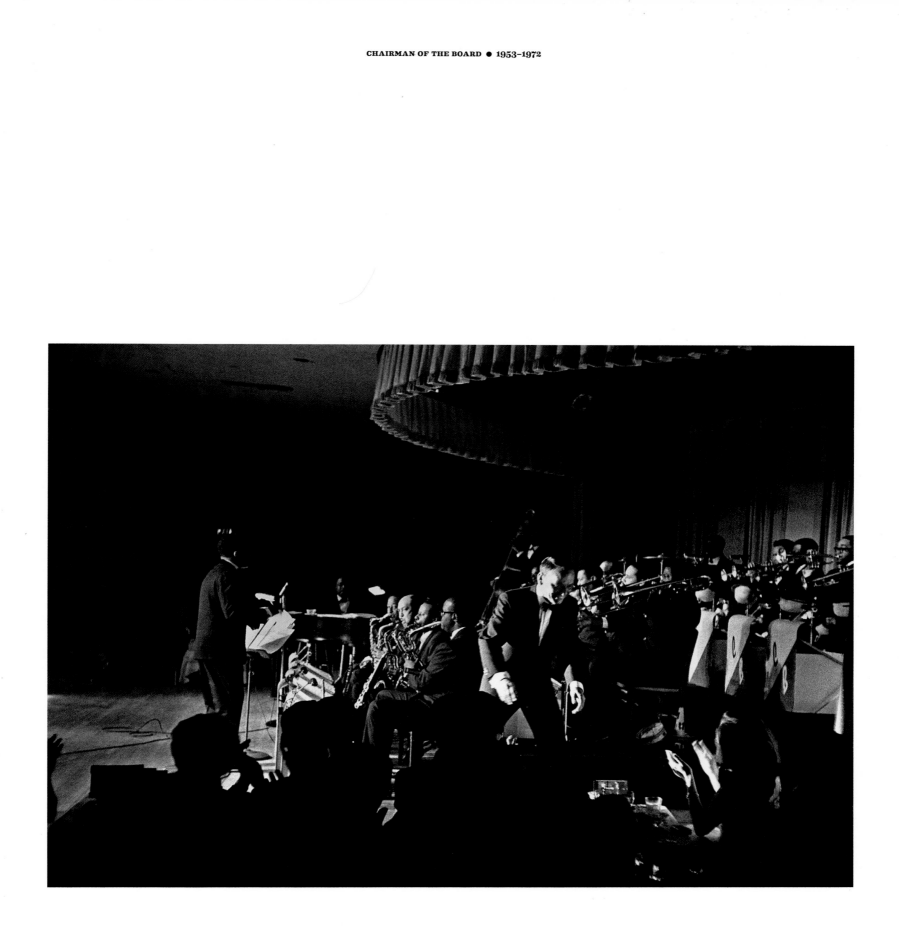

above Frank Sinatra with Count Basie's band,
conducted by Quincy Jones, playing full swing at The
Sands, Las Vegas, 1964. **overleaf** Frank Sinatra
rehearsing with Count Basie's band on a Los Angeles
sound stage before hitting the road.

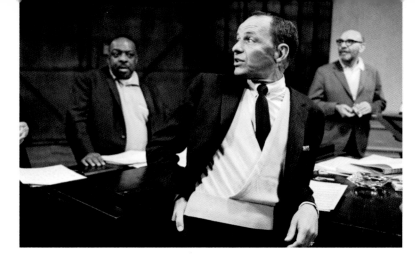
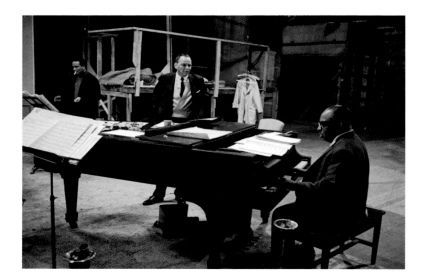
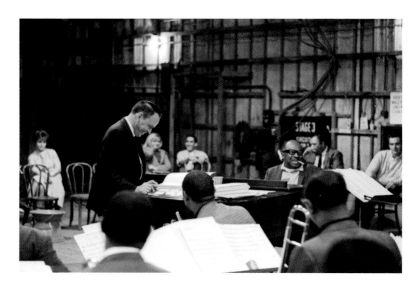
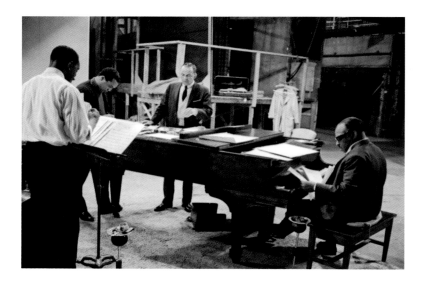
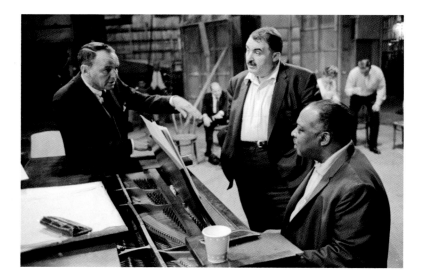
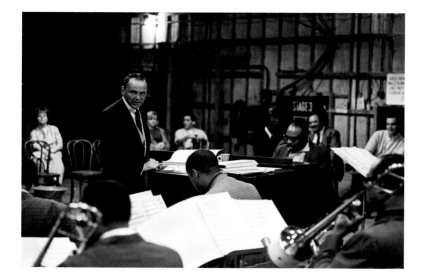
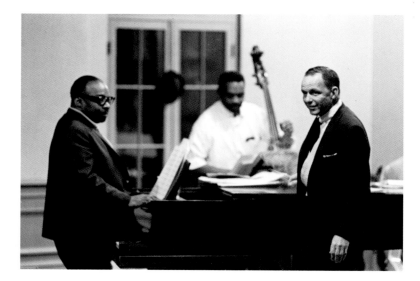

188

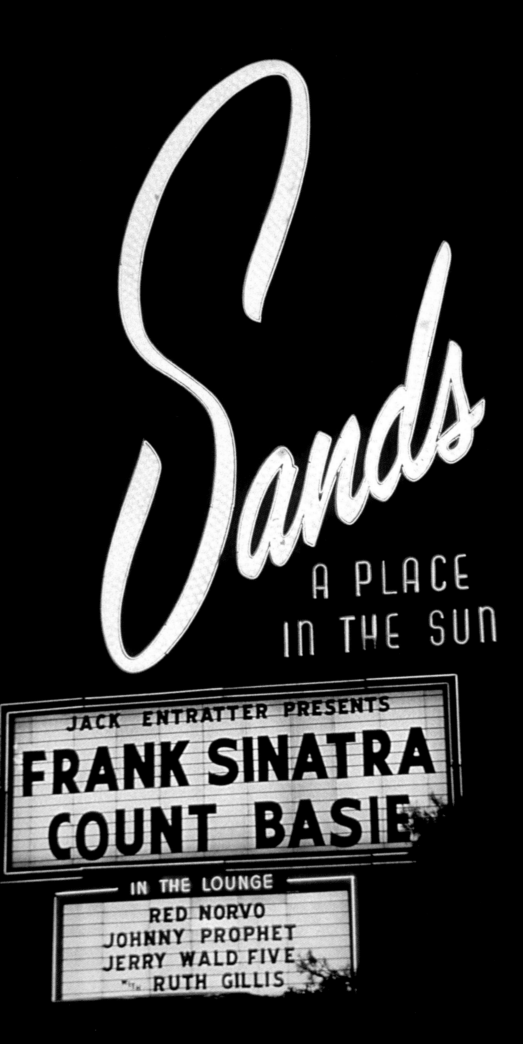

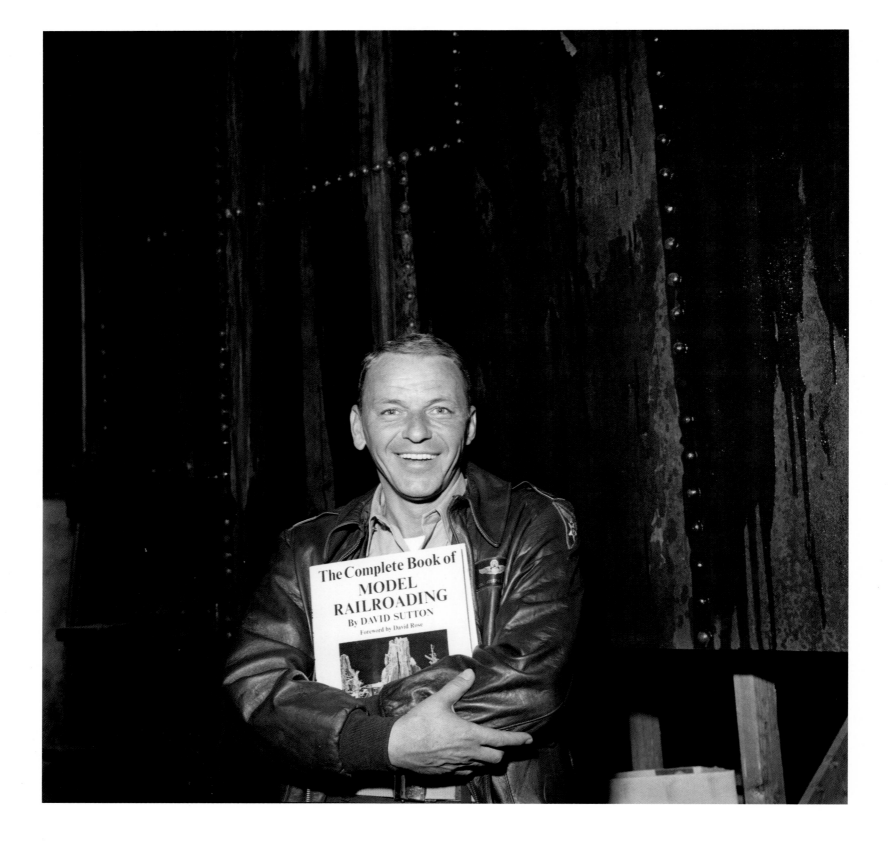

above Frank made no secret of one of his favorite hobbies
and is pictured here on the set of *Von Ryan's Express* with a book by
David Sutton, the movie's official photographer. **opposite** On location
for *Von Ryan's Express*, September 10, 1964. The World War II
adventure film was released in 1965 and was one of Sinatra's
highest grossing films of that decade.

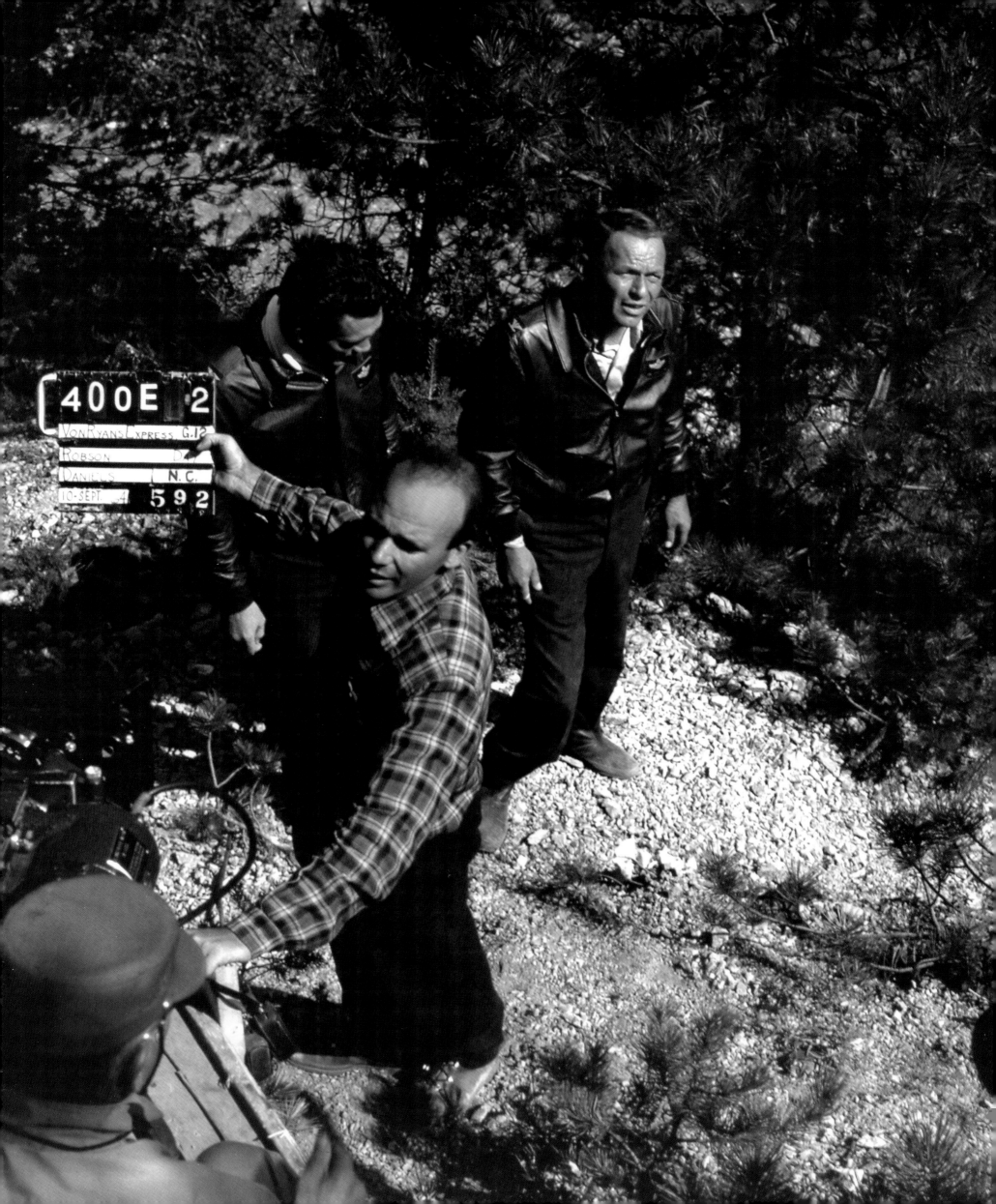

above The Sinatra family poses for a portrait shot by photographer John Engstead. **overleaf** Frank Sinatra gave photographer John Dominis an unprecedented three months' behind the scenes access for *LIFE* magazine in 1965. The shoots produced intimate photographs such as these: at Sinatra's home in Palm Springs, California, playing with his dog, Ringo (page 194); making himself a sandwich in his kitchen (page 195); iconic spotlit and silhouette photographs at The Sands (pages 196–7).

"Nancy and I divorced...those things happen, unfortunately. Nobody liked it, but she was a marvelous mother to our children. Tina is more like me. She has an impatient quality about her that I see in myself, that I had before, that will eventually lessen in Tina. It'll work its way out, to a normal degree. Little Nancy is more like big Nancy. She's 'Mother Earth,' you might say, in a sense. Frankie is really a dreamer and I like him for that, because without dreamers in the world, we'd never make any progress."

— *Frank Sinatra*

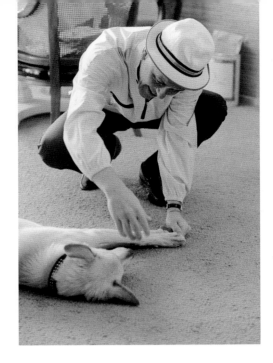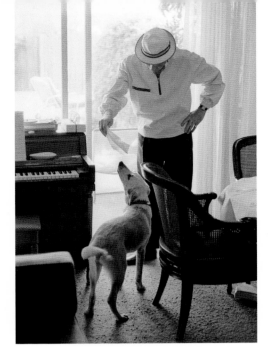
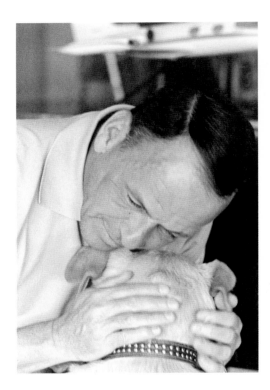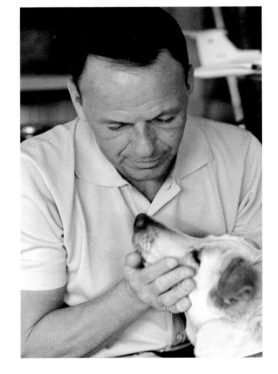

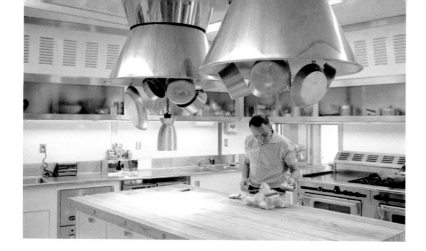

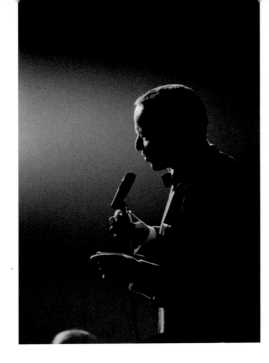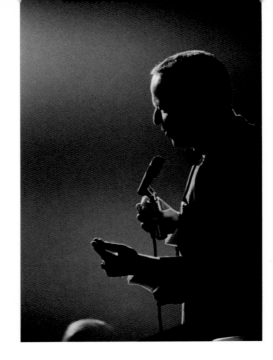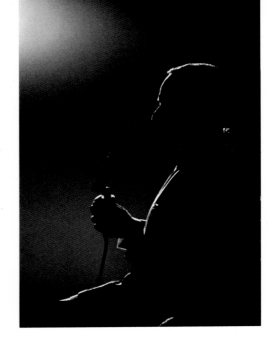
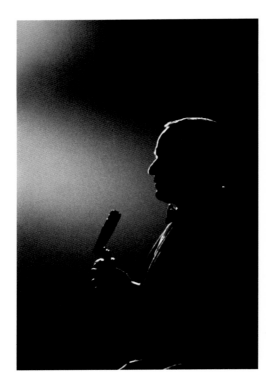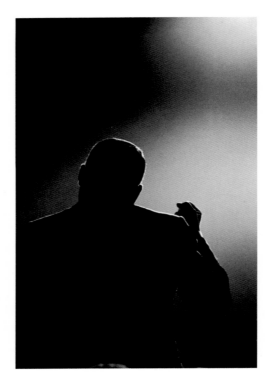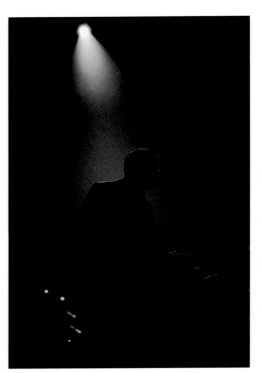
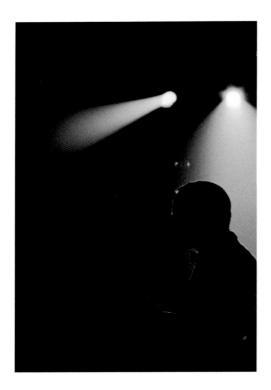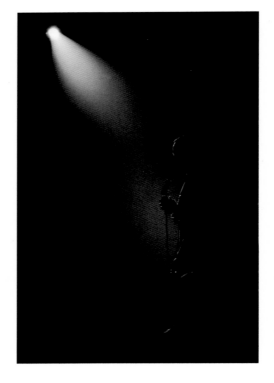

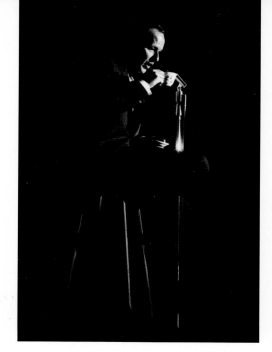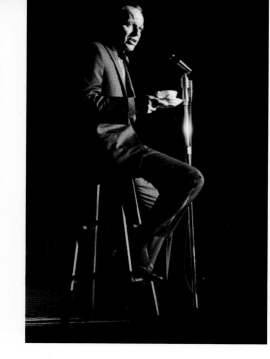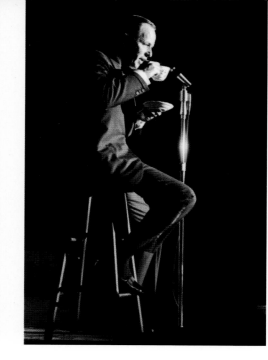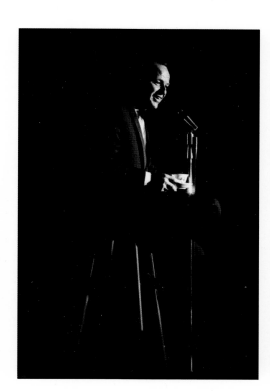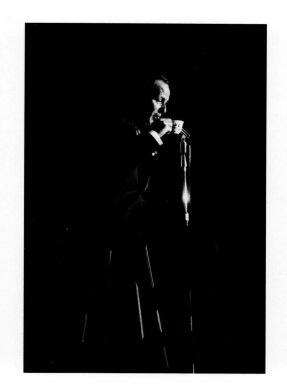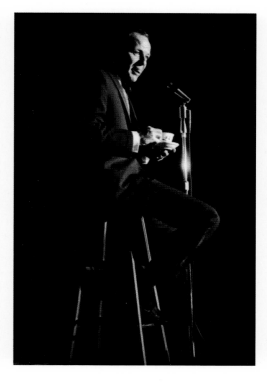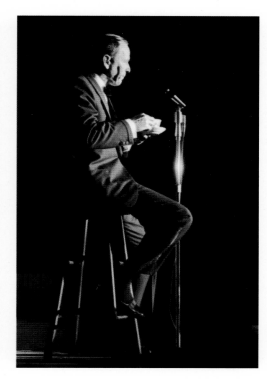

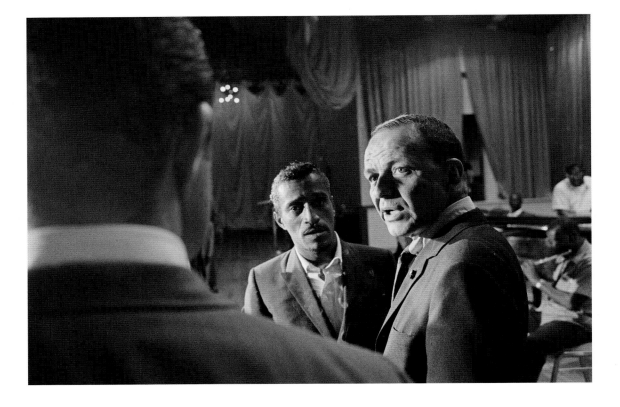

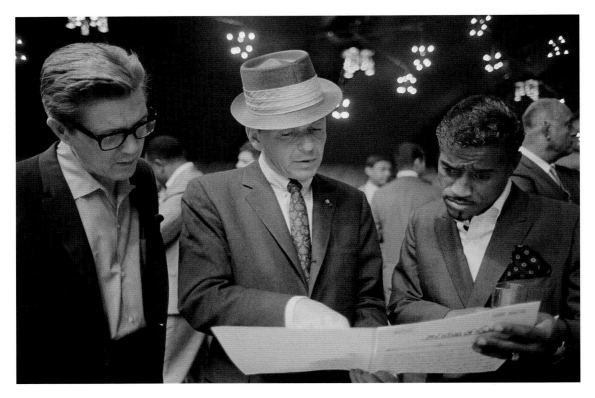

above Sammy Davis Jr., center, and Sinatra rehearsing at
the Kiel Opera House in St. Louis, Missouri on June 20, 1965.
The charity concert was organized for Dismas House, one
of the first halfway houses established for ex-convicts in the
United States. **below** Bill Miller, Sinatra, and Sammy Davis
Jr. peruse the sheet music for 'My Kind Of Town.'

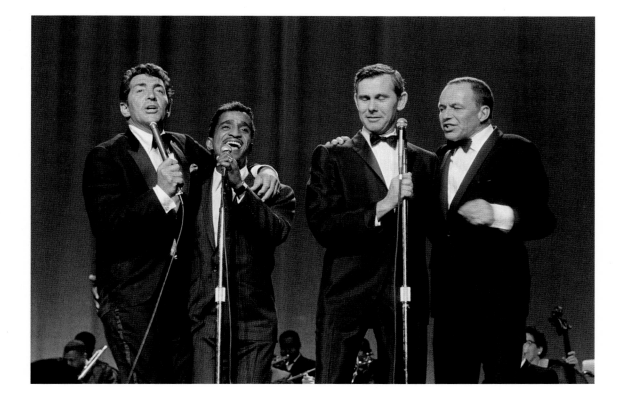

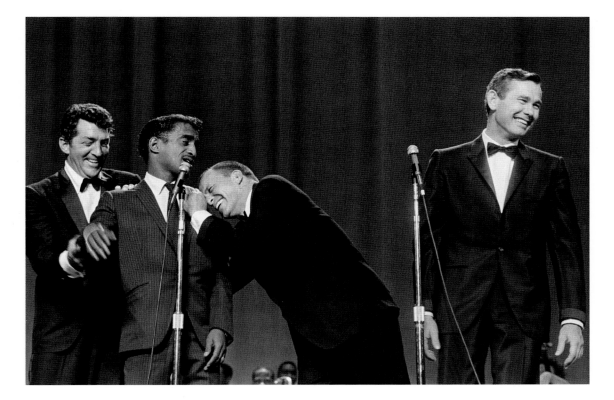

above Dean Martin, Sammy Davis Jr., and Frank Sinatra
perform on stage with American television show host Johnny Carson
as part of the benefit concert in St. Louis, Missouri, June 20, 1965.
The Count Basie Orchestra, under the direction of Quincy Jones
(not pictured) is visible behind them. **overleaf** A promotional shot
from *Marriage On The Rocks* (1965). Dean Martin, Deborah Kerr,
and Nancy Sinatra Jr. also starred in the comedy.

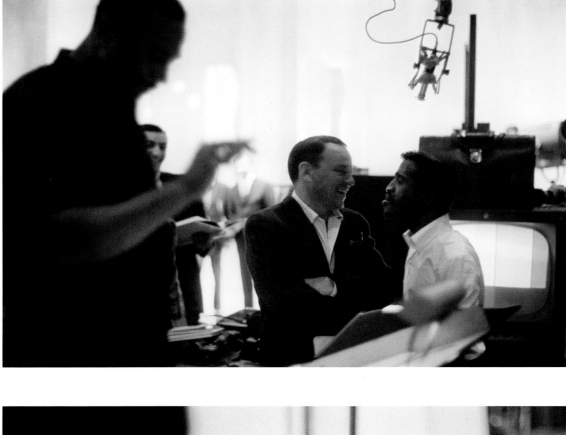

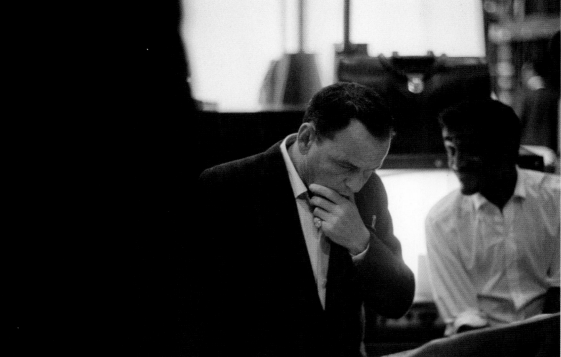

Sinatra and Sammy Davis Jr. at a rehearsal for Sammy's
ABC television special *Sammy And His Friends*, which
was taped in 1965. The show also featured Edie Adams,
Joey Heatherton, and the Count Basie Orchestra.

above Frank Sinatra, Mia Farrow, Tina, and Nancy (behind Tina)
attend a baseball game featuring the Baltimore Orioles *vs.* Los Angeles
Dodgers at Dodger stadium in 1966. Frank and Mia would remain
friends after their divorce. **overleaf** Sinatra accompanied by Count
Basie and his orchestra at the Sands Hotel, Las Vegas, in 1966.

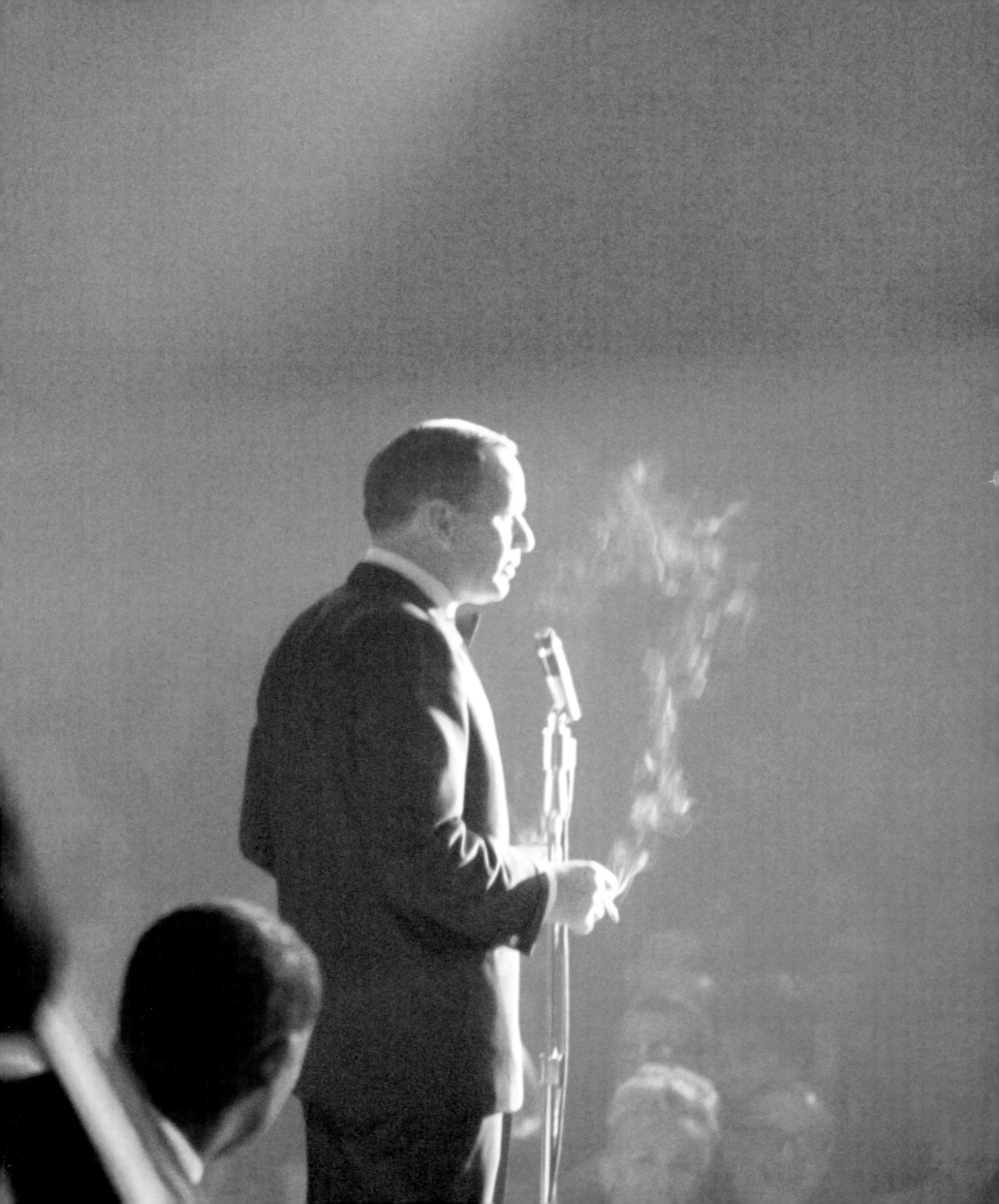

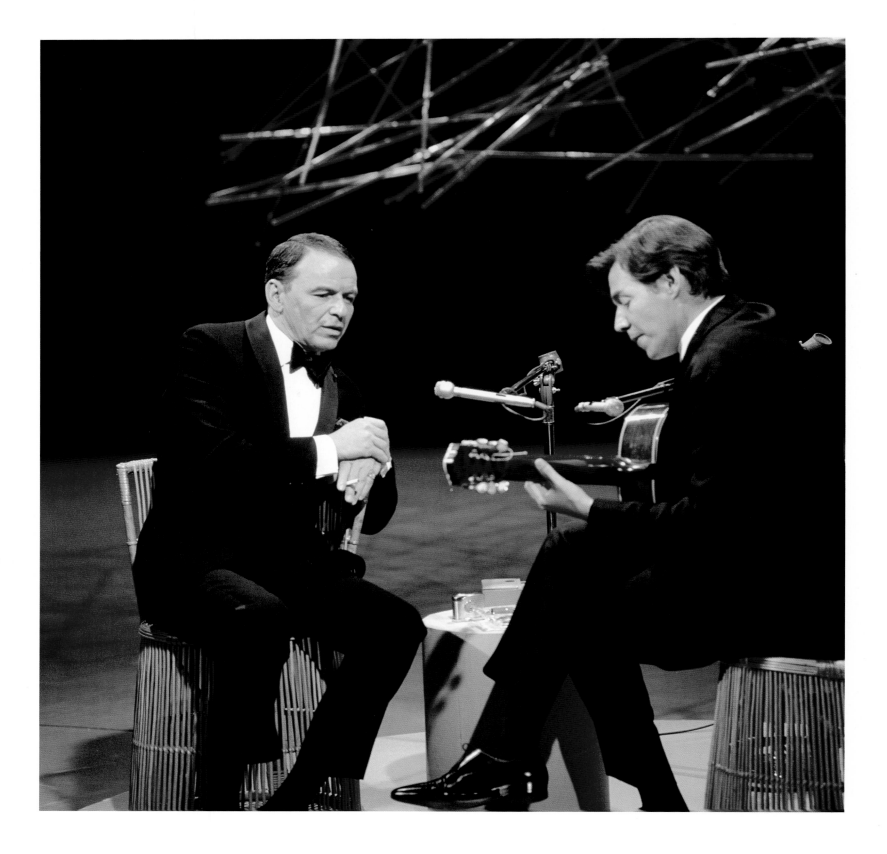

Sinatra, in October 1967, during a television taping with Antonio
Carlos Jobim. "Tom" Jobim was one of the creators of the bossa nova
and composer of 'The Girl From Ipanema' among other songs.
"The first session Frank did with Jobim is truly one of my favorites."
– producer Sonny Burke.

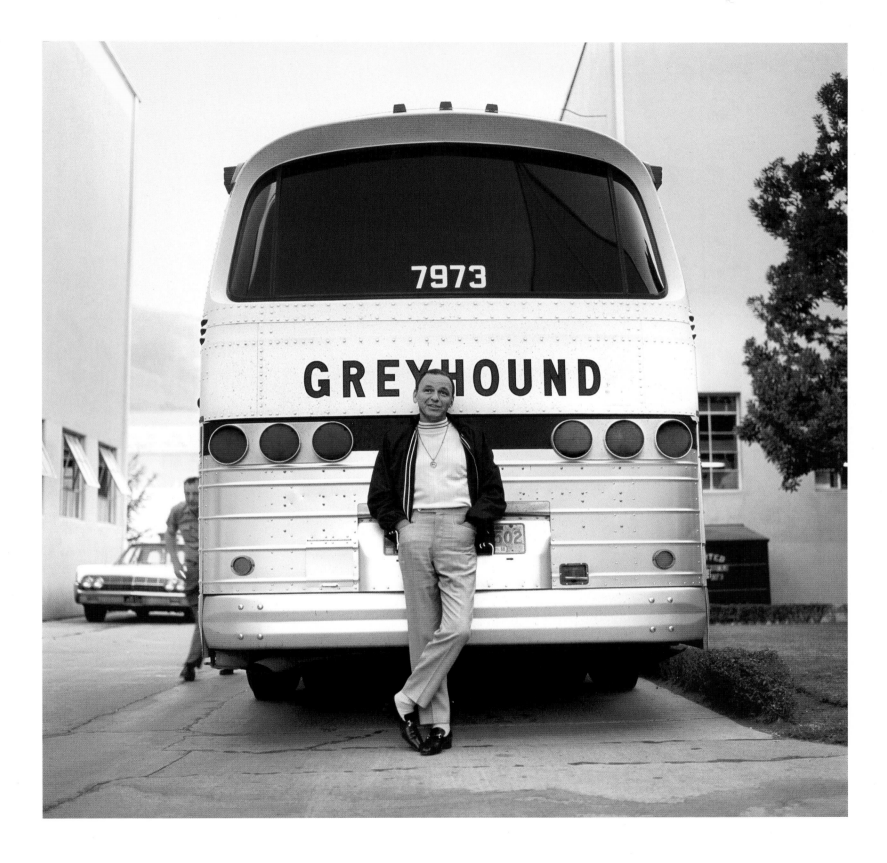

Frank Sinatra on the Warner's backlot for the cover
photograph of the unreleased *Sinatra-Jobim* album. The
album, originally scheduled as Reprise 1028, was reworked,
retitled, and released in 1971 as *Sinatra & Company*.

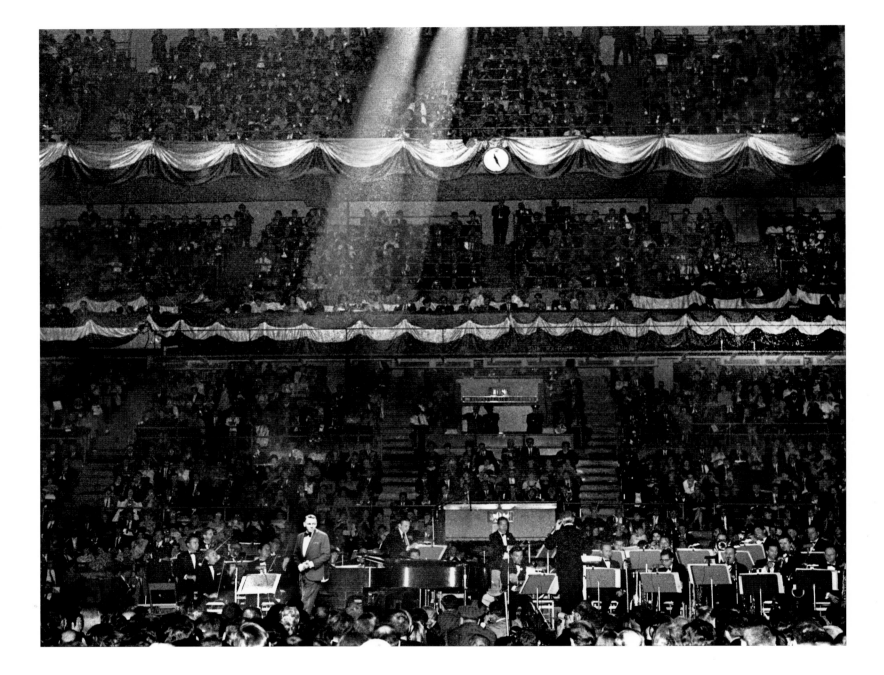

Frank Sinatra singing at Madison Square Garden for the American
Italian Anti-Defamation League, October 19, 1967.

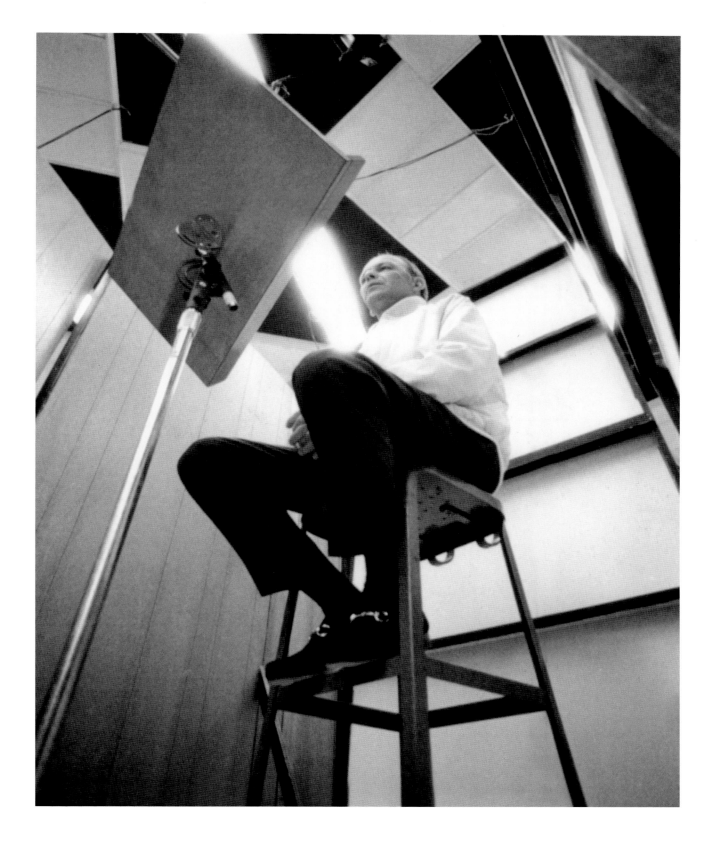

A low camera angle captures Sinatra in a sound booth at a Reprise
recording session in February 1969 for the *My Way* album.

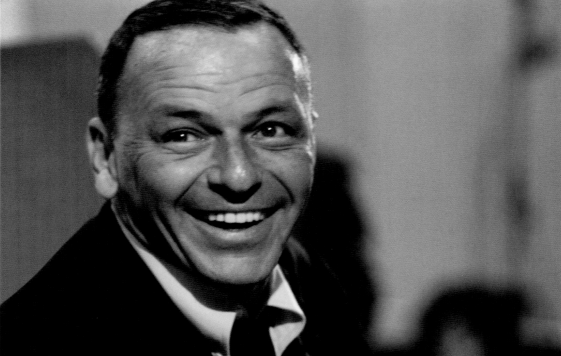

above Sinatra during a mid-1960s Reprise recording session.
"I like recording late at night. The later the better. My voice was not meant
for daytime use," said Sinatra. **opposite** Contact sheet from the set of
Sinatra's television special *A Man And His Music + Ella + Jobim*.
overleaf Ella Fitzgerald poses for publicity still with Sinatra on the set
of *A Man And His Music + Ella + Jobim*. The NBC special was taped in
early October 1967 and aired on November 13, 1967.

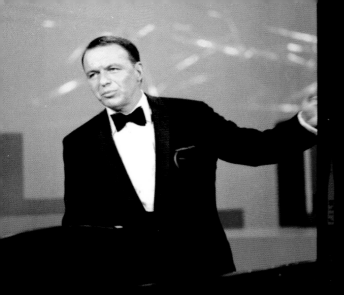

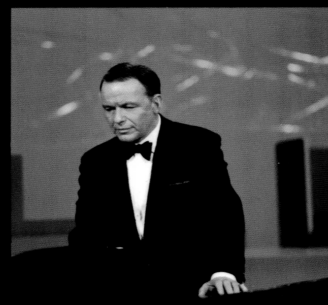
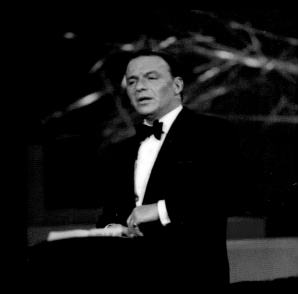
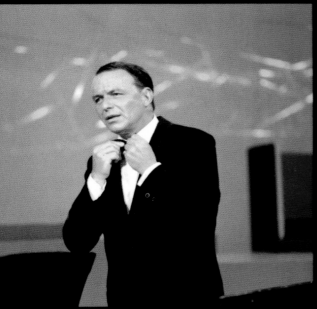
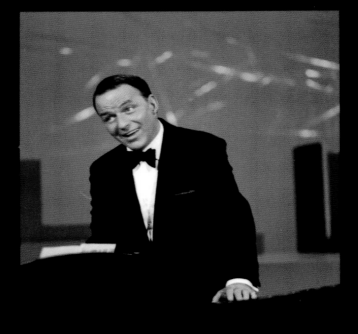
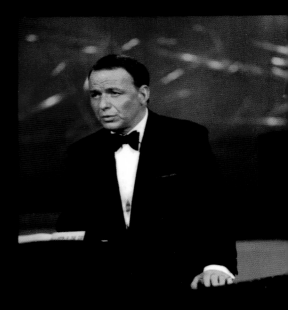
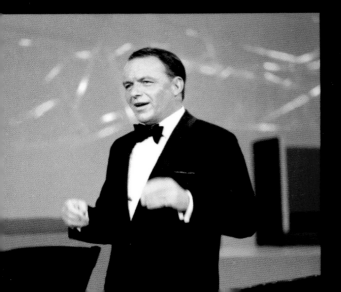
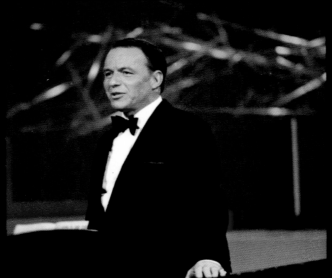
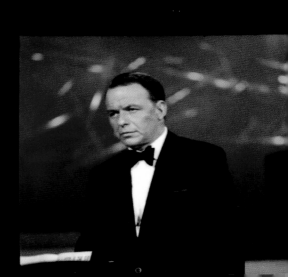

"WE WERE A FAN
OF EACH OTHER.
WHEN FRANK WOULD
GO ON I WOULD
GET A CHAIR, JUST
LIKE I NEVER HEARD
HIM BEFORE, AND
SIT RIGHT OFF
STAGE.... I DIDN'T
WANT ANYONE TO
BOTHER ME BECAUSE
I WANTED TO HEAR
WHAT HE WAS
SINGING."

– *Ella Fitzgerald*

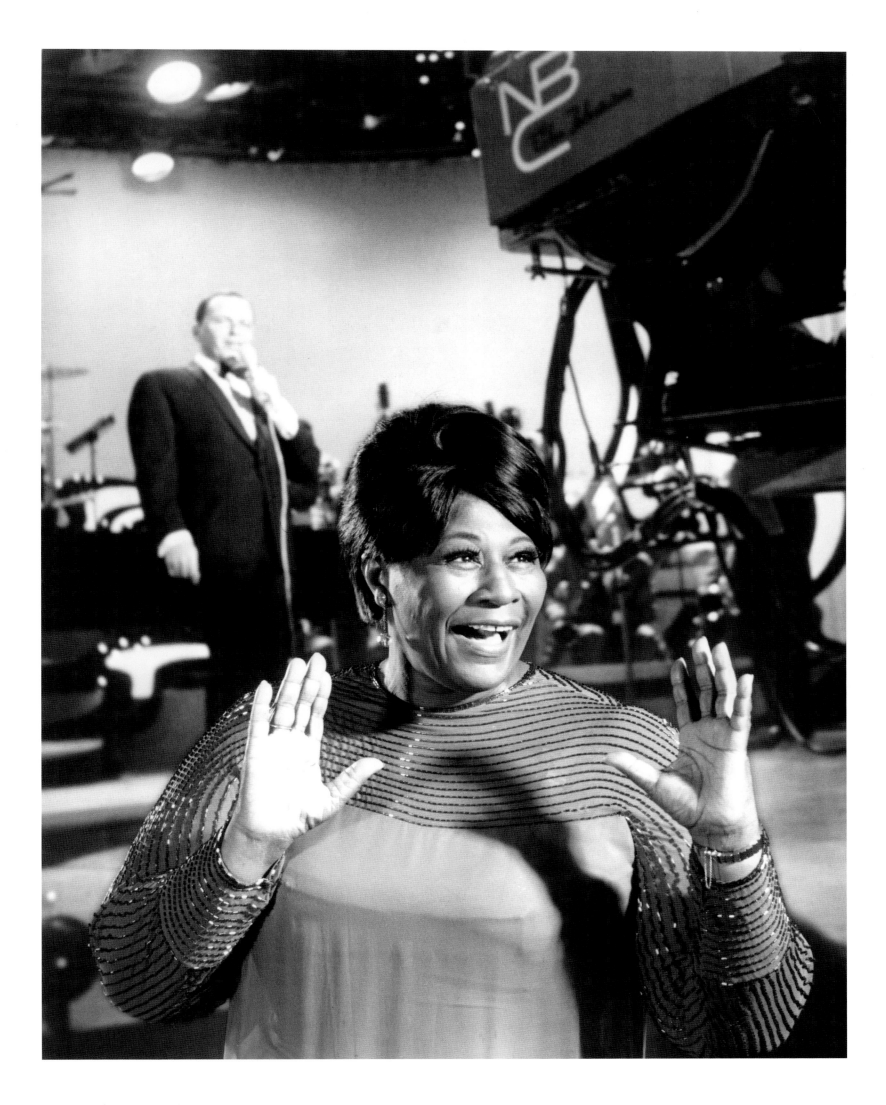

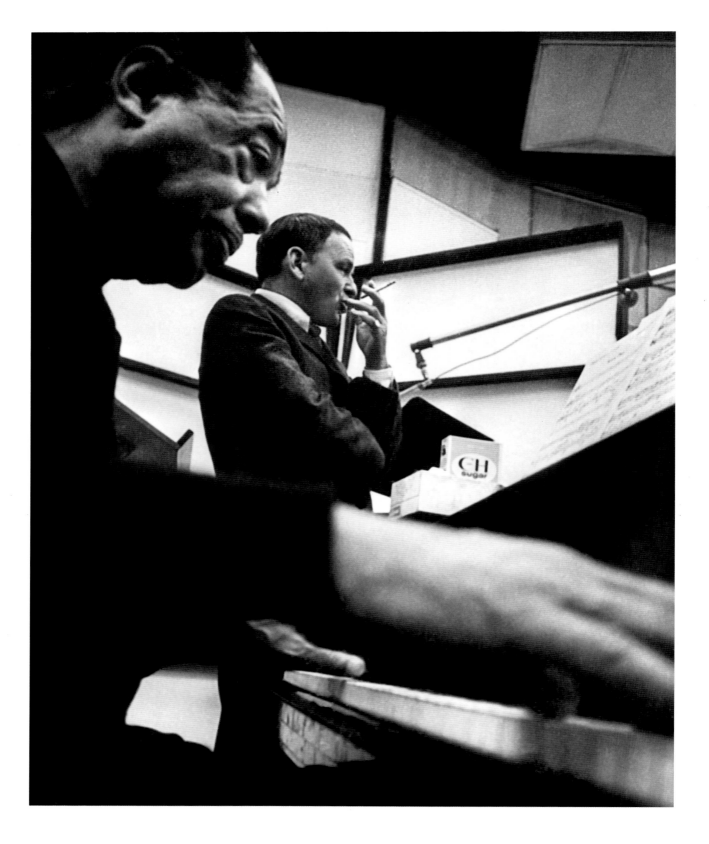

above Sinatra and Duke Ellington recording their album
Francis A. & Edward K. (1968) in December 1967. "With two heavyweights
like Sinatra and Ellington, I was very flattered that they picked me as
a replacement: Billy Strayhorn had just died... Count Basie and Harry
'Sweets' Edison were two of a whole gang of musicians who dropped
by the sessions." – arranger Billy May. **opposite** Sinatra listens intently
to the playback of 'Indian Summer' on December 11, 1967.

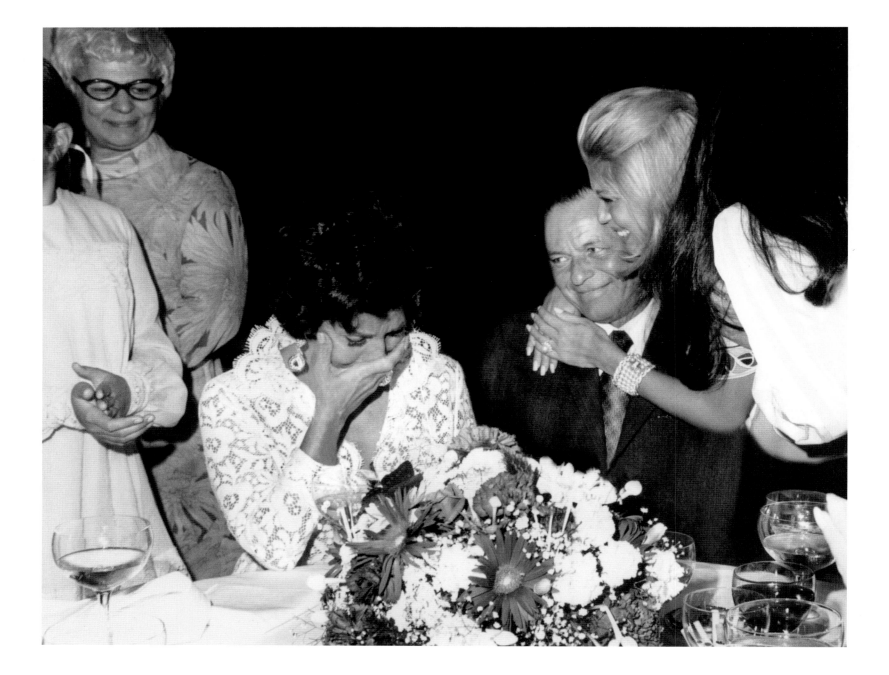

Nancy Sr. is surprised, while Frank, Nancy Jr., and Tina look on.
Sinatra said, "Nancy is probably one of the most noble women
I've ever known.... But I just got restless; suddenly home life was
really not for me any more. It was tough to do because I adored my
children. I wasn't an angel, everybody knew that. She knew that.
But the point is, we never argued. You know, we never had it out.
We always remained close to each other over the years."

In August 1968, Tina and Nancy join their father at a Reprise
recording session for *The Sinatra Family Wish You A Merry
Christmas* (1968). Sinatra sang solo on two tracks, 'Whatever
Happened To Christmas?' and 'The Christmas Waltz.'
Frank Jr. is also featured on the album.

"His reading lyrically is by far better than anyone I have ever heard – it's almost flawless. Also, he has this rare ability to phrase musically without destroying the meaning of the lyric, but at the same time maintaining the flow of the melody. To create this balance is very difficult because the words are not always meant to be read in the same meter as the melody is written in. However, Frank can place the emphasis in exactly the right way so that there is balance, and with him it always works. Also, he is the master of understatement; he can pack enough emotion into one line to the extent that by singing a sad line in a song very, very softly he creates moments of great poignancy and can bring tears to the eyes of his audience. Nothing could inspire me more than to be with this man; nothing can compare with the deep feeling I have for him, both personally and musically."

– *Don Costa*

Sinatra with the arranger/conductor Don Costa at two
different Reprise recording sessions: November 1968 (top)
and February 1969 (bottom).

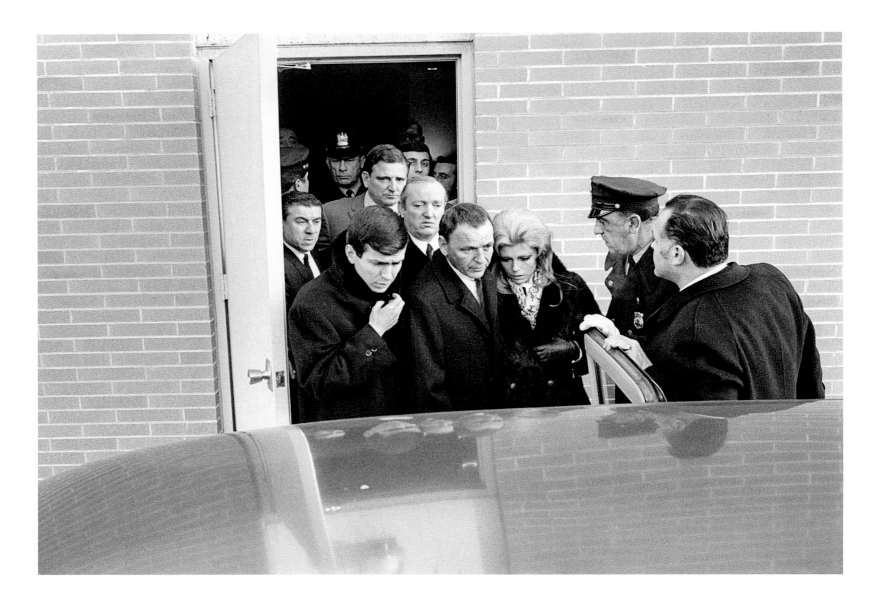

Frank Sinatra, with Frank Jr., Jilly Rizzo, and Nancy Jr., leaving
the Macagna Funeral Home, New Jersey, after attending a wake for his
father, Anthony Martin Sinatra, who died on January 24, 1969.
"My father was a darling man, a quiet man. I adored him. In some ways,
he was the greatest man I ever knew in my life," said Sinatra.

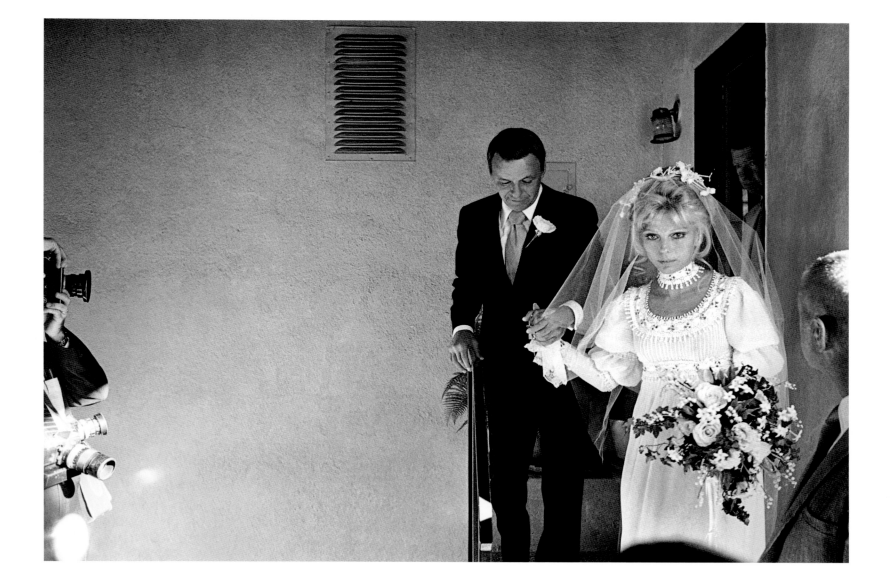

above Sinatra leads his daughter Nancy down the stairs for her
second wedding, to producer and choreographer Hugh Lambert,
on Frank's birthday, December 12, 1970. **overleaf** The luxury interior
of Sinatra's Gulfstream private jet at Gatwick Airport, May 4, 1970.
overleaf opposite Sinatra and friends arriving in London ahead
of his concert dates at the Royal Festival Hall.

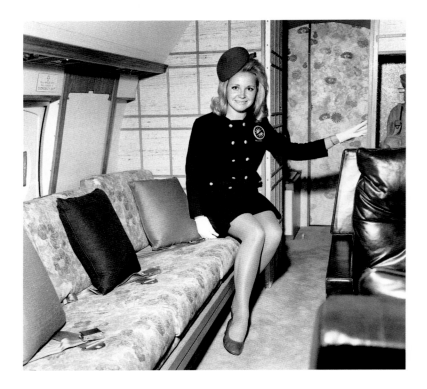

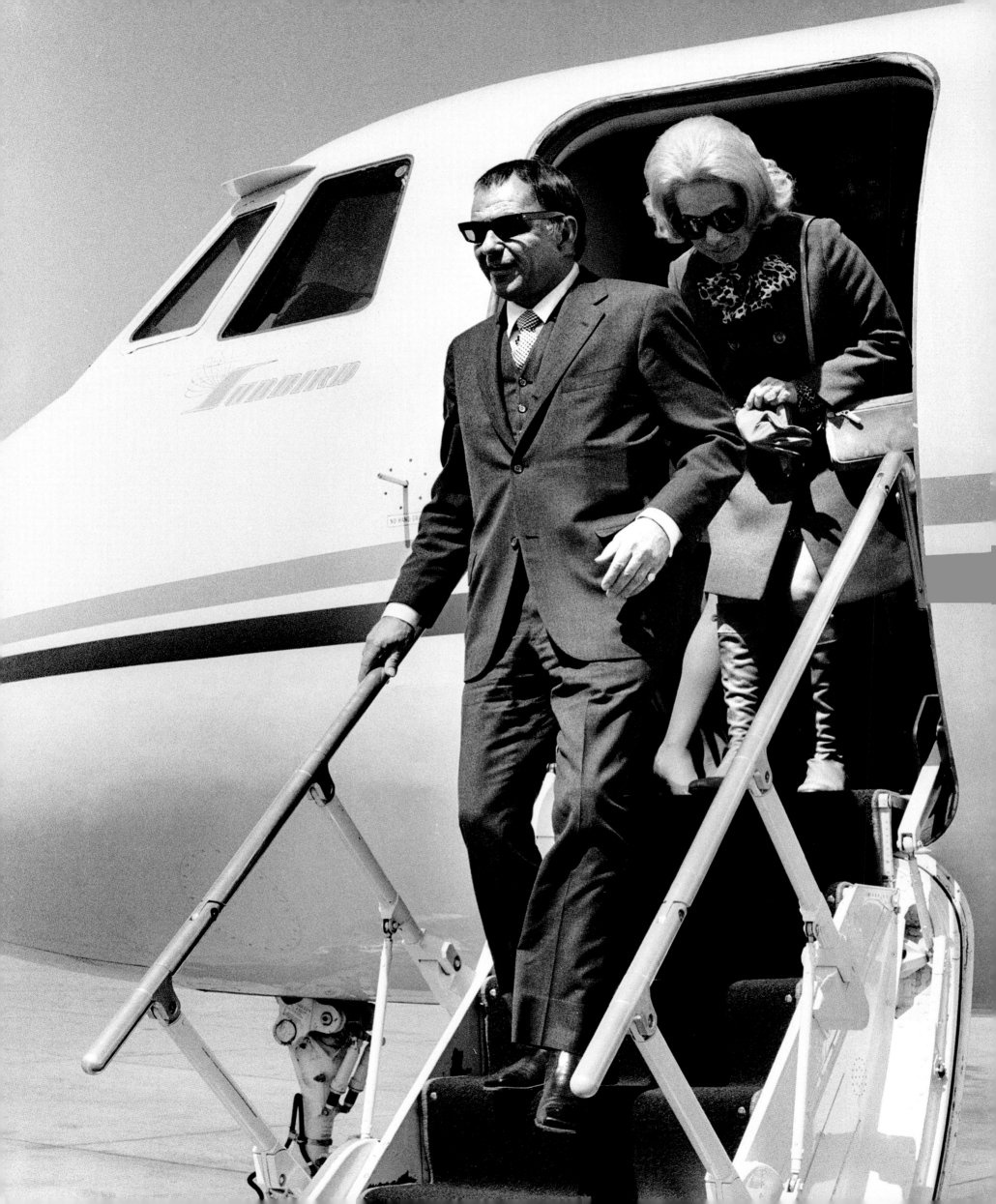

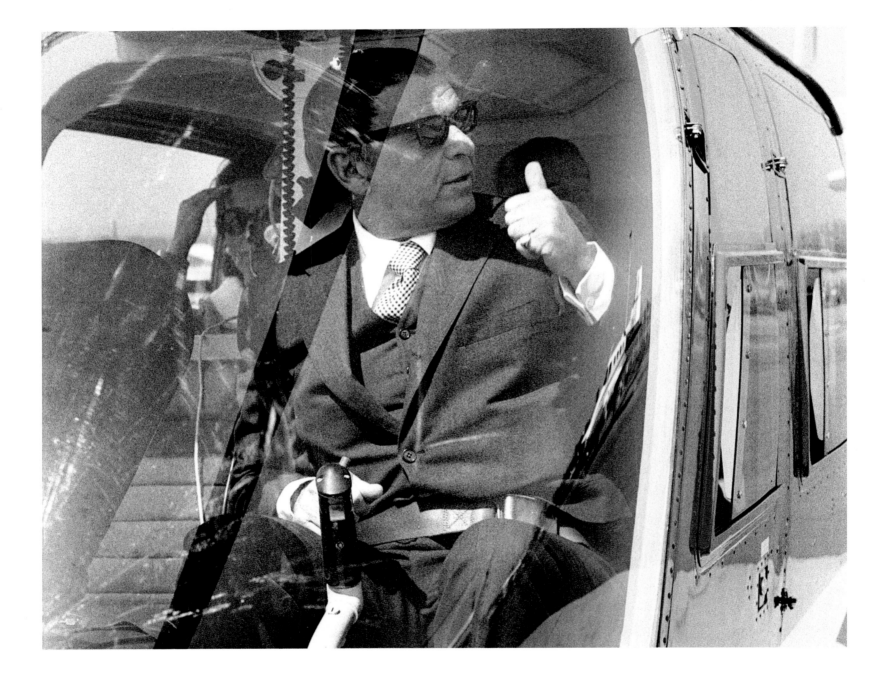

Sinatra takes a Bell Jet Ranger helicopter to Battersea to avoid
the capital's traffic, before his legendary concerts with Count
Basie at the Royal Festival Hall on May 7 and 8, 1970.

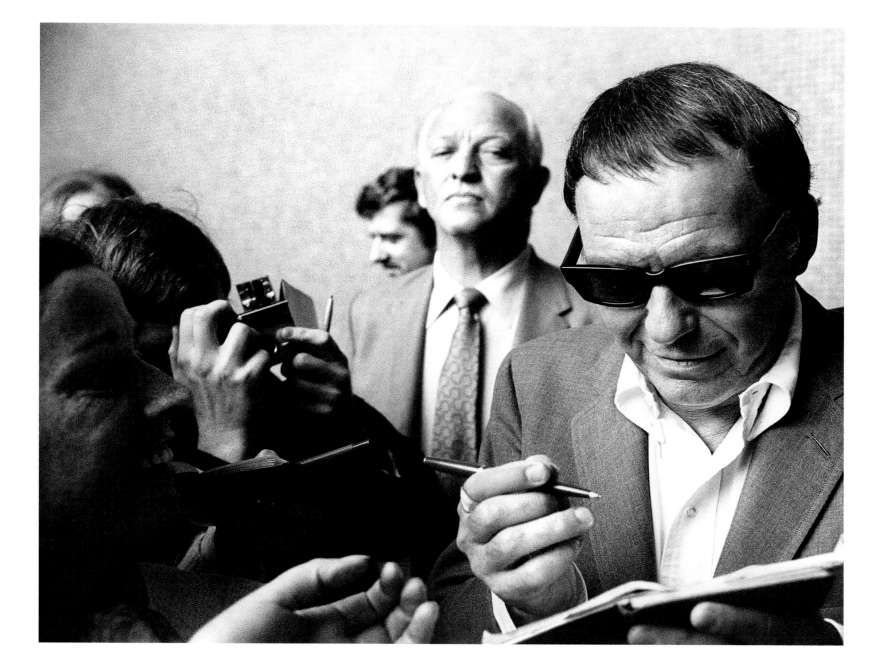

above Sinatra signs autographs outside the Royal Festival Hall, May 1970. Frank was in London to perform two benefit concerts with Count Basie and his orchestra. "I have a funny feeling that those two nights could have been my finest hour really. It went so well; it was so exciting and thrilling." – Sinatra. **overleaf** Sinatra on assignment for *LIFE* at Madison Square Garden for Ali *vs.* Frazier, March 8, 1971, billed as the "Fight of the Century." One of his shots made the cover of the magazine.

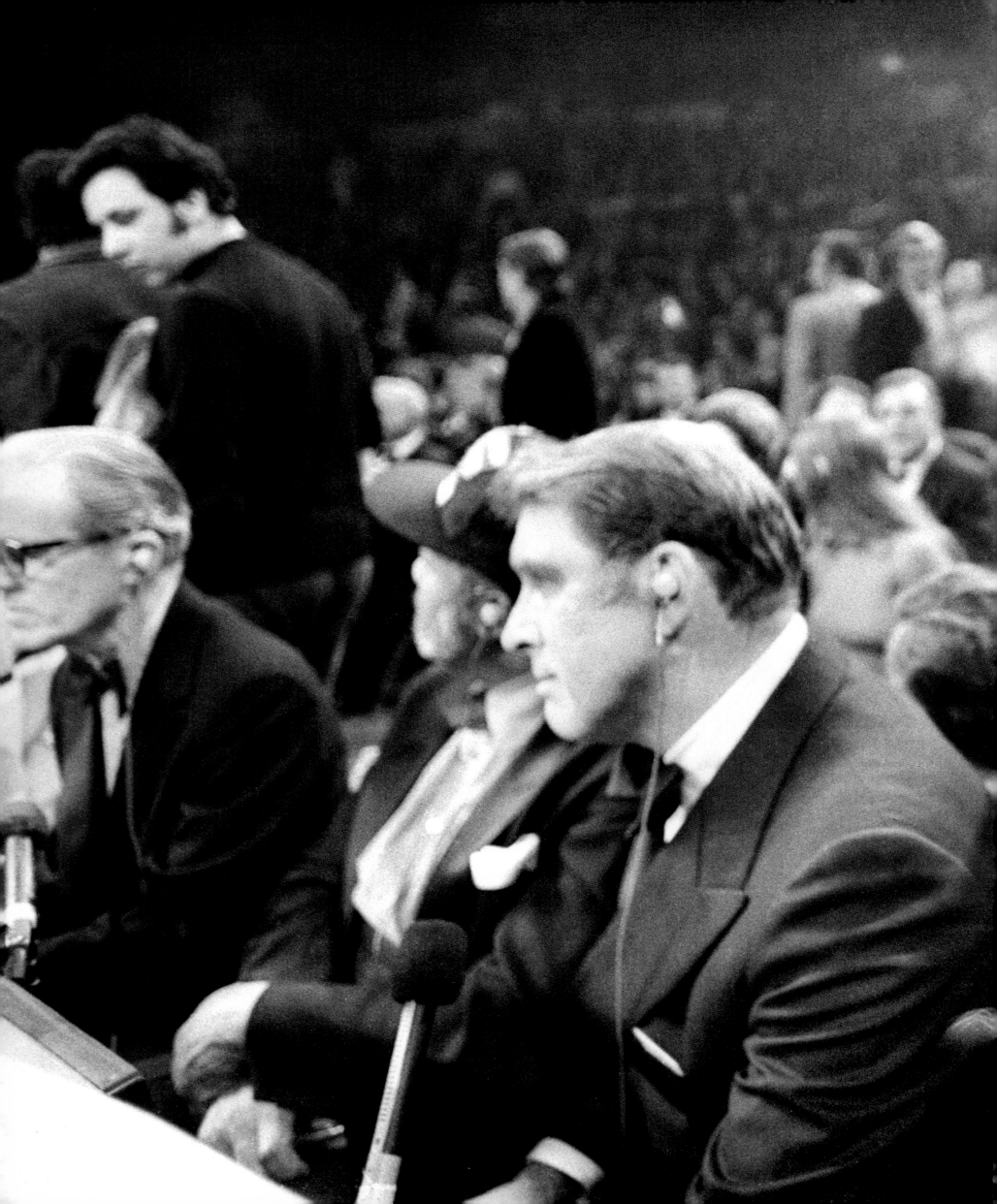

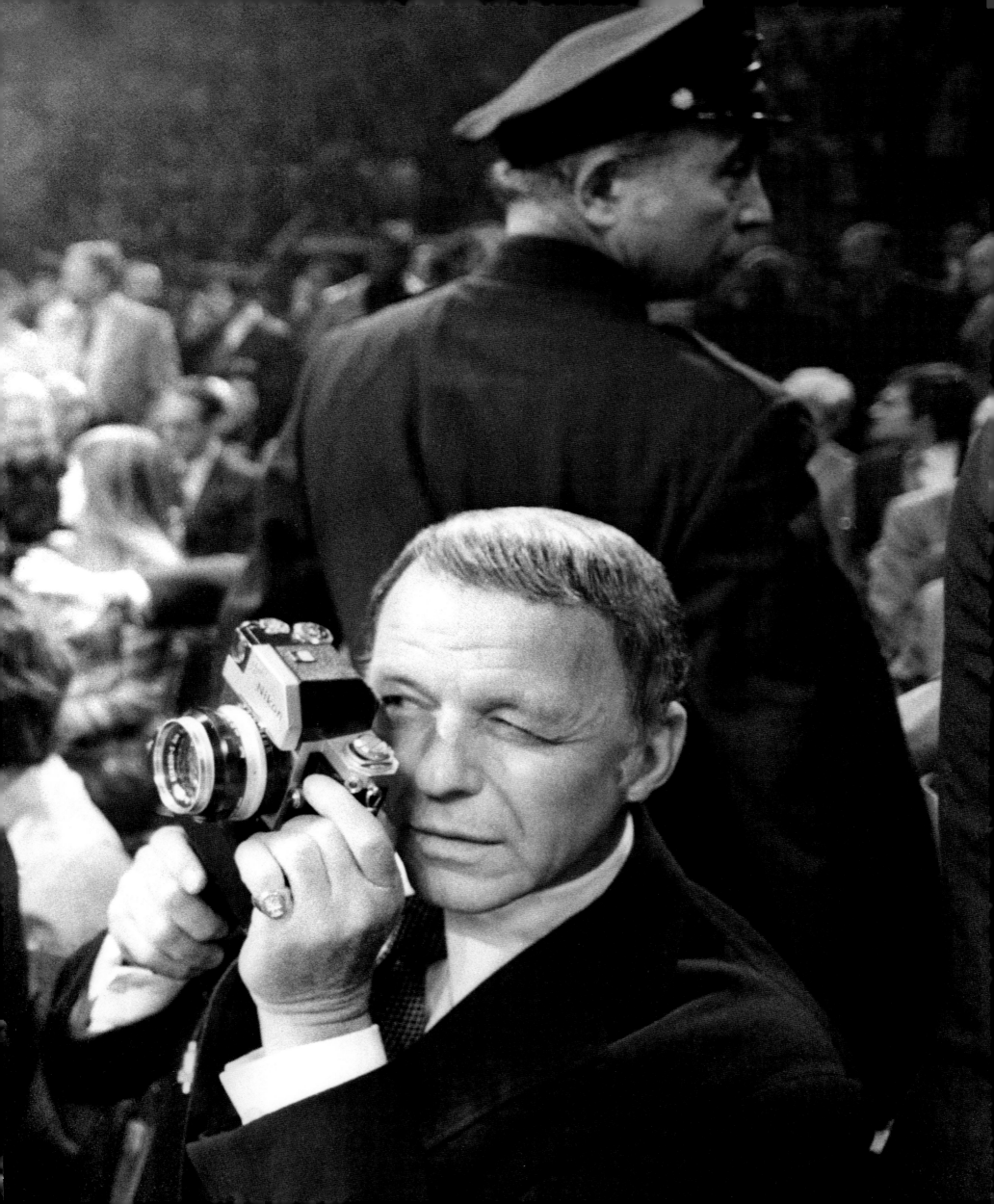

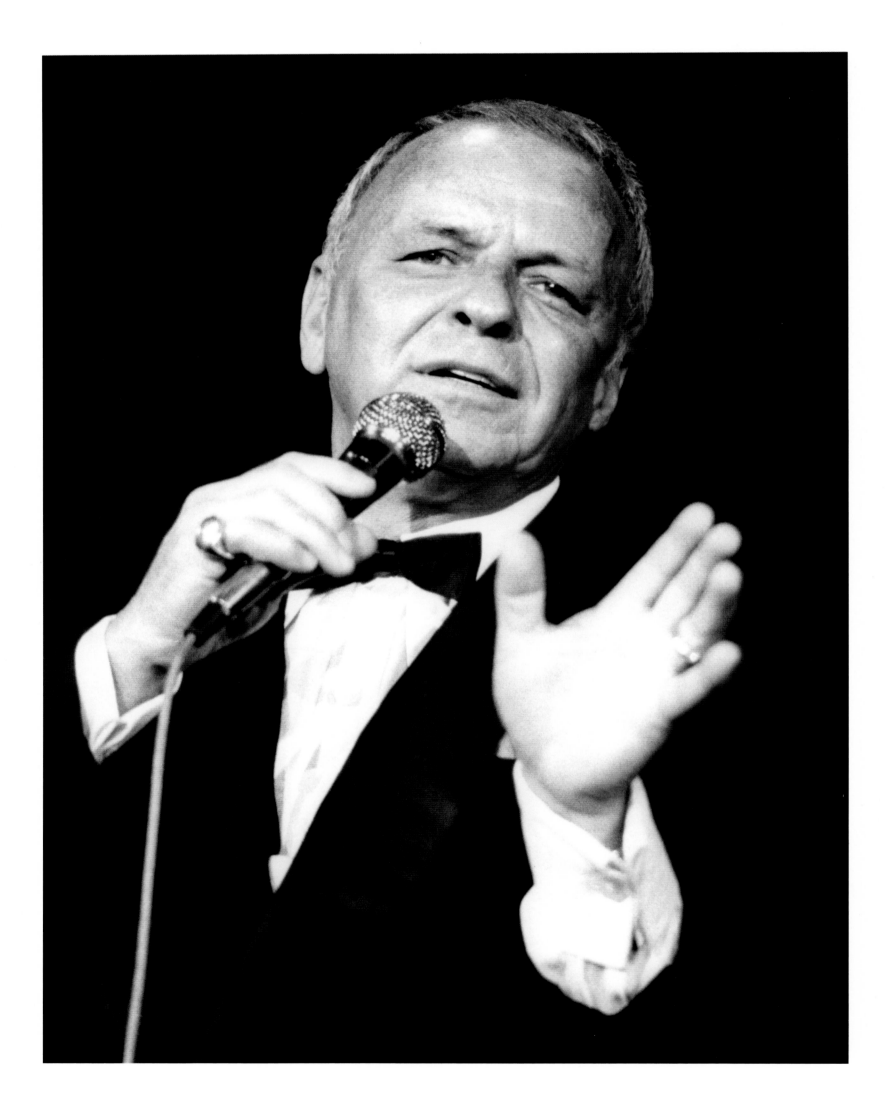

opposite Sinatra performing at Caesars Palace, Las Vegas.

Frank Sinatra first sang in his father's bar as a young child. Since that time, until his retirement in 1971, he had been singing almost on a daily basis. Music is a life force; it is sustaining. To say that music was a vital part of his life would be a gross understatement. Music was his life. It was a fait accompli that Sinatra would sing again.

I was weary, I was tired, and I had been working very hard all those years. I stayed home and caught up on a lot of reading and I just did nothing. I sat down, I played a lot of music, and I saw a lot of my friends, more than I had been able to see them prior to the so-called retirement. But after a year's time, my kids were on my back, we got a lot of fan mail and letters, my gardener thought I was barking at him too much – everyone was wishing I'd go back to work – so I went back to work. I must say, I was slightly embarrassed because I thought they'd [the public] probably feel, what is this, one of these things where he's going to come back, and then go back again, and come back again. It was really not a comeback; I just took a vacation.

Sinatra returned to his career slowly, staging a few benefits and a performance at the White House in 1973 for Giulio Andreotti, the Italian Prime Minister, before planning a new album, television special and resuming his concert and nightclub appearances. Ol' Blue Eyes was indeed back, but it was not an easy transition at first.

After the so-called retirement I was struggling, I was really fighting my way out of the doldrums because when I quit, I let everything go, and it all fell down. It's like somebody who lifts weights and they stop it for a while.

I was having a tough time vocally trying to do what I wanted to do. But I was working very hard at it. It was a matter of consistency; you have to do it every day.

For two decades, from 1974 until the end of 1994, with few exceptions, Frank Sinatra was out on the road gracing the stages of nightclubs, arenas, concert halls, showrooms or theaters – singing his songs year in, year out, to millions of people. Time marches on and has a way of swallowing the past so that things that were once relevant and important are sometimes forgotten; this was not the case with Frank Sinatra and his fans. Audiences worldwide flocked to his concerts and were thrilled to hear and see the legend himself. It was not just his loyal fan base; the current generation also appreciated his talents. Characteristically, Sinatra downplayed his broad and evergreen popularity:

I don't know what it means when people call me a legend. What is a legend? King Arthur was a legend, I'm told. I can't relate to it. People say you are a legend if everybody is talking about you. How do I know who's talking about me? Maybe longevity makes a legend? If you last long enough and are around long enough, you are a legend.

In 1976, Sinatra married Barbara Marx, in what would be his fourth and final marriage.

For the most part, the majority of Sinatra's creative output at this time was devoted to live performances. In 1979, his long time producer Sonny Burke convinced him to embark on an ambitious project called *Trilogy*.

We haven't recorded because of the kind of material that is being done; I don't fit in with that material. We had a meeting and a lot of the guys in the office just said why don't we just do what we do and see what happens.... Trilogy is three records; essentially, the past, present and future.

Sinatra scored a huge hit and established a new closing song for his performances with the 'Theme From New York, New York.'

Sinatra was endlessly feted in these years, and deservedly so. The Kennedy Center Honor for Lifetime Achievement, the Medal of Freedom, and the Congressional Gold Medal, the highest civilian honor awarded by the United States Congress, were just three of hundreds of accolades bestowed upon him. One of the most memorable came in 1983, when Variety Clubs International saluted Sinatra's lifelong contributions to charitable causes with an "All-Star Party," which was also taped as a television special. Stars such as Cary Grant, Jimmy Stewart, Vic Damone, Carol Burnett, and Julio Iglesias attended to honor both Sinatra's music and his humanitarian work.

The highlight of the evening was a moving speech by Richard Burton:

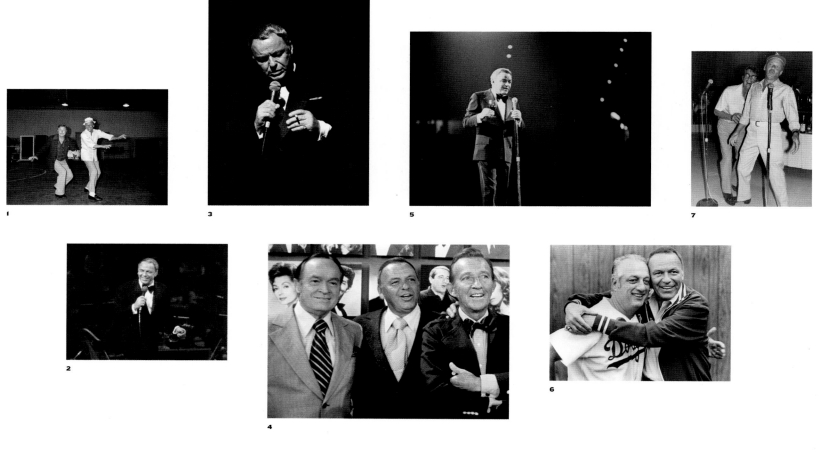

1. Frank Sinatra and Gene Kelly rehearsing at MGM for the television show *Ol' Blue Eyes Is Back*, 1973. 2. Sinatra at *The Main Event*, 1974. 3. Sinatra at the Uris Theatre, New York, 1975. 4. Sinatra with Bob Hope and Bing Crosby at NBC in 1975. 5. Frank Sinatra on stage, 1975. 6. Sinatra with LA Dodgers manager Tommy Lasorda on Opening Day, 1977. 7. Frank Sinatra and Dean Martin rehearsing in the 1970s.

I have never sung a song with Frank Sinatra. Never acted with him, shared his stage nor been a member of an orchestra under his baton. Nor was I there when he was presented with either of his Oscars, his Emmy or any of his nine Grammys, on those memorable occasions.

We are, however, old friends of some thirty years and I have risen to my feet to applaud his blazing artistry at numerous charity performances raising countless millions for the victims of the world, all over the world. This is a party for him as friend, not a tribute to him as a humanitarian, at his own insistence, I might add, but I am compelled to say, out loud, here and now, what a few of us have known for years. Fully aware it is like he hears least and discourages most.

Some several years ago I looked at a call sheet of a film I was doing and to my astonishment saw that a two-day small part was being played by one of the greatest stars of my time; I had long thought him retired. I asked him how things were going and he said that it was difficult as he couldn't get work. I asked if there was anything I could do to help and he said, "No, no, you-know-who is taking care of me."

Frank is a giant among the givers of the world, he stands among the tallest, and he has more than paid rent for the space he occupies on this planet. Forged, as he is, from legendary loyalty and compassion carefully hidden, hidden because he has so ordered it. Other than himself, there is no one who knows of the magnitude of his generosity. He has chosen to be the sole, anonymous keeper of that knowledge. Mr. Anonymous you have asked to be, Mr. Anonymous you shall be called.

At risk of further offending you Frank, I appear as the herald of grateful multitudes who have opened those unexpected envelopes special-delivering answers to their prayers, those awakened by late-night phone calls which remedied their problems only on condition they shared your covenant of secrecy, those who were surprised by signed checks with amounts not filled in, those performers down on their luck who landed that role they never expected and still don't know whom to thank, and for untold other beneficiaries of the caring and kindness of this splendid man who truly is his brother's keeper.

And they are legion, those whose lives took a turn for the better because this man, a skinny, eighteen-year-old high-school drop out unloading cargo ships by day on the Jersey waterfront and singing at night on a Hoboken corner outside Hillman's Hall. A street corner poet burnt to the bone with the fury of his own ambition. Hoping, hoping desperately someone would notice him. And they did notice you, Maggio. Grazie bene, Blue Eyes. God bless you, Mr. Anonymous.

Although Sinatra's charitable activities were the least publicized aspect of his career, such ventures occupied a tremendous portion of his time throughout his life. His generosity touched the worlds of education, medicine, science, animal, and children's needs, his favorite cause. Despite his formidable schedule, Sinatra always managed to find time to lend his name or talent to help a worthy cause. While his work ethic was legendary, he believed that most entertainers worked harder at benefit concerts than anywhere else. "I don't know why we do, but we do," he once said.

8. Frank Sinatra at The White House, 1984. **9.** Sinatra and Perry Como performing at the White House, 1982. **10.** Sinatra and Peggy Lee, 1988. **11.** Frank Sinatra, Liza Minnelli, and Sammy Davis Jr. during "The Ultimate Event" tour, 1989. **12.** Sinatra at Radio City Music Hall, New York, 1992. **13.** Sinatra clutching a bouquet of flowers handed to him by an admirer following a show at Radio City Music Hall, New York, 1990. **14.** Sinatra at London's Royal Albert Hall with his son Frank Jr., who was the conductor and musical director, in May 1992.

"Maybe we think the people who paid big money to support a charity expect more for their money." During his lifetime, Frank Sinatra raised over one billion dollars for charities across the world.

In 1984, Sinatra once again teamed up with his good friend, arranger/producer/composer Quincy Jones, for the album *L.A. Is My Lady*. It would be close to another decade before he would release another album. In 1993, Frank Sinatra re-signed with his old label Capitol Records and, in the fabled "Studio A" of so many of his classic concept albums, began work on *Duets*. Referred to as "The Recording Event of the Decade," *Duets* was released in November 1993. A dazzling array of global superstars, including Charles Aznavour, Tony Bennett, Bono, Natalie Cole, Julio Iglesias, and Barbra Streisand partnered on songs instantly associated with Ol' Blue Eyes. The first album of its kind started the trend of "superstar" duets and remains the highest selling duets album in global history. Even after more than fifty years of recording, Sinatra continued to blaze a trail and cut across all musical genres. The success of *Duets* and *Duets II* were unprecedented for an artist of Sinatra's age in a musical landscape that was littered with rock, rap, grunge, and hip-hop.

During the final decade of his touring, the fragility of Sinatra's voice in "saloon" songs such as 'One For My Baby,' 'Angel Eyes,' and 'Guess I'll Hang My Tears Out To Dry' made his performances all the more powerful and honest. Tony Bennett said it best: "His ability to communicate so strongly has hauled him to the top of the heap...above anyone else.... He has given us a legacy to aspire to and a standard to live by."

Frank Sinatra stopped performing after a benefit concert at the Marriott Desert Springs Resort on February 25, 1995. His last song that evening was 'The Best Is Yet To Come.' At the end of that year, Sinatra sang in public for the very last time. The occasion was his own spectacular eightieth birthday celebration at the Shrine Auditorium in Los Angeles. Some of those on hand to salute Sinatra included Tony Bennett, Ray Charles, Johnny Depp, Bob Dylan, and Bruce Springsteen.

Even though Sinatra's health had been declining for some time, news of his death shocked the world and the outpouring of love was palpable. Who would have thought when Francis Albert Sinatra was born that eighty-two years later his death would make global headlines, and the world would stop to mourn his passing. Millions of people who had never met him felt that he was a part of their lives and would feel the pain of a personal loss. While the world was changing, Frank Sinatra provided the one musical constant that we could rely on – for six decades. He was simply irreplaceable.

In 1965, asked by Walter Cronkite how he would like to be remembered, Sinatra replied:

I would like to be remembered as a man who brought an innovation to popular singing; a peculiar, unique fashion, that I wish that one of these days somebody would learn to do so it doesn't die where it is. I would like to be remembered as a man who had a wonderful time living his life and who had good friends, a fine family. I don't think I could ask anything more than that.

And neither could we.

233

"MY MOTHER INFLUENCED ME A GREAT DEAL. SHE WAS A SELF-TAUGHT WOMAN, AND VERY BRIGHT, AND HAD GOOD COMMON SENSE...WHATEVER SHE UNDERTOOK, SHE WAS A HARD WORKER."

— *Frank Sinatra*

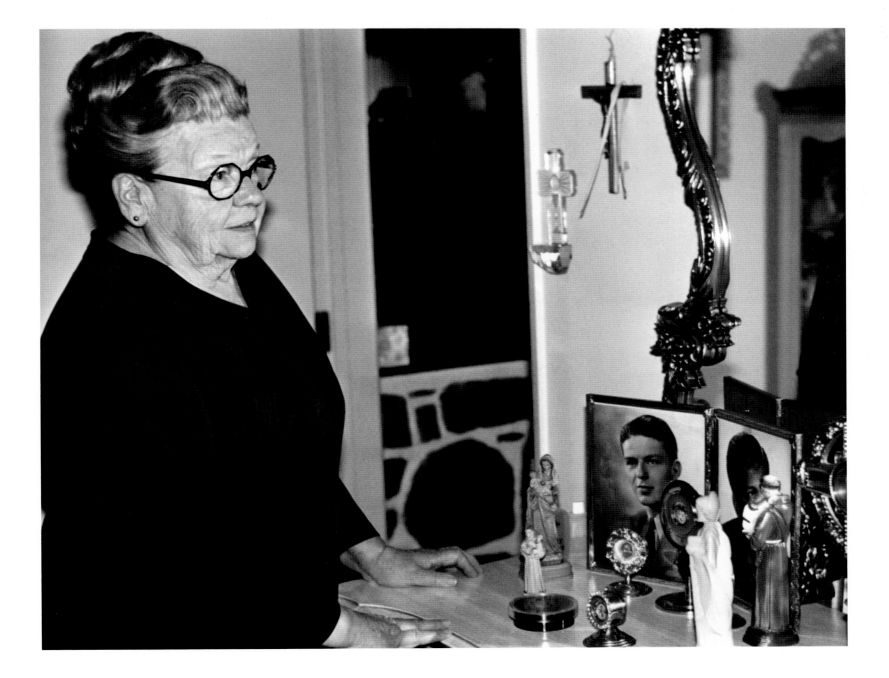

Dolly Sinatra at her home, with framed photographs
of her son and grandson, as well as religious statues.

Sinatra accompanied his album *Ol' Blue Eyes Is
Back* (1973) with an NBC television special in which
he was reunited with Gene Kelly.

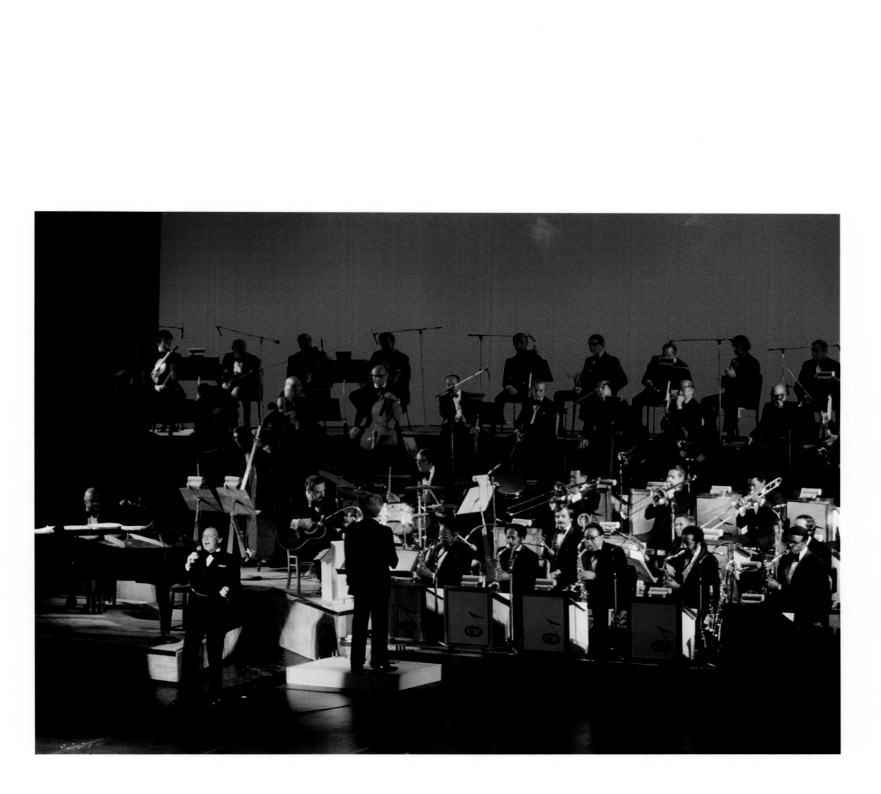

Sinatra at the Uris Theatre on Broadway in 1975.
Bill Miller conducts Count Basie and his orchestra, who
also appeared with Sinatra and Ella Fitzgerald.

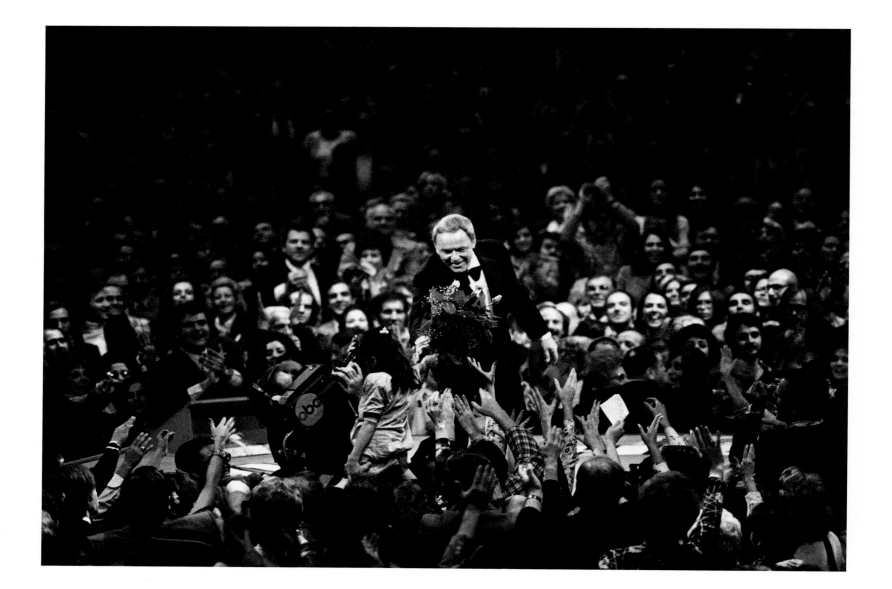

Sinatra is given flowers by his adoring fans at the end of his
performance at Madison Square Garden for the "live" ABC televised
concert special, *The Main Event*, October 13, 1974. Lengendary
sportscaster Howard Cosell introduced the show.

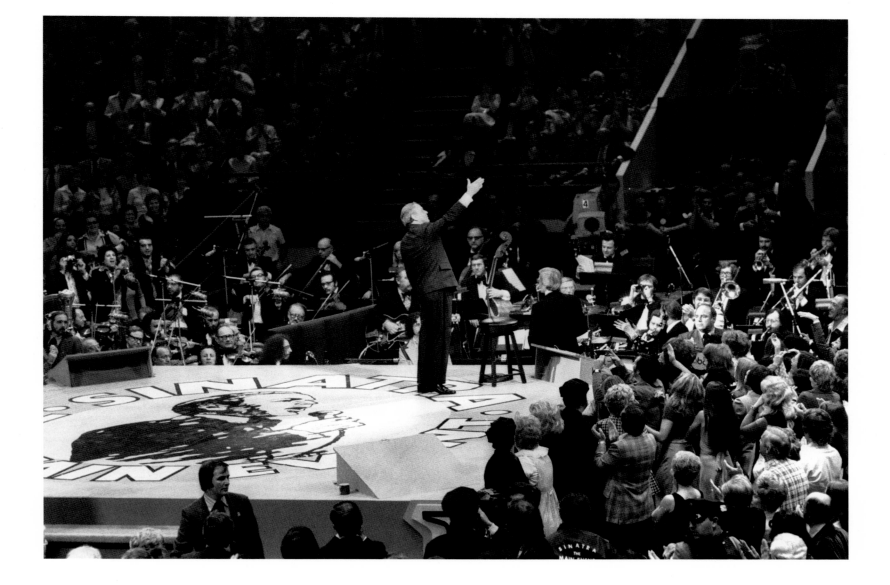

"I've never felt so much love in one room," said Sinatra of
The Main Event. Concert promoter Jerry Weintraub can be seen
on the right preventing fans from rushing the stage.

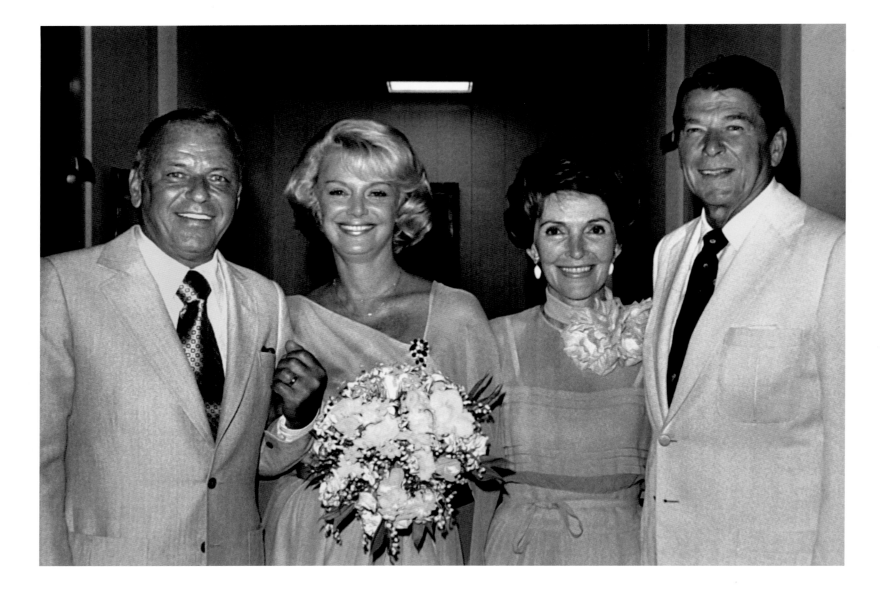

Frank Sinatra, Barbara Marx, and Nancy and Ronald
Reagan at Sunnylands, the estate of Walter Annenberg
in Rancho Mirage, California on Frank and Barbara's
wedding day, July 11, 1976.

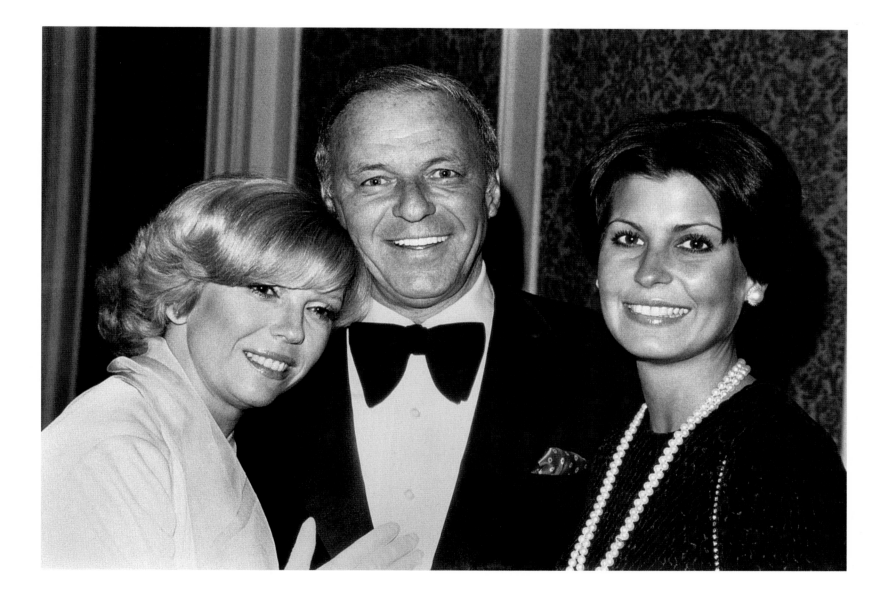

Sinatra with daughters Nancy Jr. and Tina on November 14,
1976. That evening he received the Scopus Award from the
American Friends of the Hebrew University of Israel.

242

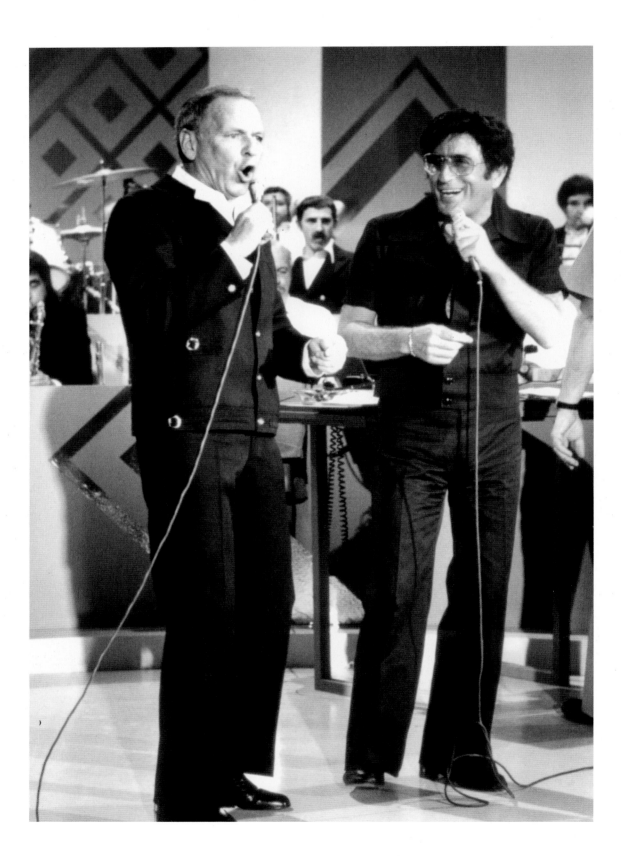

above Frank Sinatra and Tony Bennett during a rehearsal
for the television special *Sinatra And Friends*. The show aired
in April 1977. **overleaf** Sinatra on stage in the late 70s,
photographed by trumpeter Charles Turner.

"YOU CAN JUST FEEL EVERY SYLLABLE AND YOU KNOW HIS SOUL IS IN IT. HIS KIND OF TALENT CANNOT BE DISCOUNTED. AS LONG AS FRANK'S AROUND THERE WILL ALWAYS BE QUALITY IN OUR MUSIC."

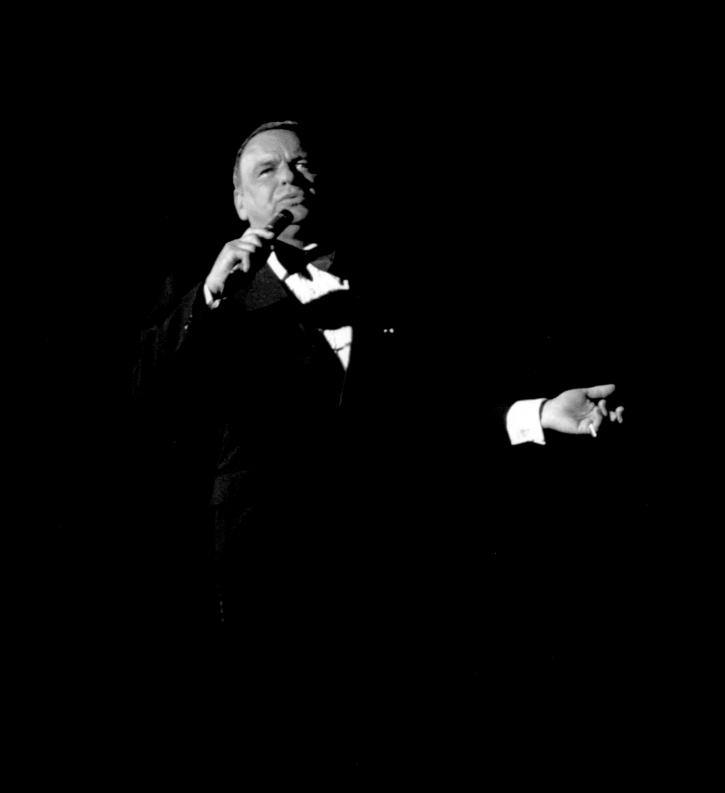

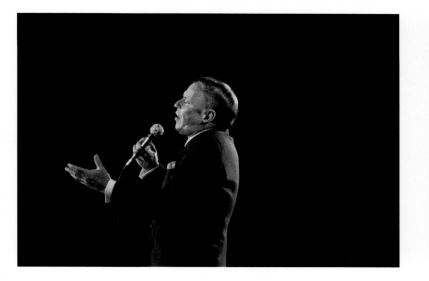
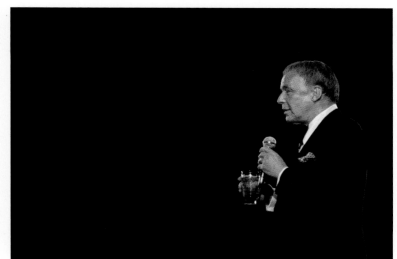
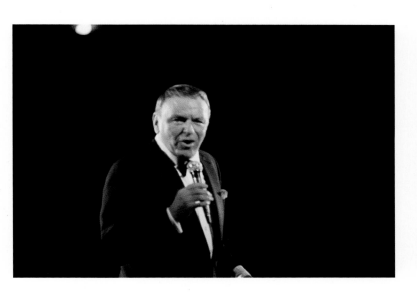
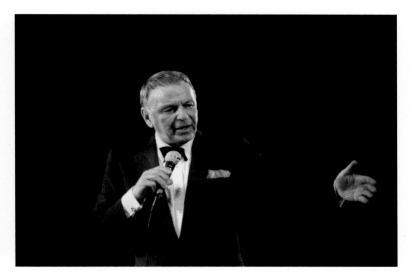
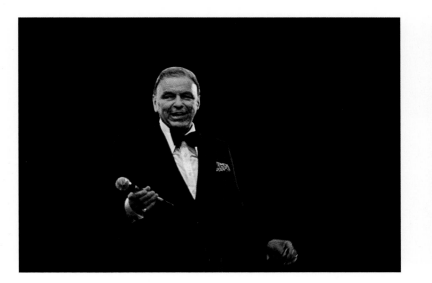
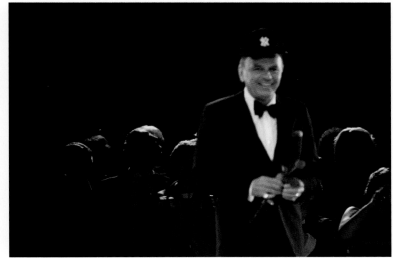

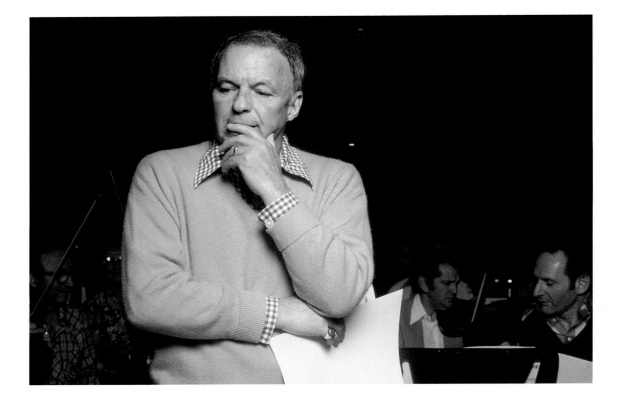

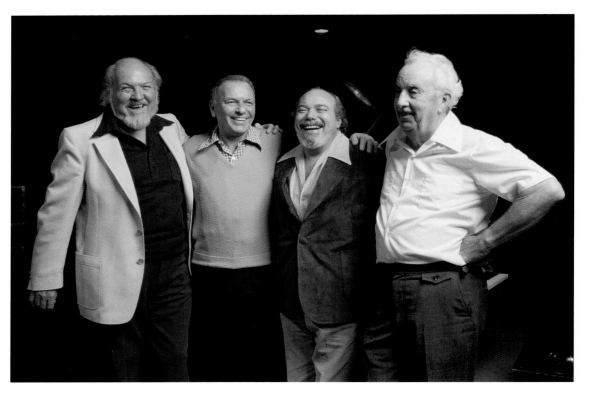

Sinatra during the 1979 *Trilogy* recording sessions with arrangers
(left to right) Billy May (*The Past*), Don Costa (*The Present*), and
Gordon Jenkins (*The Future*). "I tried to vary the arrangers so that
there was a different feel to the albums," said Sinatra.

Frank and Gordon Jenkins during a 1979 session for *The Future*,
the most experimental and final part of *Trilogy* (1980).

RICHARD NIXON

LA CASA PACIFICA
SAN CLEMENTE, CALIFORNIA

May 10, 1979

Dear Mr. Minister,

The purpose of this note is to urge your favorable
consideration of the proposal of Mr. Frank Sinatra
to appear in concerts in China.

There is no performing artist in America who has a
more enthusiastic or broad-based appeal. Television
coverage of his appearance in China would have a
dramatic effect in building better understanding
and support for China in the U.S. -- particularly
among working and middle class Americans who make
up a majority of our population.

I can vouch not only for his superb artistic ability
but also for the fact that he has been and is an
enthusiastic supporter of the new China-American
relationship which I helped to initiate in 1972.

Mrs. Nixon and I often speak of those occasions
when you and your wife honored us by visiting our
home and by acting as our hosts when we visited
China in 1976. She joins me in sending our warm
regards. We look forward to the day when we meet
again.

Sincerely,

Richard Nixon

His Excellency Huang Zhen
Minister of Culture
People's Republic of China
Peking
CHINA

Letter from President Richard Nixon, dated May 10, 1979, to
the Chinese Minister of Culture supporting Frank's proposal
to tour in China. It was never to be.

Sinatra at a rehearsal for his concert at the foot of the great pyramids
in Giza, Egypt. The September 27, 1979 concert was a benefit for
the Faith and Hope Rehabilitation Center, a charity for sick children
favored by President and Mrs. Anwar Sadat.

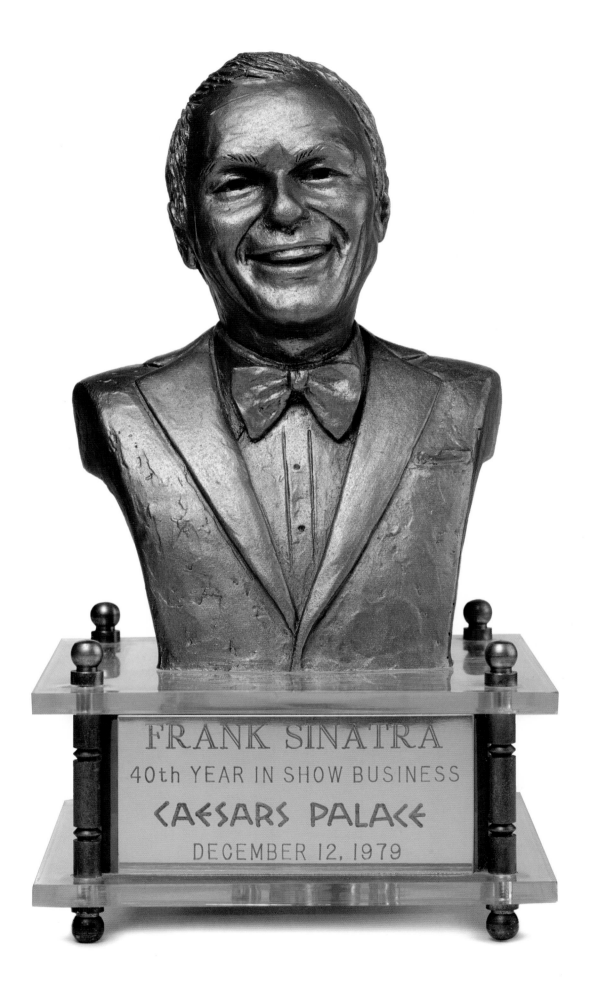

above Program for Sinatra's third "Valentine Love-In," one of a series of benefits held in the 1980s to raise money for the Desert Hospital, Palm Springs, California. **opposite** Music box, which plays 'My Way,' given to special guests to commemorate Frank's fortieth year in show business and his 64th birthday. At the event, held at Caesars Palace on December 12, 1979, "the noblest Roman of them all" was awarded the Grammy Trustees Award.

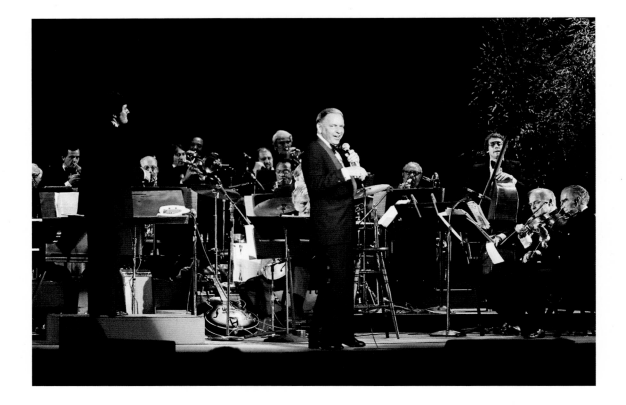

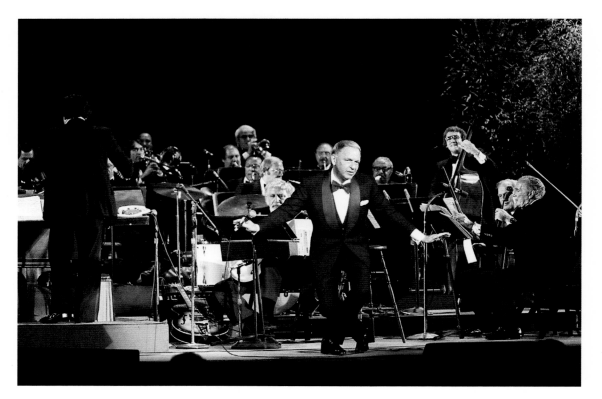

above Sinatra on stage at the Universal Amphitheater in
Los Angeles, July 1980. **overleaf** Frank acknowledging the
orchestra in one of a series of concerts at London's
Royal Albert Hall, September 1980.

"I THINK IT'S BECAUSE I GET AN AUDIENCE INVOLVED, PERSONALLY INVOLVED, IN A SONG, BECAUSE I'M INVOLVED MYSELF. IT'S NOT SOMETHING I DO DELIBERATELY. I CAN'T HELP MYSELF."

– Frank Sinatra

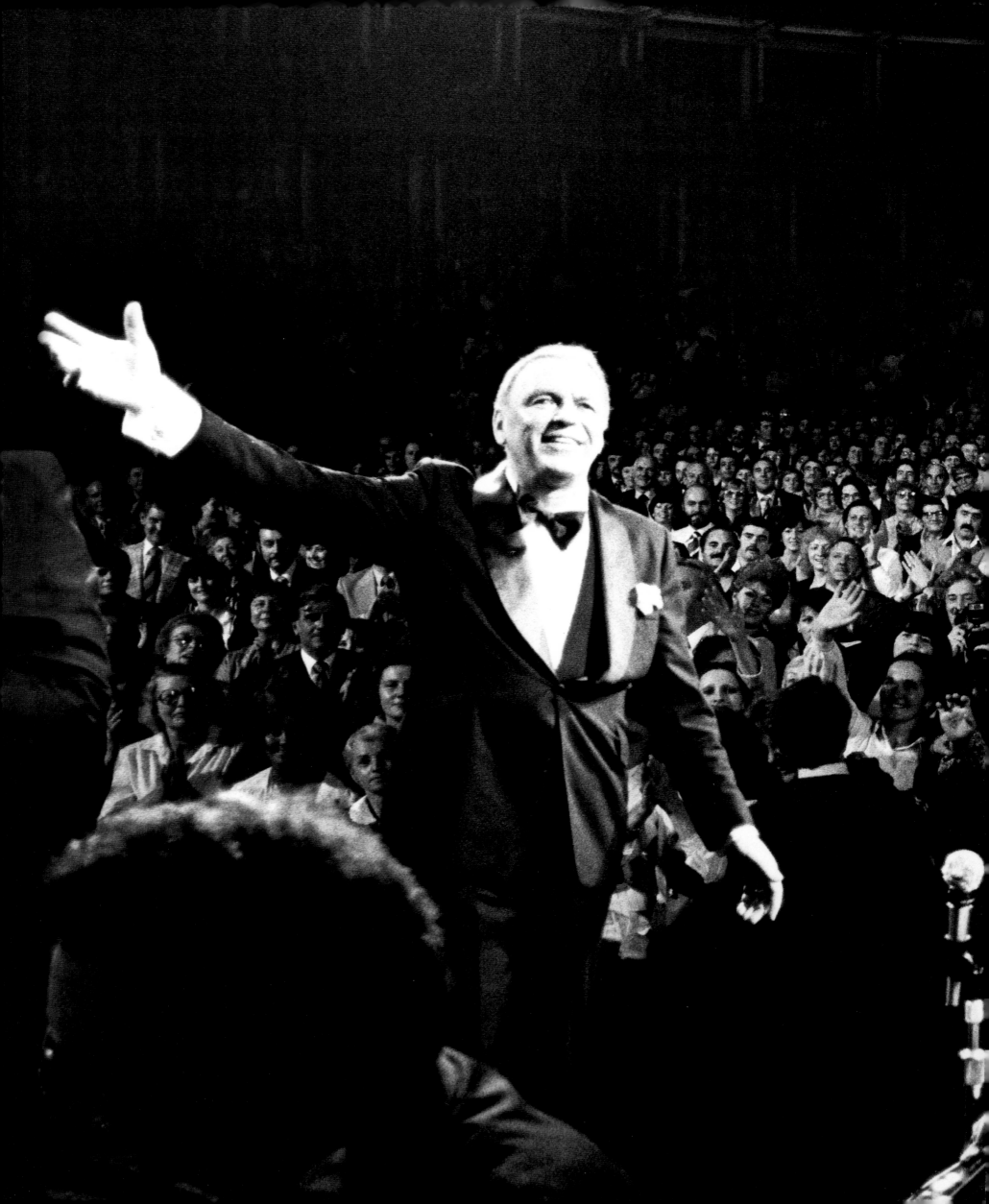

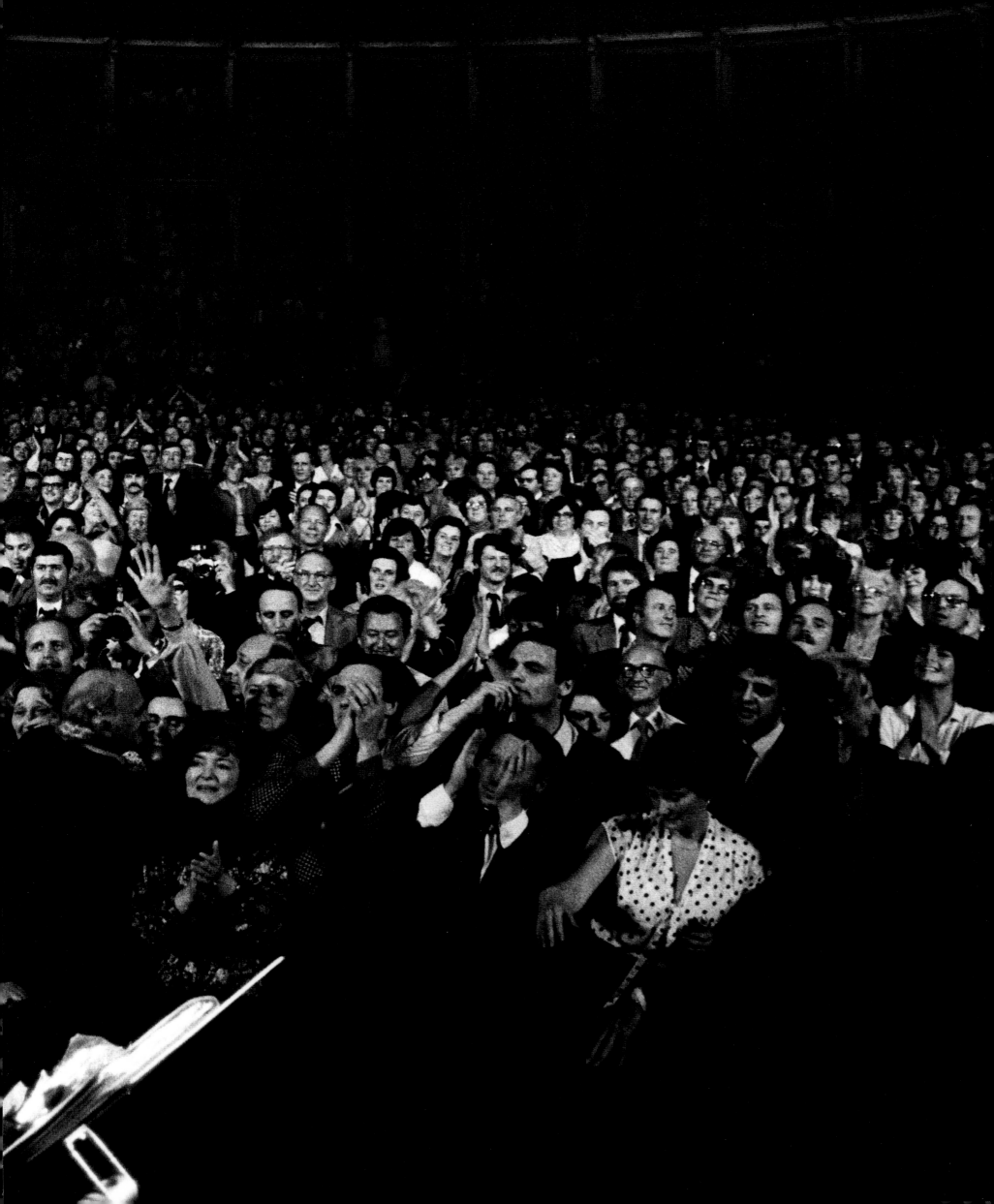

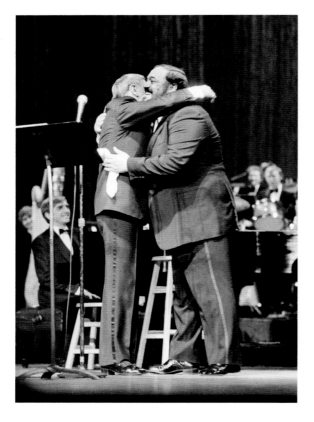

" I said to Mr. Pavarotti
once...a marvelous man
and a great artist...I said
to him 'Maestro, I'm having
trouble closing out a note
so that it's almost as thin
as a butter knife...finish it
out quietly like that.' I said,
'I have trouble doing that.
What do you think I should
do?' He said, 'Justa close
up your mouth.' That's all he
said, and I fell on the floor.
I thought he was gonna give
me a dissertation. "

— Frank Sinatra

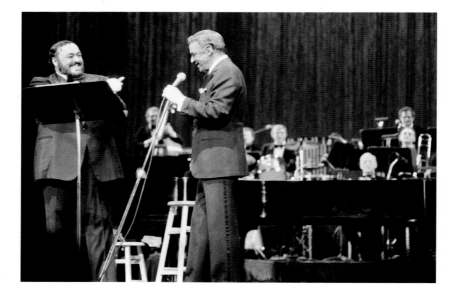

Frank Sinatra and Luciano Pavarotti performing on
stage at Radio City Music Hall, New York, January 24, 1982,
in aid of the Memorial Sloan Kettering Cancer Center.

"I KNOW THAT MY KNOWLEDGE OF SINGING HAS GROWN AND MY VOICE HAS MATURED, WHICH IS WHAT HAPPENS WHEN YOU GET A LITTLE OLDER. IT GETS MORE SETTLED AND IT GETS A LITTLE MORE ROUND AND WARM. THAT HAPPENS WITH EVERYBODY WHO SINGS, ESPECIALLY BARITONES."

– *Frank Sinatra*

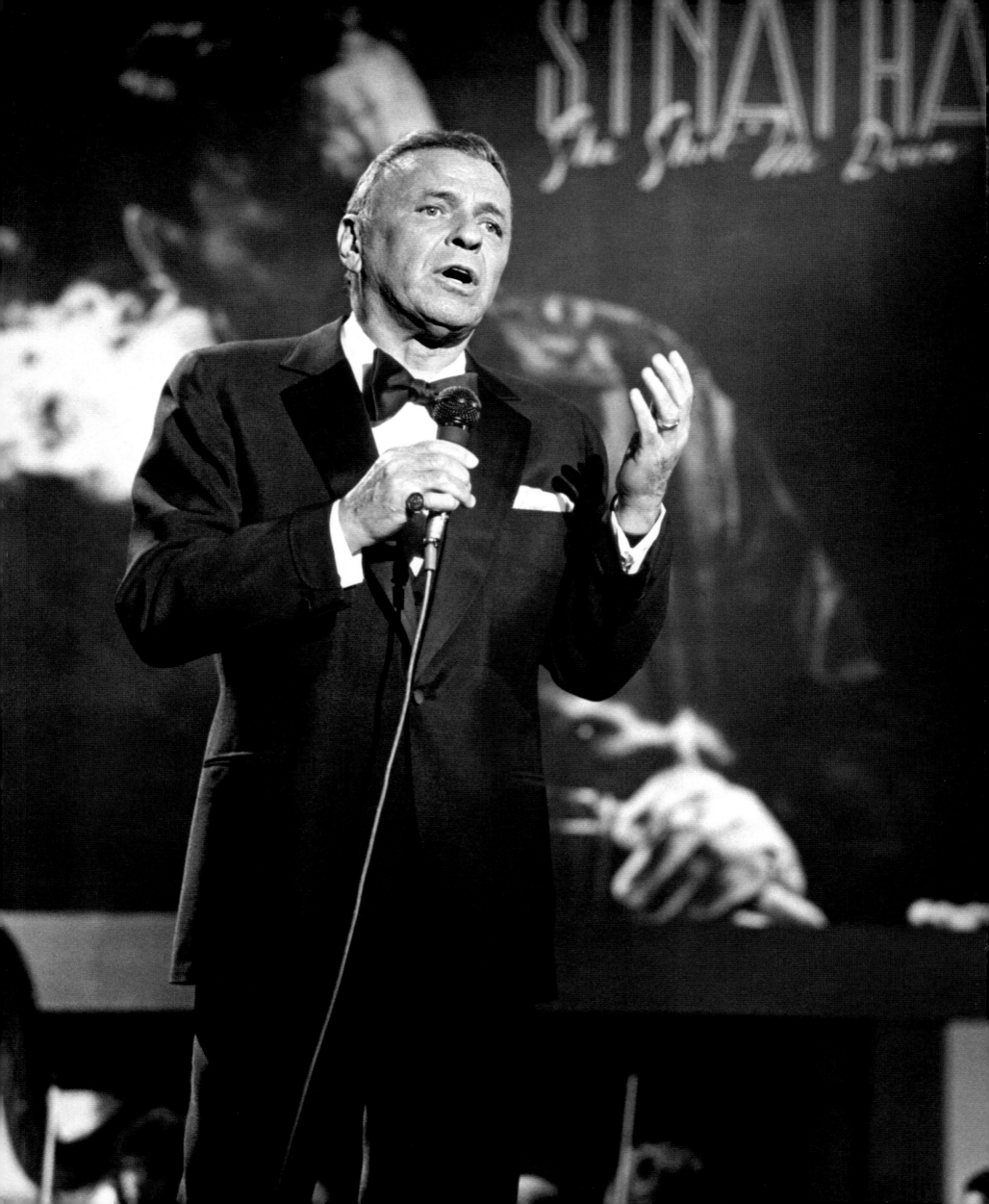

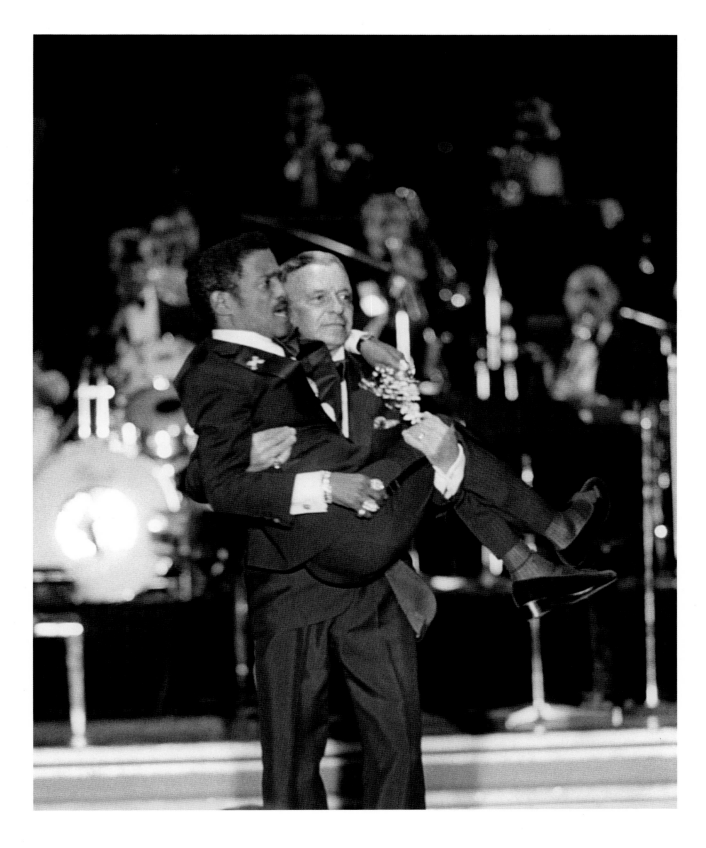

above Sinatra and Sammy Davis Jr. at the Red Cross Ball Gala
benefit in Monte Carlo, August 5, 1983. **opposite** Sinatra singing
a song from his final Reprise album *She Shot Me Down* (1981)
on his television special *Sinatra: The Man And His Music*, which
aired on NBC, November 22, 1981.

Sinatra conducts for Charles Turner, his lead trumpet player,
on his album *What's New*, recorded in early 1983.

Sinatra on stage at the Brendan Byrne Arena in the
Meadowlands Sports Complex, in his home state
of New Jersey during the 1980s.

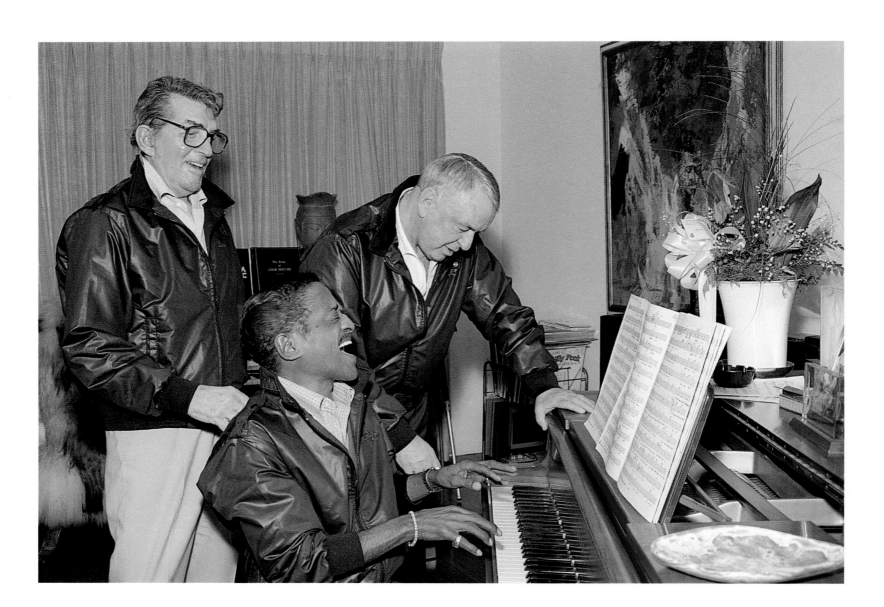

Dean Martin, Frank Sinatra, and Sammy Davis Jr. rehearse at
Davis's Beverly Hills house in March 1988, in preparation for their
"Together Again" tour. In December 1987, they had announced
they were going to do a concert tour for the first time. Note the
gray, personalized bomber jackets.

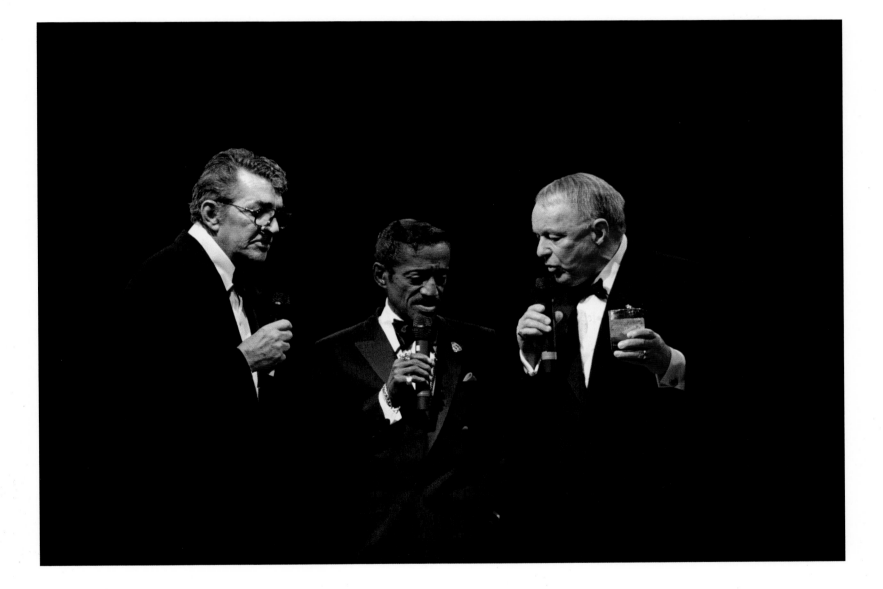

The first show of the "Together Again" tour sold out in
a few hours at the 16,000-seat Oakland Coliseum. Dean
Martin dropped out of the tour after six performances and
was replaced by Liza Minnelli. The tour was renamed
"The Ultimate Event."

"I was his musical director the last seven years of his career. It was a learning experience. I really miss the intrigue of working with him. I never knew what was going to happen, what he was going to do. My father taught me to practice what you believe in devoutly and never to be afraid to believe in something and stand with it. There's a word for it and it's called integrity."

— *Frank Sinatra Jr.*

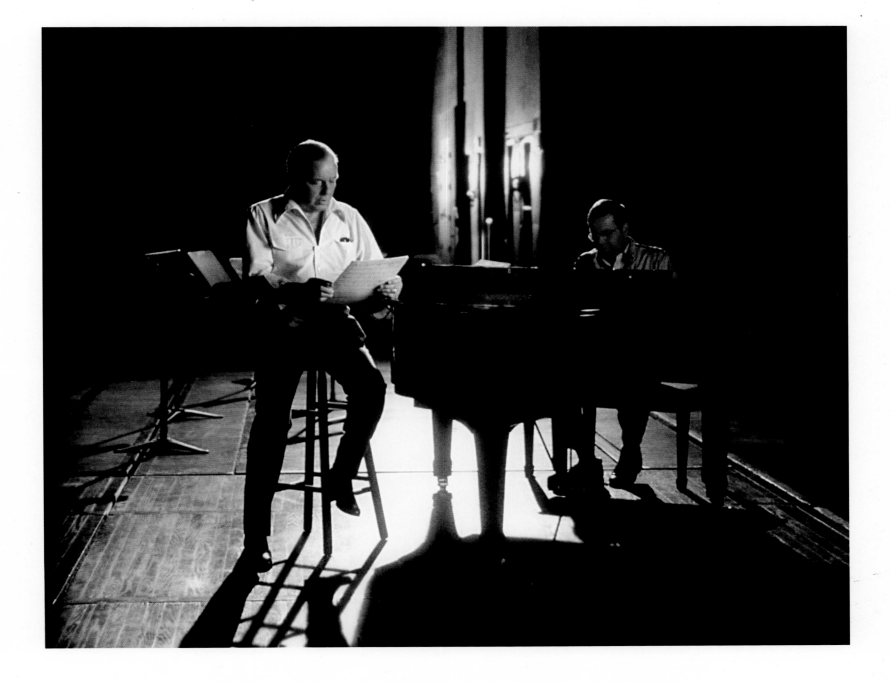

above Frank Sinatra with Frank Jr. filming backstage
for a 1988 Michelob beer commercial that featured the song
'The Way You Look Tonight.' **overleaf** Contact sheets
documenting various moments of Frank Sinatra in London
by famed photographer Terry O'Neill, including his
arrival, rehearsal, and on stage.

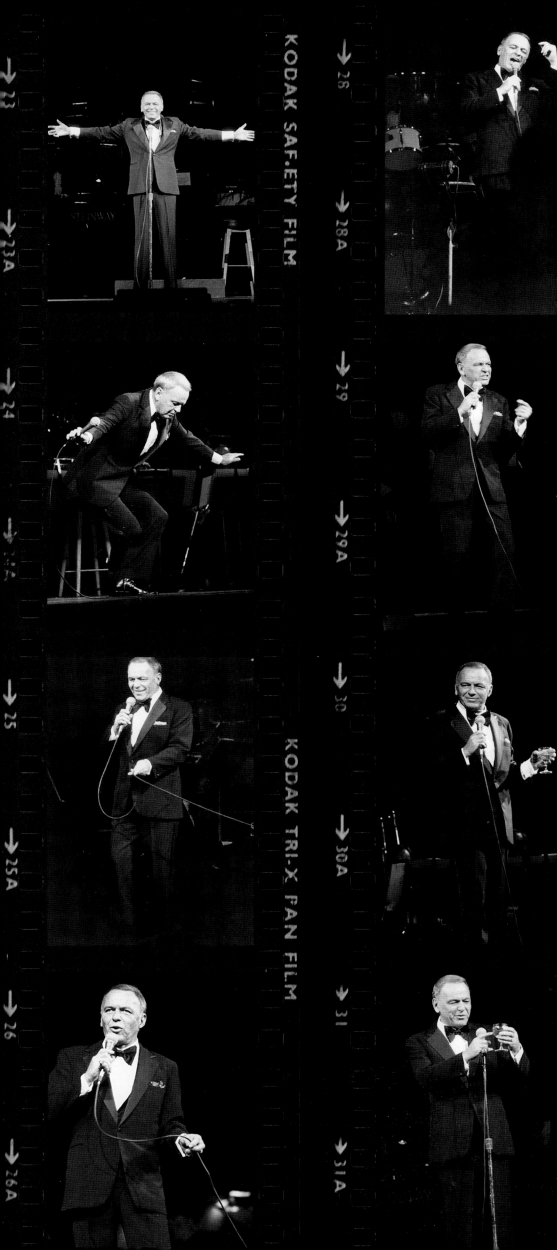

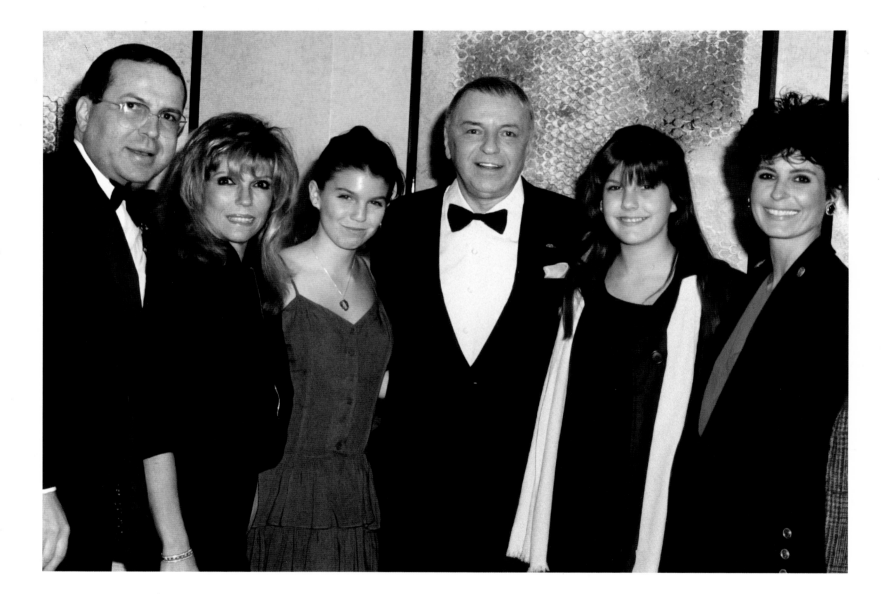

The Sinatra family – (from left to right): Frank Jr., Nancy Jr,
AJ (Nancy's first daughter), Frank, Amanda (Nancy's second
daughter), and Tina – gathers together to celebrate the New
Year at Bally's, Las Vegas, December 1988.

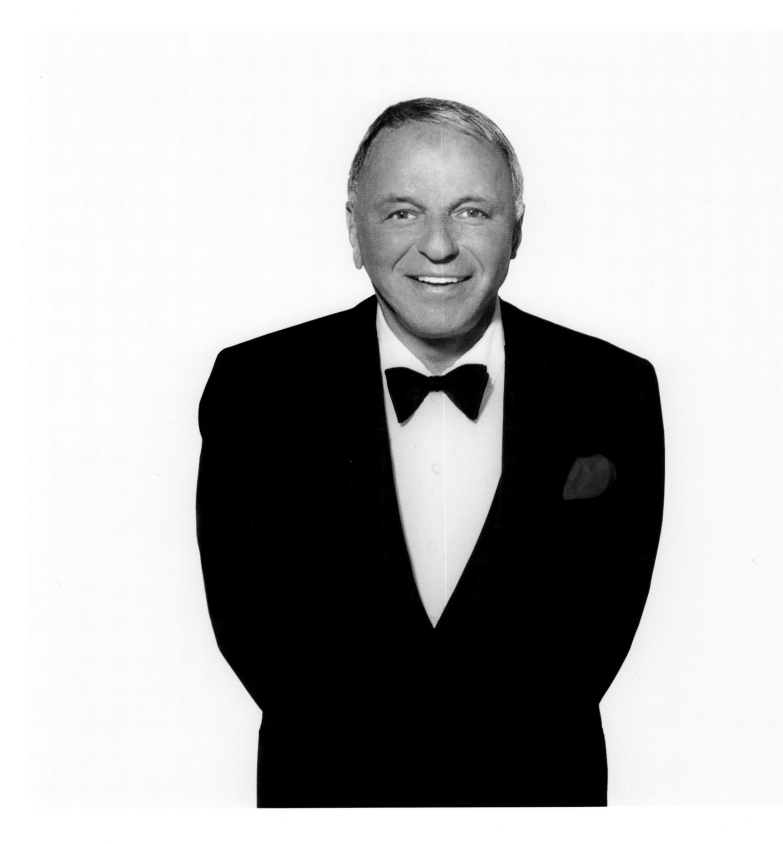

above Japan's All Nippon Airways began flying from Tokyo to New York and chose Frank Sinatra to front their advertising campaign. This, and other images of Sinatra, appeared on billboards throughout Japan in the early 1990s, where Sinatra was perhaps even more popular than in his own country. **overleaf** Frank Sinatra's televised 80th birthday event at the Shrine Auditorium in Los Angeles, California, which was taped on November 19, 1995.

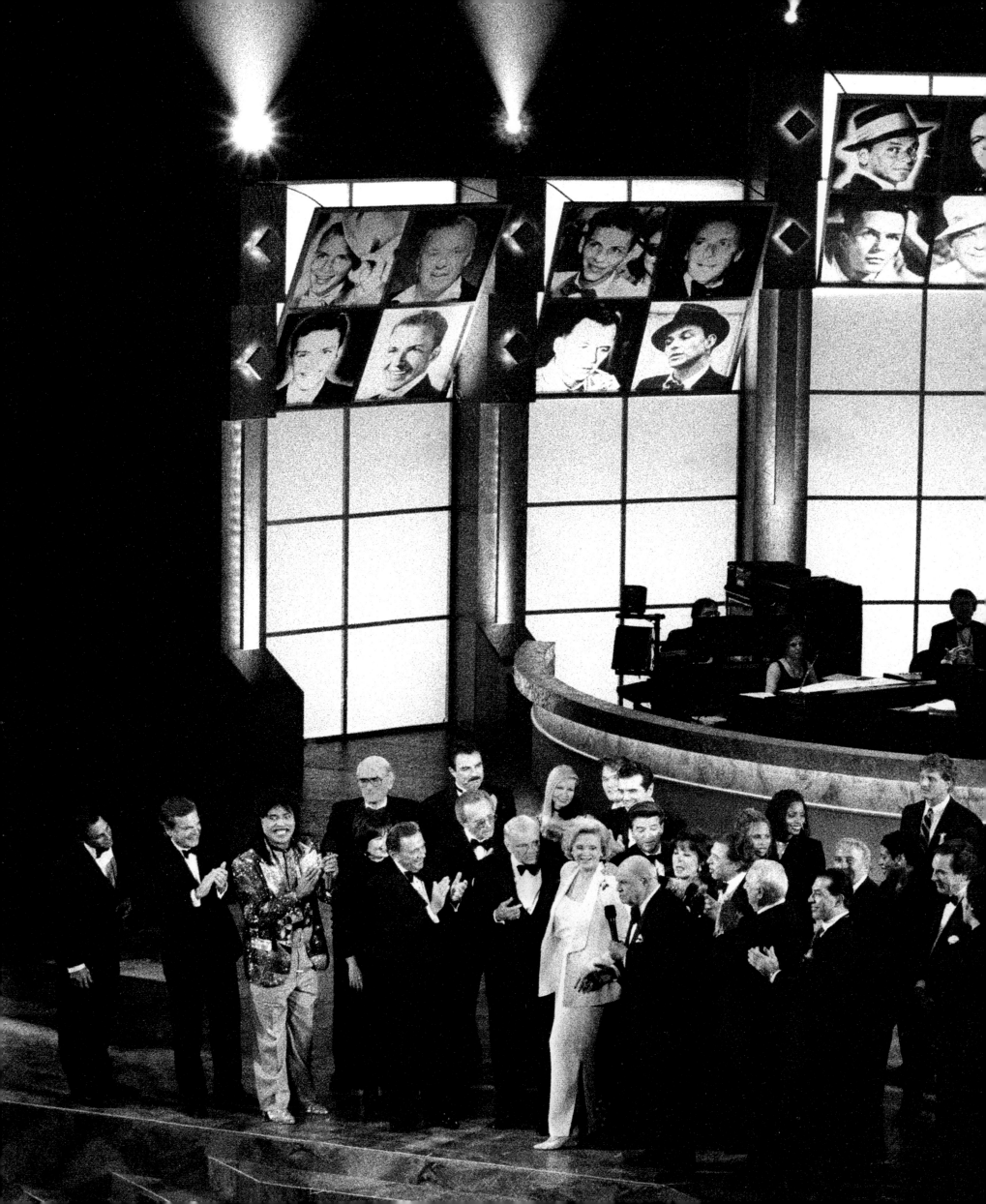

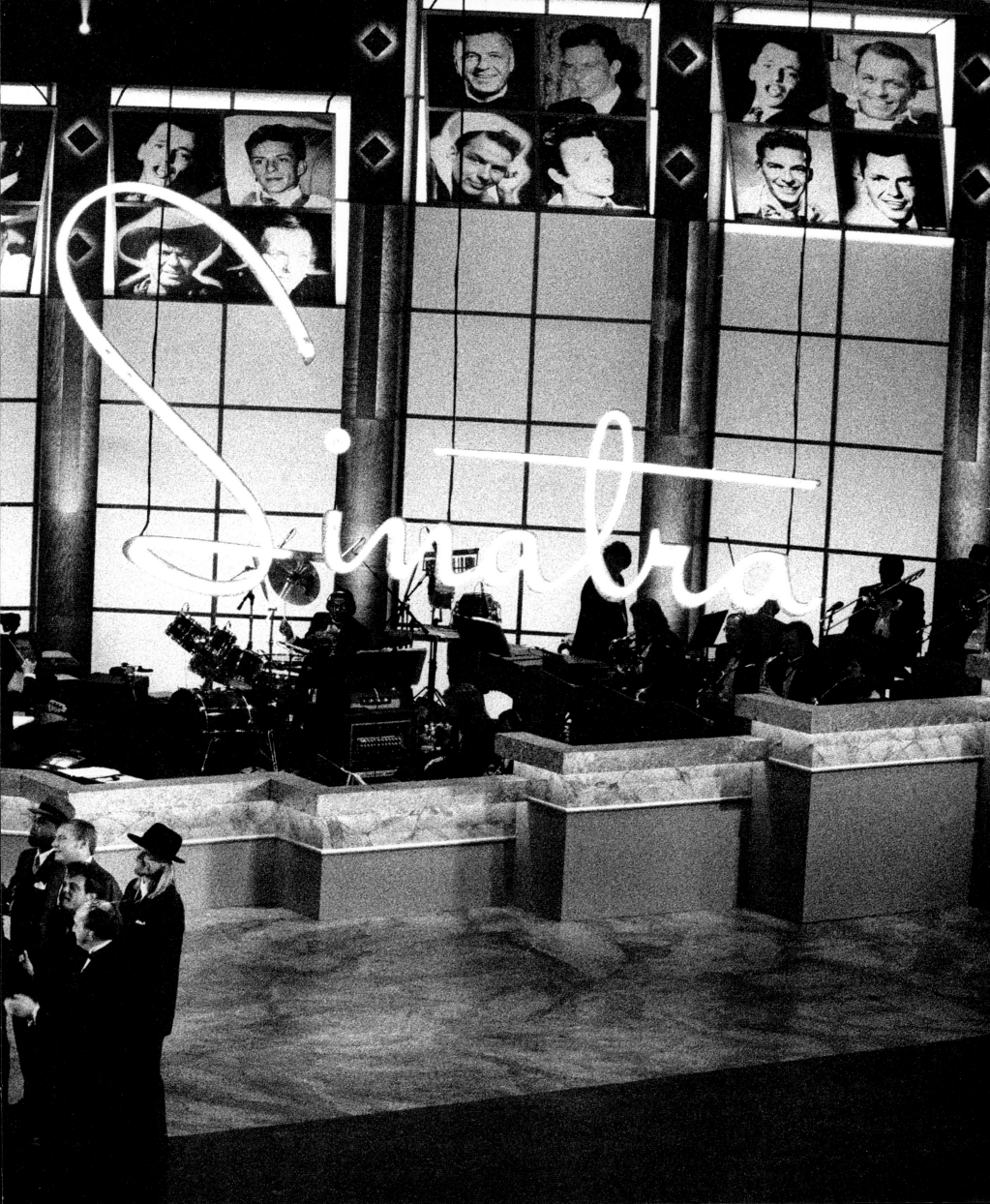

How would I describe my dad in one word?

Truthful.

He was honest to a fault.

 You didn't want to ask him anything unless you were prepared to hear the truthful answer. That honesty, plus the overwhelming generosity of spirit, was present in every scene, in every film and every song he sang. And let's not forget his talent, his intelligence, his ambition, and the twinkle in his eyes. The camera loved that twinkle. He was able to tap into his real-life experiences without studying how to do that!

 As we celebrate his one-hundredth birthday, I don't have to watch his films or play his recordings to remember him. I carry his blood in my veins, his life's music in my heart and see his immortal soul in the bright, loving eyes of my children and my granddaughter.

 For me, and millions of others, he has never left us and never will.

Nancy Sinatra

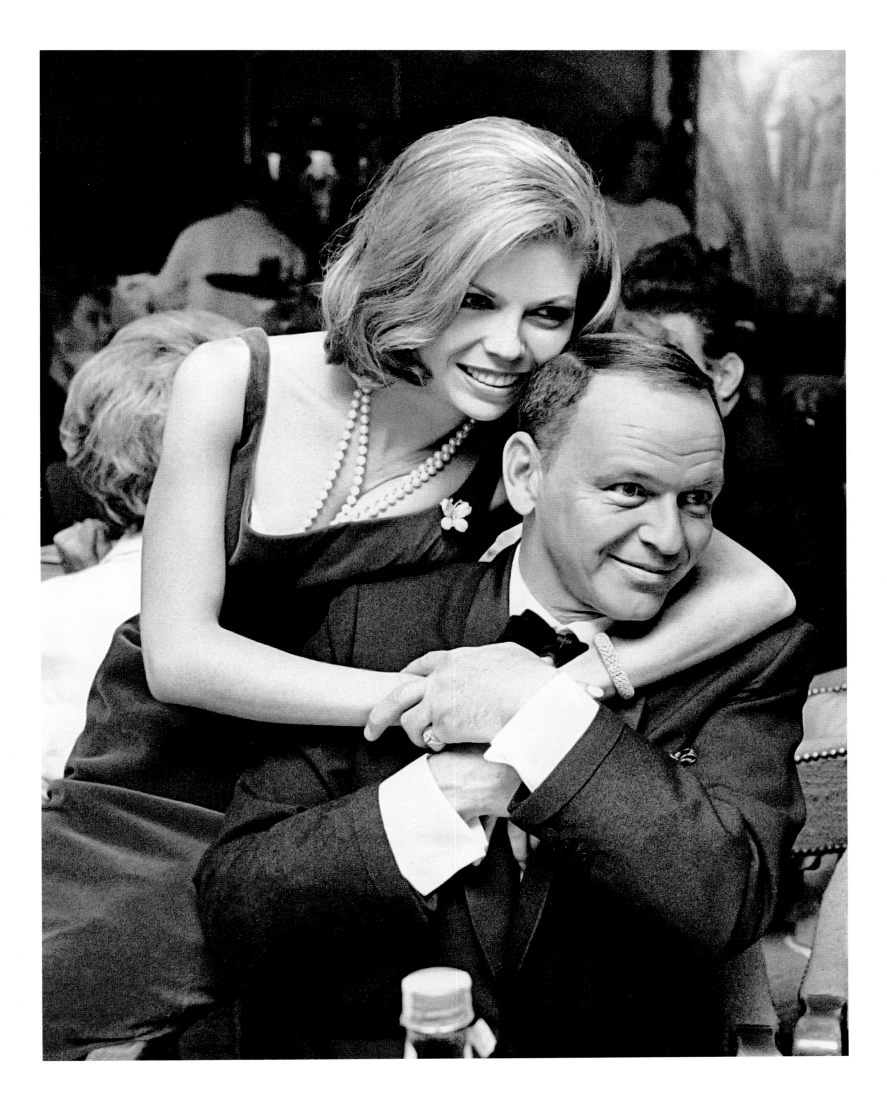

Afterword
FRANK SINATRA JR.

Historians of the twentieth century have remarked that with all of the technologies of the past century, perhaps the most important were radio and television. They further state that these two creations, that are today taken so much for granted, made information and entertainment conveniently portable. Contact with the rest of humanity could be taken wherever they chose to go. Music was available at any time...any place. Naturally, trends, styles, and tastes played a part in what people chose to hear when they turned on their radios. This was also true when they decided which movies they wanted to see when they lit up their TV screens.

How does Sinatra fit into this deduction? Before his death in 1977, Bing Crosby was asked this question by a TV interviewer: "How do you explain this popularity of Frank Sinatra that has lasted year to year and decade to decade?" For a moment, Crosby sat silent, contemplating the reporter's question. When he finally responded, his answer was more than accurate, it was prophetic. "Sinatra is the only one of us who consistently gets through to all ages." In this comment, Crosby explained what he regarded as universal appeal. Bing's friend Frank had made many great, happy, musical movies as well as many heavy, dramatic, dark movies. Bing believed that his description not only covered Sinatra the actor but also Sinatra the recording artist.

Although the Crosby conclusion could be considered debatable, it also appears to be entirely credible and very realistic.

I think a lot of people look at Sinatra as a hero. This was a little guy off the street who weighed a hundred and twenty pounds, who became a giant and lived the American dream. He had every strength that a man can have and he had every weakness that a man can have. Everyone is given certain tools while we're alive and he made the best of what he had. When he sang, it spoke to people's hearts, because he was honest. I can't give you any philosophy about it, other than the fact that he reached people.

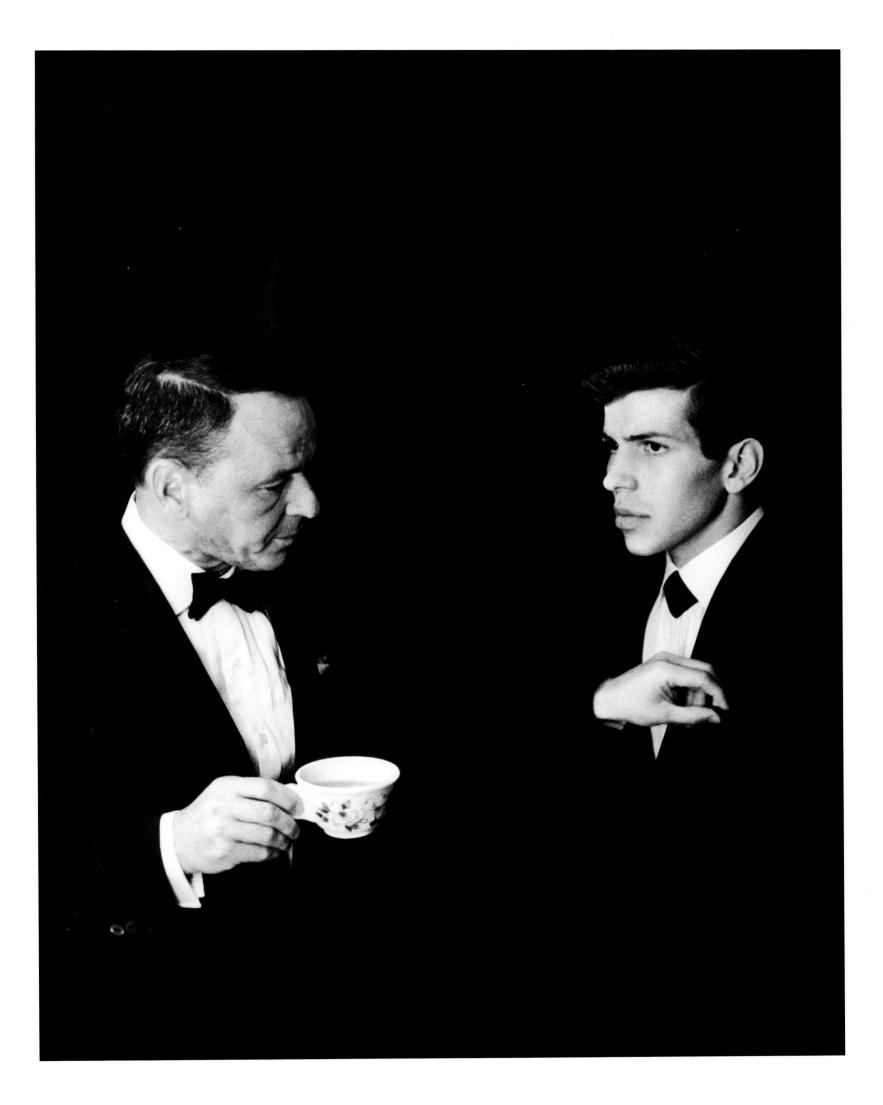

The one thing I can say about my Dad with absolute certainty is that he never took a bad picture. Why is that? Was it his to-die-for blue eyes? Or was it his gleaming white teeth and warm, engaging smile? Personally, I think he was just gorgeous. I can hear him now – "GORGEOUS, ME? NAAAH!" Okay, so maybe gorgeous is the wrong word. How about "handsome with oodles of sex appeal"? Now, *that* he'd like!

His appeal bridges the sexes and all ages around the globe, but not until his death in 1998 did I realize just how important he was to so many. At the time, it felt as though we'd all lost an old friend you don't need to see that often, but who is always there when you need them.

To this day, I miss my Dad most at five o'clock in the afternoon. That was the time he would call from wherever he was in the world; ten miles or ten thousand, he would call. One by one, we'd take the telephone receiver and chatter on like magpies about our individual days. This had to crack him up! I sure hope so.

Photographs arranged throughout our home played an important part in keeping us close, despite the long distances. God knows he was prominently displayed in my bedroom, perhaps more than anywhere else in our house in Holmby Hills. At some point, I had decided to decorate my little domain with all Dad's Capitol album covers. This was cool with Mom until I started Scotch-Taping them to the wallpaper. Likewise, Dad carried our images in accordion-folded leather picture books, small enough to carry in his kit bag. Mom made sure to have John Engstead, the renowned Hollywood portrait photographer, shoot us every couple of years, a ritual that continued until my siblings and I were old enough to say "no!" I'm kind of sorry we did that. When Dad died, I found all these very worn picture folders dropped in amongst his things – it's the little treasures that can mean the most.

My advice is to take lots of pictures and, by all means, record the voices you want to remember.

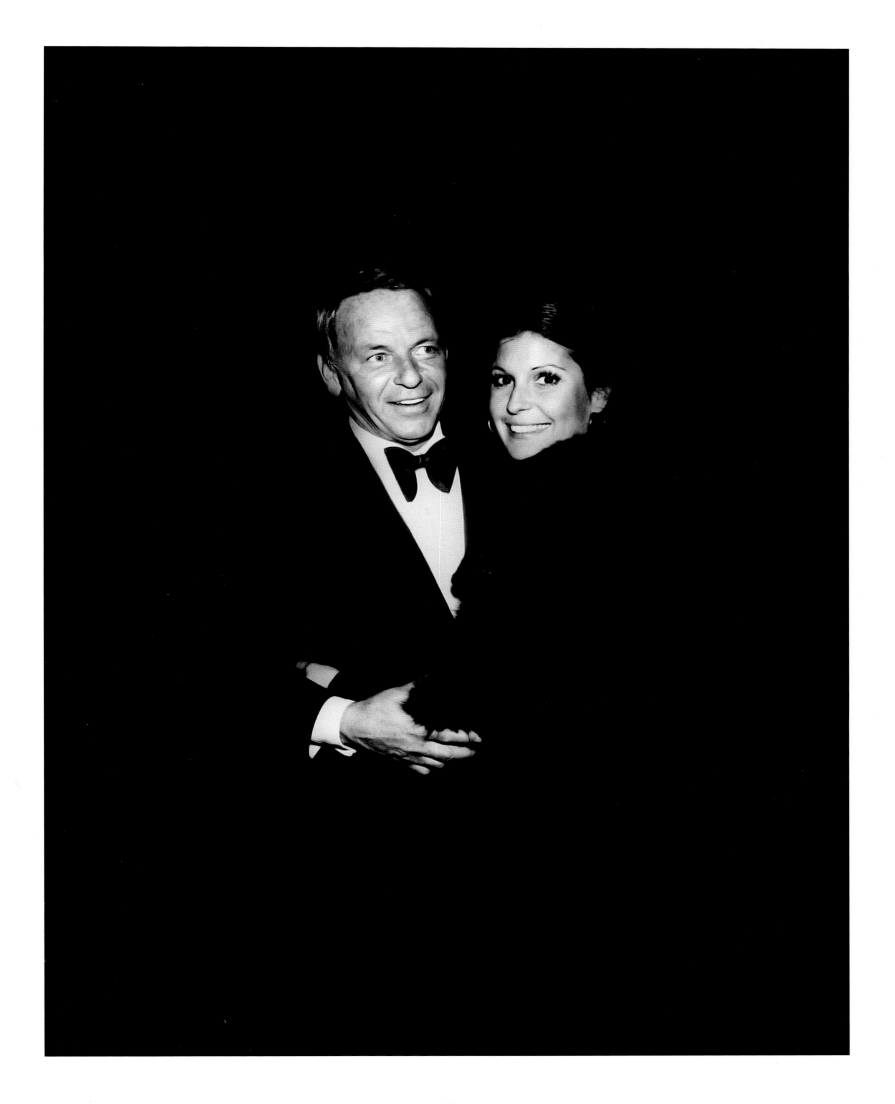

1946 • *The Voice Of Frank Sinatra* (**COLUMBIA**)

1946 • *Frank Sinatra Conducts The Music Of Alec Wilder* (**COLUMBIA**)

1947 • *Songs By Sinatra Vol. 1* (**COLUMBIA**)

1948 • *Christmas Songs By Sinatra* (**COLUMBIA**)

1949 • *Frankly Sentimental* (**COLUMBIA**)

1950 • *Dedicated To You* (**COLUMBIA**)

1950 • *Sing And Dance With Frank Sinatra* (**COLUMBIA**)

1954 • *Songs For Young Lovers* (**COLUMBIA**)

1954 • *Swing Easy!* (**CAPITOL**)

1955 • *In The Wee Small Hours* (**CAPITOL**)

1956 • *Songs For Swingin' Lovers!* (**CAPITOL**)

1956 • *High Society* (**CAPITOL**)

1956 • *Frank Sinatra Conducts Tone Poems Of Color* (**CAPITOL**)

1956 • *This Is Sinatra!* (**CAPITOL**)

1957 • *Close To You* (**CAPITOL**)

1957 • *A Swingin' Affair!* (**CAPITOL**)

1957 • *Peggy Lee: The Man I Love* (**CAPITOL**)

1957 • *Where Are You?* (**CAPITOL**)

1957 • *A Jolly Christmas From Frank Sinatra* (**CAPITOL**)

1957 • *Pal Joey* (**CAPITOL**)

1958 • *Come Fly With Me* (**CAPITOL**)

1958 • *This Is Sinatra, Volume Two* (**CAPITOL**)

1958 • *Frank Sinatra Sings For Only The Lonely* (**CAPITOL**)

1959 • *Come Dance With Me!* (**CAPITOL**)

1959 • *Dean Martin: Sleep Warm* (**CAPITOL**)

1959 • *Look To Your Heart*
(**CAPITOL**)

1959 • *No One Cares*
(**CAPITOL**)

1960 • *Can-Can*
(**CAPITOL**)

1960 • *Nice 'N' Easy*
(**CAPITOL**)

1961 • *Sinatra's Swingin'
Session!!!* (**CAPITOL**)

1961 • *All The Way*
(**CAPITOL**)

1961 • *Come Swing
With Me!* (**CAPITOL**)

1961 • *Ring-a-ding ding!*
(**REPRISE**)

1961 • *Swing Along
With Me* (**REPRISE**)

1961 • *I Remember Tommy*
(**REPRISE**)

1962 • *Sinatra & Strings*
(**REPRISE**)

1962 • *Point Of No Return*
(**CAPITOL**)

1962 • *Sinatra And
Swingin' Brass* (**REPRISE**)

1962 • *Sinatra Sings ...
Of Love And Things*
(**CAPITOL**)

1962 • *Conducts Music
From Pictures And Plays*
(**REPRISE**)

1962 • *All Alone*
(**REPRISE**)

1962 • *Sinatra Sings Great
Songs From Great Britain*
(**REPRISE**)

1962 • *Sinatra-Basie:
An Historic Musical First*

1963 • *The Concert Sinatra*
(**REPRISE**)

1963 • *Sinatra's Sinatra*
(**REPRISE**)

1963 • *Reprise Musical
Repertory Theatre* (**REPRISE**)

1963 • *Finian's Rainbow*
(**REPRISE**)

1963 • *Guys And Dolls*
(**REPRISE**)

1963 • *Kiss Me Kate*
(**REPRISE**)

1963 • *South Pacific*
(**REPRISE**)

1964 • *Days Of Wine And
Roses, Moon River* (**REPRISE**)

1964 • *Robin And The
7 Hoods* (**REPRISE**)

1964 • *It Might As Well
Be Swing* (**REPRISE**)

1964 • *12 Songs Of Christmas*
(**REPRISE**)

1964 • *Softly, As
I Leave You* (**REPRISE**)

1964 • *America, I Hear You Singing* **(REPRISE)**

1965 • *Sinatra '65* **(REPRISE)**

1965 • *September Of My Years* **(REPRISE)**

1965 • *My Kind Of Broadway* **(REPRISE)**

1965 • *A Man And His Music* **(REPRISE)**

1966 • *Moonlight Sinatra* **(REPRISE)**

1966 • *Strangers In The Night* **(REPRISE)**

1966 • *Sinatra At The Sands With Count Basie & The Orchestra* **(REPRISE)**

1966 • *That's Life* **(REPRISE)**

1967 • *Francis Albert Sinatra & Antonio Carlos Jobim* **(REPRISE)**

1967 • *The World We Knew* **(REPRISE)**

1968 • *Francis A. & Edward K.* **(REPRISE)**

1968 • *Frank Sinatra's Greatest Hits* **(REPRISE)**

1968 • *Cycles* **(REPRISE)**

1968 • *The Sinatra Family Wish You A Merry Christmas* **(REPRISE)**

1969 • *My Way* **(REPRISE)**

1969 • *A Man Alone* **(REPRISE)**

1970 • *Watertown* **(REPRISE)**

1971 • *Sinatra & Company* **(REPRISE)**

1972 • *Frank Sinatra's Greatest Hits, Vol. 2* **(REPRISE)**

1973 • *Ol' Blue Eyes Is Back* **(REPRISE)**

1974 • *Some Nice Things I've Missed* **(REPRISE)**

1974 • *The Main Event: Live From Madison Square Garden* **(REPRISE)**

1980 • *Trilogy: Past, Present, Future* **(REPRISE)**

1981 • *She Shot Me Down* **(REPRISE)**

1982 • *Sylvia Syms: Syms By Sinatra* **(REPRISE)**

1984 • *L.A. Is My Lady* **(QWEST)**

1993 • *Duets* **(CAPITOL)**

1994 • *Duets II* **(CAPITOL)**

1941 • *Las Vegas Nights*

1943 • *Higher And Higher*

1944 • *Step Lively*

1945 • *Anchors Aweigh*

1945 • *The House I Live In*

1946 • *Till The Clouds Roll By*

1947 • *It Happened In Brooklyn*

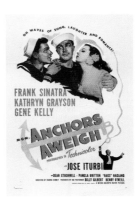

1948 • *The Kissing Bandit*

1948 • *The Miracle Of The Bells*

1949 • *Take Me Out To The Ball Game*

1951 • *Double Dynamite*

1952 • *Meet Danny Wilson*

1953 • *From Here To Eternity*

1954 • *Young At Heart*

1954 • *Suddenly*

1955 • *The Man With The Golden Arm*

1955 • *Guys And Dolls*

1955 • *The Tender Trap*

1955 • *Not As A Stranger*

1956 • *Johnny Concho*

1956 • *Around The World In 80 Days*

1956 • *High Society*

1956 • *Meet Me In Las Vegas*

1957 • *Pal Joey*

1957 • *The Joker Is Wild*

1957 • *The Pride And The Passion*

1958 • *Some Came Running*

1958 • *Kings Go Forth*

1959 • *A Hole In The Head*

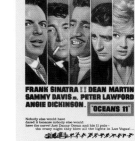

1959 • *Never So Few*

1960 • *Ocean's 11*

1960 • *Can-Can*

1960 • *Pepe*

1961 • *The Devil At 4 O'Clock*

1962 • *The Road To Hong Kong*

1962 • *The Manchurian Candidate*

1962 • *Sergeants 3*

1963 • *4 For Texas*

1963 • *Come Blow Your Horn*

1963 • The List of Adrian Messenger

1964 • *Robin And The 7 Hoods*

1965 • *Marriage On The Rocks*

1965 • *None But The Brave*

1965 • *Von Ryan's Express*

284

1966 • *Assault On A Queen*

1966 • *Cast A Giant Shadow*

1966 • *The Oscar*

1967 • *Tony Rome*

1967 • *The Naked Runner*

1968 • *Lady In Cement*

1968 • *The Detective*

1970 • *Dirty Dingus Magee*

1974 • *That's Entertainment*

1980 • *The First Deadly Sin*

1984 • *Cannonball Run II*

"My toast is simply that I wish everyone a thousand times more than I have gotten in my life. I wish everyone in the world a lot of sweet things, pleasant dreams, hugging, kissing and peace in our time. May you all live to be a hundred and may the last voice you hear be mine!"

– Francis Albert Sinatra
1915–1998

above The Good Shepherd Catholic Church, Beverly Hills, California on the day of Frank Sinatra's funeral, May 20, 1998.

•

The author would like to extend very special thanks to the following people:

Nancy Sinatra Sr., Nancy Sinatra Jr., Frank Sinatra Jr., Tina Sinatra, Robert Finkelstein, Amanda Erlinger and A.J. Lambert. Without their friendship, insight, trust and support this book would not have been possible.

• • •

Tony Bennett and Steve Wynn. Words cannot express the depth of my gratitude for their time and assistance in any project I have asked them to be a part of over the last thirty years.

• • •

Brook Babcock, Ken Barnes, Susan Benedetto, Danny Bennett, Tita Cahn, Hank Cattaneo, Stan Cornyn, Andrew Daw, Angie Dickinson, Rob Dondero, Tom Dreesen, Jimmy Edwards, George Feltenstein, Holly Foster-Wells, Rick Gray, Max Hole, Steffan Hughes, Quincy Jones, George Kalinsky, Vartan Kurjian, Anette Levine, Cindy Mitchum, Bill Moynihan, Frances Pignone, Laurie Pignone, Mark Pinkus, John Ray, Tony Renaud, Bruce Resnikoff, Herman Rush, Joe Scognamillo, Sal Scognamillo, Matt Schreiber, Jerry Sharell, Joe Soldo, Kelly Spinks, Lisa Tan, Sylvia Weiner, Terry Woodson, Tom Young and Bill Zehme.

• • •

Tristan de Lancey, Alex Wright, Dan Gottesman, Jon Crabb, Paul Hammond, Jane Laing, and Will Balliett for their dedication and support with this project at Thames & Hudson.

• • •

And a special thanks to all of those included in the book for their recollections and memories.

images pages 2–8 (pages 2–3) Sinatra recording at Capitol Records with Nelson Riddle and orchestra on August 23, 1960; (pages 4–5) Sinatra at a Reprise session recording 'Any Time At All' on November 10, 1964; (page 6) An outtake from the *Swing Along With Me* (1961) album cover photoshoot; (page 8) Sinatra recording the song 'Close To You' at Capitol Records on November 1, 1956.

•

Sinatra 100 © 2015 Thames & Hudson Ltd

Main text © 2015 Charles Pignone
Foreword by Tony Bennett © 2015 Tony Bennett
Foreword by Steve Wynn © 2015 Steve Wynn
Afterword by Nancy Sinatra © 2015 Nancy Sinatra
Afterword by Frank Sinatra Jr.© 2015 Frank Sinatra Jr.
Afterword by Tina Sinatra © 2015 Tina Sinatra

First published in 2015 in hardcover in the United States of America by Thames & Hudson Inc. 500 Fifth Avenue, New York, New York 10110

thamesandhudsonusa.com

Library of Congress Catalog Card Number 2015932472

ISBN 978-0-500-51782-6

Manufactured in China by Imago